Comics Studies

A Guidebook

EDITED BY CHARLES HATFIELD AND BART BEATY

Rutgers University Press
New Brunswick, Camden, and Newark, New Jersey, and London

Library of Congress Cataloging-in-Publication Data

Names: Hatfield, Charles, 1965– editor. | Beaty, Bart, editor.
Title: Comics studies : a guidebook / edited by Charles Hatfield and Bart Beaty.
Description: New Brunswick, New Jersey : Rutgers University Press, 2020. | Includes bibliographical references and index.
Identifiers: LCCN 2019050055 | ISBN 9780813591421 (hardback) | ISBN 9780813591414 (paperback) | ISBN 9780813591438 (epub) | ISBN 9780813591445 (mobi) | ISBN 9780813591452 (pdf)
Subjects: LCSH: Comic books, strips, etc.—History and criticism.
Classification: LCC PN6710 .C6664 2020 | DDC 741.5072—dc23
LC record available at https://lccn.loc.gov/2019050055

A British Cataloging-in-Publication record for this book is available from the British Library.

This collection copyright © 2020 by Rutgers, The State University of New Jersey
Individual chapters copyright © 2020 in the names of their authors
All rights reserved
No part of this book may be reproduced or utilized in any form or by any means, electronic or mechanical, or by any information storage and retrieval system, without written permission from the publisher. Please contact Rutgers University Press, 106 Somerset Street, New Brunswick, NJ 08901. The only exception to this prohibition is "fair use" as defined by U.S. copyright law.

♾ The paper used in this publication meets the requirements of the American National Standard for Information Sciences—Permanence of Paper for Printed Library Materials, ANSI Z39.48-1992.

www.rutgersuniversitypress.org

Manufactured in the United States of America

Comics Studies

In memory of
Don Ault and Tom Spurgeon,
mentors and great souls—
and to the comics scholars
of the future

Contents

Introduction ... 1
BART BEATY AND CHARLES HATFIELD

Part I Histories

1 Comic Strips .. 13
 IAN GORDON

2 Comic Books ... 25
 CHARLES HATFIELD

3 Underground and Alternative Comics 40
 ROGER SABIN

4 European Traditions .. 53
 BART BEATY

5 Manga ... 66
 FRENCHY LUNNING

6 The Graphic Novel ... 82
 ISAAC CATES

Part II Cultures

7 Comics Industries ... 97
 MATTHEW P. MCALLISTER AND BRIAN MACAULEY

8 Readers, Audiences, and Fans 113
 BENJAMIN WOO

9	Children and Comics PHILIP NEL	126
10	Difference THERESA TENSUAN	138

Part III Forms

11	Cartooning ANDREI MOLOTIU	153
12	Design in Comics: Panels and Pages MARTHA KUHLMAN	172
13	Words and Images JAN BAETENS	193

Part IV Genres

14	Superheroes MARC SINGER	213
15	Autographics GILLIAN WHITLOCK	227
16	Girls, Women, and Comics MEL GIBSON	241
17	Digital Comics DARREN WERSHLER, KALERVO SINERVO, AND SHANNON TIEN	253

Time Line of Selected Events	267
Acknowledgments	283
Bibliography	285
Notes on the Contributors	305
Index	311

Comics Studies

Introduction

● ●

BART BEATY AND CHARLES HATFIELD

Any field busy and productive enough to merit a guidebook will by definition be too busy and productive for a single book to cover. Comics studies is one such field, a fast-growing area of scholarship at the intersection of many academic disciplines (and confined to no single one). The growth of comics studies in the twenty-first century has been explosive, so much so that scholars and students of the form can hardly keep up. That, we believe, bodes well for the field, but is also the impetus for this book.

A number of ambitious books have sought to cover comics studies in a single bound, yet it remains difficult to map this vast and spreading field. From our perspective, it has seemed that students in comics studies still lack a dependable text that succinctly identifies the field's core issues and debates, a compact volume that can serve as a first stop, critical sourcebook, and study guide. This book aims to be just that: an overview of comics studies that sketches the contours of the field and spotlights core critical issues. Of course, it is impossible to do justice to comics studies in one volume, but this book, composed of seventeen original essays commissioned from leading scholars, offers to show the lay of the land—or rather, one set of strategies for mapping it. We hope you find this book an engaging, provocative, and useful guide.

Consider this volume, then, a timely dispatch from a dynamic, unruly project shared (and its very terms contested) by a great many scholars. Comics studies is not the most conventional and respectable of fields in academia, and the terms of its acceptance remain in dispute.[1] Certainly, the liveliness of comics has not been corralled into a settled, predictable discipline. Comics may

1

remain, as Scott Bukatman has it, a happy "monster" that works the margins and interstices of culture: impure, hybrid, and hard to place, "a threat to established order and orderliness."[2] The very idea of a singular academic guidebook to comics studies may seem crazy. Yet clearly comics studies does need maps and guides—it is that busy. The vitality of comics studies reflects the fact that comics itself, as a communicative medium and art form, has gained new ground and, indeed, undergone a drastic change in status within our culture. This book is an attempt to catch up.

While in America the disposable comic strip and comic book are no longer inescapable parts of everyday life—that is, comics no longer reach into the daily routines of millions—the cultural impact of comics has never registered more strongly among scholars than it does today. Indeed, the art form has attained greater critical if not economic clout than ever before. Even as comic books inspire world-spanning Hollywood blockbusters, introspective graphic books (novels, memoirs, histories) are making the best-seller charts and critical "best of" lists. Graphic novels have become a staple, even a pillar, of children's publishing, overcoming decades of mistrust and disregard. Translated Japanese manga, familiar to so many readers raised on visually saturated media, constitute a robust literary form. Webcomics, with us now for well over twenty years, are likewise a thriving culture. Hence comics remain embedded in the cultural vernacular.

At the same time, a new generation of curators has rushed to exhibit comics art in museums and galleries, and new forms of comics criticism have emerged. In fact, comics have never been studied more intensively than now. This young century has seen comics win major literary prizes, shape the image-making practices of filmmakers and game designers, and inspire a burst of scholarly publications, both journals and books. Comics scholarship is booming, as confirmed by the launch in 2014 of the Comics Studies Society, the United States' first professional association for comics researchers and teachers. Comics teaching in higher education has surged: courses on comics have sprouted everywhere from community colleges to public universities to Ivy League institutions. The academic landscape in North America is dotted with comics classes, and more and more schools are responding to the high demand for them. Comics studies degree programs and concentrations have begun to appear, both undergraduate and graduate. In addition, there are many comics-based studio programs within art schools, some new and some older, that are training new generations of creators.

As part of the first generation of academics to stake our careers on comics scholarship, we have witnessed this explosion gratefully and with awe.[3] Our *Guidebook* attempts to make sense of it all in terms that will help up-and-coming scholars in the field. For practical reasons, we have centered this book on (broadly speaking) Anglophone comic strips, comic books, and graphic novels, yet we seek to situate those genres within the greater context of world comics.

That is, while our *Guidebook* highlights trends in comics that have had a very noticeable impact in the United States, Canada, and the United Kingdom, it also takes an international view, tapping scholarly resources in other languages, acknowledging influences from Japanese and European traditions, and reflecting on the global circulation of comics culture. The result, we believe, will help students of comics gain much-needed perspective on the development of the form—indeed, a satellite view of comics studies as a vibrant and emerging field.

We use the satellite metaphor advisedly, to signal our interest in the entire comics world yet also to remind ourselves of the hazards of cultural imperialism. To speak or write of "world comics" invites charges of imperial overreach; after all, the Western label "comics" should not be the measure of sequential art and graphic narrative traditions worldwide. Anglophone comics traditions do not map neatly onto, for instance, Japanese manga traditions, as Frenchy Lunning shows in chapter 5 of this volume, or even other Western traditions such as that of Francophone *bande dessinée.* Nor do the many other histories of comics from around the world align easily with each other—and again, even to call them histories of *comics*, when other terms and concepts may take precedence in their cultures of origin, perhaps seems like a form of colonization. To be sure, the *lianhuanhua* of China, the *manhwa* of Korea, and the *historietas* of Mexico or Argentina (to name but a few examples) are not interchangeable with, or simply adjuncts of, Anglophone comics from the United States, Canada, or the United Kingdom. To posit them all as aspects of a single object of study may flatten out important differences.

While certain comics cultures—take for instance Japanese manga, Franco-Belgian BD, and U.S. comics—have been exported widely and influenced the comics of other cultures, this does not mean that they are the only templates necessary for understanding how comics are made worldwide. Even what we have called "Anglophone comics" is a cluster of traditions rather than a single one, a complex field in which multiple national histories overlap and sometimes compete. Consider, for instance, the differences between U.S.-style comic books and the British tradition of comic weeklies. Australian artist-scholar Pat Grant, who was raised in a remote coastal town in New South Wales, describes his sense of distance from "the Anglophone comics tradition" in an essay included in his graphic novel *Blue* (2012): "Someone like me ought to take the dominant history of comics well salted." Grant reflects, "I grew up with other things," and notes that his own "local comics tradition" does not "intersect with the grand narratives" of comics history in any obvious way.[4] Yes, he knows those grand narratives—his essay, dotted with famous American names, shows as much—but they don't speak to either his own history or his sense of the current possibilities of comics. We take Grant's point: there is always a risk that rehashing the grand narratives will hide other riches, that too great an emphasis on the famous and oft-exported will blind us to local scenes *and* to a larger, fuller world, one of diverse narrative art traditions.

We should admit up front that this *Guidebook* repeats certain grand narratives that seem important to grounding our sense of Anglophone comics. Yet our contributors have also brought new conceptual frameworks that can help boost understanding and appreciation of works from around the world. We do believe that there is such a thing as *world comics*, or international comics, insofar as lines of influence among comics creators and industries increasingly overstep national boundaries. Many comics artists are aware of and draw inspiration from major figures in world comics, and translations play an important part in the reading lives of many comics readers. Whatever terms we use to denote the form—comics, BD, manga, or others—we know that many dedicated readers affirm the continuity of graphic storytelling across cultures and seek out graphic narratives in diverse traditions and styles. Comics, then, is a recognizable art form across borders.[5] Further, the idea that any one culture "invented" comics is a canard that we can do without. Influence moves in every direction: for example, to understand American comic books, graphic novels, and webcomics in the twenty-first century, it helps to know about the influence of Japanese manga and anime; conversely, to understand the development of twentieth-century manga, it helps to know about the influence of early American comic strips and animated cartoons. Calling all these phenomena "comics" is, for us, a convenient way of tagging a multifaceted global art form, one that is never cordoned off from other influences but draws inspiration from myriad centers of culture (just as other cultural forms draw from comics). We see the idea of world comics as a pathway to cross-cultural understanding, not an inducement to search all over the world for the same few, familiar things. May this *Guidebook*, in part through its very limitations, spur further efforts at mapping, countermapping, and (re)framing.

To assist readers in mapping out the comics studies world, this *Guidebook* is divided into four sections focusing on, respectively, "Histories," "Cultures," "Forms," and "Genres." The first of these is the most extensive and yet still would benefit from an even greater number of essays, for the history of comics around the globe is fascinating and multivaried. Ian Gordon, whose 1998 book, *Comic Strips and Consumer Culture, 1890–1945*, remains an essential academic volume on the history of the early American strip, here offers an overview of the development of the comic strip publishing format from the nineteenth through the twenty-first centuries. Rooting his discussion in the way that comic strips circulate not only in newspapers but, more importantly, in the culture of a nation, Gordon persuasively demonstrates the important ways that comic strips helped shaped twentieth-century mass media. Gordon's chapter is followed by that of Charles Hatfield, who maps the development of that particularly American publishing format, the "comic book," from the 1930s through to the present day. Hatfield discusses the commercial and artistic influences that shaped the development of the comic book as a sentimental object whose contributions to the public imagination have been both celebrated and challenged. In

his contribution here, Roger Sabin—whose 1993 volume, *Adult Comics: An Introduction*, was one of the earliest peer-refereed books in the field—looks at the important comic book subgenres of underground and alternative comix. Defining themselves as starkly distinct from the mass-market material of their day, these works brought countercultural values and new aesthetic norms to the field. Sabin cannily locates this ferment in its historical period and considers the movement in all of its transnational complexity. Following Sabin, Bart Beaty has assumed the frankly impossible task of writing about the entire comics culture of Europe, a subject that merits (at least) another volume of this size. Beaty finds connections across this heterogeneous field marked by linguistic and cultural differences, suggesting that it can be best understood through a series of oppositions that that are common throughout many national comics traditions—children/adult, mass market / niche market. Similarly, Frenchy Lunning, the longtime editor of *Mechademia* (the pioneering English-language journal dedicated to the study of Japanese comics, animation, and popular culture), provides insights into the historical trajectory of comics in Japan. Tracing the development of manga over the course of centuries, Lunning complicates our understanding of comics as a particularly modern form of communication while also problematizing the historian's quest for definitive "origins." Finally, we conclude our foray into history with Isaac Cates's consideration of the development of the "graphic novel," which in the twenty-first century has come to be regarded as an important publishing category and, for many readers—and indeed scholars—a cultural object distinct from "comics" (a somewhat contentious claim). Cates elegantly sorts through the origins of the graphic novel as an idea—and an ideal—showing how this publishing format, or rather movement, has worked to construct a shared set of assumptions about the possibilities inherent in the comics form among successive generations of comics creators.

Part 2, "Cultures," opens the floor to the consideration of four of the most consistently engaging debates in current comics studies; these are the big questions to which our field returns again and again. Matthew P. McAllister and Brian MacAuley lead off with a consideration of comics as a form of cultural industry. For much of the twentieth century, comics were an art form that earned relatively little respect from institutional tastemakers like museums and universities. Their historic association with mass culture and their inexpensive and sometimes shoddy nature militated against the idea that comics might be "art"; they were clearly "business." McAllister and MacAuley do not challenge that conclusion but rather tease out the ramifications of comics as a specific cultural industry, or industries, with its own unusual arrangements in terms of production, distribution, and licensing. If comics is a business, then it must also have its customers, and this is the subject of Benjamin Woo's chapter on audiences and fans. Woo, the author of *Getting a Life: The Social Worlds of Geek Culture* (2018), draws on the rapidly growing literature on the sociology of fandom to demonstrate how comics readers have interacted with the field

as hobbyists, collectors, commentators, and creators. Woo complicates the commonplace mental image of the comic book fan as a nerdy introvert, extends the notion of audience beyond fandom and highlights the complex ways that readers shape the comics industry rather than merely allowing themselves to be shaped by it. In the succeeding chapter, Philip Nel, whose publications include *Was the Cat in the Hat Black?* (2017) and collections of Crockett Johnson's beloved strip *Barnaby* (1942–1952), considers one of the most important of comics' audiences: children. Specifically, Nel explains how comics developed a sense of children as their key audience, and how they have communicated to children over time. For Nel, the space between comics and children's literature is a narrow one, and he guides readers to understand the way these two fields, often considered to be distinct, mutually reinforce the way that we understand young people and their use of media. Finally, Theresa Tensuan takes on one of the most pressing questions in contemporary comics scholarship, the representation and structuring of difference. Beginning with the work of cartoonist Lynda Barry and concluding with a close reading of Carla Speed McNeil's *Finder: Voice* (2011), Tensuan considers the way that comics, an art form historically rooted in visual stereotypes, has worked to inspire reflection upon ethnoracial, gender-based, and other types of difference. While this too is a topic much too vast to be contained by a single chapter, Tensuan provocatively opens an entryway to urgent areas of scholarship and debate.

Our third section, "Forms," offers three essays on distinctive formal and aesthetic qualities of comics. Every art form has its unique formal affordances or features and each its own history and rules. In literature, we might think of the formal constraints that define a sonnet; in cinema, the rules of continuity editing. Comics, too, have formal qualities not commonly appreciated by scholars working in adjacent fields, and these essays invite reflection on how these qualities may shape meaning-making. First, Andrei Molotiu explores the art of cartooning: the practice of narrative drawing that has been central to most comics. An art historian and comics artist, Molotiu considers cartooning from various perspectives, moving from theories of cartooning as they have been developed over time to considerations of "cartoonism" as an aesthetic preference (or even bias) and then to cartooning as a form of acting. In comics art, the hand of the artist is usually presumed to be visible to readers through the material traces of pen and brush on paper—and that stylized handiwork, cartooning, is at the heart of aesthetic debates about the comics form. Next, Martha Kuhlman examines the place of design in comics, shifting from drawing to the totality of the page and thence to the entirety of books. Kuhlman highlights the important ways that *sequence* structures our reading of comics and revisits many of the core debates in the formal evaluation of comics as they have developed since (at least) the 1960s, providing a point of entry to the overlooked complexities of the comics form. Finally, Jan Baetens asks us to consider the complications that arise in

an art form that relies heavily on both image and text. Baetens reminds us that since the Enlightenment, logocentrism and iconoclasm have tended to privilege the written word over the drawn image, a fact that has tended to diminish the status of comics. Demonstrating that this need not be so, Baetens considers the conflicts and correspondences that arise in comics' mixing of word and image: complexities that challenge us to set aside preconceptions about what comics can and cannot do.

Our final section, "Genres," considers four of the most important types or subfields of comics as they have developed over time. Central among these in U.S. comic books is the genre of the superhero, a type of character that arose in the nascent comic book industry of the 1930s and has since come to dominate mass culture via film, television, and video games. Marc Singer is our guide here, tracing the history of the superhero from its initial frenzy of interest just before and during the Second World War, through a fallow postwar period, and then to periods of not only renewed interest but increasing narrative and psychological sophistication. Through the course of his chapter, Singer demonstrates the way that the superhero has proven to be a flexible vehicle for creators working in the genre. Gillian Whitlock provides a strong contrast in the next chapter, focused on autographics, or comics and graphic texts with autobiographical foundations. Autographics has, in important ways, become a hallmark of contemporary comics studies, opening pathways in the larger academy by connecting the field to other ongoing debates. Whitlock's chapter addresses some of the most influential works in the genre, including Art Spiegelman's *Maus* (1986 and 1991) and Alison Bechdel's *Fun Home* (2006), both prestigious award winners and frequent classroom texts. The critical acclaim afforded these and other works of graphic memoir helped expand the scope of comics study and promote the idea that comics might be taken seriously by literary scholars. Whitlock, however, poses more expansive questions about these texts, interrogating the way that they depict individual subjectivity and memory while challenging notions of representation. Mel Gibson takes up a related subject in her consideration of comics for girls and women, specifically developments in the United Kingdom, the United States, and Japan. Rejecting the idea that comics is, or has been, a predominantly masculinist field, Gibson turns a critical eye toward girls' comics, romance comics, and explicitly feminist comix to discuss the ways that their creators and readers carved out unique spaces in the field. In the following chapter, Darren Wershler, Kalervo Sinervo, and Shannon Tien address one of the most vital developments in comics studies, the rise of digital comics. The authors here are not interested in just webcomics, though webcomics are central to their argument; they also focus on the way that traditional comic books and strips have gradually migrated to digital forms of creation and distribution. Today online delivery systems—whether through web platforms or apps for mobile devices (such as smart phones and tablets)—are

taking on an ever more important role in the way that comics are consumed. This chapter traces the history of comics' shift toward the digital world through all its remarkable fits and starts.

We close the *Guidebook* with a time line of selected events from the early eighteenth to the twenty-first century: a chronology that is by no means complete but serves to contextualize many events, titles, and creators discussed in this book while providing other landmarks and a more comprehensive view of comics' development. Partial and selective as it is, this time line offers a braided set of paths through a complex global phenomenon.

The present volume does not claim to be a comprehensive overview of comics studies as it exists today; as noted, the field is a vast, unruly enterprise that refuses to be charted so easily, and every day we receive reminders of just how fast it has been moving and changing. Yet we hope this constellation of essays will serve as a concise and helpful introduction to the major concerns that animate discussions in the field. Though comics studies is relatively young, the essays collected here highlight the steps generations of scholars have already taken toward addressing some of the field's most pressing concerns. If not brand-new, comics scholarship remains a lively, promising, fast-growing area of interdisciplinary study. This *Guidebook* offers multiple points of entry: a kind of map, with contours broadly sketched, but also an invitation.

Notes

1. See, for example, Bart Beaty and Benjamin Woo, *The Greatest Comic Book of All Time: Symbolic Capital and the Field of American Comic Books* (London: Palgrave Macmillan, 2016); and Christopher Pizzino, *Arresting Development: Comics at the Boundaries of Literature* (Austin: University of Texas Press, 2016). An overview of the contrasting positions offered by these volumes is provided in a review essay by Matthew Levay, *The Journal of Modern Periodical Studies* 10, nos. 1–2 (2019).
2. Scott Bukatman, *Hellboy's World: Comics and Monsters on the Margins* (Berkeley: University of California Press, 2016), 208.
3. Regarding the roots of comics scholarship as an academic field, see, for example, Matthew J. Smith and Randy Duncan, eds., *The Secret Origins of Comics Studies* (New York: Routledge, 2017); and "Pioneers of Comic Art Scholarship," an occasional series of autobiographical essays edited by John A. Lent for the *International Journal of Comic Art*. See, in particular, *IJOCA* 5, no. 1 (Spring 2003) and no. 2 (Fall 2003); and *IJOCA* 7, no. 2 (Fall 2005).
4. Pat Grant, *Blue* (Marietta, Ga.: Top Shelf Productions, 2012), n.p.
5. The coinage *world comics* obviously echoes the prevailing but contested concept of world literature, one often criticized for its normalization of global relations of power and its assumptions about translatability and universal appeal. See, for example, Wail Hassan, "World Literature in the Age of Globalization: Reflections on an Anthology," *College English* 63, no. 1 (2000); Kate McInturff, "The Uses and Abuses of World Literature," *Journal of American Culture* 26, no. 2 (June 2003); and Emily Apter, *Against World Literature: On the Politics of Untranslatability* (London: Verso, 2013). That said, the concept of *world comics* is gaining ground. See, for example,

Bill Kartalopoulos, ed., "International Comics," special section, *World Literature Today* 90, no. 2 (March–April 2016): 37–75. Kartalopoulos spotlights "artists from all over the world who are pushing the boundaries of what comics can be [and] finding one another and publishing their work together in international anthologies," thus constituting or strengthening "an international comics avant-garde" distinct from the mainstream traditions of their respective countries (39). In a comparable vein, Frederick Luis Aldama's promised book *World Comics: The Basics* (forthcoming), while acknowledging differences among comics traditions, envisions a "world republic of comics" in which influence propagates across borders. Aldama also curates a website titled the *Planetary Republic of Comics* (https://professorlatinx.com/planetary-republic-of-comics), which asserts that the history of comics "is a global one. Comic book creators from around the world are grown within their respective national soils but always with an insatiable appetite to learn from others beyond their proximate experience." See, in addition, Shane Denson, Christina Meyer, and Daniel Stein, eds., *Transnational Perspectives on Graphic Narratives* (New York: Bloomsbury, 2013), which examines how comics "have been shaped by aesthetic, social, political, economic, and cultural interactions that reach across national boundaries in an interconnected and globalizing world" (1). A related Summer School in Transnational Graphic Narratives was held at the University of Siegen in the summer of 2017. Since 1999, the *International Journal of Comic Art* (edited and published by John A. Lent) has argued by its very existence for the importance of thinking about comics and cartooning globally. Pragmatically speaking, of course, this remains a challenge, especially in terms of pedagogy (as is reflected in the limitations of this very book). At the 2019 Comics Studies Society conference in Toronto, Nina Mickwitz provocatively questioned "The Politics of Espousing a Global Comics Studies"—a talk that called for the decolonialization of the field and sparked much discussion, both during the conference and after.

Part I

Histories

1
Comic Strips

• •

IAN GORDON

Comic strips belong to the larger continuum of comics art: from single-panel cartoons to broadsheets and comics magazines and papers to albums and graphic novels to webcomics and more. There is no distinct aesthetic that isolates the comic strip from these other forms. Strips may be best described as a particular form of comics that appears regularly, usually daily or weekly, and tends to tell stories or gags in a short series of sequential panels. Typically strips convey speech via balloons and feature a continuing cast of characters; however, what constitutes a comic is a fluid mix of visual, textual, and panel arrangements, and it is possible to omit one or two of the common elements and yet still have a comic strip. Placing strips on the broader continuum of comics art may finesse this problem by allowing a certain looseness of definition (while still, of course, eliding the issue of just what constitutes comics art). Given the difficulty of defining just what makes something a comic strip, it is better to move away from definitions based purely on formal properties and think instead in terms of *political economy*. Indeed, defining comic strips as appearing regularly and with continuing characters is already one step in that direction.

Approaching strips through their political economy makes sense because this sort of comics art owes its development to a specific set of historical circumstances. Akin to Michael Newman's comments on the indie film, comic strips cohere as a category not only through "a set of industrial criteria or formal or stylistic conventions" but more importantly as "a cluster of interpretative

strategies and expectations."[1] In the case of comic strips, these expectations and habits were formed under rapidly changing conditions; in Britain and the United States, strips developed out of earlier forms of comics at a time of great social change. For instance, both London and New York experienced rapid population growth between 1850 and 1900: London more than doubled in size, while New York increased sixfold. The accompanying development of newer and cheaper printing technologies ushered in new types of magazines and newspapers that reached much larger audiences than had prior publications. Comics played an important role in attracting and retaining this new audience. The creation of railway transportation networks also contributed to the development of comics, and the different types of spatial relations in which this happened arguably led to distinct sorts of strips. In Britain, for instance, the relatively smaller distances were quickly spanned, and so the press took on more of a national character than in America, where greater geographic distances meant that cities, though now linked in an emerging national market, still retained a more localized press.[2] In the United Kingdom, the development of Board Schools between 1870 and 1902 increased literacy rates. Meanwhile, the United States, which began moving toward a public school system as early as 1830, had a very high literacy rate by the 1890s, with over seventy-five percent of the population in the densely inhabited northeastern states able to read.[3] In Britain, Alfred Harmsworth, better known by his later title as Lord Northcliffe, understood these changes in literacy and developed a line of publications that included *Comic Cuts*—and, later, the array of newspapers that earned him his title—to appeal to this newly empowered readership.[4] Comic strips then were present at the birth of a community of new readers imagining new senses of themselves and the body politic to which they belonged. As the historian Eugene Weber has noted, in France, this process of spreading a national culture through print transported by railways was somewhat delayed, for it was only after the First World War that newspapers like *Petit Journal*, with its illustrated supplement, began to circulate more broadly through the country.[5]

From Töpffer to Ally Sloper

The association between the bustling unfolding of economic modernity and the sort of regulation it required—trains, for instance, need organization, such as in timetables; indeed, it was the railroads that established the time zones in the United States—is what shaped the career of the pioneering comics artist Rodolphe Töpffer, according to comics historian Thierry Smolderen. Töpffer is widely regarded as the father of comics art because of his series of comic albums that developed many of the techniques familiar to modern readers of comic strips and comic books. Smolderen argues that Töpffer deliberately used sequential panels and diagrammatic representations in order to tie the *form* of his satire to the very object of his ridicule: the sort of "generalized formatting"

contained "in works on theatrical gestures, manuals on manners, and technical encyclopedias."[6] This sort of reduction of difference to standardization was part and parcel of the coming age, as handmade artisanal craft gave way to industrial production.[7] Ironically, in the format of his satire Töpffer invented something perfectly suited to the broad object of that satire. Smolderen considers the satirical impulse of comics artists the saving grace of the form, while pointing out that once strips were introduced to newspapers, comics "turned decisively against their creator[s] . . . [and] contributed to the rhythms and the routines of the urban and industrial world."[8]

If Töpffer shaped the emerging form of comics, the work he produced was nonetheless not comic *strips* (in the familiar sense) but rather self-contained comic *albums*. Smolderen identifies the appearance of this sort of material in newspapers as the moment that the form took on a particular characteristic somewhat contrary to the vision of Töpffer. To be sure, newspapers were important, but before comic strips arrived on the newspaper page, one comic showed the way that this art fit the emerging urban and industrial world. The character Ally Sloper, as Roger Sabin has shown, appeared in various British publications beginning with *Judy* in 1867, and his adventures were almost certainly the first significant comic strip. By 1884, Sloper appeared in the eponymous *Ally Sloper's Half Holiday*—his own comic weekly, which, as Sabin shows, depended on aggressive cross-marketing promotion. The art was comic strip–like, the character continuing and promoted through an array of products.[9] The fact that Sloper appeared in a weekly rather than a daily newspaper reflects the different lines of development of newspapers in Britain and in the States. *Ally Sloper's Half Holiday* was certainly circulated on a mass basis, selling up to 340,000 copies a week by one account.[10]

Moreover, the character appeared across media. While a comic strip can be a strip without spawning a character that moves beyond print, the key early strip characters, those that shaped the form, almost all had more than a print incarnation. Sloper, through a variety of merchandise, reached beyond print into the daily lives of his audience. As Sabin points out, the character demonstrates Martin Barker's notion of a contract between reader and text, a contract that, in Barker's words, entails "an agreement that a text will talk to us in ways we recognise. It will enter into a dialogue with us. And that dialogue, with its dependable elements and form, will relate to some aspect of our lives in our society."[11] With Sloper, this sort of contract with the reader expanded beyond the confines of the printed text to include reprints of the *Judy* strip, a relish sauce, cigars, liver pills, bicycles, ties, and musical instruments. We know *Ally Sloper's Half Holiday* was meant for rail commuters because—and this is somewhat grim humor—promotional advertisements offered a reward to victims of rail accidents if a copy of the latest issue of the comic was found on the deceased—the contract with readers almost extended to an insurance policy, the premium being regular purchase of the comic!

Sabin describes this as Sloper "transcending his role as a vehicle for humour and becoming associated with, in particular, the rise of leisure consumerism." Sloper appealed to an emerging lower middle class who came into being because of the very changes that produced comics; the growing industrialization of society that inspired Töpffer's satire also enabled the production and distribution of comics on a large scale. As Sabin explains, "Sloper was developing as a 'brand,' and as ever the cultural role of brands was to respond to the zeitgeist."[12] I would suggest, however, that Sloper did not so much "transcend" his role as intimately tie different roles together in ways that not only were mutually reinforcing but indeed laid down a template for an emerging culture of consumption. Sabin's ambivalent use of "brand" indicates uncertainty regarding whether we should view comic strips as defined by their political economy rather than, or as much as, their formal properties. *Ally Sloper* was a comic strip, but either it was so much more—a brand—or the nature of the comic strip at this time was such that the comic was *more than what appeared on the printed page*. A comparison with the American comic *Hogan's Alley*—home of the "Yellow Kid" and often erroneously called the first comic strip ever—supports the latter contention.

The Yellow Kid

Touted as the first comic strip by many comics fans and scholars (Americans in particular), Richard F. Outcault's *Hogan's Alley* was no such thing. Before Ally Sloper, and even before Töpffer created his works, the short-lived *Glasgow Looking Glass*, first published on June 11, 1825, had carried a series of sequential narrative illustrations spread over several issues that would meet a formalistic definition of a comic strip.[13] But this comic floundered for lack of a sufficient audience. Likewise, distinctive comic figures such as Thomas Rowlandson and William Combe's Dr. Syntax had been widely popular and given rise to numerous associated products. What made the "Yellow Kid" comics the first strip in so many people's view was the distinctive character *and* its regular appearance in a newspaper—qualities more to do with the political economy of the feature than its formal properties. The Yellow Kid first appeared in protean form in a panel cartoon within the illustrated humor journal *Truth* on April 15, 1893, and then again more clearly, though not yet fully formed, on June 2, 1894, under the heading "Feudal Pride in Hogan's Alley." By the time of his third appearance, again in *Truth*, on February 9, 1895, the Kid was clearly recognizable as the character that would go on to appear in the *New York World* and then the *New York Journal*. But even in the Kid's first colored appearance in the *New York World* (May 5, 1895), under the title "At the Circus in Hogan's Alley," his distinctive nightshirt that was later to give him his name was not yet yellow. Indeed, Outcault did not ever refer to the Kid as the Yellow Kid during the feature's run at the *World*. Moreover, for the duration of its run at the *World*

the comic was a single panel—or page rather, typically filled to bursting with typeset text as well as a giant comic illustration. Nor did word balloons, another supposed hallmark of comic strips, appear very much. How the Yellow Kid became a comic strip, then, is no simple tale of author's intention and the invention of a form.

On January 5, 1896, the Kid appeared in the *World* with his nightshirt colored yellow. Thereafter he became known as the Yellow Kid. Outcault himself did not use the term until much later that year. Again here, much as Sabin argues for Ally Sloper, a contract existed with the reading audience, and in the Kid's case, it was they who named the character. Even with a name, though, the Yellow Kid was still not a comic strip, at least in the conventional sense of appearing regularly in panels. Unlike Ally Sloper, who made scheduled appearances, the Yellow Kid appeared on a haphazard basis—at best every other week in the Sunday supplement of the *World*—up until June 1896. After that, Outcault produced a comic every week (until he left the *World* for Hearst's *New York Journal* in October 1896), and only because something forced his hand: a May 31, 1896, *Hogan's Alley* comic in the *World* drawn by George Luks that was almost identical in style to Outcault's.[14] Once more, the regular production of a comic, a typical feature of comic strips, came about for other than a strictly artistic reason: Outcault needed to assert his ownership of the feature and the character against the newspaper and Luks. Outcault's subsequent actions in trying to copyright the Yellow Kid, and, failing that, then moving the Yellow Kid under that name to Hearst's paper—all defined comic strips as much as did questions of form.[15] Moreover, the Yellow Kid, like Sloper, was the subject of reproduction in goods like cigars, dolls, and chewing gum. Here again, the comic strip was something more than what appeared on the page.

The Question of Word Balloons

Word balloons have traditionally been seen as an essential feature of comic strips, and they are indeed important to many comics, though not all.[16] Outcault hardly used balloons in the Yellow Kid comics, and it was not until another artist's innovation late in 1900 that balloons truly became a regular feature of the Sunday funny pages. Frederick Burr Opper deserves credit for reshaping American comics through the regular use of balloons, and in this case, unlike many innovations in comics history, there appears to have been a moment, a singular instance, where that transformation occurred.

Opper's strip from December 30, 1900, "Cupid's Everlasting 'Jolly,'" combined both rhyming text and word balloons, and this comic, though it has not received the attention it deserves, led to the widespread adoption of the latter. Before it, artists had used balloons over many years, but only haphazardly; in fact, balloons themselves were not original to comics art but an extension of the medieval art mannerism of using *phylactery* or *banderole*—basically scrolls

emanating from the mouths of subjects—as a means of conveying speech. But Opper's comic, with its twelve panels using balloons, presaged the rapid adoption of the device by nearly all comics artists. Reading Hearst's Sunday funny pages from 1896 through to 1901, the change is particularly noticeable. Up to the end of 1900, word balloons were used sparingly; by March 1901, Opper used them in almost all his work, and by mid-1901, Hearst's entire group of comics artists used them regularly.

Why this happened in those six months is not clear, but it accompanied a shift to a more structured newspaper comic section with a number of regularly appearing features, such as Opper's *Happy Hooligan* and Rudolph Dirks's *The Katzenjammer Kids*. In all likelihood, efforts at shaping a supplement that was more constant in its features, and therefore better able to enter into a contract with readers by giving them what they wanted without too many surprises, fed a need for more distinctive characters who could, if not literally, then figuratively speak to the audience.

Smolderen has proposed that after the invention of the phonograph, the use of word balloons shifted the understanding of text within comics: it was no longer read as internal dialogue but rather as a theatrical projection of sound.[17] This suggests that in a growing mechanized society, the notion that speech could be captured and reproduced in one medium lent credence to its reproduction in another. In turn, then, the contract with readers could be extended and made more personal. Such an idea is not so easily provable, of course. In any case, although the Yellow Kid enjoyed some nationwide exposure, the spread of comics beyond newspapers in cities like New York, St. Louis, and San Francisco (where Pulitzer and Hearst owned papers) occurred only after the introduction of more regular strips with word balloons in 1901, long after Outcault had retired the Yellow Kid from the funny pages.

The Business of the Comic Strip

The spread of comic strips to newspapers across the United States occurred very rapidly in the early years of the twentieth century. Within two years of 1901, when Opper inspired widespread adoption of word balloons, strips had spread to at least forty-eight newspapers across the country and were available to at least 15.5 percent of the population. By 1913, these figures had increased to 114 newspapers and 21 percent of the population.[18] At the turn of the century both British and American comics appeared weekly: in Britain, there were weekly magazines such as *Comic Cuts* and, in America, weekly Sunday supplements to newspapers. The looks of the magazine and supplements were not wildly dissimilar, though they were different in content and the American comics appeared in color. But by 1903, the weekly American supplement had taken on a more distinct character. The supplements tended to have a single comic strip on the front page using between six and nine panels (later, twelve panels also

became standard). The rest of the supplement consisted of full-page or half-page comics using similar panel layouts. The comic strips, which had been fairly regular or semiregular features of the funny pages, became continuing weekly titles, a shift that helped define the supplement as primarily a vehicle for comics. This format became the template for American strips for the best part of the next fifty years. Regularization of the supplements' contents was part and parcel of the growing mechanization of society.

The comic strip supplements were mostly assembled in New York. At first, Hearst and Pulitzer had the area to themselves, but then newspapers like the *New York Herald* and syndicates like McClure's added comic strips to their arrays of products, and other companies entered the field. Distribution across the country required regular production schedules because companies needed to prepare printing matrices for dispatch to newspapers across the country in order to print the comics on the same day. As a result, comic strips were shaped by production schedules and railroad timetables. At the same time, though, the broader sense of what made a comic strip—as an entire array of products beyond the printed page, along the lines of Ally Sloper and the Yellow Kid—was starting to change.

Although the Yellow Kid replicated the success of Ally Sloper by colonizing a variety of products, one crucial difference made the American comic strip distinct from the British. Published in a newspaper, the Yellow Kid was not just self-reinforcing but intimately linked first to the *World* and then to the *Journal*. A debate exists about just how Pulitzer's and Hearst's newspapers became known as the "yellow" press, but the common perception that this was because of the Yellow Kid shows how closely the comic was coupled with the papers.[19] The Yellow Kid, of course, had nothing like the longevity of Ally Sloper but still represented an important step: though the Kid demonstrated that comic strips were more than appeared on the printed page and had to be understood more broadly, the strip also cemented comics' relationship to a particular form of print, the newspaper. But because the Yellow Kid was so short-lived, the best way to understand this development is to examine Outcault's greatest success: *Buster Brown*.

After abandoning the Yellow Kid (for reasons that remain unclear), Outcault experimented with different characters. Eventually, on May 4, 1902, the *New York Herald* debuted his new strip *Buster Brown*. It proved immediately popular, and by 1903, *Buster Brown* ran in at least three other papers: the *Chicago Tribune*, the *Los Angeles Herald*, and the *St. Louis Republic*. Outcault licensed the character of Buster Brown to a vast array of goods, including a piano and a harmonica and foodstuffs like apples, bread, flour, and milk. Among the many licensees, two lines of goods became especially important because they attained national distribution: Buster Brown Shoes, from the Brown Shoe Company of St. Louis, and a range of children's textile goods under the brand Buster Brown Apparel, produced by a textile mill in Chattanooga, Tennessee.

The popularity of *Buster Brown* proved lucrative to Outcault, who made $44,000 (roughly $1.2 million in 2020 dollars) between 1903 and 1907 from a stage-show version. Also, because the comic strip business had changed, Outcault had a better chance of maximizing his return from the strip itself, which could now be syndicated more widely. In 1906, Outcault took the strip to Hearst's newspapers, and so for a time, there were two competing versions. A legal case established that though Outcault owned the right to license Buster Brown, the *Herald* owned the copyright for a comic strip of that name; therefore the *Herald* ran a *Buster Brown* by other artists even as Outcault continued his version for Hearst, sans title. The character enjoyed enormous popularity for many years and bridged the divide between a centralized business economy and smaller-scale local economies.[20] Both the shoe and textile company promoted their goods by sending teams of drummers around the country with dwarfs dressed as Buster Brown. Such activities continued into the 1950s, long after the comic strip itself had stopped running. Whereas the strip ceased in the 1920s, the shoe brand survived into the twenty-first century. The long-term success of the brand supports the argument that comic strips are more than what appears in a newspaper.

This argument helps explain not only the longevity of the brand but also, perhaps ironically, the disappearance of the printed Buster Brown. If we think of readers as engaged in a contract with a character and to varying degrees engaging with that character across different figurations, we can better understand the success of Ally Sloper, the Yellow Kid, and Buster Brown. Yet when newspapers started to carry daily comic strips, that implicit contract most likely shifted to include the expectation that the character would appear in print every day. *Buster Brown* was only ever a Sunday strip, and in that sense, Outcault failed to adapt to further changes in the business end of comics.

While the Yellow Kid and Buster Brown mark the zenith of the nonprint exploitation of comic strips in the early twentieth century, even Winsor McCay's vaunted *Little Nemo in Slumberland* (1905–1927), the most sophisticated and stunning comic of the day, existed off the page as well: as a stage play, a vaudeville act by McCay, and an advertisement for gardening tools. However, McCay's career with *Little Nemo* was episodic (the strip's high point occurred in its early run in the *New York Herald*), and this most accomplished comic strip never enjoyed as great a commercial success as Buster Brown, a strip with nowhere near the strength of McCay's art. The point here is that the art was not the deciding factor in a strip's success.

Daily Comic Strips

In the days of Ally Sloper, the Yellow Kid, and Buster Brown, the popular model of the comic strip was a once-a-week printed experience perhaps accompanied by some engagement with licensed (or unlicensed) spin-off products: the

character smoking a cigar, say, or eating bread and drinking milk. Of course, not all comic strips had such broad commercial ambitions, but Sloper, the Kid, and Buster were touchstones, representing the medium's potential for cross-platform exploitation. After *Buster Brown*, it was some years before a comic again thrived to such a great extent beyond the printed page. Daily comics, however, kicked the business up a notch, broadening the idea of what a comic strip could be. This started in 1907 with the publication in the *San Francisco Chronicle* of *A. Mutt* by Bud Fisher, better known by its later title *Mutt and Jeff* (1907–1983). Fisher's strip originally ran on the sports page and depicted bets on real-life horse races; in this regard, it resembled the short-lived 1903 daily *A. Piker Clerk* by Clare Briggs. But unlike that earlier strip, *Mutt and Jeff* found a broad audience, particularly after 1908, when it was picked up and syndicated by Hearst. In that year, at least eleven newspapers across the United States began carrying daily strips. By 1913, that number had increased to almost one hundred papers, of which almost a quarter carried *Mutt and Jeff*. It is significant that the daily strip owes its origins to an adult activity, betting on races. The Sunday comic strips, though not aimed at children exclusively, achieved a broader, more polysemic appeal, across ages. By contrast, Britain did not launch a daily strip until April 1915, when the *Daily Mail* commenced Charles Folkard's *Teddy Tail*, which was meant for children.[21]

Simply put, the advent of dailies changed the nature of comic strips. The difference between a weekly reading experience and a daily one alone would have been substantial. Gag strips had been accustomed to spreading a joke out over up to twelve panels, with one gag a week; they now had to produce seven gags and fit six of these into the three or four panels of a daily. Some artists coped with this increased demand by creating formulas in which the same sort of gag recurred every day, but the humor lay in clever variations. George Herriman's *Krazy Kat* (1913–1944) is a case in point, with the humor deriving from Ignatz Mouse's delivery of a brick to Krazy's head and Krazy's delusion that these assaults were acts of love. Herriman took this gag and expanded it into the realms of the sublime, particularly in his Sunday pages. Other strip artists took a different tack, adapting melodrama with exaggerated plots and drawn-out story lines, complete with cliff-hanging episodes to capture and hold readers' attention. Among the most famous of these was the saga of Mary Gold, an arc in Sidney Smith's *The Gumps* (1917–1959), a very popular strip syndicated by the *Chicago Tribune*. The Mary Gold story line ran from May 1, 1928, through May 3, 1929, generating tremendous suspense and reader involvement, and ended with Mary's death (to an avalanche of complaints). Melodramatic strips of this sort opened the way to various adventure strips like Milton Caniff's *Terry and the Pirates* (1934–1973).

That these latter two titles were syndicated by the *Chicago Tribune* indicates some of the other changes to comic strips wrought by the daily format. The *Tribune*, with its stablemate the *New York Daily News*, syndicated one

of the strongest arrays of strips, including several that, in both daily and Sunday form, are beloved as classics of the medium: *Dick Tracy* (1931–), *Gasoline Alley* (1918–), *The Gumps*, *Little Orphan Annie* (1924–2010), *Moon Mullins* (1923–1991), *Terry and the Pirates*, and *Winnie Winkle* (1920–1996). These strips have inspired many reprint efforts; several have formed the backbone of IDW Publishing's ongoing book series the Library of American Comics. The need for both a daily and a Sunday strip as part of a business strategy became clear to this syndicate in the early 1920s. *Gasoline Alley*, which began as a Sunday-only in November 1918, added a daily in August 1919. *Winnie Winkle* commenced in September 1920 and added a Sunday page in June 1922. Some Sunday-only comics survived, but more and more, a strip required a daily version as well.

For all their appeal, none of the characters in these comics seems to have captured the public's attention to the same extent as Ally Sloper, the Yellow Kid, or Buster Brown. Though they had many appearances beyond the comic page (which included animated shorts, radio and film serials, toys, and the like), they were not as all-pervasive as the earlier three comics. One reason none of these individual comics ever had the reach of, say, *Buster Brown* may be that individual strips no longer had to have broad polysemic appeal, since syndicates sold a mixture of strips to create a daily comics page that collectively had that appeal. This is not to say that a comic strip could never again gain such appeal: clearly Charles Schulz's *Peanuts* did so, though it grew into that popularity gradually.

The advent of dailies represented a shift by which the printed versions of comics assumed an even greater importance in their relationships with readers, though one still marked by an existence beyond the page. Even Garry Trudeau's politically informed, often controversial *Doonesbury* (1970–), perhaps the most unlikely strip ever to be associated with a range of merchandise, made the leap with a 1991 mail-order catalog of products in aid of charity. Indeed, the only major comic strip artist to reject the standard model—the comic strip as both daily and Sunday, accompanied by a range of products—was Bill Watterson, who refused to merchandise his strip *Calvin and Hobbes* (1985–1995). But the worldwide availability of unlicensed *Calvin and Hobbes* T-shirts and the like confirms that a strip's contract with its readers may be beyond even the creator's control. If Watterson would not give the audience what they wanted, they created it themselves or were happy to buy it from someone who had done so. Again, we see that expectations for a comic strip derive from the conditions of its production and reception more than any particular aesthetic innovation or singular artistic statement.

Understanding what makes a comic strip requires more than understanding the formal language of comics and how it conveys meaning. A strip is a historical and commercial entity as well as a formal one. As newspapers have declined, and newer media like television and the internet have replaced their function, new ways of making, distributing, and reading comics have developed. For example, reducing the size of comics and jamming more onto a page—a general trend in

the late twentieth century—was a response to television. Likewise, the recent decimation of the print newspaper in the face of the internet has seen a dramatic rise in webcomics, many of which exist in a variety of materialities (e.g., *Penny Arcade*, *Girl Genius*, and *PhD Comics*; see chapter 17). The medium is so fluid that it can exist without print, yet at the same time, it continues to generate material merchandise in huge numbers. Such developments underscore the importance of the political economy of the comic strip as a cultural institution tied to concrete historical circumstances, not a form in the abstract.

Notes

1. Michael Newman, *Indie: An American Film Culture* (New York: Columbia University Press, 2011), 11.
2. George Perry and Alan Aldridge, *The Penguin Book of Comics: A Slight History* (Harmondsworth: Penguin, 1971), 201.
3. Ian Gordon, *Comic Strips and Consumer Culture, 1890–1945* (Washington, D.C.: Smithsonian Institution Press, 1998), 13.
4. Kevin Williams, *Read All about It! A History of the British Newspaper* (New York: Routledge, 2009), 127.
5. Eugene Weber, *Peasants into Frenchmen: The Modernization of Rural France, 1870–1914* (Palo Alto, Calif.: Stanford University Press, 1976), 565–566n46.
6. "Töpffer l'avait conçue expressément pour ridiculiser le formatage généralisé qu'impliquait, à ses yeux, la rhétorique de l'action progressive, telle qu'elle se présentait dans les ouvrages sur le geste théâtral, les manuels de savoir-vivre, les encyclopédies techniques." Thierry Smolderen, *Naissances de la bande dessinée: De William Hogarth à Winsor McCay* (Brussels: Impressions Nouvelles, 2009), 6. This passage hails from the introduction to Smolderen's original edition, which is omitted in the English translation, *The Origins of Comics: From William Hogarth to Winsor McCay*, trans. Bart Beaty and Nick Nguyen (Jackson: University Press of Mississippi, 2014).
7. David Hounshell, *From the American System to Mass Production, 1800–1932: The Development of Manufacturing Technology in the United States* (Baltimore: Johns Hopkins University Press, 1984).
8. Smolderen, *Naissances*, 6–7.
9. Roger Sabin, "Ally Sloper: The First Comics Superstar?," *Image & Narrative* 7 (October 2003): http://www.imageandnarrative.be/inarchive/graphicnovel/rogersabin.htm.
10. Peter Bailey, "*Ally Sloper's Half-Holiday*: Comic Art in the 1880s," *History Workshop* 16 (1983): 4–31.
11. Martin Barker, *Comics: Ideology, Power and the Critics* (Manchester: Manchester University Press, 1989), 261.
12. Sabin, "Ally Sloper."
13. John McShane, "Through a Glass, Darkly—the Revisionist History of Comics," *Drouth* 16 (2007): 62–69.
14. Gordon, *Comic Strips*, 31.
15. Gordon, 31–33.
16. David Beronä, *Wordless Books: The Original Graphic Novels* (New York: Abrams, 2008).
17. Thierry Smolderen, "Of Labels, Loops, and Bubbles: Solving the Historical Puzzle of the Speech Balloon," *Comic Art* 8 (Summer 2006): 90–113.

18 Gordon, *Comic Strips*, 38–42.
19 Mark D. Winchester, "Hully Gee, It's a War!!! The Yellow Kid and the Coining of 'Yellow Journalism,'" *Inks* 2, no. 3 (November 1995): 22–37; and W. Joseph Campbell, *Yellow Journalism: Puncturing the Myths, Defining the Legacies* (Westport, Conn.: Praeger, 2001), 32.
20 Hal Barron, *Mixed Harvest: The Second Great Transformation in the Rural North, 1870–1930* (Chapel Hill: University of North Carolina Press, 1997), 189.
21 Perry and Aldridge, *Penguin Book of Comics*, 201.

2

Comic Books

••••••••••••••••••••••

CHARLES HATFIELD

What is a comic book? The answer is not as obvious as might be supposed.

Defining the Format

The annual *Overstreet Comic Book Price Guide* (fig. 2.1) is the most widely used guide (in fact, practically a bible) among collectors of American-style periodical "comic books"—that is, comic magazines.[1] This *Guide* is an enormous paper database, crowdsourced and continually updated: a handy reference point for hobbyists and historians alike. It focuses on the standard U.S. comic magazine format that arrived in the 1930s, now roughly 7 by 10.5 inches in dimension, though formerly about 8 by 10.5 (closer to half-tabloid size). That particular format is what American collectors typically have in mind when they use the term *comic book*: a half-tabloid magazine full of comics, usually sixty-four pages or less. The *Overstreet Guide*, launched by Robert Overstreet in 1970, tracks the resale prices of such magazines in the aftermarket. This *Guide* has become so integral to comic collecting that, among hobbyists, shorthand phrases like "below *Guide*" need no explanation, serving as a received jargon. Yet the *Guide* has a quirky, seemingly inconsistent way of defining comic books.

Since the 1997 edition, *Overstreet* has included data about certain nonmagazines, such as hardbound collections of newspaper strips, that predate the hobby's mythic "Golden Age" of the 1930s and onward. Though these earlier

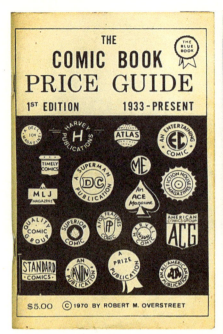 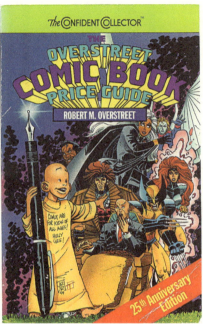

FIG. 2.1 A comic book collector's bible, *The Overstreet Comic Book Price Guide*. Left: the first edition (Overstreet Publishing, 1970), image courtesy of Heritage Auctions / HA.com. Right: the twenty-fifth edition (Avon Books, 1995), cover by John Romita Jr., from the author's collection. The X-Men © Marvel.

collections of comics, many from the so-called Platinum Age of the late nineteenth to early twentieth century, scarcely resemble the prototypical comic magazine, they appear in the *Guide* anyway. On the other hand, certain comic magazines are excluded from the *Guide*. Notably, the bulk of underground comic books, or comix, most of which sought to mimic the format of their mainstream comic book kin, has been pointedly kept out. This means that a ten-by-ten-inch cardboard-covered book collection of George McManus's newspaper strip *Bringing Up Father*, published by Cupples & Leon in 1919, appears in the *Guide*, but R. Crumb's explosive *Zap Comix* #1, published by Apex Novelties in 1968 in precisely the standard comic book format, does not. This inconsistency cannot be explained away in terms of print run, accessibility, or fame, for *Zap* #1 is a famous, widely read comic book. Such discrepancies are accepted as a routine feature of American comic book collecting.

It appears, then, that the "comic book" beloved of hobbyists is a field delimited by ideological as well as formal borders. This comic book is not only a material historical artifact but also an imaginative construct of its fandom, and certain objects appear easier to absorb into that construct than others. Platinum Age antecedents of the standardized comic book format now get admitted into the field readily, per *Overstreet*, while scandalous countercultural comix,

despite adhering to that very format, meet resistance. This ideological border complicates efforts to recount the medium's history accurately. On the one hand, the label "comic book," as used by collectors that favor *Overstreet*, tends to be strict, as it does not equate simply to "any book consisting of comics" but rather tends to mean a specific pamphlet format. On the other, the label has arbitrary limits, provisionally admitting other formats, such as Platinum Age forerunners, even as the *Guide* marginalizes a key development in the history of pamphlet comics, the underground explosion of the 1960s and '70s.

The term *comic book*, then, despite *Overstreet*'s embrace of various kinds of publications, is not endlessly flexible. Among U.S. collectors, it does not extend to all other comics periodicals, even those that occupy, or formerly occupied, cultural niches arguably similar to that of the American comic book (such as the British comics weekly, Japanese *zasshi*, or Franco-Belgian *journal*). In short, *comic book*, in the collectors' sense, refers to a social object with a certain identity and history; it is not an expansive umbrella term.

The standard American comic book (as defined per that specific definition) once produced a flood of different genres and styles that sold millions of units each month, saturating the United States and making long-form comics storytelling an almost inescapable part of mass culture. It was a disposable triumph. Now, however, that same format is the focus of an intense object fetishism within a collecting culture that privileges some examples of the object but neglects others. With that in mind, this chapter does not take the term *comic book* as simply the sum of "comic" and "book" but rather focuses on just that one standard definition—in today's perhaps derisive parlance, the "floppy," as formularized by the U.S. comic magazine industry since the 1930s. (Contrary to *Overstreet*, however, we will include underground comix as well.)

In *Overstreet*'s culture, hobbyists expect a comic book to follow a prototypical format inherited from the pioneering experiments of a Connecticut-based printing company, Eastern Color, a format first used as an advertising premium or giveaway. Eastern published promotional comic papers for various client companies starting in 1933, and the *Gulf Comic Weekly*, a tabloid made for Gulf Oil and given away at Gulf service stations, became a trendsetter.[2] Eastern's sales manager Harry Wildenberg pushed these projects, which were meant simply as sales incentives. Later in 1933, Wildenberg and Maxwell Gaines, an Eastern salesman, created the one-shot *Funnies on Parade*, a premium for Procter & Gamble, in a new, smaller format, roughly 7.5 by 10.5 inches—the start of the modern comic book, in *Overstreet*'s sense. Eastern tested the waters for such comic books as independent commodities with further one-shots in 1933 and 1934, which led to the ongoing series *Famous Funnies* (1934–1955), widely distributed to newsstands and often described as the first successful modern comic book. Other publishers soon offered competing series in the same format, such as *King Comics*, *Popular Comics*, and *Tip Top Comics* (all 1936). All these, like *Famous Funnies*, consisted mostly of material reprinted from newspaper strips. In this

way, comic books began as a clever Depression-era tactic for making a little extra money without creating anything fundamentally new.

However, new, original material began appearing in these magazines as early as 1935, championed by the tabloid *New Fun* and a follow-up (in the smaller format), *New Comics*, both published by National Allied. By early 1937, new material had become standard for comic books, but it was not until 1938 that the medium began to become a commercial powerhouse—thanks to the success of *Action Comics*, published by National Allied's successor, Detective Comics Inc. (DC). *Action*'s first issue introduced Superman, giving birth to the popular, much-imitated superhero formula that galvanized the business (see chapter 14). Thus the now-standard comic book format became the basis of a distinct industry. Since then, all precursors or alternate formats, such as albums or tabloids, have been judged by their resemblance to or divergence from this prototype (a standard not changed by the rise of Platinum Age comic book collecting).[3]

In sum, the American "comic book," in the narrow sense argued here, begins with *Famous Funnies* as a template and the cottage industry that it spawned. After 1938 and the advent of the superhero, that industry mushroomed—yet there was more to these magazines during their salad days than just the superhero. In the not-quite twenty years after *Famous Funnies* appeared, comic books offered a slew of genres and moods: adventure fiction in a globe-trotting imperialist mode, as well as Westerns and war stories (all carrying on traditions from dime novels, pulp magazines, and newspaper adventure strips); funny animals and other children's humor comics; teenage-themed humor in the *Archie* vein; movie and media tie-ins; science fiction; morally improving, adult-sanctioned comics (including adaptations of literary classics, hagiographic life stories, and other "true" tales); and outrageous, less-approved genres such as crime, horror, scurrilous satire à la *Mad*, and the hugely popular genre of romance. All of these and more were in the mix: from the presumed wholesomeness of *Walt Disney's Comics and Stories* (1940) to the hard-nosed gallows literature of *Crime Does Not Pay* (1942), and from the earnest, emphatic *Young Romance* (1947) and all that it inspired to the ghoulishly amused, ultraviolent horror of *Crypt of Terror* (1950) and its offspring. Almost all this work was produced in a febrile rush, under tight deadlines, in eye-grabbing, attention-begging styles shaped by many forces: pulp and comic strip formulas, the demands of the market and of editors, the youthful ardor of on-the-job training, the cynical resignation of hardened if not exhausted freelancers, and a sense that anything could be thrown at the wall to see what might stick.

"Comic Book" Tradition and Nostalgia

The comic book as artifact and cultural signpost (think "comic book style," "comic book movie," and so on) still carries connotations from this early, crazily

prolific period, the mid-1930s to the mid-1950s. When American hobbyists say "comic book," this is the tradition they have in mind. Its connotations are those of formula entertainment offered on the cheap, yet occasionally, improbably, catching fire and inspiring uninhibited work that unites commercial imperatives and personal style. *Comic book* carries with it the whiff of childhood pleasures yet also a faintly remembered scandalousness, a far cry from the bid for seriousness implicit in more recent terms like *graphic novel* (see chapter 6). Pop art seized upon this louche reputation in the 1960s, recasting the history of the medium in a wash of retrospective irony. Suffice to say that the comic book is not just a format but a cultural touchstone. Attempts to sidestep the "comic book" label testify to anxiety about the form's cultural status.

At the same time, that label appeals strongly to the dedicated fandom that has made the comic book its own. To embrace the term is to claim the tradition embodied by *Overstreet* and conserved by that fandom: a nostalgic populism upheld by the monkish study of minute data. For fandom, the label conjures up a long, mazy history defined by putative "Ages" (Golden, Silver, etc.) as well as a pantheon of publishers and creators. Most present-day fans focus on two surviving industry giants: DC, launched as National Allied circa 1935, and Marvel, founded as Timely in 1939 (and called by many other names in fine print over the 1940s and '50s). Both DC and Marvel have had complex ownership histories and are now subsidiaries of multinational conglomerates: WarnerMedia and Disney, respectively. They concentrate on superheroes and serve as licensing farms for other media, including films, television, and video games (see chapter 7). Collectors deeply invested in the medium's history, however, will remember competing major publishers such as the still-going Archie Comics (founded as MLJ in 1939) and the now-defunct Dell, Quality, Fiction House, Lev Gleason, Fawcett, Hillman, Prize, Gilberton, Harvey, Charlton, American Comics Group, Standard, Fox, EC, St. John, Gold Key, and Canada's Anglo-American and Bell Features. Littered along the historical wayside are many others that appeared early and are now poignantly obscure. Bygone publishers of more recent vintage include pioneering independent comics outfits of the 1970s and '80s such as Star*Reach, Pacific, Eclipse, First, Comico, and Canada's Vortex. These were precursors or early rivals of still-going independents like Fantagraphics, Dark Horse, and Image and their newer competitors such as IDW and Boom! Studios. (The full lineage of the independents should also include underground comix publishers largely excluded from *Overstreet*, like The Print Mint, Apex Novelties, Rip Off Press, San Francisco Comic Book Company, Kitchen Sink, and Last Gasp.)

More than a history of publishers, comic books offer a chronicle of objects. As a class of object, the comic book was perhaps always fated to become the focus of an organized nostalgia. A piece of fragile, throwaway ephemera (only later reconceived as a ready-made collectible), the comic book began as a

ten-cent wonder that a child might scrounge up enough spare change to buy and then share with other kids: something to be bartered, traded around, and read to bits. As an artifact redolent of childhood, defined by its disposability (by the likelihood that it would disintegrate soon enough), the early comic book underscored—but, as it turned out, could also potentially *defy*—the inevitability of time and change. Every survival of an old comic book into future decades scored an improbable, therefore sweet, victory over time. Also, the precisely dated nature of comic books as periodicals (street date, cover date, and so on) enabled collectors to map private remembrances onto more public forms of memory: to join individual and social perceptions of historical time. That is, comic book collecting provides a way for private and public time to intersect and for subjective memories to be, in a sense, mapped, charted, and organized along a shared time line. In addition, enduring genres like the superhero draw on recognition codes shared between text and readers, such that readers' appreciation may be deepened by awareness of what has gone before: a surplus pleasure that invites nostalgic investment. Moreover, as Thierry Groensteen suggests, the visual and haptic appeal of the medium, and its spatial organization, may encourage a particularly intense relationship between reader and text. As narrative objects constituted by the sequencing and rhythmic interplay of small images, comic books offer a specific form of pleasure: an "art of details" that is not merely the sum of story- and art-related pleasures, and that, argues Groensteen, urges an up close, "fetishistic" relationship between reader and object, one that entails minutely poring over and rereading the texts.[4] In short, the very design of comic books, as objects thick with significant detail, contributes to their appeal as memorabilia. For all these reasons, comic books seem fated to have become evocative talismans of past experience: precious because they were flimsy; timeless because they were dated; loved because they were childish or brought childhood back to mind; fondly recalled because they were a source of self-chosen, even illicit fugitive reading that many readers encountered at a formative age; and involving because they were often detailed, tightly organized, densely nested objects. The whiff of old newsprint—and all the apparatus designed to preserve old newsprint, from acid-free boxes to Mylar sleeves—carries comic book collectors away, backward, into a richly reconstructed (or imagined) past.

Yet there is a danger in describing comic book fandom simply as nostalgic investment. Comic books are not stamps or coins; they are first, and most obviously, *readable*. These are narrative objects: they tell stories, and stories can change the world. The comic book hobby has not just been an inward-turning nostalgia machine, and its readers have not simply been in retreat from present to past. Rather, the hobby has supported, if at times inadvertently, the further artistic growth and even continued social relevance of the comic book, helping to make possible subsequent challenging developments such as alternative

comics (see chapter 3) and graphic novels (again, chapter 6). Improbably enough, the comic book did not go the way of other bygone popular press formats such as the dime novel or pulp magazine but instead grew and changed—even as so many of its nostalgic collectors resisted change. Comic books have not simply survived but transformed.

The History in Outline

Broadly speaking, the American comic book has gone from a mass to a niche medium. Its history divides roughly as follows: an embryonic period of experimentation (through 1938); a heyday defined by big sales and cultural notoriety (from 1939 to the mid-1950s); a near-collapse, followed by retrenchment and suffocating self-censorship (after 1954); and finally, an era of nostalgic reclamation and active intervention by fans (notable after 1960). Curiously, that last period coincided with a radicalization—that is, the redefining of the medium as a vehicle for personal expression (the underground period, post-1967). After all this, in the 1970s, came the entrenchment of a specialized comic book market catering to fans, one that has simultaneously kept alive yet boxed in the medium. This specialty market, called the *direct market*, consists of dedicated comic book stores and is what enabled comic books to survive after 1980. The direct market led at once inward—to increasingly specialized, hermetic comics—but also outward, to new artistic heights and opportunities to engage the larger culture. For example, it became the seedbed of the graphic novel movement of the '80s and after, which went mainstream and flourished post-2000.

Collectors remember a Golden Age that lasted, most will say, from the late 1930s to the early '50s. Superman's launch in 1938 is the mythological flashpoint for that era, while the scandals and setbacks of the mid-1950s define its end. *Famous Funnies* and its ilk are often thought of as preceding the Golden Age in a nascent period of research and development, circa 1934 to 1938, marked by the practice of building comic books out of reprinted newspaper strips. That reprinting strategy, as noted, was how the medium got started, and in the very early years, the layout and design choices of comic books reflected their roots as pasted-up newspaper strip compilations, with regular, lockstep grids of panels and little variation. Comic books in those days were a small, frankly parasitic industry built up by recycling existing material. The format was created not for the sake of inventive storytelling or self-expression but as a sales tool, and its aesthetic horizons were defined early on by the industry's cheapness. The idea was to continue putting out comic books (whether consisting of new or reprinted material) that could be published just as cheaply as those early reprints had been. The limited amount of newspaper strips ripe for reprinting, along with the prospect of growing profits, soon incited the bulk of publishers to follow National Allied's example and invest in new material—but then they

typically invested *as little as possible*. The industry earned a reputation for delivering entertainment cheaply to young and undiscriminating readers and for paying its talent as little as it could get away with.

Superman and his imitators—of which there were quite a few by late 1939 and a horde soon after—enabled the comic book industry to shift into overdrive (see chapter 14). Comic books enjoyed a meteoric rise between 1939 and 1940 and continued growth until circa 1944–1945. Wartime privation, including paper rationing, did not much slow the industry's growth, and in fact GIs became a major audience, reading comic books in the millions. Sales rose again postwar, hitting a peak in 1952, when, as Jean-Paul Gabilliet estimates, about a billion copies of comic magazines, representing over 3,100 new releases, hit the market.[5] By then, the comic book had become a staple of American popular culture—part of the landscape—and especially a main ingredient in the reading lives of young people.

Throughout this period of tremendous popular growth, however, comic books inspired dislike and even fear among many parents and cultural gatekeepers—educators, psychologists, critics—who regarded the new, mushrooming medium as an invitation to illiteracy, social degeneracy, and crime. Published commentary against comic books began as early as 1940. It surged again postwar, by which time the industry had shifted away from superheroes to a broader range of genres, including sensationalistic ones like crime comics (distinct as early as 1942 but more common after 1947), romance comics (launched in 1947, booming by 1949), and horror comics (famously popularized by publisher EC in 1950). These bred controversy. Sales of comic books grew even as a wave of moral panic, and attendant political and legal challenges, assailed the medium from 1947 to about 1950, prompting half-hearted industry attempts at self-moderation. This wave of distrust and fear, even revulsion, toward comic books recurred and spiked from 1952 to 1954, inspiring outcry from many sectors and in many forms: academic and professional articles and symposia; newspaper editorials; the drafting of statutes and resultant debates about constitutionality and freedom of speech; public burnings of comics. Most notorious for leading the professional outcry against comic books was psychiatrist and progressive social critic Fredric Wertham—known for articles on comics from the late 1940s on and, especially, for the incendiary book *Seduction of the Innocent*—published in 1954 to great public and political interest (again, see chapter 14). In the spring of 1954, the U.S. Senate held hearings into the alleged links between juvenile delinquency—a topic of intense social concern in postwar America—and comic book reading, and these drew much media coverage, inspiring op-eds and further uproar. Wertham appeared as expert witness. The comic book industry, pummeled by this criticism, unable to marshal effective legal defenses, and myopically profit-driven in general, resorted to self-censorship along the lines of Hollywood's Motion Picture Production Code, or Hays Code.

Comic books' equivalent of the Hays Office came late in 1954, when a majority of comic book publishers based in New York established the Comics Magazine Association of America, and through it, the Comics Code Authority, a censorship body that functioned semi-independently from the publishers—and perhaps more forcefully than they had expected. The CCA applied the Comics Code, which enforced rigid, authoritarian standards on comic book content. It became the gateway through which most American comic books had to pass from late 1954 onward (after the 1980s, the direct market rendered the CCA moot, though the Code hung on in vestigial form until 2011). The Code not only forbade explicit depictions of violence and sex and strong hints of danger and sensuality—thus putting a damper on crime, romance, and horror comics—but also espoused unambiguous moralism and obedience to official authority. In effect, it imposed on the medium a narrow, protectionist notion of childhood reading (see chapter 9). This was a restrictive recipe, squashing much of what had been thrilling and strange about pre-Code comic books.

In the mythology of comic book fandom, the Code nearly killed comic books, throttling all by itself what had been a Golden Age. That is an oversimplification. True, comic books right after the Code appear constricted and bland, and after their near-collapse in the midfifties, comic magazines never again enjoyed the same sales numbers or cultural reach. The field has never regained the prolificacy and vitality it enjoyed prior to about 1953, when the most popular comic books could sell over a million per issue and the total circulation of comics approached that fabled billion. However, other factors besides the Code also sapped the comic book industry, including shake-ups in magazine distribution[6] and declining profit margins brought about by the fixed ten-cent price of comic books, a policy seemingly based on the assumption that comic books were bought with children's pocket money. (Between the mid-1930s and 1962, a dime was the price standard; by contrast, magazines like the *Saturday Evening Post* and *Life* typically increased in price fourfold during those years.) Perhaps most importantly, the meteoric rise of commercial television posed stiff competition for comics as a source of serial storytelling.

The Code's onset, however, functions as fandom's myth of the Fall. For many fans, hating the Code appears to serve a crucial identity function. In truth, a haze surrounds this era despite the fact that the anti–comic book crusade and resulting Code are the most-studied topics in comic book historiography.[7] It is fair to say that the period is obsessed over yet poorly understood. That said, the Code truly did signal a turn in the comic book's fortunes: post-Code, the medium transformed from a flourishing, endlessly adaptable part of mass culture to a cosseted and specialized niche devoted to a fixed idea of childhood. Comic books after 1954 struggled to adapt to changing times, for their editorial horizons were firmly fixed by the CCA regime, which prescribed a narrow, patronizing view of the readership.

Post-Code Superheroes and Fandom

If certain genres (such as *Archie*-style teen comedy, funny animal stories, and TV tie-ins) did well under the Code, one pre-Code genre in particular dramatically resurged and thrived in the new climate: ironically, the superhero. As Marc Singer recounts (see chapter 14), superheroes made a definitive comeback in the post-Code era and thus came to dominate, if not comic book sales, then organized fandom (*Archie* continued to outsell superheroes for much of the sixties, but you would never know that from most comics scholarship). Many comic book histories have taken the superhero as the unquestioned core of the industry, at the cost of mystifying the medium's actual development. For fans, the superhero, which had already played a starring role in the myth of the industry's rise, became the reason for the industry's (partial) resurgence, its "Silver Age." In fact, comic book fandom and the newly revived, Silver Age superhero grew up together; the incremental revival of superheroes after 1956 coincided with the gradual rise of a newly self-conscious, more focused and structured fan culture. The years 1960–1961 proved a watershed, the moment when fanzines (amateur fan magazines) began to draw together formerly isolated fans or purely local enclaves into a larger national community. Comic book fandom had always been a participatory culture, and there had been earlier attempts to organize fans (such as fanzines devoted to the publisher EC in the early 1950s), but 1960–1961 saw a new and deliberate wave of activity among fans, including the launch of seminal zines: *Xero*, *Comic Art*, and the superhero-oriented *Alter Ego*. These signaled that comic book fandom was not merely an adjunct of science fiction fandom but its own growing phenomenon. In particular, *Alter Ego* became the template for superhero fandom, spawning much fanzine and amateur press activity; its nostalgia for old superheroes, and active support for the superhero revival, modeled the direction much of comics fandom would take.[8]

Fanzines and amateur press associations took the barter economy and underground culture of fandom to new heights (for detailed discussion of fandom, see chapter 8). By knitting together correspondents and friends beyond the local level, these grassroots publications helped establish the familiar features of fan culture, including dealers, mail order, used bookstores that catered to comic book collectors, conventions, and masquerades (or cosplay, in today's parlance). They not only were backward-looking (though nostalgia was of course a motivator) but also endorsed, critically examined, and encouraged conversation around the renascent comic book field and, in effect, took ownership of the resurgent superhero genre. Even as comic books shrank from mass to niche medium, the new discourse of fandom inspired newspaper articles about collecting, popular historical books about comics, and a continued outpouring of specialized zines, bulletins, and papers. The two leading publishers of superheroes in the sixties, Marvel and DC, encouraged this growth by running letter

columns in their comics that gave out not only fans' critical opinions but also, in some cases, full addresses for the fan correspondents—a move that enabled fans to contact each other outside the pages of the comics and establish their own networks of friendship, barter, and publication.

This shot in the arm for the industry, however, did not restore comic books to pre-Code numbers. Although DC thrived on the "Batmania" marketing craze sparked by the *Batman* TV series (1966–1968) and Marvel capitalized on its air of Pop art and college campus hipness, in truth, the comic book revival was only partial. The comic book never regained its status as a truly mass medium; instead, it became a hobby. The "campy" or Pop art superhero became simply a sixties fad. Nonsuperhero franchises such as those of Archie Comics and Harvey Comics remained commercially vital, but histories of the era tend to neglect them in favor of Marvel and DC, the two companies whose courtship of superhero fandom enabled them to weather what turned out to be an industry-wide decline in the late sixties and after. By the late seventies, comic book sales had crumbled, and the industry's future seemed in doubt, despite rearguard efforts to adapt to the times. A revision of the Comics Code in 1971 had relaxed the old strictures a bit, allowing more socially relevant content and the revival of once-forbidden genres like horror. This, combined with a post-Vietnam malaise, brought new levels of questioning and at times tortured self-awareness into the comics mainstream—what Bradford Wright has called "the culture of self-interrogation."[9] At the same time, however, comic books plunged headfirst into nostalgic revivalism, recognizing fandom as their core audience. Pulp magazine heroes such as Conan, The Shadow, and Doc Savage, forebears of the comic book superhero, became important names among comics fans, yet beyond hardcore fandom, the medium was languishing. Many creators assumed that they would be out of work in a few years. What changed all this—what rallied the industry, albeit gradually—was a new means of comic book selling dreamed up by organized collectordom: the direct market. Though rooted in the underground business model of late-'60s comix, the direct market effectively arrived in 1973 when fan entrepreneur Phil Seuling and his partner Jonni Levas persuaded mainstream comics publishers to funnel comic books to their distribution company (later called Sea Gate), which then sold the comics to shops around the country on a nonreturnable basis.

The Direct Market

This direct market transformed a grassroots aftermarket in old comic books into a distribution network for new ones. In the sixties and early seventies, a number of specialized shops had sprung up to serve the nostalgic demand for vintage comic books; these were the brick-and-mortar adjuncts of mail order and convention dealers. The direct market coalesced when shops like these found a

reliable and affordable way to stock new comics. This novel distribution system did not compete with the newsstand market but simply bypassed it, empowering collectors' shops to sell a mix of collectible old comic books and brand-new ones. In the early days of this so-called direct distribution, most shops sold more old comic books than new, since new ones were relatively few. By the late seventies, however, a new sector of independent publishing arose to take advantage of direct distribution; at the same time, new distributors rose up to challenge Sea Gate (whose near-monopoly on direct distribution was undone by a 1978 lawsuit). Further, by decade's end, the reigning old guard of comic book publishers, Marvel and DC, began to focus their attention away from the faltering newsstand market and toward comic shops. After 1981, this trend was overwhelming, as Marvel and DC staked their futures on fandom. Their new emphasis on direct sales encouraged an explosion of comic shops, regional distributors, and small publishers: a competitive frenzy that yielded a generation of non-Code, direct-only comics that included not just independents but also special titles from Marvel and DC. This upsurge made the so-called local comic shop (LCS) a reality.

Direct distribution professionalized, or perhaps colonized, fandom's shadow economy, enabling publishers to sidestep the more traditional yet increasingly unprofitable newsstand market for periodicals.[10] Its inspirations were partly underground, in the alternative grassroots economy constituted by the comix-carrying head shops of the counterculture; indeed, some early comic shops sought to champion underground comix alongside more mainstream fare. Overall, though, this was not a radical new market but a nostalgia-oriented collectors' market. Direct sales catered to a captive, or at least loyal, audience that could be relied on to spend much of its money and time buying, reading, and thinking about comic books. Direct sales fed a hobby, even an all-consuming lifestyle.

That market, still in place today, favors publishers and asks retailers to assume risks. It works on the basis of nonreturnability: retailers must keep all the comics they order, with no hope of a refund for unsold product. The retailers may enjoy deep discounts and a loyal customer base but also bear the costs of whatever does not sell—which means that publishers do not have to bear the cost of returns. This practice sets comic book shops apart from newsstands and regular bookstores, which work on a returnable or consignment basis. Essentially, the market serves as a de facto subscription system, for orders are solicited months before the comics are printed, in effect underwriting the publication of the comics and, again, minimizing publishers' risk. This combination of preordering and nonreturnability gives publishers a distinct advantage, which historically has meant an incentive to try out more experimental or narrowly fan-oriented publications. The result for independent or self-publishers was access to the same market enjoyed by DC and Marvel at a relatively low risk.

The result for DC and Marvel, meanwhile, was both a plethora of spinoff publications (for example, Marvel's industry-leading *X-Men* franchise spawned many derivative titles) and the exploration of new publication formats and methods, including the "limited" series, improved paper stocks, new coloring processes, square-bound or "prestige" comic books, large-format albums, and ultimately "graphic novels." In other words, the direct market became a hotbed of entrepreneurial activity, new publishing gimmicks, and in some cases, substantially new and formula-defying content.

Much of this activity centered on the superhero, and indeed direct sales enabled the so-called revisionist superhero titles that defined the late 1980s (again, see chapter 14). These comics were undeniably offspring of the direct market and epitomized the market's tendency to resell familiar genre formulas in upscale packages. For example, Frank Miller's seminal Batman graphic novel, *Batman: The Dark Knight Returns*, appeared first as four successive forty-eight-page comic books titled *Batman: The Dark Knight* (February–August 1986) in standard comic book size but "prestige" format—that is, with heavy cardstock covers and perfect (i.e., square-bound and glued) bindings. *Dark Knight* represented a departure not only in content but also in look and feel: at $2.95 per issue, these ad-free, deluxe comics contrasted sharply with the standard thirty-two-page, $0.75 Batman comics of the time (which generally included about twenty-two pages of story and many pages of ads). Moreover, the *Dark Knight*'s coloring—lush full-process (painted) coloring by Lynn Varley—was another watershed for superhero comics, upping the ante on what they could achieve. In production values as well as in terms of genre, this series marked the ascendancy of a new kind of direct-market comic and its readership, who were engaged, passionate, willing to spend more, and fiercely attuned to the news circulating through comic shops.[11] The success of *Dark Knight*—and its peer/successor, Alan Moore and Dave Gibbons's twelve-part *Watchmen* (1986–1987)—helped establish the single-issue-to-graphic novel model that still defines direct-market comic book publishing. Comic books may have lost much of their mass audience, but they gained a devoted one that pored over new comics like holy writ.

The direct market has suffered through severe upheavals and, in the 1990s, a near-collapse that resulted in drastic consolidation at the distribution level (regarding current conditions, see chapter 7). The past quarter century of comic book publishing, distribution, and retail has been a story of speculation, artificial spikes and catastrophic troughs in sales, and the rise and fall of many publishers and thousands of shops. More recently, the market has seen a guarded opening-out to popular culture at large as internet commerce, a new generation of readers, and the huge success of comic book–based films, television, and games have brought the tentative signs of a new diversity to what was once viewed, with justice, as a hobby for an aging cohort of mostly white male

collectors. At the same time, conservative backlash, seemingly an inescapable feature of social media in the Trump era, has sought to paint these cautious moves as a betrayal of the tradition.

The odd, largely unacknowledged role of underground comix in revitalizing the medium—and modeling a new way of doing business—remains the elephant in the room of comics historiography, in or out of the *Overstreet Price Guide*. In essence, the underground remains marginalized in the discourse, as if too controversial or discomfiting to absorb into the hobby's nostalgic ideology. At the same time, as noted, comic books are not simply nostalgic time machines; they have opened new avenues for long-form graphic storytelling. They have led to (while yet offering a form of pleasure different from) the vaunted graphic novel. Improbably, they endure: the root and focus of a robust collecting and reading culture.

Notes

1. See, for example, Robert M. Overstreet, comp., *The Overstreet Comic Book Price Guide*, 49th ed. (Timonium, Md.: Gemstone, 2019).
2. Jean-Paul Gabilliet, *Of Comics and Men*, trans. Bart Beaty and Nick Nguyen (Jackson: University Press of Mississippi, 2010), 8.
3. *The Funnies*, a sometimes-weekly published by George Delacorte in 1929–1930, is the nearest and best-known precursor to the *Famous Funnies* prototype but tends to be ignored by collectors due to its size (roughly tabloid) and short life. It published original material, not reprints. *The Funnies* was printed by Eastern Color, and in fact, Delacorte also partnered with Eastern on the one-shot *Famous Funnies* series 1 in 1934, though he elected not to continue with the *Famous Funnies* series. Delacorte reentered the comic book business with *Popular Comics* in 1936, and his company, Dell, went on to become one of the most successful comic book publishers.

 Other reported precursors include a *Comic Monthly* in 1922 (Embee Distribution Company), which devoted each successive 8.5-by-9-inch issue to reprints of a different newspaper strip, and three detective-themed tabloids of all-new material published in 1933 (reportedly by the now-obscure Humor Publishing Co.). Gabilliet's *Of Comics and Men* is the best guide here.
4. Thierry Groensteen, "Why Are Comics Still in Search of Cultural Legitimization?," trans. Shirley Smolderen, in *A Comics Studies Reader*, ed. Jeet Heer and Kent Worcester (Jackson: University Press of Mississippi, 2009), 10.
5. Gabilliet, *Of Comics and Men*, 22, 29–30.
6. Regarding the instability of magazine distribution in the fifties, see Theodore Peterson, "The Economic Structure of the Industry," chap. 4 of *Magazines in the Twentieth Century* (Urbana: University of Illinois Press, 1956), esp. 90–94. The American News Company, which had "practically monopolized the distribution of periodicals" (including comic magazines) from the late nineteenth to mid–twentieth century, faced increased competition by the 1950s, which only grew when a federal antitrust suit brought in 1952 loosened their grip on the market (90–92). Their profits in freefall, American News folded in 1957, which drastically affected the comic book industry. See also Amy Kiste Nyberg, *Seal of Approval: The History of the Comics Code* (Jackson: University Press of Mississippi, 1998), 125–126; "American News to Sell

Assets," *New York Times*, 18 June 1957, 53; and "Newsstand Giant Shrinks Away," *Business Week*, 25 May 1957.

7 Academic and nonacademic accounts of the anti–comic book crusade are legion. Helpful signposts are Nyberg, *Seal of Approval*; Bart Beaty, *Fredric Wertham and the Critique of Mass Culture* (Jackson: University Press of Mississippi, 2005); and David Hajdu, *The Ten-Cent Plague: The Great Comic Book Scare and How It Changed America* (New York: Farrar, Straus and Giroux, 2008). A recent article that somewhat fortifies fandom's view of Wertham as dishonest and self-serving is Carol L. Tilley, "Seducing the Innocent: Fredric Wertham and the Falsifications That Helped Condemn Comics," *Information & Culture* 47, no. 4 (2012): 383–413 (Tilley's view differs drastically from that of Beaty). For thoughtful assessment of the still-continuing impact of the comic book panic and the medium's degraded reputation, see Christopher Pizzino, *Arresting Development: Comics at the Boundaries of Literature* (Austin: University of Texas Press, 2016).

8 The *Alter Ego* fanzine lasted from 1961 to 1978. It has since been revived as a slick "prozine" (1998–) and continues as of this writing under the editorship of longtime fan, writer, and editor Roy Thomas.

9 Bradford Wright, "From Social Consciousness to Cosmic Awareness: Superhero Comic Books and the Culture of Self-Interrogation, 1968–1974," *English Language Notes* 46, no. 2 (2008): 155–174.

10 See Dan Gearino, *Comic Shop* (Athens, Ohio: Swallow Press / Ohio University Press, 2017); Gabilliet, *Of Comics and Men*, 143–146; and Charles Hatfield, *Alternative Comics: An Emerging Literature* (Jackson: University Press of Mississippi, 2005), 20–25. Gearino offers the best—indeed, the only—thorough popular history of the market; Gabilliet's chapter on "The Business of Comic Books" is the fullest academic compendium of data. Matthew Pustz, *Comic Book Culture: Fanboys and True Believers* (Jackson: University Press of Mississippi, 1999), now dated, offers a deep ethnographic study of the culture of comic book shops, though with little attention to their political economy. Mark Rogers, "Political Economy: Manipulating Demand and 'The Death of Superman,'" in *Critical Approaches to Comics*, ed. Matthew J. Smith and Randy Duncan (New York: Routledge, 2012), redresses that neglect. Benjamin Woo, "The Android's Dungeon: Comic-Bookstores, Cultural Spaces, and the Social Practices of Audiences," *Journal of Graphic Novels and Comics* 2, no. 2 (2011), gives an especially trenchant analysis of the comic shop as a subcultural locale. See also chapters in this volume by Woo (chapter 8) and McAllister and MacAuley (chapter 7).

11 On a personal note, I recall vividly the palpable hunger of many fans for each new issue of the *Dark Knight* series in 1986 and the buzz the project generated at my LCS. Reserving a copy was a definite must.

3

Underground and Alternative Comics

•••••••••••••••••••••

ROGER SABIN

Where there's a mainstream, there's an alternative. By the 1960s, the mainstream comics industries in the United States, the United Kingdom, and Western Europe were known primarily for serials produced for young readers on an assembly-line model, with creators employed on a work-for-hire basis (see chapter 7). But a paradigm shift in what a comic could be was imminent; the movements known as "underground comix" and "alternative comics" would usher it in. These new comics, in the words of Charles Hatfield, "transformed an object that was jejune and mechanical in origin into a radically new kind of expressive object."[1] This chapter considers groundbreaking examples from the 1960s to the '90s and asks what made them so different—and so influential.

Underground comix are linked with the counterculture in North America and Western Europe from the late 1960s on into the '70s. While the term *underground* has other associations—for example, work produced clandestinely in opposition to totalitarian political regimes—those are beyond our remit here. Countercultural comix started small but had a seismic effect: in the words of historian Patrick Rozenkranz, they were

> about action and reaction—advocating revolution in the streets and sexual freedom, but also springing from a postwar suburban angst and a fatalism steeped in atomic bomb drills; drawn in a pictographic language that reflected the shared

rites and customs of American youth in mid-century. These comic books were created and published completely outside of the New York comic establishment and were spread far and wide through alternative distribution, demonstrating to cartoonists and publishers everywhere that it was possible to work outside the system.[2]

Because this outsider movement arose from a wide variety of sources, tracing a "first" exemplar is problematic. The influence of the *Mad* magazine (1952) tradition was undoubtedly important for pushing back the boundaries of satire. Harvey Kurtzman, the first editor of *Mad*, was esteemed by many underground cartoonists, and his later magazine *Help!* (1960) gave several of them their first break. Less well documented, other publications also fed into the story, such as Beat publications, literary magazines, and especially college magazines (with titles like the University of Texas's *Texas Ranger* and the University of Wisconsin's *Snide* having an influence far beyond their campuses).

The underground comics were alternative in other ways. Where the Comics Code (see chapter 2) had stipulated "no violence, no sex, and no drugs," as well as no obvious social relevance, the underground took these prohibitions as an encouragement in every category. The new comics gradually adopted the moniker *comix* both to set them apart and to emphasize their "X-rated" (a now-dated reference) or adult nature. A new political awareness among youth in the 1960s was the final ingredient. Though the counterculture could often seem middle-class, male-dominated, and white, its engagement with protest against the Vietnam War as well as causes like the civil rights movement, women's liberation, gay liberation, anarchism, socialism, and the green movement gave it vitality. Add to this an interest in the spiritual and recreational value of psychoactive drugs (marijuana and LSD especially) and of "free love" (the birth control pill had become widely available in the early sixties) and you had a shift in the zeitgeist. Whether this shift constituted a genuine "social movement" is another, and perhaps endlessly debatable, question. Braunstein and Doyle's *Imagine Nation* (a much-cited text on this era) hedges its bets, arguing that the counterculture was "an inherently unstable collection of attitudes, tendencies, postures, gestures, 'lifestyles,' ideals, visions, hedonistic pleasures, moralisms, negations and affirmations. These roles were played by people who defined themselves first by what they were not."[3]

The Birth of the Underground

The underground comix boom lasted roughly from 1968 to 1975, a period during which thousands of titles were produced, often on a self-published basis (most lasted for only one or a few issues). Unlike mainstream creators, the underground artists owned every facet of what they did and split any profits accordingly, a stance that was a political riposte to the work-for-hire system

that existed in the comic book mainstream. Distribution was initially secured through so-called head shops, a grassroots network of countercultural emporia that sold hippie clothing, drug paraphernalia, and psychedelic poster art.

Creatively, comix opened up space. As Joseph Witek has argued, cartooning in comix was "*not* professional drawing as it was defined prior to the underground"; the comix movement not only "provided a venue . . . for the reworking of obsolescent traditional styles, but opened the way for a wide range of new graphic approaches to enter the visual vocabulary of comics, including those derived from avant-garde art and from psychedelic poster design."[4] Nobody exemplified this better than Robert "R." Crumb, who influenced the underground immensely. Indeed, the reason historians so often choose 1968 as a starting point for the movement is that Crumb's comic book *Zap* appeared at that time. Strips of an underground nature, including those by Crumb, had been appearing in countercultural newspapers such as *The East Village Other* and *Berkeley Barb* for some time, and there had been forerunners in booklet form (for example, Frank Stack's *God Nose*, 1964). But *Zap* set a new standard with its tripped-out, *Mad*-influenced art and radical free-spiritedness. It was unquestionably an "expressive object," and as its sales grew, it made comic books in the underground mode fashionable. Crumb's art was familiar (riffing on Disney styles, retrograde racist imagery, and so-called bigfoot cartooning that harkened back to the visual aesthetics of the Depression era) but also of-the-moment with its sex and drug references and occasional breathtaking leaps into improvisation or abstraction.

In retrospect, *Zap* stands as one of the most important titles in comics history. It went on to become an ongoing anthology (1968–2014) featuring Crumb and his colleagues even as Crumb himself continued to produce his own solo titles (such as *Despair*, *Big Ass*, and *Motor City Comics*). Some of Crumb's characters, like Mr. Natural and Fritz the Cat, became countercultural icons. Crumb also published stories with versions of himself as a protagonist, and strips like "The Confessions of R. Crumb" have been cited as important forerunners of the recent autobiographical comics boom (discussed in chapter 15). Crumb was certainly defining himself via what he was not, and cultural historian Emma Tinker has insightfully linked the uncertain tone of much of his work to the ambiguities in the counterculture noted above.[5] Crumb's self-knowingness, especially evident in his autobiographical work, and despair in the face of ethical quandaries marked him out as a creator who could never be at peace with the counterculture, even though he lived within its bosom. He was certainly critical of it, and his more outrageous strips—flaunting, for example, grotesque racist and sexist stereotypes—can be interpreted, though not excused, as a howl of protest against the earnest "right on!" conventions of hippiedom. Crumb was a spiky individual who did not take kindly to being told what to do or how to think. His reception today is fraught and contentious, though a great many artists have cited him as an inspiration or spark.

The *Zap* stable went on to include Gilbert Shelton, who had begun on the *Texas Ranger* and later went on to produce *The Fabulous Furry Freak Brothers* and *Fat Freddy's Cat* (some of the best-loved characters in the underground), and S. Clay Wilson, famed for his excessive drawing style and content (including sadomasochistic pirates, outlaw biker-lesbians, and nonstop sexual violence). The lineup was completed by Spain Rodriguez, future lowbrow painter Robert Williams, psychedelic abstractionists Victor Moscoso and Rick Griffin, and (later) Paul Mavrides. *Zap* appeared regularly from 1968 to 1970, then again from 1973 to 1975, and then very sporadically afterward.[6] Other comix anthologies in a *Zap* mold included, for example, *Bijou Funnies* (with contributions from Jay Lynch and Skip Williamson) and *Young Lust* (with Bill Griffith and Art Spiegelman). Before long, many cities in North America had their own local gangs of underground cartoonists, often pursuing a friendly rivalry.

A Growing Underground

The underground era also saw a crucial miniboom in comix by and for women, reflecting the politics of women's liberation while challenging sexism and misogyny within the male-dominated underground. This again was a revolutionary step for comic books and enabled women to claim a space within the field in a way that had been impossible before (as discussed in chapter 16). Trina Robbins, Willy Mendes, Lee Marrs, Melinda Gebbie, Shary Flenniken, and Aline Kominsky-Crumb were among the pioneers. Titles like the Robbins-edited one-off *It Aint Me Babe* (sic) in 1970 and the series *Wimmen's Comix* (1972–1992) and *Tits & Clits* (1972–1987) led the way, establishing a precedent for feminist and, later, queer comics.[7]

Less well remembered, though important to the U.S. underground, were horror comix that challenged the antiviolence strictures of the Code and revived, albeit in a satirical vein, the pre-Code horror tradition associated with publisher EC in the early 1950s. The pioneer was *Skull* (1970–1972), complete with mock EC logo and strapline on the covers, which included work by Rory Hayes, Richard Corben, Jack Jackson, Greg Irons, and Tom Veitch. Among other horror titles were *Bogeyman*, *Fantagor*, *Insect Fear*, and *Deviant Slice*. Such comix anticipated the eighties' "body horror" fashion in cinema and the concurrent horror renaissance in comics.

As underground publishers began to prosper (among them The Print Mint, Rip Off Press, San Francisco Comic Book Company, Krupp Comic Works / Kitchen Sink Press, and Last Gasp), and with best sellers by Crumb and Shelton shifting hundreds of thousands of copies, other subject matter gained a foothold. The important anthology *Arcade* (1975–1976) became known for its avant-garde content, especially by Art Spiegelman. Gay liberation informed titles like Mary Wings's *Come Out Comix* (1973) and *Dyke Shorts* (1978), Larry

Fuller et al.'s *Gay Heartthrobs* (1976–1981), Roberta Gregory's *Dynamite Damsels* (1980), and the groundbreaking anthology *Gay Comix* (1980–1991, then *Gay Comics*, 1992–1998), initially edited by Howard Cruse. Ecopolitics came to the fore in *Slow Death* (1970) and Leonard Rifas's EduComics line (starting in 1976), while *Anarchy Comics* (1978) tapped into a postpunk resurgence of interest in anarchism.

International Influence

The impact of the underground was not restricted to the United States but also gave rise to comix scenes in certain European countries. In the United Kingdom, American comix had been imported since the beginning, but homegrown British comix had their own flavor and sometimes invoked traditional U.K. titles like the *Beano* and *Eagle*. The United Kingdom also had a localized counterculture to draw from. Publications like *IT* (*International Times*) and *Oz* fulfilled for the British the same function as newspapers like the *East Village Other* in the United States, and underground comic books per se began to appear in numbers in the early 1970s. The anthologies *Cyclops* (1970) and *cOZmic Comics* (1972–1974) reprinted U.S. material alongside British artists like Chris Welch, Ed Barker, and Mike Weller. Work by Dave Gibbons and Brian Bolland also appeared—names that would later become much better known in the context of mainstream American comics. The two best-known U.K. creators were Bryan Talbot, who made his name on *Brainstorm* (1975–1978) with the character "Chester Hackenbush: Psychedelic Alchemist," and Hunt Emerson of the Street Comix line (1976–1978), whose vigorous artwork mixed influences from Crumb, the *Beano*, and *Krazy Kat*. Other British creators included Angus McKie, Antonio Ghura, and Mike Matthews. Female creators challenged sexism with emphatically feminist work; in particular, Suzy Varty created the pioneering *Heröine* (1978).[8]

Further afield, many European comics were strongly influenced by the underground; attitudes stemming from the revolutionary upsurge of 1968 found an apposite vehicle. Across the continent, humor magazines took on a comix sensibility, with popular Americans (e.g., Crumb and Shelton) being widely republished. The mainstream industry was dominated by the Francophone *bande dessinée* tradition (see chapter 4), and in France, some key creators of adult comics (notably, Jean Giraud, alias Moebius) declared themselves fans of the underground. The seventies' wave of French science fiction comics (e.g., *Métal hurlant*, launched in 1975) owed much to comix. Underground publishers thrived elsewhere too: for example, the Netherlands' Real Free Press.

The End of the Underground

Why the underground died out is a vexed question. Some historians maintain that it never did, instead morphing seamlessly into the alternative comics of the 1980s onward. But certainly by the midseventies, the old counterculture was retreating, and establishment clampdowns were becoming more serious. For example, *Zap #4* was ruled obscene in the State of New York, and *Air Pirates Funnies* was sued, eventually successfully, by Disney (for depicting Mickey Mouse involved in sex and drug-taking). Head shops were prosecuted and closed down, and the whittling down of the distribution network had serious consequences. In Britain, a similar backlash took hold, with the *Oz* trial of 1971 (which focused on a reprinted and altered Crumb strip) becoming something of a cause célèbre.

At the same time, the underground was being coopted by so-called straight culture. Most visibly, Ralph Bakshi started a fashion for adult animated movies with the Crumb-inspired *Fritz the Cat* (1972). Marvel Comics attempted its own form of cooption with their anthology *Comix Book* (1974–1975), a would-be "mainstream underground comic" edited by underground veteran Denis Kitchen that included work by Wilson and Spiegelman, among others. Yet the end of the Vietnam War in 1975, which removed the movement's focus for protest, accelerated the end of the counterculture. When a new youth subculture, punk, erupted in the late seventies, the comix were branded as a symbol of a long-haired, naively utopian, newly irrelevant past.

Alternative Comics

Sections of the underground, however, lived on after the decline of the 1960s counterculture, and indeed, its spirit influenced a new wave of alternative comics. In fact, the 1980s and '90s were a golden age for nonconformist comics, and the principles established by the underground were continued and extended—not just in the aesthetic sphere but also in terms of economics (for example, royalty splits and control of copyright), as the idea of the "expressive object" was taken to its logical conclusion. These "alternative comics" of the 1980s and '90s are admittedly hard to define as a genre; though comparable to, and often inspired by, the underground, they are acknowledged by historians to have been different. (Other nearly synonymous terms such as *independent* or *indie* comics have also been applied to this period, though each of these terms carries its own definitional difficulties.) With the development of the direct market (see chapters 2 and 7), these new alternative comic books could piggyback onto a distribution system designed for collectors of more mainstream, especially superhero, titles. This method of selling had advantages: it was a wide and flourishing network, with roughly four thousand shops in the United States

alone by the late 1980s. It also had disadvantages: for one thing, in an economic slump the first titles to be cut back would be the alternatives.

The new alternatives offered a wide range of so-called mature subject matter, including "genre" fiction in the pulp tradition (horror, science fiction), autobiography, politics, satire, and erotica. There was also a greater willingness to explore character development, emotional depth, and stylistic experimentation. Charles Hatfield, whose book *Alternative Comics* is the key text here, explains that this new movement entailed "a more considered approach to the artform, less dependent on the outrageous gouging of taboos (though that continued, too, of course), and more open to the possibility of extended and ambitious narratives," which in turn "raised the intoxicating possibility that comics might be viewed . . . as a literary form."[9] The alternative scene was thus more "inclusive" than the underground and certainly more so than the commercial mainstream, with a greater number of comics that reflected the social concerns of creators who were, for example, female, LGBT, and of different ethnic backgrounds. This is a broad generalization, of course, and the process of inclusion was painfully slow, yet marginalized voices were indeed brought closer to the center, giving the scene an unprecedented richness. Publishers like Raw Books and Graphics, Fantagraphics, and later, Drawn & Quarterly led the way, while in the United Kingdom, Escape Publishing made a significant impact. Other companies, such as Eclipse and Dark Horse, published both alternative and more mainstream material, straddling the main audiences in the direct-market shops. Meanwhile, a few houses with their origins in the underground (Kitchen Sink, Last Gasp, and Knockabout) kept going.

In the 1980s, one anthology stood out in particular: *Raw* (1980–1991), the brainchild of Art Spiegelman and Françoise Mouly. An avant-garde arts magazine centered on comics, *Raw* took unusual formats (eleven by fourteen inches for its first eight issues) and included work by old undergrounders (Crumb, Griffith, etc.) alongside newer talent (such as Mark Beyer, Charles Burns, Sue Coe, and Gary Panter). It also embraced a great deal of European material, such as work by Ever Meulen, Joost Swarte, and Javier Mariscal. The centerpiece was Spiegelman's famed serial *Maus*, which was later filleted out to become the award-winning two-volume graphic memoir.

Other anthologies in this early period included *Weirdo* (1981–1993), launched by R. Crumb and often viewed as a punk-inflected response to the alleged art-school preciousness of *Raw*. *Weirdo* included work by old undergrounders like Aline Kominsky-Crumb and Spain Rodriguez alongside fledgling talents such as Peter Bagge, Dori Seda, and Phoebe Gloeckner. Crumb himself produced some of his best work for this title.[10] Meanwhile, the British *Escape* (1983–1986) also had room for work by old undergrounders, notably Hunt Emerson; newer names such as Rian Hughes, Ed Pinsent, and Eddie Campbell; and Europeans such as Serge Clerc and Jean-Claude Götting. In the late 1980s and '90s, many other alternative anthologies came and went: for

example, *Honk* (1986–1987), *Prime Cuts* (1987–1988), *Graphic Story Monthly* (1990), *Snake Eyes* (1990–1993), and *Pictopia* (1991–1993). *Blab!* (1986–2007) and *Drawn & Quarterly* (1990–2003) would prove rather long-lived, and the latter was particularly influential in the field of autobiographical and literary comics. This trend would continue into the 2000s, with, for instance, the anthology *Kramer's Ergot* (2000–) championing a new breed of art comics and the more recent *Mome* (2005–2011) serving as a sort of literary journal for comics. The anthology format has proved key to the development of the alternative scene in general.

Humor, often pitch-black, continued to be a mainstay genre, taking underground themes to ever-darker places. Chester Brown's *Yummy Fur* (1986–1994) featured "Ed the Happy Clown," who was not very happy at all, due to the horrific misfortunes that beset him. Peter Bagge's *Neat Stuff* (1985–1989) and later *Hate* (1990–1998) starred members of the Bradley family, who were dysfunctional in a way that only suburban living can inspire (when they fight with each other, their bodies contort into spike-featured demons). Daniel Clowes's *Eightball* (1989–2004) mixed hilarious strips about failure and alienation with kitsch and grotesque takes on a "Generation X" sensibility. Chris Ware's *Acme Novelty Library* (1993–) could be funny yet didn't strain for humor; it featured emotionally stranded characters, evocations of loneliness, and a new high for production quality. Ware's design-influenced formalism, muted palette, and meticulous detail made him one of the most influential cartoonists since Crumb. Things went differently in Britain, with the most successful humor publication being *Viz* (1979–). Begun as a punkish stapled zine, *Viz* ended up selling over a million copies per issue and becoming a national institution. The content was a mix of alternative comedy and parodies of both the *Beano* tradition and British tabloid newspapers. Its attitude fit perfectly with the "anticulture culture" fostered by Thatcherite conservatism.

Other genres also thrived under the alternative banner. Soap opera took several forms, but *Love and Rockets* (1981–) by brothers Jaime, Gilbert, and Mario Hernandez was the most applauded. *Love and Rockets* featured several continuing main stories, including one (by Jaime) set in postpunk southern California and one (by Gilbert) initially set in a mythical Central American village called Palomar. It achieved a blend of mainstream and underground styles and spotlighted women in central roles with remarkable depth of characterization. The queer-positive, Latinx, and multicultural ethos of *Love and Rockets* made the title a pillar of the alternative era. Fantasy and horror also had their place and led in more personal directions than in prior eras. *Cerebus* (1977–2004) by Dave Sim, about a talking anthropomorphic aardvark in a fantasy world, started as a spoof of *Conan the Barbarian*, yet became an eccentric, often controversial commentary on bigger themes, including religion, politics, and gender. Sim inspired many other artists to self-publish and to adapt pulp genre material for self-expressive ends, though his antifeminism, reactionary

politics, and reputation as a crank would ultimately isolate him. Wendy and Richard Pini's *Elfquest* (1979–) was a seemingly Tolkienesque but in fact sex-positive and arguably feminist fantasy epic about a community of elves that inspired its own distinct and enduring fandom. The British title *Luther Arkwright* (1987–1989) by Bryan Talbot, a complicated science fiction epic, imagined a parallel universe in which a Moorcock-style adventurer tries to stop an English civil war. In the horror genre, *Taboo* (1988) took its lead from underground horror comics (such as *Skull*) but explored a new level of psychological unease. In Britain, David Britton's *Lord Horror* (1989) was a satirical horror tale about fascism that ended up being prosecuted for obscenity. Alan Moore and Eddie Campbell's *From Hell* (1991), originally serialized in *Taboo*, took the Jack the Ripper story into postmodern territory. Charles Burns's *Black Hole* (1995) was a Cronenberg-esque tale of body horror about a sexually transmitted virus that causes mutations. The 1990s also saw a boom in sex comics that invoked the no-limits attitude of the underground, and these sometimes served as a money-spinning genre to subsidize other kinds of comics (such was the logic behind the founding of the Eros Comix imprint by Fantagraphics in 1990). Content could range from risqué comedy to unrelenting hardcore porn, the latter often drawing fire from the establishment. A particularly controversial erotic title was Howard Chaykin's hardboiled *Black Kiss* (1988), described in one edition as "carefree polymorphous promiscuity" but accused by detractors of misogyny.

However, it was autobiography that became the defining genre in the field—somewhat ironically, since its practitioners commonly viewed it as a rejection of "genre" altogether. Harvey Pekar, a major early figure, assumed the voice of an urban everyman: a working-class thinker with a street-level view of life. In his *American Splendor* (1976), he collaborated with various artists, including Crumb, on stories that re-created quotidian incidents from his life. Confessional comics, inspired by underground work by Crumb, Aline Kominsky-Crumb, and Justin Green, became the rage: for example, Joe Matt's *Peepshow* (1992) showed the creator in an unflattering light as a self-obsessed "sexaholic." Julie Doucet's *Dirty Plotte* (1988–1998, collected in 2018) was a melancholic but hilarious journey through her everyday woes, complete with fantasies of self-mutilation. As an offshoot of autobiography, first-person journalism flourished, its exemplar being Joe Sacco, whose *Palestine* (1993–1995, since collected several times) was a remarkable piece of reportage from the Occupied Territories. Sacco's presence in the story underlines its subjective nature (a tactic derived from 1970s New Journalism). Having established his reputation as a major figure for this kind of work, Sacco went on to cover war-torn Bosnia and Iraq, and war crimes trials at The Hague.

Finally, minicomix, also called small-press or "Newave" comix, enriched the alternative movement while offering an alternative-to-the-alternative. These titles, homemade and generally cheaply produced (accessible photocopiers were an important enabler), often took a quarter-page or half-page format. Print

runs were small—anything from tens to thousands but typically in the low hundreds—so that trading by post became de rigueur. Many names that would later become well known in the alternative comics world started this way: for example, Eddie Campbell, John Porcellino, Chester Brown, Julie Doucet, Adrian Tomine, and Jessica Abel.

Supporting Institutions

The coalescence of the alternative comics phenomenon into a distinct scene was facilitated by the rise of metazines that reviewed alternative titles, interviewed creators, and published mail-order addresses (for example, *Factsheet Five* in the United States, *Broken Pencil* in Canada, and *Bypass* in the United Kingdom). Similarly, specialized conventions and marts provided networking opportunities: in the United States, APE (the Alternative Press Expo) and SPX (Small Press Expo) became increasingly popular, while in Britain, the Caption festival served the same role. Prizes awarded at these events (e.g., the annual Ignatz Awards at SPX) gave a further sense of cohesion. In this way, alternative comics could be self-sufficient, to a degree, offering a parallel infrastructure away from the direct market. Thus the alternative scene moved toward seeing itself as a distinct culture.

This move was undergirded by increasingly sympathetic coverage in some major fan and trade publications. In the United States, the *Comics Journal*, guided by Gary Groth and a succession of editors, had launched in 1976 (taking over a previous zine called the *Nostalgia Journal*) but, through the 1980s and '90s, devoted more and more of its space to the alternatives, pioneering a style of critical advocacy journalism for comics. The contribution of this publication to comics scholarship should not be underestimated; many scholars and artists credit the *Journal* for shaping their view of the art form and its possibilities. (The United Kingdom's *Comics Forum* [1992–2003] was similarly pugnacious, but its influence was not on the same scale.)

Debating the Alternatives

Notwithstanding the range of content and styles on the alternative scene, internecine political arguments were common. Often these spiraled around the question of "authenticity," which was couched in terms of a countercultural or punk-inflected agenda based on a romantic view of the old underground. As in many music subcultures, the accusation of "sellout!" was heard when creators moved into more commercial work, though how this betrayal was defined varied, and the gradations of imagined cultural capital could sometimes be extreme. For example, Peter Bagge took flak for switching to color with *Hate* in 1994 (departing from the alternatives' black-and-white tradition), and creators in the small press were sometimes derided for simply finding a publisher (by the

2010s, for example, Peter Bagge would frequently be published by DC Comics). Similarly, the increasing fashion for collecting longer stories into graphic novels was viewed with suspicion by some readers.

But of course the mainstream culture industries were bound to be looking to the alternatives for inspiration, just as they had to the underground. Critics opined that the 1980s and '90s saw an "indie" comics aesthetic enter low-budget filmmaking, and indeed, several alternative comics became movies (notably, *Ghost World* in 2001 and *American Splendor* in 2003). In advertising, the work of alternative cartoonists was used to lend a patina of hipness (Coca-Cola's OK Soda used designs by Clowes and Burns; Comme des Garcons used panels by Brian Ralph and Megan Kelso). In the world of fine art, the work of creators like Chris Ware became collectable. As the handful of multinational corporations controlling the entertainment industries grew in power through these decades, the tendency for alternative talent to be absorbed by the machine became more pronounced.

Arguments about authenticity draw a veil across the fact that many alternative comics creators did not identify themselves as "countercultural" in the first place (though it could be argued that producing work outside the mainstream is a political statement in and of itself). A few were even politically right-wing, some even to the far right. Similarly, religious comics complicated the picture. Nonetheless, alternative comics have a reputation of resisting co-option and corporatization in a manner like that of punk and other oppositional music cultures.

International Alternatives

In Western Europe, alternative comics developed along a similar path but with important differences, not least because the mainstream had a different history. Mainstream adult comics in Europe took the form of albums as well as monthly magazines (which commonly serialized the stories that would appear in the albums) and had already shown that they could encompass sex, violence, and political themes. In some cases, as in France, the lessons of the underground had been absorbed into distribution systems more expansive than that of alternative comics in the United States (which had to rely on the direct market). Therefore, alternative material could be mainstreamed rather than ghettoized. Yet certain European titles did garner a reputation for being more "alternative" than others: for example, Spain's *El víbora* (1979) mixed work by Crumb and Shelton with homegrown *Raw* favorites like Javier Mariscal. Certain artists' groups, too, were known for an oppositional, punkish stance, such as the Bazooka collective in France and Valvoline group in Italy.

In the 1990s, a more focused conception of what "alternative comics" could mean in a European context began to develop, invoking the artist's book as aesthetic model and often based in artist-run cooperatives. Bart Beaty's *Unpopular*

Culture, the key book on this topic, argues that comics in this new mode departed from the traditions of Franco-Belgian *bande dessinée* by "incorporat[ing] fine arts techniques including linogravure, etching, photography, collage, and sculpting, in an effort to find new expressive means within the comics form."[11] The most important artist co-op was the France-based L'Association (founded 1990), closely followed by Ego Comme X (1993–2016)—houses known for publishing intense autobiographical psychodramas by the likes of David B., Fabrice Neaud, and Dupuy and Berberian. The most commercially successful of L'Association's line would be Marjane Satrapi's series *Persepolis* (2000–2003), which depicts her youth in Iran during and after the Islamic revolution. Meanwhile, important anthologies emerging from non-Francophone scenes included *Strapazin* (Switzerland), *Nosotros somos los muertos* (Spain), *Quadrado* (Portugal), *Mano* (Italy), and *Napa* (Finland).

Back in North America, the comics industry was evolving. By the midnineties, the web promised to be a major factor in comics' future, and the alternative sector was quick to make a home there, not least because this allowed creators to circumvent the direct-market shops (see chapter 17). Webcomics started to flourish (for example, *Slow Wave*, *Roomies!*, and *PhD*), while at the same time, a reaction took place in the form of some creators fetishizing the book as object; "handmade" once again becoming a marker of authenticity. Limited-edition, high-quality, relatively expensive alternative comics became a feature of some stalls at the conventions: a kind of alternative Folio Society idea, akin to the artist-book model. This tendency, encouraged after 2000 by small presses such as Buenaventura Press or PictureBox, ironically reached a mass-market apotheosis with Pantheon's publication of Chris Ware's elaborate boxed narrative *Building Stories* in 2012.[12]

Long before this, by the late nineties, graphic novels had become the fastest-growing sector in publishing. This trend appears consistent with the "consecration" of comics, as traced by Jean-Paul Gabilliet in his book *Of Comics and Men* (the term *consecration* deriving from sociologist Pierre Bourdieu's work on cultural capital). This consecration was accomplished first by fans, then by a critical elite, including academics. As a corollary, Gabilliet argues, it was no surprise that the graphic novel should become such a widely publicized and hyped format, with the writer/artist "auteur" elevated ever further above the factory-line workers of the mainstream.[13] Interestingly, a great many titles in the graphic novel "revolution" have come from an alternative lineage and have enjoyed a disproportionate share of attention in the form of reviews in the quality press and adoption by academia. Certain examples may sound familiar by now: Spiegelman's *Maus* (the title that started it all, academically), Sacco's *Palestine* (collected in 2001), Ware's *Jimmy Corrigan: The Smartest Kid on Earth* (2000), Moore and Campbell's *From Hell* (collected in 1999), Burns's *Black Hole* (collected in 2005), and more recently, the often-taught *Fun Home* (2006) by Alison Bechdel and *Persepolis* by Satrapi. Yet this trend has its ironic side, for the new graphic novels,

with their distribution to high-street bookstores, elevated profile in the arts media, and reception in the academy, now constitute a mainstream in themselves (despite sales that in some cases are modest compared to blockbuster superhero media). Have we reached the point where we need to reconsider what the term *alternative* means? *Alternative* and *mainstream* are in constant flux, and the transformations of the comics industries set in motion by the underground are not yet over.

Notes

1 Charles Hatfield, *Alternative Comics: An Emerging Literature* (Jackson: University Press of Mississippi, 2005), 7.
2 Patrick Rosenkranz, *Rebel Visions: The Underground Comix Revolution* (Seattle: Fantagraphics, 2008), 221.
3 Peter Braunstein and Michael William Doyle, eds., *Imagine Nation: The American Counterculture of the 1960s and '70s* (New York: Routledge, 2002), 10.
4 Joseph Witek, "Comics Modes: Caricature and Illustration in the Crumb Family's Dirty Laundry," in *Critical Approaches to Comics: Theories and Methods*, ed. Matthew J. Smith and Randy Duncan (New York: Routledge, 2012), 37.
5 Emma Tinker, "Identity and Form in Alternative Comics, 1967–2007" (PhD thesis, University College, London, 2009), available online at http://emmatinker.oxalto.co.uk.
6 Robert Crumb, Rick Griffin, Paul Mavrides, Victor Moscoso, Spain Rodriguez, Gilbert Shelton, S. Clay Wilson, and Robert Williams, *The Complete Zap Comix* (Seattle: Fantagraphics, 2014), a deluxe five-volume set, compiles the entire history of *Zap*: seventeen issues' worth of comix produced over roughly forty-seven years.
7 Recently, Trina Robbins et al., *The Complete Wimmen's Comix* (Seattle: Fantagraphics, 2016), a two-volume set, has made much of this groundbreaking feminist work available once again, including *It Aint Me Babe* and the entire twenty-year run of *Wimmen's Comix*.
8 David Huxley, *Nasty Tales: Sex, Drugs, Rock 'n' Roll and Violence in the British Underground* (London: Headpress, 2001), gives a helpful chronicle of the U.K. underground.
9 Hatfield, *Alternative Comics*, x.
10 Jon B. Cooke, ed., *The Book of Weirdo* (San Francisco: Last Gasp, 2019), offers an exhaustive history of the magazine in the context of the alternative comics scene.
11 Bart Beaty, *Unpopular Culture: Transforming the European Comic Book in the 1990s* (Toronto: University of Toronto Press, 2007), 8.
12 Regarding the impact of digital comics on the design aesthetics and material qualities of print comics, see Aaron Kashtan, *Between Pen and Pixel: Comics, Materiality, and the Book of the Future* (Columbus: The Ohio State University Press, 2018).
13 Jean-Paul Gabilliet, *Of Comics and Men: A Cultural History of American Comic Books*, trans. Bart Beaty and Nick Nguyen (Jackson: University Press of Mississippi, 2010).

4
European Traditions
• •

BART BEATY

In 2015, the Festival international de la bande dessinée (FIBD) in Angoulême, France, one of the largest annual comics festivals in Europe, was briefly interrupted by the unusual sight of cartoonists demonstrating in the streets. Behind a banner reading "Sans auteurs, plus de bande dessinée" (Without authors, no more comics), award-winning industry figures—including Lewis Trondheim, David B., and Fabrice Neaud—protested on behalf of the Syndicat des Éditeurs Alternatifs (SEA), an organization representing "nonindustrial" comics publishing houses. While some of the issues that led to the protest, including proposed changes to public pension plans, were specific to the contemporary politics of France, others were more widely generalizable across Europe. Specifically, the gathered authors were expressing their concern that comics is no longer an industry in which it is possible to make a living in France and that their working conditions had become too precarious.[1] In 2014, the year before the protest, a working group, the États généraux de la bande dessinée, had been created to investigate the conditions within the French comics industry. Their 2016 report was dire: 36 percent of comics creators lived below the poverty threshold, and 53 percent of comics authors earned less than the annualization of the minimum wage.[2]

How did such a situation arise? There are multiple, reinforcing reasons that intersect with the entire history of comics in Europe. The proximate cause is widely regarded to be overproduction, a notion that has been discussed for more than a decade. In 2008, the Cité internationale de la bande dessinée et de l'image

in Angoulême hosted a colloquy on the topic of "comics in crisis," and since that time, the topic has been covered in newspapers across Europe.[3] Arguments about overproduction are solidly rooted in evidence. Since 2000, Gilles Ratier, of the Association des critiques et journalistes de bande dessinée (ACBD), has compiled comprehensive data about the number of annual comics publications in France. According to his data, in 2000, there were 1,137 new comics released in France, but by 2008, when talk of overproduction became common enough to merit an investigation, that number had more than tripled to 3,592. Further, by 2012, new releases in France had reached 4,109, or an average of 79 new books published each week.[4] During that period, the number of publications grew in all categories—Franco-Belgian albums, translated Japanese manga, translated American comic books, and original graphic novels—although, as a percentage, the highest rate of growth was for manga. By 2016 (the most recent year for which we have clear data), there were 1,558 Franco-Belgian albums published, 1,575 manga, 494 comic books, and 361 graphic novels. At its most basic level, therefore, the crisis in Franco-Belgian comics publishing is a crisis of globalization. In 2000, an average of 22 comics were released in France each week, of which 14 were European works; *bande dessinée* albums accounted for not quite two-thirds of the books published (though, owing to variances in cost, a higher percentage of the monetary amount). By 2016, however, Franco-Belgian albums accounted for only 39 percent of the market. Moreover, as the total market was divided among a massively inflated number of authors, average earnings necessarily declined. Increasingly integrated into both the American comic book industry and the Japanese manga industry, sales of traditional French-language albums were squeezed by the globalization of comics.

This chapter will address the development of European comics within the context of the globalization of comics culture. While most scholars of comics now trace the origins of the art form to (at least) the inventions of Swiss educator Rodolphe Töpffer in the 1830s (see chapter 1), the very idea that comics are a "European" form is clearly reductionist, as is the notion that there exists a single category that we might recognize as "European comics." While the unique histories of comics in Asia (see chapter 5) and North America (see chapter 2) make charting the development of the form in those areas challenging, the linguistic and cultural diversity that has characterized Europe over the past two centuries makes a chapter on "European comics" virtually impossible. Substantial differences exist in publishing formats, industrial policies, distribution, national support for the art form, visual stylistics, and genre preferences. Rather than try to account for the vagaries of Italian *fumetti* and Danish *tegneserier* in a reductive manner, I will present a series of oppositions that have structured the field of comics production over time across a large number of European comics traditions.

The Commercial Logic of Series and Characters

While the French comics industry of recent years is marked by a high degree of precariousness, this is not true for all participants. Works that typically top the best-seller lists have one commonality: they are part of successful series and generate substantial economic rewards for creators and publishers. According to figures compiled by Ratier, between 2010 and 2016, sixteen albums had initial printings of more than 400,000 copies.[5] These sixteen works represent only eight series, however. Five *Blake and Mortimer* books had print runs ranging from 400,000 to 450,000 copies during this period and were joined at the top of the sales charts by three volumes of *Lucky Luke* (450,000 to 500,000 copies); two of *Largo Winch* (550,000 copies); two of *Titeuf* (1,000,000); *Joe Bar Team*, volume 7 (500,000); *XIII*, volume 20 (500,000); and two volumes of *Astérix* (an astonishing 2,250,000 and 2,480,000 copies in 2013 and 2015; more recently, a new *Astérix* album published in October 2017 reportedly had a French-language print run of some 2,000,000 copies and total circulation worldwide of 5,000,000—figures breathlessly touted in the mainstream press). Not surprisingly, as in other comics cultures, well-known series dominate the best-seller charts. Three of these series are among the most venerable in European comics: *Lucky Luke*, created in 1946 by Morris and which had its peak period when written by René Goscinny and drawn by Morris; *Astérix*, also written by Goscinny, with art by Albert Uderzo, which debuted in 1959; and *Blake and Mortimer*, created by Edgar P. Jacobs, which also launched in 1946. Even the "new" series on the list are relatively old at this point: *XIII* by Jean Van Hamme and William Vance was created in 1984; *Largo Winch*, also written by Van Hamme and drawn by Philippe Francq, was created in 1990; and *Joe Bar Team*, created by Bar2, and *Titeuf*, by Swiss author Zep, debuted in 1990 and 1992, respectively. Notably, of these sixteen books to have the largest initial print runs in France during this decade, only the *Largo Winch* and *Titeuf* books were produced by the series creators.

The French comics best-seller lists highlight one of the most important elements of European comics production: characters are better known, and better loved, than are their creators. While this is also undoubtedly true in the United States (consider the relative fame of Superman vis-à-vis Jerry Siegel and Joe Shuster) and Japan (Naruto versus Masashi Kishimoto), the literalization of the phenomenon can be seen, for instance, in the way that Tintin's name has always been vastly larger than that of his creator, Hergé, on the books collecting his adventures. Despite the canonization of Hergé as a major popular artist (he has an entire museum dedicated to his work in Louvain-la-Neuve, Belgium), Tintin is by far more visible and important than Hergé's other works. Significantly, each of the series discussed above exists beyond the confines of printed comics: they have been adapted for film, television, video games, and toys. This is not to say, however, that author-centered comics cannot also be best sellers. In 2014,

the first volume of the autobiographical memoir *L'Arabe du futur* by Riad Sattouf had a print run of 150,000 copies, and the subsequent books in the series rose to 230,000 and 220,000 copies in the two years that followed. Similarly, cartoonists like Marjane Satrapi and Jirō Taniguchi have sold millions of books in France despite having created no well-known characters. Nonetheless, the logic of the commercial comics industry in France—and across Europe—has always focused on the creation and maintenance of popular comics characters whose adventures unfold over the course of decades.

The Origins of Comics in Europe

The marketing logic of the popular character is intimately tied to the modes of production that have dominated European comics publishing, particularly during the twentieth century. While in the United States, comics were predominantly associated with daily newspapers until the rise of the comic book format in the 1930s, in Europe, there has not generally been a precise equivalent to the U.S. comic book, which has retained a specifically American significance (see chapter 2). The early history of comics in Europe, drawn from Töpffer, can be traced through a range of humor comics, generally quite short, that appeared in illustrated magazines targeting an adult readership. Thierry Smolderen has traced the complex international development of cartooning traditions across Europe in the nineteenth century,[6] and as he has shown, the transnational circulation of comics and protocomics (the eighteenth-century sequential narrative engravings of William Hogarth in London, for example) established the vocabulary of comics long before the form was "invented" by American newspaper publishers in the 1890s. Contributions to the early development of comics came from across Europe. While Töpffer is commonly given pride of place, we would be remiss to ignore the significant contributions of Gustave Doré in the 1840s; Wilhelm Busch's *Max und Moritz* in 1865; the first appearance, in *Judy*, of Charles Henry Ross and Marie Duval's Ally Sloper in 1867; and the creation of Christophe's *La famille Fenouillard* in 1889, to name but a few nineteenth-century precursors to the comics explosion that would take place in the twentieth century.

Yet across Europe, in the years prior to World War I, with notable exceptions like Oskar Andersson's work in the Swedish *Söndags-Nisse* beginning in 1897 and Charles Folkard's *Teddy Tail* in the *Daily Mail* (1915), the development of comic strips in newspapers lagged the American example. Among the most popular comics created during the first two decades of the twentieth century were, in France, Joseph Pinchon and Jacqueline Rivière's *Bécassine* (1905) in the children's magazine *La semaine de Suzette* and Louis Forton's *Les pieds nickelés* (1908) in *L'Épatant*; in Italy, *Il corriere dei Piccoli* (1908), a newspaper that included four pages of mostly American newspaper comics but also Attilio Mussino's strip *Bilbolbul* and Antonio Rubino's *Lola e Lalla*; and in Spain, *TBO*

(1917) by Arturo Suárez, a magazine of such great influence that the Spanish word for comics, *tebeo*, is based on it. Following the war, Alain Saint-Ogan's *Zig et Puce* (1925) became one of the earliest strips in Europe to fully adopt the techniques of American comic strips (including word balloons), but it was the creation of *Tintin* by Hergé (Georges Rémi) in 1929 that fundamentally transformed the public idea of comics in Europe.

Serialized in the Belgian children's newspaper supplement, *Le petit vingtième*, the early adventures of Tintin were a phenomenon in Brussels, leading to the collection of his first adventure, *Tintin in the Land of the Soviets*, as a hardcover book in 1930. The success of this and subsequent volumes in the series established one of the norms of European comics: successful series were collected as hardcover books that could be kept perpetually in print. In contrast to the American comic book industry, in which work disappeared once it left the newsstand, the best-known French-language comics have remained available since their origins, passed down generationally by parents and grandparents to new readers. The fact that comics from the 1930s and 1940s are as readily available in bookstores as current work—perhaps, due to overproduction, even more available—means that European comics have a patrimonial disposition that tends to privilege notions of "the classics." While Superman may be a well-known American comics icon, few children today have read collections of his earliest adventures from the 1930s and 1940s. The same is not true for Tintin and other popular Franco-Belgian comics characters, whose early stories remain constant sellers. In this way, European comics publishing adopted a strategy closer to American children's books (where multiple generations read the work of Dr. Seuss or Maurice Sendak) than to the American comic book industry (see chapter 9).

The Comics Magazine in Europe

Beginning in the 1930s, and particularly after World War II, the dominant mode of comics circulation in Europe became the weekly comics magazine (newspapers took on a decidedly secondary role). These anthology magazines trace their roots to *Il corriere dei Piccoli* but became more popular when, in 1934, Paul Winckler launched *Le journal de Mickey*, a collection of American strips from King Features Syndicate in French translation. Other notable comics magazines launched during this period included *Coeurs vaillants* in France (1929), *Topolino* in Italy (1934), *Bravo* in the Netherlands (1936), the *Dandy* (1937) and the *Beano* (1938) in the United Kingdom, and in 1938, the Belgian magazine *Spirou* (also published in Flemish as *Robbedoes*). Notably, each of these comics magazines specifically targeted young children as their readership, and even the Nazis created a comics magazine for children (*Le téméraire*) in occupied France. Following the war, comics magazines again proliferated. In 1945, *Asso di Picche*, which featured the work of Hugo Pratt, Dino Battaglia, and other

members of the Venice group, was founded in Italy, while in 1946, Hergé and his associates launched *Tintin* magazine in Belgium, the first issue of which also contained the earliest *Blake and Mortimer* pages by Jacobs, which became an enormous success. In the 1950s, a battle of sorts played out in Belgian comics between the two best-known comics weeklies, *Spirou* and *Tintin*. The struggle for talent that occurred at this time led to the creation of many of Europe's best-loved comics personalities, including the titular characters of Jijé's *Jerry Spring*, Tillieux's *Gil Jourdan*, Roba's *Boule et Bill*, and André Franquin's *Gaston*, all in *Spirou*, as well as Paul Cuvelier's *Corentin* and Raymond Macherot's *Chlorophylle* in *Tintin*.[7] In 1959, Belgium's *Tintin* and *Spirou* were joined by France's *Pilote*, home of *Astérix* by Uderzo and Goscinny, as well as of *Michel Tanguy* by Jean-Michel Charlier and Uderzo and *Barbe-Rouge* by Charlier and Victor Hubinon. *Pilote* is the last of the well-known children's comics magazines of the postwar period.

As in the United States, the 1960s witnessed the beginning of a period of transformation in the comics culture of Europe. In France, *Pilote* began to produce adventure and science fiction comics for a slightly older age segment than did *Spirou* and *Tintin*, while *Hara-Kiri*, launched in 1960, brought a strongly adult satirical point of view to the news kiosks. In 1963, Charlier and Moebius (Jean Giraud) created the Western hero *Blueberry*, whose adventures would become increasingly sophisticated and antimilitaristic over the course of the decade as the Vietnam War grew to ever-greater prominence. Self-referential humor and surrealist experimentation were on offer through Nikita Mandryka's *Le concombre masqué* in *Vaillant* and Fred's *Philémon* in *Pilote*, while sexually charged adventure could be found in Jean-Claude Forest's *Barbarella* and Guy Peellaert's *Jodelle*. At the same time, in Italy, the creation of *Linus* in 1965 provided a home for Guido Crepax's sexually frank *Valentina*, while two years later, the magazine *Sgt. Kirk* would provide a home for the first publication of Hugo Pratt's adventures of *Corto Maltese* and, later, *The Scorpions of the Desert*.

Spurred by the political upheavals that spread across Europe at the end of the 1960s, many cartoonists chafed at the restrictions imposed by magazines whose audience consisted primarily of children. In the 1970s, several adult-oriented comics magazines were created including *L'Écho des savanes* (1972), *Métal hurlant* (1975), and *(À suivre)* (1978) in France; *Tante Leny presenteert* (1970) in the Netherlands; *Alter* (originally *Alter linus*, 1974) in Italy; *2000 AD* (1977) in the United Kingdom; and *El víbora* (1979) in Spain. These magazines would be the home of a new generation of superstar cartoonists (Pratt, Jacques Tardi, Claire Bretécher, Druillet, Gotlib, François Schuiten, Moebius, Milo Manara, Vittorio Giardino) until the market for comics magazines collapsed in the 1980s and '90s. Today, of the major comics magazines of the postwar period, only *Spirou* is still published.

The collapse of the comics magazine in the 1980s and '90s led to new processes of production across the industry as the established publishing model

folded in upon itself. Ironically, given contemporary concerns about overproduction, in the early 1990s, the dominant concern was underproduction, specifically the lack of opportunities for young cartoonists. One result of the constricted market was the creation of new outlets. In 1990, following the shuttering of Futuropolis, an independent and famously artist-friendly publisher in Paris, a group of seven cartoonists created a new cooperative—L'Association. Dedicated to editorial independence, they vehemently opposed the norms of European comics. Rather than publishing full-color hardcover albums, as was the rule in France, they focused on black-and-white comics of varying lengths inspired by the American underground and independent/alternative comics movements, which were already in full swing (see chapter 3). Over the decade, they were joined by dozens of similarly focused publishers: in France, Ego Comme X, Cornélius, Amok, Les Requins Marteaux, and Stakhano; in Belgium, Fréon; in Switzerland, Drozophile, Edition Moderne, and Atrabile; in Germany, Reprodukt and Avant Verlag; in Italy, Mano, and so on across the continent. Though many of these fledgling publishers struggled and ultimately failed, the movement toward editorial freedom grew perceptibly and expanded the boundaries of the comics form. Publishers have proliferated, despite a trend toward consolidation within the commercial end of the comics industry (Média participations, which was founded in 1985, has acquired three of the most venerable Franco-Belgian comics publishers—Dargaud, Lombard, and Dupuis—while Groupe Madrigall, created in 1992, controls Gallimard, Denoël, the revived Futuropolis, and Casterman). In 2015, a remarkable 368 publishers were active in the French market.[8] While the struggle for editorial independence in European cartooning has its roots in the student movement of the 1960s, it is particularly acute in the present moment, with publishing and distribution issues debated as ideological positions.[9] At its most reductive, the avant-garde equates commercial success with a backward-looking nostalgia for the glory era of magazine serialization, which stands in stark contrast to the ideal of authorial independence that finds fullest expression in the contemporary stand-alone "graphic novel."

Who Reads European Comics?

The dynamics that have characterized European comics production across the twentieth century—series versus authors; magazines versus books; commercial publishing versus independent publishing—are, in many ways, simple proxies of a larger debate around audience (see chapter 8). While European comics have their origins in publications for adults in the nineteenth century, in the twentieth, they were deliberately reconceptualized as material for children, with the vast majority of commercially successful work, from *Tintin* to *Titeuf*, aimed at a young audience. Although the 1970s witnessed a rapid growth in adult-themed (meaning highly sexualized and often realistically violent) genre comics

across Europe, it was not until the 2000s that the notion of comics for adult readers became a commonplace. One effect of the general decline of magazine serialization has been the rise of the graphic novel tradition across Europe, which has had the unintended consequence of contributing to the precarious nature of work in comics because of the absence of page rates (i.e., payment by the page for publication in magazine installments prior to collection in novel-length form). With the rise of the original graphic novel as a publishing option, comics gained the ability to touch on a much wider range of social, political, and personal topics than previously, with major figures like Marjane Satrapi, Riad Sattouf, and Joann Sfar emerging as significant public figures in the twenty-first century.

The tension surrounding the desire to create comics for adult readers in an art form popularly regarded as childish has led to several productive clashes. In France, for example, a 1949 law prohibited magazine publications that might harm the sensibilities of minors, leading to state intervention in the industry, while in Italy, the government simply banned "corruptive" American comic books outright in 1938. French examples of outright censorship of comics include the famous ban on *Hara-Kiri* in November 1970, when that magazine lampooned the death of former president Charles de Gaulle. It was relaunched one week later as *Charlie Hebdo*, and that magazine has also had many run-ins with the authorities, having been regularly taken to court.[10] (Of course *Charlie* is now known worldwide as the target of the 2015 shootings.) Similar comics censorship debates played out across Europe: in Germany, comics were banned by the Nazi regime, and in the postwar period, West Germany adopted a law prohibiting writings harmful to young persons; Spanish comics were heavily censored during the Franco era; and as late as 2010, a cartoonist was convicted under Swedish child pornography laws for the possession of manga.[11] The protection of children, and the concomitant assumption that comics are a childish art form, has been as commonplace across Europe as it has in the United States and Japan. For decades, comics were structured by the understanding that they produced for children and thus needed to be regulated, while in more recent decades, they have been shaped by the desire to upend this previous understanding.

The Diversity of European Traditions

Despite the many conceptual similarities across European cartooning as it has played out in its various histories, it would be a mistake to assume that the field is homogenous. Far from it. While the popular image of "European comics" that exists outside of Europe is one that emphasizes the Franco-Belgian album traditions that grew out of the postwar magazines, other important traditions pertain. The equation of "European" and "Franco-Belgian" tends to arise precisely because that segment of the field as a whole dominates industrial practices, but

this oversimplifies the European scene. For example, many of the best-known Italian cartoonists—Hugo Pratt, Guido Crepax, Lorenzo Mattotti, and Vittorio Giardino—are the ones who have been most widely published in French, while well-regarded Italian cartoonists who have not been published in that country, such as Andrea Pazienza, are generally much less well known. The same can be said about almost any national comics tradition in Europe.

While elaborate histories have been written about most European comics scenes, many of the major figures from them are obscured by linguistic and cultural differences and by publishing decisions that have rendered them minor figures in the most dominant markets.[12] Particularly absent from the dominant understanding of comics in Europe are works presented in atypical formats. For instance, in Italy, the success of the publishing model introduced by Gian Luigi Bonelli in the postwar period (complete black-and-white stories of more than 100 pages in a single pocketbook-sized volume) held tremendous sway and made characters like Tex Willer, Martin Mystère, and Diabolik household names, but these comics have not circulated outside of Italy with much success. In Great Britain, children's comics have long centered around the *Beano* and the *Dandy*, both of which launched as weekly comic papers in the late 1930s, and weekly adventure magazines like the *Eagle*, created in 1950. In Spain, two publishers, Editorial Bruguera and Editorial Valenciana, dominated children's comics publishing, carrying on in the tradition of *TBO*. Within the confines of a "European comics" tradition defined by the largest player, these comics scenes tend to be minimized as highly localized oddities; they fail to make the transition into a "global comics" publishing industry. Such is the power of Paris and Brussels as the metropolises of European cartooning that, in many instances, cartoonists, having established a reputation in their home countries, find it necessary to produce work for the largest Franco-Belgian publishers in order that it may be sold back to publishers in their homelands. In this way, those Franco-Belgian publishers act as gatekeepers, defining what it means to create "European" comics, while publishers working in other languages are left with the production of merely "local" comics.

Nonetheless, the localization of comics in Europe is an important factor in contributing to the tremendous vitality and diversity within the field. Take, for example, the case of Switzerland, a relatively small country whose four official languages have boundaries that are roughly, though not precisely, geographical. Switzerland has several distinct comics cultures. French-language publishers like Atrabile and Drozophile are based in Geneva, near the French border. That city hosts its own comics prizes, the Prix de la ville de Genève. Founded in 1997 and supported by the city's Department of Cultural Affairs, these annual awards honor an international book and also include a Prix Töpffer, awarded to a cartoonist who has lived for at least two years in the city. Among the notable cartoonists associated with Geneva, and its prizes, are Alex Baladi, Frederik Peeters, Peggy Adam, Tom Tirabosco, and Isabelle Pralong. On the other side

of the country, in Zürich, the German-language publisher Edition Moderne has published the influential international comics magazine *Strapazin* for more than thirty years and supports a German-speaking Swiss cartooning culture that includes Thomas Ott and Anna Sommer, while the Fumetto festival in nearby Luzern annually brings together cartoonists from across the country alongside international guests. These local Swiss comic scenes have significant differences beyond questions of language. Notably, Geneva's practice of direct democracy and frequent referenda has supported a significant tradition of poster art that provides work and visibility for cartoonists based in that city.

State support for local and national comics traditions is common throughout much of Europe, which markedly differentiates it from the comics culture of the United States. At the local level, many European cities underwrite comics festivals as a boost to local tourism. Most countries in Europe have one or more cities that hold major annual comics festivals (in France, Angoulême; in Italy, Lucca; in Germany, Erlangen; in Finland, Helsinki; and so on), and long-standing festivals like Angoulême's (established in 1974) receive funding from multiple levels of government and take on national significance, driving media interest and focusing attention on the comics industry for a few days each year. Similarly, state support for comics at the local level often includes funding for cultural institutions such as museums and libraries. Major museums dedicated to comics exist in Angoulême (the Cité national de la bande dessinée), Brussels (Centre Belge de la bande dessinée), Copenhagen (Tegneseriemuseet I Danmark), Basel (Cartoonmuseum Basel), and Hannover (Wilhelm Busch Museum), among others, and comics libraries exist in venues as diverse as Cremona (Centro Fumetto Andrea Pazienza) and Stockholm (Serieteket). These institutions serve to raise the profile of comics within local and national contexts, providing opportunities for education and outreach. Finally, in many countries across Europe, cartoonists and comic book publishers are eligible for subsidies that help to defray the costs of producing new comics work, a factor that has allowed small presses to flourish in an otherwise challenging publishing climate.[13]

International Relations

Relations among European comics traditions are not, of course, limited to the Continent, but reflect differing types of engagement with other dominant global comics industries. While the American newspaper comic strip played an important role in the shaping of early twentieth-century comics magazines in many European nations, post–World War II concerns about Americanization in countries including the United Kingdom, France, and Germany curtailed the importation of American comic books and permitted indigenous comics industries to develop along their own pathways. For much of the twentieth century,

comics produced in Europe had almost no circulation abroad. The vaunted translation of Hergé's *Tintin* into dozens of languages beyond French and Dutch did not gather momentum until the 1960s; though several *Tintin* adventures were published in American editions by Golden Press in 1959 and 1960, they were not particularly successful and no attempt was made to complete the collection. The first significant effort to translate European comics on a large scale in the United States occurred with the launch of *Heavy Metal* magazine in 1977, which introduced the new wave of adult science fiction and fantasy comics to an international audience[14] and created a transnational star in Moebius. Translations of European comics remained limited to a small handful of American publishers in the 1980s (Catalan Communications) and 1990s (NBM, Fantagraphics) until the twenty-first century, when the simultaneous flowering of the small-press revolution in the United States and across Europe meant that shared aesthetic sensibilities fostered a greater level of international cooperation and translation. Nonetheless, European-produced comics have been relatively rarely translated in Japan, where publishing norms remain quite different.

While comics exports from Europe to the United States and Japan have been marginal, the same cannot be said of imports from those industries, particularly in recent years. While American superhero comic books in translation circulated only sporadically across Europe for most of the twentieth century, the rise of the superhero blockbuster film era created a new demand for the original stories that has led to translations of most contemporary superhero comics in a variety of European languages. Similarly, the translation of Japanese manga has been, since about 2000, a predominant part of the comics industry in several European nations—notably France and Germany, where the scale of translation outstrips production even in the United States. Manga traditions have had a strong impact on European cartooning, leading to the creation of European manga-influenced comics including Baru's prize-winning *L'Autoroute du soleil* (1995) and *Last Man* by Balak, Sanlaville, and Bastien Vivès, one of the more commercially successful series created in the 2010s.

That European comics was, in the 2010s, profoundly influenced by national traditions from beyond Europe comes as no surprise. While the origins of modern cartooning may reside in Europe, large-scale comics production on the continent initially drew on American traditions for inspiration before undergoing a profound de-Americanization, often backed by legislation. Hybridity has long been the hallmark of European comics, where an extensive interchange of cartooning traditions has produced a plethora of options. Recall that at the current juncture, the biggest perceived threat to comics in Europe is the fact that there may be too many; overproduction threatens the viability of the field, though it is a function of the field's success. Cartoonists across Europe have worked to define and redefine the cultural status of comics as both national and transnational objects; at the same time, they have redefined our very

understanding of the form while contributing to the unequal mosaic we know of as "European comics."

Notes

1. Nicolas Gary, "Auteur de bande dessinée, 'un métier compatible avec la surproduction?,'" *ActuaLitté*, 12 February 2015, accessed 20 July 2018, https://www.actualitte.com/article/bd-manga-comics/auteur-de-bande-dessinee-un-metier-compatible-avec-la-surproduction/53793. This article reports statements made by Jean-Louis Gauthey, president of SEA.
2. Quentin Girard, "36% des auteurs de BD sont sous le seuil de pauvreté," *Libération*, 2 February 2017, accessed 20 July 2018, https://next.liberation.fr/culture-next/2017/02/02/36-des-auteurs-de-bd-sont-sous-le-seuil-de-pauvrete_1545636. Notably, only 13 percent of workers in France earn the minimum wage, so this figure is more than four times higher within the comics industry than it is across the French economy generally.
3. See, for example, Philippe Peter, "BD: Le cercle vicieux de la surproduction," *France Soir*, 5 January 2012, https://archive.francesoir.fr/loisirs/litterature/bd-cercle-vicieux-surproduction-170993.html; and Philippe Muri, "Trop de bandes dessinées publiées en 2014," *Tribune de Genève*, 7 January 2015, both accessed 6 July 2017, https://www.tdg.ch/culture/bandes-dessinees-publiees-2014/story/12795888. The papers from the 2008 colloquy were published as Gilles Ciment et al., *L'État de la bande dessinée: Vive la crise?* (Brussels: Impressions Nouvelles, 2009).
4. Gilles Ratier, *Rapport sur la production d'une année de bande dessinée dans l'espace francophone européen: 2016, l'année de la stabilization*, Association des critiques et journalistes de bande dessinée (ACBD), accessed 20 July 2018, https://www.acbd.fr/wp-content/uploads/2016/12/Rapport-ACBD_2016.pdf, 5.
5. All of Ratier's reports are available at the ACBD website, https://www.acbd.fr/category/rapports. Of course, actual sales greatly exceed the initial print runs as successful series go on to multiple printings.
6. Thierry Smolderen, *The Origins of Comics: From William Hogarth to Winsor McCay*, trans. Bart Beaty and Nick Nguyen (Jackson: University Press of Mississippi, 2014).
7. The history of these two magazines is presented by Hugues Dayez, *Le duel Tintin-Spirou* (Brussels: Toyrnesol Conseils SPRL, 1997).
8. Ratier, *Rapport 2016*, 7.
9. See Bart Beaty, *Unpopular Culture: Transforming the European Comic Book in the 1990s* (Toronto: University of Toronto Press, 2007); and Jean-Christophe Menu, *Plates-bandes* (Paris: L'Association, 2005).
10. See Stéphane Mazurier, *Bête, méchant et hebdomadaire: Une histoire de* Charlie Hebdo *(1969–1982)* (Paris: Buchet-Chastel, 2009).
11. Frederik Stromberg, "Naked Manga = Child Pornography," *Comics Journal*, 4 August 2010, accessed 20 July 2018, https://classic.tcj.com/manga/naked-manga-child-pornography. Web page no longer extant; last archived via Internet Archive: Wayback Machine (archive.org) on 25 May 2018.
12. See, for instance, Gianni Bono and Matteo Stefanelli, *Fumetto! 150 anni di storie italiane* (Milan: Rizzoli, 2012); Frank Günter Zehnder, *Wow! 100 Jahre Comics: Die Originale* (Cologne: Rheinland-Verlag, 1996); and João Paulo Paiva Boléo and Carlos Bandeiras Pinheiro, *Le Portugal en bulles: Un siècle et demi de bandes dessinées* (Lisbon: Bedeteca Lisboa, 2000).

13 A common argument is that such subsidies have allowed the rampant growth of overproduction in the comics field, though others counter that the subsidies reduce precarity within the field. Of course, both of these arguments can be true at the same time.
14 For more on this particular history, see Nicolas Labarre, Heavy Metal: *L'autre* Métal hurlant (Pessac, France: Presses Universitaires de Bordeaux, 2017).

5

Manga

●●●●●●●●●●●●●●●●●●●●●●

FRENCHY LUNNING

<div style="text-align: right;">

Manga is difficult to define.
—Isao Shimizu[1]

</div>

Western readers often seek what superhero fans refer to as the "origin story": a founding tale of beginnings, of roots. Such tales tend to center on an essential moment, yet also provide a rich contextual surplus that prompts us to trace the progress of events as history. In the case of Japanese manga, that origin story is in dispute. Many critics and historians cite differing moments in Japanese art history as the starting point of contemporary manga. With an absence, or rather a plethora, of proposed origin points, influences, and significant objects—each with differing logics and criteria—the "history of manga" becomes a messy, fragmented, and controversial formation. As Marilyn Ivy puts it, "A plurality of voices unravels to exceed the bounds of its enframing discourses."[2] Why does this question of origins matter so much? *Nostos*, or "the desire for origins," as Ivy observes, imagines "tradition (*dentô*) as unbroken transmission": an affirmation of cultural continuity through "a return to the voice," a voice that can guarantee an authentic link to the enduring, the premodern.[3] As she notes, diverse and even "nonstandard Japanese practices of the voice"—or in our case, printed manga—may "become spectacularized as the singularly representative voice of the nation-culture."[4] In simpler terms, manga, and associated popular cultural objects, as well as the identities represented by and in manga, have come to represent a national identity and culture that for many *is* "Japan."

This chapter, while it can offer only a short, highly compressed history, will touch upon the entry points suggested by scholars as potential origins, and attempt—through brief mention of its cultural hybridities, continuities, discontinuities, and controversies—to come to terms with the messy braid that is the story of manga.

Pre-manga

The first evocations of caricature and other "manga-esque" aspects that evolved in earlier periods of Japanese history have been classified by manga scholar Fusanosuke Natsume as "pre-manga."[5] The famous "Animal Scrolls" of Bishop Toba (circa 1053–1140 CE), which caricatured the everyday lives of people as animals, are the most famous of these to have been (mis)labeled as the very "origin" of manga. Frederik L. Schodt refers to these scrolls as "among the oldest surviving examples of Japanese narrative comic art,"[6] though his phrasing suggests a distinction between this and the familiar manga form. Much later, in the Heian period (794–1185), *emakimono* (handscrolls) presented certain intriguing continuities with contemporary manga, such as the conventional depiction of faces through the *hikime kagihana* (line-eye, hook-nose) style, "which indicates features but does not identify individuals."[7] This visual style (fig. 5.1) is akin to contemporary manga, especially shōjo manga, with its facial formula of huge complex eyes, a small hook nose, and a tiny mouth. The division of *emakimono* into *onna-e* (female pictures) and *otoko-e* (male pictures) suggests both a firm gender distinction and distinctive stylistic tendencies, with *onna-e* favoring "introvert, emotional feelings" and *otoko-e* "extrovert, physical action."[8] Although contemporary manga tend to blur these lines as twenty-first-century culture reacts to gender and sexuality transformations and challenges, mid-twentieth-century manga still recalled the *emakimono* gender divides by drawing a line between shōnen (boys' manga) and shōjo (girls' manga). While obvious discontinuities between the *emakimono* and contemporary manga belie the claim that the former are *the* point of origin, *emakimono* certainly suggest that particular cultural and aesthetic tendencies in early Japan established a tradition of representation that influenced manga's pioneers.

Manga Emerges as "Random" and Comic "Sketches"

For Jaqueline Berndt, the definition of the term *manga* can be traced to the late Edo period (1603–1868). As she explains, the word was at first written with two Sino-Japanese characters, *man* and *ga*; specialists in Japanese art history, when referring to eighteenth- or nineteenth-century art, typically translate this compound as "random sketches." The use of the word "sketches" for the second character, *ga*, as opposed to "pictures" or "paintings," is noteworthy: as Berndt remarks, *sketching* "points to activities employing brush and ink and resting

FIG. 5.1 Conventional depiction of faces in the *emakimono* of the Heian period: *hikime kagihana* (line-eye, hook-nose) style. Detail from "36 Poems about Heroes," *kibyōshi*, n.d. From the author's collection.

mainly upon the potential of the line." Further, the first character, *man*, can also be interpreted in a way related to brushstrokes. Besides connoting funniness or laughter, when translated as "random," *man* alludes to the artist's "rather uncalculated visualizations of observations and thoughts in quick brushstrokes," suggesting movement rather than deliberation.[9]

From the Genroku period (1688–1704) to the Kyōhō period (1716–1736), picture book collections (*ehon*) of fairy tales and stories for children, called *akahon* because of their red front covers,[10] became very popular and later developed into "a picture book for adults."[11] During the Hoei period (1704–1711), humorous caricatures called *Toba-e* pictures (no doubt after the work of Bishop Toba

earlier) began to circulate in Kyoto; when they were published in book form in Osaka, they "marked the start of the commercialization of manga."[12]

Many manga scholars suggest as the potential origin of manga the *kibyōshi* in the Genroku period, which was a moment of "monumental transformation."[13] *Kibyōshi* were "yellow jacket booklets" that contained humorous, sometimes ribald adult stories, frequently in series, with strong story lines about the urban society of the time, and "in a pattern similar to the development of today's adult comics . . . grew out of illustrated books for children that stressed fables."[14] *Kibyōshi* images (fig. 5.2) were woodcuts and combined text with pictures: "Text could be smoothly incorporated within images and the two elements conceived, printed and read together, as in the basic system of comics."[15] Adam L. Kern, however, observes discontinuities as well as continuities with contemporary manga and therefore argues that *kibyōshi* are not a "direct progenitor" of the latter. Both, he notes, are "products of consumer societies," but they represent "vastly different stripes of capitalism—one early and preindustrial, the other advanced and perhaps postindustrial."[16] Nonetheless, *kibyōshi* are among the earliest books of comics art with embedded text.

FIG. 5.2 *Kibyōshi* woodcuts of the Genroku period incorporated text within images, anticipating contemporary manga. Example circa 1800, drawn from random sheets found in an antique shop. Author's collection.

An urban legend still touted by fans and even by some art historians is that the revered Katsushika Hokusai (1760–1849) was the first to coin the term *manga*. However, historian Isao Shimizu has suggested that "manga was initially an abbreviation of *manpitsu-ga* which stemmed from *manpitsu* (rambling, or meandering essayistic writing)," a usage that has been found in the late eighteenth century.[17] Nevertheless, Hokusai's work figures prominently in art historical reckonings of manga's origins because of its sophisticated development of caricature. Indeed, it is not uncommon to say, as Joan Stanley-Baker does, that caricature "reached its zenith in the hands of the woodcut master Hokusai."[18] His exquisite line and humorous caricatures of everyday life—sometimes narrativized, while other times single portraits or sketches—resemble contemporary manga even while their cultural context and perspective remain lodged in the late Edo period.

Ukiyo-e, perhaps the best known of early Japanese cartoon styles, were woodblock prints that illustrated the "floating world" or nightlife of Kyoto especially. Actors, geisha, and prostitutes were among the portraits and scenes created in this style. Hokusai, Moronobu, and Utamaro were among the principal innovators. Their caricatured subjects suggest only a distant relation to contemporary manga, though that connection is made more pronounced in the *ukiyo-e* subgenre of *shunga*, or "spring pictures" (erotic, or some would say pornographic, pictures), which were driven underground by a ban in 1722 but are now sought after. Paul Gravett suggests that *shunga* link to contemporary manga through the now-familiar genre of pornographic, or *hentai*, comics.[19]

Despite this, Berndt, Kinsella, Gravett, and other key scholars draw a number of distinctions between Edo manga and contemporary manga. Berndt lists three distinct hallmarks of manga today: (1) the way of intertwining images and script for the purpose of storytelling, nowadays usually supported by comic-specific devices such as speech balloons, impact lines, and panel layout; (2) the empathy with psychologized characters by means of privileging facial expression; and (3) the role of calligraphic script, or "sketches," recalling the art-historical translation of *manga* (the employment of typographs distinguishes contemporary manga both from Hokusai manga and from Euroamerican comics).[20] It is only long after, in the late nineteenth century, that comics in Japan begin to use the term *manga*, when it "entered occasional, specialist usage, principally to describe wood block prints with comic themes," such as Hokusai's *hyakumensō* (caricatures), published in 1819.[21]

Meiji and Taishō: Manga and Western Intervention

The Meiji period (1868–1912) was marked by a radical shift in the culture and goals of Japan, and has been commonly understood as a period of "severe dislocation, indiscriminate Westernization, and headlong modernization,"[22] which resulted in a "wide-ranging intermingling of mediums and techniques by

painters, printers, illustrators ... and the nascent press and printing industry."[23] One of these hybrid phenomena came in the form of the distribution and adoption of Western cartoons and caricatures, through "'*manga* journalism,' which satirized the period and Meiji politics, [and] appeared in the Japanese newspapers and magazines."[24]

Prior to the onset of the Meiji period, in 1863, the English painter and illustrator Charles Wirgman "founded a satirical illustrated journal, *The Japan Punch*, for the foreigners in the [Yokohama] concession and continued it until 1887 with brief breaks during 1863–1864. This was the origin of the Japanese loanword *ponchi* (punch), used to describe cartoons."[25] According to Kinko Ito, "The term *ponchi* (stemming from the English word 'punch') began to refer to what we call manga today. Words such as *Toba-e*, *Ōtsu-e*, and *Kyoga* ('crazy pictures'), all of which referred to caricature and witty pictures, were replaced by the term manga."[26] The *Japan Punch* was basically a magazine for the in-group of foreign Westerners but was also enjoyed by Japanese readers. Wirgman's cartoons satirized Japanese life, specifically from the point of view of foreigners, and were drawn in "the typically low-key style of the British"[27] while "often employ[ing] word balloons."[28] Despite their suffocating—and racist—point of view, the *Japan Punch* represented a new sort of humor and cartoon style that was highly influential for the Japanese, such that "Wirgman is today considered the patron saint of the modern Japanese cartoon."[29]

In 1887, the French Georges Bigot, who had arrived in Japan five years earlier to teach art, formed a magazine called *Tōbaé*, harkening back to the animal scrolls of Bishop Toba. *Tōbaé* presented Meiji life and political satires of Japanese politics; Bigot frequently got in trouble for this. Both Bigot and Wirgman represented the importation of new printing technologies into Japan, leading to, as Kinko Ito notes, "the emergence of mass production of *manga* satire in a very short time"; among such new technologies were "zinc relief printing, copperplate printing, lithography, metal type, and photo engraving technology," as documented by Shimizu.[30]

In 1905, a visually rich monthly color cartoon magazine, *Tokyo pakku* (*Tokyo Puck*), appeared, bringing, through the work of Rakuten Kitazawa and Ippei Okamoto, chromolithographic, American-style cartoons into Japan. Both Kitazawa and Okamoto had traveled in America and seen Richard F. Outcault's "Yellow Kid" work (see chapter 1), and so they created a "Japanese version of 'Yellow Kid' in the *Jiji Shimpo* newspaper's Sunday edition."[31] They also created seminal comic strips for other Japanese newspapers, such as *Tagosaku to Mokubē no Tōkyō kembutsu* (Takosaku and Mokube sightseeing in Tokyo) in 1902.[32] Kitazawa was the first to use the word *manga* in its modern sense.[33]

Comic strip conventions solidified during the Taishō era (1912–1926). By 1923, Katsuichi Kabashima (artist) and Shōsei Oda (writer) had created the first serialized comic strip for children in newspapers, *Shō-chan no boken* (Adventures of Little Shō; fig. 5.3). Produced in black and white and in daily

FIG. 5.3 Katsuichi Kabashima (artist) and Shōsei Oda (writer), *Shō-chan no boken* (Adventures of Little Shō), Japan's first serialized newspaper strip for children, appearing January 25, 1923, in the first issue of the paper *Asahi Graph*. Image courtesy of Paul Gravett.

installments, each story was divided "into units of four framed pictures. The writing beside each frame [panel] told the story; the balloons (*fukidashi*) inside the frame gave the characters' speech."[34] Soon after, in 1924, Yutaka Asō created a four-panel strip called *Nonki na tōsan* (Easygoing daddy) in direct response to the popular American family strip *Bringing Up Father* by George McManus.[35]

Traumatic changes were coming. For Japan, World War II began in 1937, with the war between Japan and China (in Western parlance, the Second Sino-Japanese War). By 1940, most professional cartoonists and their groups in Japan had been either eliminated or absorbed into "umbrella organizations like the New Cartoonist Association of Japan (*Shin Nippon Mangaka Kyōkai*) . . . created with government support to unite cartoonists under an official policy."[36] One national priority, the need to increase factory production of war materials, inspired the genre of *zosan manga*, or "increasing production comics."[37]

Postwar Manga

Japan was in dire straits as it worked to rebuild under the postwar Allied occupation. The end of the war brought the rapid development of manga in a new register—indeed, manga as we now know it. In 1946, a young woman named Machiko Hasegawa created the extremely popular family strip *Sazae-san*, opening the door for women to enter into the field. The postwar period also introduced a practice now acknowledged as a forerunner of contemporary manga and animation: *kamishibai*, a street-level performance art in which "a set of pictures [is] used by a performer to tell a story to an audience, usually of children."[38] Importantly, many *kamishibai* artists (such as Sanpei Shirato and Shigeru Mizuki) became *mangaka* (manga artists) when the practice of *kamishibai* faded due to competition from television.[39]

The most profound postwar influence on Japanese manga and animation (anime)—and indeed, on global comics and animation—is found in the life and work of Osamu Tezuka. Although Tezuka is known as the "God of Manga," he disliked that title, saying that by granting him divinity, it denied his hard work and sacrifice as a human being.[40] Tezuka made a serious breakthrough in 1947 with his landmark manga *Shin Takarajima* (New Treasure Island; fig. 5.4).

Manga • 73

FIG. 5.4 Osamu Tezuka's *Shin Takarajima* (New Treasure Island) of 1947 introduced a cinematic style of extended storytelling that revolutionized postwar manga.

Influenced by the animation of Walt Disney and the Fleischer brothers, Tezuka brought a cinematic style of extended storytelling to the page, one that showed the potential for psychological content, and thus mature adult narratives, in both manga and anime. This allowed Tezuka to innovate in terms of narrative and character creation to a degree that altered both comics and animation globally. The scope of Tezuka's creative works is astounding: as Gravett summarizes, "He wrote and drew a record 150,000 pages for 600 manga titles as well as some 60 animated works, and wrote essays, lectures and film reviews."[41] Obviously, his entire oeuvre is impossible to address in this chapter, but Gravett notes especially the groundbreaking techniques found in *Shin Takarajima*: "From one panel to the next . . . Tezuka constantly shifted the reader's point of view, mimicking the movements of a film camera to generate a feeling of restless action and to propel the characters through the tale. At times the focus zooms in and the figures threaten to burst out of the panels. Motion lines, speed distortions, sound effects, sweat drops—the full armoury of comics symbols served to heighten the experience. Tezuka even stacked his wide, cinema screen–sized frames in vertical columns on the page to look like sequences cut from a roll of film."[42]

These innovations continued into his later serial works, including, famously, *Jungle Taitei* (Jungle emperor, 1950–1954, ultimately the animated television series *Kimba the White Lion*) and *Atomu Taishi* (Ambassador Atom, later

Tetsuwan Atomu or Mighty Atom; 1952–1968, and known globally through the TV series *Astro Boy*). The profound effect of Tezuka's works on global popular cultures cannot be overstated.

Yet even the so-called God of Manga has been challenged as the originator of the medium in its contemporary form. Scholar Gō Itō, in his 2005 book *Tezuka Is Dead: Postmodernist and Modernist Approaches to Japanese Manga* (*Tezuka izu deddo: Hirakareta manga no hyōgenron e*), argues that too great a focus on Tezuka and his generation hampers the development of a useful "theoretical framework" for reading manga as such. As translator Miri Nakamura notes in her introduction to his essay on the subject, "Itō problematizes the dominant position of Tezuka Osamu as the absolute origin of Japanese manga history, a view he argues has prevented the construction of a history of representation in manga (*manga hyōgenshi*). Itō instead reveals that the realism of modern manga originated from the suppression and effacement of its postmodern elements."[43] Itō argues that to ignore such issues, or to take Tezuka's innovations (such as increased psychological depth through cinematic storytelling) as the very core of manga, is to fail to read manga *as* manga. However, the fact that even Itō's intervention is framed in terms of a polemical resistance to Tezuka (*Tezuka Is Dead*) testifies to Tezuka's enduring impact on the discourse of manga and manga studies.

Japan's immediate postwar period, as Kinko Ito notes, saw a boom in manga magazines: *Manga kurabu* (Manga club), *Kodomo manga shimbun* (Children's manga newspaper), *Kumanbati* (The hornet), *Manga shōnen* (Manga boys), *Kodomo manga kurabu* (Children's manga club), and more.[44] These magazines became showcases for a generation of emerging artists who are now among the most celebrated mangaka, including Fujiko Fujio, Fujio Akatsuka, Mizuno Hideko, and Shōtarō Ishinomori, as well as other acclaimed figures, among them major writers, designers, illustrators, and performers.[45]

With the introduction of American comic books and strips during the occupation, *story manga* (that is, lengthy comics with extended story lines) became very popular, a tendency of course encouraged by Tezuka's innovations. This led to a boom in comics production. The 1957 development of *gekiga* (dramatic pictures) signaled a major change in manga readership. *Gekiga*, pioneered by artists like Takao Saitō, Masaaki Satō, and Yoshihiro Tatsumi, "dropped the Disney-style of drawing . . . and adopted a more serious, graphic approach to depict more adult and action-oriented themes."[46] The *gekiga* movement, born out of the commercial lending library (*kashibon'ya*) market, extended the readership for the new manga magazines appearing in the late 1950s and throughout the 1960s, notably including *Shūkan shōnen magajin* (Weekly boy's magazine; published by Kodansha in 1959), which spotlighted stories for boys and young men, followed closely by *Shūkan shōnen sande* (Weekly boy's Sunday; Shogakukan, 1959), which favored stories about sports and about heroes with "guts" (*konjō*). Later, in 1968, the now famous *Shōnen Jump* appeared (published by Shueisha).

Adult male manga (*seinen manga*) also saw an explosion in magazines at this time, including *Manga panchi* (Manga punch), *Manga akashon* (Manga action), *Biggu komikku* (Big comic), and many others. In addition, manga-related merchandise became big business, to the extent that, as Ito notes, popular manga often "existed symbiotically with their animation and character goods and toys."[47] Additionally, more sophisticated and experimental magazines appeared, such as *Garo* (1964–2002), which included highly personal and at times avant-garde manga alongside criticism and commentary, and *COM* (1967–1972), founded by Tezuka, featuring sophisticated *gekiga*.

Shōnen manga, dripping with machismo and sweat, became known for stories about sports, adventures, samurai, and war, but in the mid to late seventies, as Frederik L. Schodt notes, competition emerged in a drastically different form, as "light love stories that [did] not fit the traditional mode" became popular. Says Schodt, it was "as if a gentle mist ha[d] settled over the traditional Japanese male persona, calmed, and feminized it. The change emanate[d], of all places, from girl's comic magazines"—shōjo manga.[48] Shōjo had roots in several different sources in the 1950s and 1960s, with the publication of girls' manga magazines including *Nakayoshi* (Good friends; Kodansha, 1954–), *Ribon* (Ribbon; Shueisha, 1955–), *Shōjo furendo* (Girl's friend; Kodansha, 1963–1996), and *Māgaretto* (Margaret; Shueisha, 1963–), among others. In addition, Rachel Matt Thorn points out that the fashion magazines *Soreiyu* (Soleil; 1946–1960) and *Himawari* (Sunflower; 1947–1952), though not manga, had an enormous impact; both "were edited and illustrated by the multi-talented [Jun'ichi] Nakahara," whose work offered "an ideal (if largely unrealized) lifestyle for the postwar Japanese teenaged girl" in terms more mature and enticing than the manga of the time (*Junior soreiyu* would follow in 1954).[49] However, it is Tezuka's gender-bending *Ribon no kishi* (*Princess Knight*; 1953–1968) that is most frequently cited as the founding narrative of shōjo manga.[50] Indeed, it has many of the aspects of what has since become a radical form stylistically, socially, sexually, and globally, with numerous offshoot practices such as cosplay and diverse fashion-oriented merchandise and events. The visual aspects of shōjo manga, much elaborated and conventionalized since Tezuka's day, now constitute a recognizable graphic code: baroque, visually florid depictions of romance and desire; unrestrained emotional expressivity; and the large doe-eyes of the heroine—who is nonetheless able to slip in and out of gender as her desire commands.

The original creators of the early shōjo manga were men who "began drawing this new type of comic, often because they were unable to break into the more competitive boy's magazines."[51] Slowly, women creators emerged, starting with Yoshiko Nishitani, drawing "heroines [who] were teenaged Japanese girls" (styled after Nakahara's aesthetic) and stories "in which romance, formerly taboo in magazines for children, was a prominent theme."[52] By 1969, a group of young women creators had coalesced into what is now known as the

24 *Nengumi* (Year 24 Group)[53] and included Moto Hagio, Keiko Takemiya, and Yumiko Ōshima, but also Ryōko Yamagishi, Minori Kimura, and Toshie Kihara. Some of the stunning stylistic innovations by these shōjo mangaka have been summarized by Frederik L. Schodt: "Girls' comic magazines are characterized by a page layout that has become increasingly abstract . . . [and the] use of montage . . . a medley of facial close-ups, free-floating prose . . . rays of light, and abstract flowers and leaves that waft slowly across pages with no seeming relationship to the story. . . . Unfolding roses, drifting petals, and falling leaves symbolize both femininity and the transience of life . . . exclamation marks and periods are often replaced by small hearts and stars. At the extreme, this page style is a prolonged sigh of inner longing."[54] These codes for the romantic emotions and sexual longings of young women have continued to appeal not only to younger women and girls but increasingly to older women as well. Shōjo manga of the seventies and after have often combined these emotional flourishes with extended and ambitious storytelling, as in, for example, Riyoko Ikeda's French Revolution epic *Berusaiyu no bara* (The rose of Versailles; 1972–1974), a roughly 1,700-page-long blend of history, politics, passion, and (in *Princess Knight* tradition) gender nonconformity (fig. 5.5). Shōjo manga stories involving gender transformations, homosexuality, and bisexuality—when depicted, as Schodt says, "aesthetically"[55]—have become extremely popular to women and men in the early twenty-first century.

Since the 1980s, certain manga have targeted young women in their twenties and thirties. Called *redīsu* manga or *redikomi* (ladies comics), or *josei* (women's) manga, these have explored emotions, relationships, and themes of sexuality and identity, with art that is sometimes, though not always, sexually explicit. From the 1990s to the present, themes of horror, gothic mystery, and magical realism have developed in josei manga, sometimes in conjunction with costumes, fashion trends, or other fan cultural practices and interests.

Conclusion

This chapter merely skims the salient points from an immensely complex and at times contradictory historical heap of both hybridization and isolation, in which Japanese and transnational influences, commercial and artistic practices, and ancient and modern objects have come to be seen through a contemporary viewpoint. Yet as Jennifer Robertson suggests, history is not only a spatiotemporal process but also "a social production constituting ways in which the past is continuously organized, represented, reclaimed, reworked and reproduced as memory"—and, we might add, as narratives, as origin stories.[56] Certainly, manga, this mishmash of "commingled media,"[57] has been all that and has delivered, in spite of its mixed and highly controversial heritage, transformations in global cultures.

FIG. 5.5 Shōjo manga of the 1970s combined emotional graphic flourishes with extended and ambitious storytelling, as in Riyoko Ikeda's classic *Berusaiyu no bara* (*The Rose of Versailles*; 1972–1974). Shown here are the cover to and an interior page (slightly cropped) from volume 7 (Shueisha, 1974).

Manga has, for example, attracted both younger and older female readers and creators to comics in both Japanese and English (see chapter 16). Comic book production in America had been, since its inception in the early to mid–twentieth century, a male-centered practice, and despite the open secret that many girls and women read comics at the midcentury, the readership has also been assumed to be male. Certainly, relatively few women (even fewer of whom were acknowledged) had participated in comics production up until the late twentieth century. Japanese manga helped to change this. Manga began to seep into the United States in the late 1970s and early '80s through various means, building toward a landslide with the addition of new translation and distribution companies like Viz (still a major player in the market) and Tokyopop (now drastically downsized) in the late 1980s and especially the 1990s. As the readership expanded, anime clubs and conventions brought translated manga into the hands of a huge number of readers—but girls in particular. As they took to shōjo manga, art classes and art schools began to get an influx of young women wanting to learn to draw manga. This was happening at the same time that comics studies was finally entering academic art departments as a major, and manga played a huge part in confirming that trend. Consequently, manga

has had a tremendous influence on the styles and narrative being created in contemporary American and European comics, particularly in the independent publishing sector.

Another transformative practice was "scanlation"—the practice of scanning and translating manga for free distribution, performed by a network of dedicated groups, typically over the internet—which began with fan projects, often encouraged through anime conventions. The technique of fan-subbing anime had expanded in the late 1990s and led directly to this "fanscanning" of manga. The existence of already established IRC (Internet Relay Channel) chat servers enabled scanlation to be done quite quickly. Fanscanning became a prevalent grassroots phenomenon; by decade's end, "individual fanscan efforts became more organized and structured," as fans increasingly joined together to found distinct, semiformal "groups dedicated to scanning, translating, and editing" manga.[58] After 2000, such scanlation groups coalesced and multiplied rapidly,[59] and since then, they have exploded in number.

What is the motivation for all this work? Scanlators tend not to be interested in competition with licensed books or even among themselves, focusing instead on "bringing to light the estranged corners of the medium and showing what incredible depth the world of manga has to offer."[60] As one scanlator comments, "What is interesting is that there are many, many people working in these scanlation groups . . . it takes up [sic] an incredible amount of work to put out a single chapter. And they do it all for free. That is an incredible amount of passion."[61] That passionate desire seems to embrace two separate compulsions: first, to share their favorite manga with other speakers of their own language in the world; and second, and perhaps more importantly, to feed and sustain their own desires, constellated around the manga objects themselves. For scanlators and their readers alike, that desire originates in the storytelling, characters, and aesthetics of authentic Japanese manga.

The manga scanlation phenomenon, fueled by the passion of an international network of fans, suggests a larger, more profoundly transformative social structure that is in the process of emerging. National and ethnic tensions, which continue to cause so much strife in the world, are dissipated in an international community that seeks to distribute the art of a particular culture internationally. Through this vast and global distribution, Japanese manga is promoted to the world as an art at once respected and admired for its authentic "Japaneseness" yet celebrated as a transnational cultural product. Manga's identity—from the beginning—has been a hybrid; consequently, fans reach across old boundaries and old territories to secure a "place" where such distinctions mean nothing in the face of the larger desires of the manga-reading community. Japanese manga's future will exceed its current forms as it moves with the fast pace of the global culture, but as anthropologist and globalization theorist Arjun Appadurai suggests, "We can see the potential for a vocabulary of participation, justice and dialogue which is not wholly dominated by reasons of state or by national

boundaries or by protectionist motives. This is a vocabulary which, even if emergent and rudimentary, might provide the beginnings of a push to a world of sites and networks, rather than of ethnicities and territories."[62]

Notes

This chapter is dedicated to the Fulbright Organization, which funded much of this research; to my friends and colleagues Isao Shimizu, Asako Watanabe, and Michael Baxter; and to the Kyoto International Manga Museum, with profound gratitude and affection.

1. Isao Shimizu, interview by Frenchy Lunning, March 2008, Tokyo Imperial Hotel, Tokyo, Japan. In accordance with this book's overall style, Japanese names here are presented per Western convention: given name first, surname last.
2. Marilyn Ivy, *Discourses of the Vanishing: Modernity, Phantasm, Japan* (Chicago: University of Chicago Press, 1995), 17.
3. Ivy, 16. Here Ivy draws upon Michel de Certeau, *The Practice of Everyday Life*, trans. Steven Rendall (Berkeley: University of California Press, 1984), which acknowledges the impossibility of recovering a unique, unifying, "pure" voice untouched by modernity.
4. Ivy, *Discourses of the Vanishing*, 17.
5. Paul Gravett, *Manga: Sixty Years of Japanese Comics* (London: Laurence King, 2004), 18.
6. Frederik L. Schodt, *Manga! Manga! The World of Japanese Comics*, updated paperback ed. (Tokyo: Kodansha International, 1986), 28.
7. Joan Stanley-Baker, *Japanese Art*, rev. ed. (London: Thames & Hudson, 2000), 81.
8. Stanley-Baker, 84.
9. Jaqueline Berndt, "Traditions of Contemporary Manga (1): Relating Comics to Premodern Art," *Signs: Studies in Graphic Narratives*, no. 1 (2007): 34.
10. The word *ehon* comes from picture (*e*) and book (*hon*). The *akahon* were picture-dominated softcover booklets aimed at children, named for their front cover colors (*aka*, red, plus *hon*, book). Later came books aimed at older readers, including *kurohon* (black books) and *aohon* (blue books). Collectively, these various genres were known as *kusazoshi*. The *kibyōshi*, or "yellow-jacket books," marked a distinct formal change in that they added substantial text. Information drawn from Kinko Ito, Adam L. Kern, and Frederik L. Schodt.
11. Kinko Ito, "A History of Manga in the Context of Japanese Culture and Society," *Journal of Popular Culture* 38, no. 3 (2005): 459.
12. This denotation of the *Toba-e* books comes from Ito, "History," where she uses the word *manga* broadly to represent "comic art" from "607 CE in the ancient capital of Nara" (458) to the present time and to cover a range of work, including "caricature, cartoon, editorial cartoon, syndicated panel, daily humor strip, story-manga, and animation" (456).
13. Adam L. Kern, *Manga from the Floating World: Comicbook Culture and the Kibyōshi of Edo Japan* (Cambridge, Mass.: Harvard University Asia Center, 2006), 6.
14. Schodt, *Manga! Manga!*, 37.
15. Gravett, *Manga*, 2.
16. Kern, *Manga from the Floating World*, 12.

17 Berndt, "Traditions," 35, drawing upon Isao Shimizu, *Manga no rekishi* (Tokyo: Iwanami Shoten, 1991).
18 Stanley-Baker, *Japanese Art*, 91.
19 Gravett, *Manga*, 20.
20 Jaqueline Berndt, "Manga and 'Manga': Contemporary Japanese Comics and their Dis/similarities with Hokusai Manga," in *Civilisation of Evolution, Civilisation of Revolution: Metamorphoses in Japan 1900–2000*, ed. Arkadiusz Jabłoński, Stanisław Meyer, and Koji Morita (Kraków: Manggha Museum of Japanese Art & Technology, 2009), 210–222. See also Berndt, "Drawing, Reading, Sharing: A Guide to the *Manga Hokusai Manga* Exhibition," in *Manga Hokusai Manga: Approaching the Master's Compendium from the Perspective of Contemporary Comics* (Tokyo: Japan Foundation, 2015), 3–38.
21 Sharon Kinsella, *Adult Manga: Culture and Power in Contemporary Japanese Society* (2000; repr., London: Routledge, 2013), 20.
22 Ellen P. Conant, introduction to *Challenging Past and Present: The Metamorphosis of Nineteenth-Century Japanese Art*, ed. Ellen P. Conant (Honolulu: University of Hawai'i Press, 2006), 1.
23 Conant, 3.
24 Ito, "History," 462.
25 Kiyoko Sawatari, "Innovational Adaptations: Contacts between Japanese and Western Artists in Yokohama, 1859–1899," in *Challenging Past and Present*, 87.
26 Ito, "History," 461. *Ōtsu-e* ("Ōtsu pictures"), Ito notes, refers to Ōtsu, a town outside of Kyoto, where, during the Tokugawa period, caricatures were sold to travelers "on the main road from Kyoto to the north" (458).
27 Schodt, *Manga! Manga!*, 38.
28 Ito, "History," 461.
29 Schodt, *Manga! Manga!*, 40.
30 Ito, "History," 463.
31 Ito.
32 Schodt, *Manga! Manga!*, 42.
33 Isao Shimizu, *"Nihon" manga no jiten: Zenkoku no manga fan ni okuru*, Shohan ed. (Tokyo: Sanseidō, 1985), 53–54, 102–103.
34 Roger S. Keyes, *Ehon: The Artist and the Book in Japan* (Seattle: University of Washington Press, 2006), 248.
35 Schodt, *Manga! Manga!*, 46–48.
36 Schodt, 55.
37 Ito, "History," 465.
38 Sharalyn Orbaugh, "Kamishibai and the Art of Interval," in *Mechademia*, vol. 7, *Lines of Sight* (Minneapolis: University of Minnesota Press, 2012), 78.
39 Orbaugh, 79.
40 Kotoku Minoru, interview by Frenchy Lunning and Michael Baxter, April 2008, Takadanobaba, Tokyo, Japan.
41 Gravett, *Manga*, 24.
42 Gravett, 28.
43 Miri Nakamura, translator's introduction to "Tezuka Is Dead: Manga in Transformation and Its Dysfunctional Discourse," by Gō Itō, in *Mechademia*, vol. 6, *User Enhanced* (Minneapolis: University of Minnesota Press, 2011), 69.
44 Ito, "History," 466.
45 Schodt, *Manga! Manga!*, 66.

46 Schodt.
47 Ito, "History," 469.
48 Schodt, *Manga! Manga!*, 87.
49 Rachel Matt Thorn, "Shôjo Manga—Something for the Girls," *Japan Quarterly* 48, no. 3 (2001): 4. Other scholars affirm Nakahara's influence, both on shōjo manga and the larger culture of *kawaii* (cuteness): see, for example, Masuda Nozomi, "Shojo Manga and Its Acceptance: What Is the Power of Shojo Manga?," in *International Perspectives on Shojo and Shojo Manga*, ed. Masami Toku (New York: Routledge, 2015), 24; and Kyoko Koma, "Kawaii as Represented in Scientific Research: The Possibilities of Kawaii Cultural Studies," *Hemispheres* 28 (2013): 8.
50 Schodt, *Manga! Manga!*, 96.
51 Schodt.
52 Thorn, "Shôjo Manga," 4.
53 Also known as the Magnificent 24s or '49ers, or *Nijūyonen gumi*, this group of pioneering artists were so labeled "because so many were born in the 24th year of Showa," or 1949. Thorn, 5.
54 Schodt, *Manga! Manga!*, 89.
55 Schodt, 100–101.
56 Jennifer Robertson, *Native and Newcomer: Making and Remaking a Japanese City* (Berkeley: University of California Press, 1991), 4.
57 "Commingled media" is J. L. Anderson's well-known description of various Japanese arts characterized by an "aesthetic tendency [toward] extreme complexity with heterogeneous, often redundant elements brought together to form a work." See Anderson, "Spoken Silents in the Japanese Cinema, or Talking to Pictures: Essaying the *Katsuben*, Contextualizing the Texts," in *Reframing Japanese Cinema: Authorship, Genre, History*, ed. Arthur Nolletti Jr. and David Desser (Bloomington: Indiana University Press, 1992), 261–262. Thanks to Sharalyn Orbaugh for this quotation.
58 gum [pseud.], "The Land before Time," Inside Scanlation, accessed 10 June 2019, https://www.insidescanlation.com/history/history-1-1.html.
59 gum [pseud.], "The First Modern Scanlation Group," Inside Scanlation, accessed 10 June 2019, https://www.insidescanlation.com/history/history-1-2.html.
60 Dirk Deppey, "Scanlation Nation: Amateur Manga Translators Tell Their Stories," *Comics Journal*, no. 269 (July 2005): 34.
61 Quoted in Deppey, 35.
62 Arjun Appadurai, "Modernity at Large: Interview with Arjun Appadurai," by Anette Baldauf and Christian Hoeller, Translocation_New Media/Art symposium, Vienna, 29–30 January 1999, http://www.translocation.at/d/appadurai.htm. Web page no longer extant; last archived via Internet Archive: Wayback Machine (archive.org) on 22 June 2008.

6

The Graphic Novel

••••••••••••••••••••••

ISAAC CATES

The term *graphic novel* generally denotes a substantial and self-contained comic, bound as a book with a spine, with storytelling ambitions beyond the genre formulas that defined American comics in the mid–twentieth century (see chapter 2). The graphic novel movement, and the term itself, are relatively new, having gained traction in the late 1970s and '80s. Exactly what defines the graphic novel has been contested or quibbled with by practitioners ever since. The term has suffered from ambiguity and even antipathy as different discourse communities have used it to designate distinct but overlapping categories of comics production. It is easy to construct a short list of texts that clearly fit under its rubric—Art Spiegelman's *Maus*, Alan Moore and Dave Gibbons's *Watchmen*, Alison Bechdel's *Fun Home*, Chris Ware's *Jimmy Corrigan*, Will Eisner's *A Contract with God*—but the boundaries of the category have historically depended on confused and at times conflicting definitions. With that in mind, this chapter will describe common uses of the term but will also offer a corrective to those definitions in order to sketch in the characteristics most emphasized by contemporary cartoonists working on comics of this sort. Many nonspecialist writers use the term to designate a form or publishing format, while others refer to the graphic novel as a genre; in the end, however, the best application of the term in its historical context construes *the graphic novel* in relation to an aesthetic movement, not a particular product or set of story constraints. Of course, this sociohistorical understanding may make the definition's boundaries even more permeable, and may therefore pose its own problems, but

this is what the graphic novel has come to signify among its practitioners and avid readers: more than a format or specific genre, *the graphic novel* represents a movement, a shared aspiration for thematic scope, sophistication, and a readership beyond the niche of superhero comic book fandom.

Origins of the Graphic Novel

The popularly accepted narrative of the advent of the graphic novel credits the master cartoonist Will Eisner with producing the first such work. There are lesser-known historical antecedents both for the application of the term *graphic novel* to long-form comics and for the use of such comics to explore themes of personal and social significance, but Eisner's role in popularizing the term (and in contributing prolifically to the graphic novel corpus) earns him a special place in the history of the movement. Yet Eisner's own story about coining the phrase *graphic novel* establishes it as a term of convenience, even desperation. One of the pioneers of the adventure comic book in the 1930s and '40s, Eisner attended a comics convention in 1971 and was surprised by the intimate, personal, and socially engaged comics published by underground cartoonists (see chapter 3). Inspired by their work—and by the new distribution networks that were allowing that work to reach more mature readers—Eisner returned to making comics in order to tell stories drawn from his life experiences, particularly in the hardscrabble Bronx tenements of his childhood. His first effort along these lines, *A Contract with God and Other Tenement Stories* (1978), collected four short stories around the themes of betrayed faith, disillusionment, and the loss of innocence. Pitching *A Contract with God* to a publisher (Oscar Dystel at Bantam Books), Eisner abruptly realized that given the cultural position of comic books, he needed a label with greater cachet: "A little man in my head popped up and said, 'For Christ's sake, stupid, don't tell him it's a comic. He'll hang up on you.' So I said, 'It's a graphic novel.'"[1] Although Eisner told this story as if he had invented the term, he was not the first to use *graphic novel* to designate a long and ambitious comic book: a fanzine writer named Richard Kyle had used it as early as 1964, and other writers subsequently invoked the term; for example, Richard Corben's *Bloodstar*, an adaptation of a Robert E. Howard short story, called itself a "graphic novel" in 1976, as did George Metzger's *Beyond Time and Again* (a compilation of his underground comic strip), also in 1976.[2] Moreover, as Andrew J. Kunka has demonstrated, Eisner's correspondence with the cartoonist Jack Katz introduced Eisner personally to the fanzine use of the term at least as early as 1974.[3]

A Contract with God differs significantly from Katz's *First Kingdom* (1974–1986, first book edition 1978) and the Corben and Metzger projects in both its genre and setting: Eisner's crumbling tenements and humble, thoroughly imperfect characters are a long way from typical heroic fantasy or science fiction. If Eisner's appropriation of the term for his works shifted the meaning

of *graphic novel*, it was through his insistence that, unlike the long-form comics that had appeared in the past,[4] his graphic novels would pursue the potential of comics as a "literary medium" or a "literary form."[5] Eisner does not seem to have questioned this appeal to the literary very rigorously, nor was he precise about what *literary* might mean, though for him the term seems mainly to be defined by realism and engaged social critique—that is, *generic* features rather than characteristics of complexity, self-awareness, or quality. About the underground cartoonists who inspired his turn to the graphic novel, he later said, "Whether they intended it or not, they were using comics the way literature is normally used, to dramatically deal with a social problem.... *MAD* [magazine] never made the pretense of being a social commentary."[6] Eisner had long believed that comics is as capable as any storytelling medium of engaging social issues or reflecting the life experiences of its creators—a position we can now take as a given—but at the time, the position of comics in both the culture and the marketplace seemed to preclude that sort of seriousness until underground cartoonists, and Eisner in turn, attempted it.

In fact, although they had either been popularly neglected by the 1970s or originally published underground or for small audiences, there had been a number of earlier substantial works that shared Eisner's literary ambition for the comics medium. Though these works never referred to themselves as graphic novels, it is easy to see groundwork and precedent for Eisner's mature work in, for example, the wordless woodcut novels of Lynd Ward (*Gods' Man*, in 1929, and five other books in the following decade) and Frans Masereel before him (*A Passionate Journey*, 1919, and nine other works)—or in Milt Gross's 1930 parodic take on the novel-in-pictures, *He Done Her Wrong*. We might also reasonably nominate, say, *Harvey Kurtzman's Jungle Book* (1959) or Justin Green's *Binky Brown Meets the Holy Virgin Mary* (1972) as ancestors of the graphic novel, though neither of those books makes novelistic claims in the same manner as *Gods' Man* or *A Contract with God*. It would even be possible to locate the potential for literary aspiration and extended storytelling in the great newspaper strips (the humane unfolding narrative of *Gasoline Alley*; the poetic variations of *Krazy Kat*), but to call these works *graphic novels* would be both an anachronism and a distortion of the term's use after Eisner's pioneering precedent.

The Developing Field

In the decade that followed the publication of *A Contract with God*, other ambitious long-form and self-contained comics, most of which had originally been serialized chapter by chapter, were collected and marketed as graphic novels. Most notably, Alan Moore and Dave Gibbons's *Watchmen*, Frank Miller's *Batman: The Dark Knight Returns*,[7] and the first volume of Art Spiegelman's *Maus* were all published as books in 1986 and 1987, to significant public attention and acclaim, inaugurating what promised to be a new era in storytelling ambition for

comics. The difference in these works' binding meant a difference not merely of scope (though lengthy but self-contained comics stories were a somewhat new phenomenon in the United States in the 1980s) but also of market status: as a book, *Watchmen* could stay in print on bookstore shelves and not just at specialist comics stores with rotating stock; *Maus*, handled by a major trade publisher, could reach a vastly greater number of readers than could its self-published parent magazine *Raw*. Although bookstores were initially uncertain about where to shelve graphic novels (*Maus* would sometimes wind up in the same section as the *Garfield* paperbacks), the existence of distribution channels outside of comic shops meant that cartoonists could reasonably imagine new and broader audiences, which invited a wider range of genres.

However, the end of the 1980s did not see a radical rise of the graphic novel, partly because the movement was still new and developing, and partly because comics simply take a long time to compose (especially when, as with books by Eisner or Spiegelman, a single cartoonist handles all creative duties). The second volume of *Maus* was not completed until 1991. After parting company with DC Comics, Alan Moore conceived several ambitious projects that took a decade or more to complete (*From Hell*, 1989–1999; and *Lost Girls*, 1991–2006) or had to be abandoned incomplete (*Big Numbers*, 1990). By the 1990s, many of the artists who would appear at the vanguard of the graphic novel movement—such as Gilbert and Jaime Hernandez, Daniel Clowes, Chris Ware, Charles Burns, and Eddie Campbell—were serializing work that would later be collected into major books, but the tipping point in public readership and awareness of the movement had to wait until the turn of the millennium. Meanwhile, the term *graphic novel* was also appropriated by the publishers of so-called mainstream superhero comics, Marvel and DC, as a marketing label for republished collections of serialized superhero story arcs, which served to further confuse its neatness as a conceptual category.

Nominative Issues

When Chris Ware's *Jimmy Corrigan: The Smartest Kid on Earth* won the *Guardian* First Book Award in 2001, it stood among a cluster of relatively new and soon-to-be-collected works, such as Jason Lutes's *Berlin: City of Stones* (2002), Dylan Horrocks's *Hicksville* (1998), Joe Sacco's *Safe Area Goražde* (2000), Posy Simmonds's *Gemma Bovery* (2000), Moore and Eddie Campbell's *From Hell* (1999), Clowes's *Ghost World* (1997) and *David Boring* (2000), and several collections by the Hernandez brothers as well as later works by Eisner. These comics established the graphic novel as a substantial category and, specifically, a body of work generically and conceptually distinct from the collections of superhero work that were simultaneously being marketed as "graphic novels."

The more literary of these cartoonists' distaste for the company their works kept on bookstore shelves appeared in their resistance to the term *graphic novel*,

which had for the decade and a half since *Watchmen* and *Dark Knight Returns* been most extensively used for superhero marketing and had acquired an aura of pretense and hucksterism. Thus the cartoonist Seth's 1996 faux-autobiography *It's a Good Life, If You Don't Weaken* is designated, in the subtitle, "a picture novella"; Lutes's *Berlin* is "a work of fiction"; Horrocks's *Hicksville* is "a comic book"; Craig Thompson's *Blankets* (2003) is "an illustrated novel"; Moore and Campbell's *From Hell* is "a melodrama in sixteen parts"; and Clowes's *David Boring* is "a story in three acts" while his later *Ice Haven* (2005) is, parodically, a "narraglyphic picto-assemblage."[8] Although none of these options offers a serious alternative to *graphic novel*, they all resist the term for reasons that persist to some degree even in its moment of begrudged acceptance. (In 2010, Clowes told an interviewer, point-blank, "It's a terrible term."[9]) On the one hand, it seemed like an attempt to dress a proudly lowbrow form in a pretense of prestige, as evidenced in Eisner's own account of his first desperate use of it. On the other hand, the reputation of the graphic novel in the public consciousness was dominated by the genre stories against which the new literary movement in comics had wanted to define itself: while the major works of the turn of the millennium were being drawn, bookstore "graphic novel" shelves were quickly dominated by "every old nonsense" from the inventories of the major comics companies.[10] Hence cartoonists were (ironically) apprehensive about the highbrow/lowbrow valence of *graphic novel* from both directions at once. To some extent, this double-edged anxiety has diminished as the term and its situation in our reading culture have stabilized, but there are still significant reasons for cartoonists to push against its use.

One persistent awkwardness about *graphic novel* is its seeming connection to the novel in prose, a comparison that makes sense for relatively few graphic novels. Kyle's and Katz's initial comparisons to the novel dealt mostly with scope or scale, distinguishing longer self-contained stories from continued serialization on the one hand and short comics on the other, so that *novel* was construed merely as an analogous unit of story length—something between, say, *series* or *trilogy* and *short story*. Eisner, however, by invoking standards of literariness as part of his definition of *the graphic novel*, also invites more substantive comparison with the accomplishments of the novel in terms of characterization, thematic development, plot complication, and voice—all of which can be approached in comics, though there are many storytelling strengths native to the comics form that have little to do with novelistic narration. *Graphic novel* may therefore discomfit cartoonists in that it implicitly belittles the challenge of visual storytelling and the strengths of the comics form, as if subtracting the "graphic" drawings would leave an editor somehow with the "real" text, a novel.

A further problem emerges very early in the history of the graphic novel: many of its defining works are nonfiction or memoir: *Maus*, most obviously, but also Howard Cruse's *Stuck Rubber Baby* (1995), Alison Bechdel's *Fun*

Home (2006), Eddie Campbell's *Alec* books (1978–1990), Joe Sacco's *Palestine* (2001) and *Safe Area Goražde*, Chester Brown's *I Never Liked You* (1994) and *The Playboy* (1992), Lynda Barry's *One Hundred Demons* (2002), Craig Thompson's *Blankets*, and so on. Because novels are typically fiction—outliers like the "nonfiction novel" being exceptions that prove the rule—the term Eisner popularized implies a genre of fiction, even though one of the four stories in *A Contract with God* itself is autobiography (as are Eisner's later books *The Dreamer* [1986] and *To the Heart of the Storm* [1991], though, like Cruse or Campbell, veiled by fictionalized personas). Granted, readers versed in the term's history may know better than to presume a graphic novel must resemble the prose novel generically; beyond the borders of fandom, however, apprehensions or misunderstandings persist. For example, the quantity and popularity of autobiographical comics (and the attention they have drawn from literary scholars) have brought us the ungainly neologisms *graphic nonfiction*, *graphic narrative*, and *graphic memoir* to distinguish *Maus* and its congeners from *graphic novels* narrowly conceived. These new coinages perhaps reflect a misapprehension of the grammar of the original term: *graphic novel* is more like a compound word than it is like a noun-and-adjective pair.[11] Such neologisms also have the unfortunate quality of suggesting to those unfamiliar with the term *graphic novel* that the adjective *graphic* is being used less in the original sense of *having to do with mark-making* than in the modern sense of *sensationalistic, explicit*, or *gory*.[12] Merely modifying the original term (as in *autobiographical graphic novel*) is still more ungainly, if perhaps more accurate. In dealing with the terminological repercussions of an imperfect original, we should remember that "graphic novel," as a category, counterintuitively contains "graphic nonfiction," which in turn contains "graphic memoir."[13]

Toward a Definition

Even accepting the semantic problems built into the name for this new and interesting sort of comics, there remains the difficulty of applying or defining the term. The most commonly understood definition of *graphic novel* relies on the length of the work and thus the publishing format: by this definition, a graphic novel is any work in the comics medium that is long enough to require a bound spine instead of saddle-stitching (that is, staples). This notion of scale as a necessary and sufficient defining factor is behind Spiegelman's half-ironic suggested alternative to the term: "a comic book you need a bookmark for." Privileging length over other factors has the advantage of requiring no one to police barriers of genre or tone, so there could be a comedic "funny animal" graphic novel or a hyperbolic one featuring superheroes. Moreover, it eliminates any qualifications of aesthetic value, leaving critical assessment outside of the question of definition: if length is what matters, there could be a lowbrow graphic

novel or a failed one. (Outsider or alternative cartoonists, accustomed to working without any institutional imprimatur, often value aesthetic inclusiveness; a nonjudgmental definition helps.) Also, the length of the graphic novel does enable some of the novel-like literary qualities to which Eisner and those who have followed him aspired. The cartoonist Chester Brown, in a comic on the cover of the *New York Times Magazine* (accompanying an article on the graphic novel by Charles McGrath), shows an interviewer asking a cartoonist, "I hope my first question doesn't seem rude, but aren't graphic novels just comic books? Comic books with more pages and better paper but comic books nonetheless." The cartoonist replies, "But just the fact that graphic novels have more pages makes a difference. The scope for telling stories of greater complexity and depth is increased." (When the cartoonist points out the attraction of longer works for artists "interested in more mature themes," the interviewer interrupts him, saying they don't have any more room to discuss it on the cover; when the comic continues inside the magazine, the interviewer has been abruptly replaced with a talking duck.[14]) Although short comics with a mature and literary sensibility have always been possible, the developing accumulative complexity we associate with the novel is not what a short form calls out for; the formal container of a bound book would at least seem to invite a degree of character elaboration, contemplative pacing, and plot complication that are less at home in shorter forms.

If length is the standard, however, we would need to imagine a page count at which a graphic book might change, by a process of mere extension, from a nonnovel into a graphic novel. Art Spiegelman's *In the Shadow of No Towers* (2004) contains only ten comics by Spiegelman himself, each originally a single newsprint page but printed in the book as a two-page spread (Spiegelman's strips are followed by as many pages of archival newspaper comics by other artists); it was bound with a spine mainly because it was published in board-book format—that is, on pasteboard. At only thirty-six pages, if it had been printed on paper and bound with staples, would that decision alter the kind of comic Spiegelman had created?

As it turns out, this definitional boundary can be checked, without creating any hypothetical changes in publishing format, by examining two works by Daniel Clowes. The final two issues of Clowes's comic book *Eightball* (2001 and 2004) each contained a single story composed of many short strips, with each strip at most two pages long; both issues were originally bound with staples, but then they were repackaged and republished, by Pantheon and by Drawn & Quarterly respectively, as *Ice Haven* and *The Death-Ray* (2011). In both cases, Clowes added a few pages of new drawings for the graphic novel collection; in *Ice Haven*, the original portrait-format pages are divided in half and presented as two landscape-format pages apiece, doubling the book's page count before any new material is added. (The bound *Ice Haven* also adds ten pages of new strips that slightly extend and complicate the story.) For *The Death-Ray*, however, the

forty-two pages retain their original numbering, there are no new story pages, and only the thick cover boards seem to justify its being bound with a spine. If the length of a comic determines whether it is a graphic novel, then the reformatted pages of *Ice Haven* (pushing it from thirty-seven pages to eighty-nine) translate it to a new literary category; if the binding of the story is what matters, then *The Death-Ray* is a graphic novel in its Drawn & Quarterly form but a comic book, not a graphic novel, as *Eightball* #23. If the advent of the graphic novel is to be considered a watershed moment in the history of comics, its distinguishing features should not be trivial enough to be ruptured by a pair of staples.[15]

It might also be possible to define the graphic novel, in contrast to comic books or comic strips, as a self-contained book-length comics story—with the physical fact of the book's binding embodying the storytelling bounds of beginning, middle, and end. This definition, however, would be immediately troubled by the books that inaugurated the graphic novel corpus: *A Contract with God* is four unconnected short stories and *Maus*, *Watchmen*, and *The Dark Knight Returns* were all serialized in several installments before being collected as books. In fact, although comic book serialization of literary graphic novels has in the past decade become rarer (and less economically feasible for publishers), it is still common for cartoonists to serialize their first works, whether online or through a small publisher (or by self-publishing). Clearly, although the self-contained story is an important aspect of the graphic novel's storytelling model, a definition of the term cannot privilege the book, or book-length story, without beginning to exclude some of the field's most seminal texts.

A comprehensive definition of *graphic novel* therefore needs to rely on more than form or publishing format. Critics do often refer to the graphic novel as a genre, but that label can be misleading, for the existing set of graphic novels already contains many comics genres—which sometimes make different use of the medium's strengths. Memoir, for example, in such works as *Fun Home* or *Blankets*, functions differently from even strictly realist fiction, as in *Berlin* or *Ice Haven*. Moreover, it seems absurd to insist that the graphic novel must be realist; drawing that boundary line would exclude not only *Watchmen* and *The Dark Knight Returns* but also *The Death-Ray* for their superheroes, a gesture that seems to willfully ignore a significant segment of American comics history and to preclude the possibility of superhero tropes being deployed for sophisticated purposes. Requiring that all graphic novels hew to a single genre, whether that is realist fiction or autobiography, would also exclude significant works of horror (*From Hell*), allegorical fantasy (Gene Luen Yang's *American Born Chinese*, 2006), science fiction (Dash Shaw's *Bodyworld*, 2010), and expository criticism (Scott McCloud's *Understanding Comics*, 1993), just to name a few alternate genres. As with the prose novel itself, long-form comics are clearly capable of storytelling in almost any setting and with almost any set of genre

conceits, whether the trappings of genre are accepted without question or interrogated and bent. In other words, calling the graphic novel a genre threatens to oversimplify either the term *graphic novel* or the word *genre*.[16]

And yet, the serious and sustained works that have been brought together under the umbrella of the graphic novel do share something on the level of content, in particular the way they imagine or project an audience. Eddie Campbell, in a 2005 interview for the *Graphic Novel Review*, made this distinction: "My Batman book [*The Order of Beasts*] is a comic book, while my [autobiographical] *Graffiti Kitchen* is a graphic novel. They are both forty-eight pages,"[17] a remark that splits hairs based partly on genre but also on Campbell's sense of who would read the books and how they would be read. (His main argument against the superhero comic as a genre, in this interview, seems to be that its tropes have been repeated and reduplicated enough that, separated from their original impetus, they can now be reinscribed, and can please their accustomed audience, "without ever having to truly mean anything.") The common purpose of the contemporary artists working on the graphic novel is to use comics for more than predictable repetition of the same reading pleasures: to challenge the genre, the medium, and the comics-reading public.

The cartoonists behind these works constitute an artistic community focused on a shared goal: that of making the comics medium do more than the American or British public had long assumed it could. The direction of this striving varies from cartoonist to cartoonist: some, like Eisner, may stake claims to socially significant themes; autobiographical cartoonists may aspire to an intimacy beyond that of prose; cartoonists like Chris Ware or Matt Madden may restlessly test the formal resources of the medium. Some privilege text and story, while others innovate in the visual or graphic field. Storytellers like Dylan Horrocks or Seth find new resources by situating the ambition of contemporary comics within traditions that the comics-reading community either treasures or forgets.

When Campbell, in his "Graphic Novel Manifesto," refers to the graphic novel as "a movement rather than a form,"[18] he means that the aspirations of its cartoonists matter more to our sense of *the graphic novel* than the physical form those aspirations take. The graphic novel movement has attempted to expand the artistic range of comics, chiefly by opening up their readership to adults interested in other contemporary literature—and by justifying the attention requested of these readers. Therefore the movement is, at its roots, established in contrast to the formulaic so-called mainstream comics many of the graphic novel cartoonists grew up reading. Indeed, even to construe the graphic novel as an artistic movement means that (as Campbell points out) it must be linked to a specific historical moment: the graphic novel is a contemporary response to comics history and a willed intervention in how that history is to be understood. Therefore, though we might consider the woodcut novels of Lynd Ward, the poetic flights of George Herriman's *Krazy Kat*, or the confessional comics of Justin Green as forebears or influences for the graphic novel, they precede its

historical moment. Rather than petitioning for such works to be labeled retroactively as graphic novels themselves, we ought to acknowledge them as antecedents to the movement. Furthermore, although many graphic novel cartoonists have learned from the comics of other nations and cultures (see chapters 4 and 5), it would be misleading to construe a single volume of *Tintin* or *Lone Wolf and Cub* as a graphic novel, because those other comics traditions developed separately and in tension with different histories and market forces.

That said, many comics cultures appear to have been converging toward international acceptance of the graphic novel ideal. For example, many contemporary Anglophone graphic novels can be likened or linked to French alternative comics such as those published by L'Association; books like Lewis Trondheim's *Little Nothings* (begun in 2006) and David B.'s *Epileptic* (1996–2003), when translated and reformatted, resemble American graphic novels in their storytelling, themes, and visual idioms. Presumably, this common ground is the effect of a generation of cross-pollination and shared influences. We may therefore think of Marjane Satrapi's *Persepolis* (a set of four *bande dessinée* albums in its original French publication, 2000–2003) as a two-volume graphic novel after it was reformatted and published in English (2003–2004), or even a single-volume graphic novel when it was collected as *The Complete Persepolis* in conjunction with the release of the film version (2007). In this translation, as with Clowes's *The Death-Ray* or Campbell's *Graffiti Kitchen* (1993), context and audience trump format or genre: Satrapi's story changes only in that, when it is shelved alongside *Maus* and *Fun Home*, its American readers construe a place for it in the graphic novel movement.

In 2001, the cartoonist Dylan Horrocks wrote a perceptive critique of Scott McCloud's effort, in *Understanding Comics*, to define comics as a formal medium. In this critique, Horrocks points out that such acts of definition inherently involve boundary-making and territorial dispute.[19] (He cites Thomas McLaughlin to point out that the *term* in the etymology of *terminology* is a literal, territorial, geographical "line of demarcation."[20]) Much of this chapter has concentrated on correcting the territorial boundaries of *the graphic novel* in our common parlance so that the center of the category might be occupied by long-form works characterized more by their ambitions and sophistication than by their genre or publication format. In fact, as Horrocks would suggest, the examination of a boundary reveals a great deal about a definition, and we should be interested not only in what defines a graphic novel but also what makes some works seem more difficult to define. Borderline cases, problematic exclaves, and "dual-citizen" hybrids help us see what we value in the very category being defined. If, as we've already seen, changing the binding on *The Death-Ray* doesn't fundamentally change its literary category, then publishing format if not length may be irrelevant to the graphic novel; if a single issue of Kevin Huizenga's excellent (and literarily ambitious) *Ganges* comic book (2006–2017) is longer than *In the Shadow of No Towers*, should we describe *Ganges* as a graphic

novel, or as a comic book that participates in the graphic novel aesthetic?[21] Does that in turn raise questions about the categorization of Spiegelman's *Shadow* or his recollected *Breakdowns* (2008)?

If we are intuitively certain that, for example, Maurice Sendak's picture book *In the Night Kitchen* (1970) is not a graphic novel—even though it is bound as a book and uses comics devices like speech balloons, narrative captions, and storytelling via multiple panels per page—is this because graphic novels aren't for children? (What, then, would we call Jeff Smith's *Bone* [1991–2004] and its successors? In fact, the graphic novel has become a hugely prolific and lucrative category of children's book, and children's publishers now dominate the graphic novel field, as discussed in chapter 9.) Do we exclude Sendak because children's books claim a different cultural terrain than comics, even when their narrative devices are the same, or do we exclude him simply because his book is short?

A hundred-page *Night Kitchen* would have been a tremendous and unusual book, but it would not have been the first graphic novel unless, in its creation and readership, it triggered a movement of its own. This, in the end, is why critics generally grant Eisner the distinction of beginning the history of the graphic novel, and it is why both *Maus* and *Watchmen* must be important to our definition: not because Eisner was the first to use the term, nor because Spiegelman or Alan Moore offer templates or holotypes for future cartoonists, but because their works are retrospectively seen as continuous with (and influential upon) the growing body of aesthetically ambitious and thematically sophisticated graphic novels being written and drawn in the present day.

Notes

1 Will Eisner, "Keynote Address from the 2002 'Will Eisner Symposium'" (paper presented at University of Florida Conference on Comics and Graphic Novels, Gainesville, Fla., February 2002), published in *ImageText: Interdisciplinary Comics Studies* 1, no. 1 (2004): http://imagetext.english.ufl.edu/archives/v1_1/eisner, accessed 23 July 2018.

2 Regarding the growing currency of the term *graphic novel* in the mid-1970s, and early attempts to distinguish the graphic novel from other comics, see Paul Williams, "The Strange Case of Byron Preiss Visual Publications," *Journal of American Studies*, 14 May 2019, https://doi.org/10.1017/S0021875818001494.

3 Andrew J. Kunka, "*A Contract with God, The First Kingdom*, and the 'Graphic Novel': The Will Eisner / Jack Katz Letters," *Inks: Journal of the Comics Studies Society* 1, no. 1 (2017). In a letter to which Eisner responded, Katz announced his ambition to make *The First Kingdom* "a graphic novel in which every incident is illustrated." Copy on the cover of the collected *First Kingdom* published by Pocket Books in 1978 calls it "the first graphic novel."

4 This insistence of Eisner's, of course, leaves aside the picture novels of Lynd Ward, which Eisner cited as an influence.

5 Will Eisner, "Looking Back," interview by Arie Kaplan, *Comics Journal* 267 (April–May 2005): 127–128. In the Eisner symposium keynote (cited above from *ImageText* 1, no. 1), Eisner points out that Katz or Kyle "had never intended [the term

graphic novel] the way I did, which was to develop what I believe was viable literature in this medium."

6 Eisner, "Looking Back," 128. Cartoonists of a later generation, like Art Spiegelman, might make larger claims for *Mad*'s literary qualities; satire is a literary mode and a mode of social critique, after all.

7 Earlier works by both Moore and Miller would eventually be collected as graphic novels. For example, *V for Vendetta*, serialized in *Warrior* (United Kingdom) from 1982 to 1985, would be collected in 1990, and Miller's *Ronin* (1983–1984) was bound in book form in 1987.

8 On its dust jacket, Ware's *Jimmy Corrigan* (Pantheon, 2000) is described not as a graphic novel but as "a bold experiment in reader tolerance, disguised as a gaily colored illustrated romance in which tiny pictures seem to come alive, dance, sing and weep. (Full particulars and instructions inside.)"

9 Daniel Clowes, "Clowes Encounter," interview by David Gilson, *Mother Jones*, 13 May 2010, accessed 23 July 2018, http://www.motherjones.com/media/2010/05/dan-clowes-comics-cartoons-interview.

10 Eddie Campbell, *Alec: How to Be an Artist* (Paddington, Australia: Eddie Campbell Comics, 2001), 96.

11 Consider, for example, the words *alcoholic* and *chocoholic*, *hamburger* and *turkey burger*, or *helicopter* and *Bat-Copter*. In all three cases, the etymological makeup of the parent word is lost in the transformation into a new word. Linguists call this process *reanalysis*. Something similar is afoot with *graphic novel* and *graphic memoir*, although the misprision of the parent term is less obvious in this case.

12 About a decade ago, two of my students expressed relief on the first day of our course on the graphic novel when they heard we weren't going to be reading a semester of gory or prurient prose works. I'm not sure why they had signed up initially.

13 For a rather different take on this terminological problem, see Gillian Whitlock's chapter 15 in this volume, which criticizes the usage of the term *graphic novel* when discussing graphic memoir.

14 Chester Brown, cover and interior illustration to Charles McGrath, "Not Funnies," *New York Times Magazine*, 11 July 2004.

15 Physically transforming *The Death-Ray* into *Eightball* #23 would not be quite this simple, however, because *The Death-Ray* is printed in four quires; *Eightball* #23 is all one quire.

16 The word *genre* is notoriously elastic, of course, and may be taken to refer not only to literary modes (such as prose narrative, poetry, or drama) and specific narrative formulas (as in romance fiction or the superhero) but also, as recent theory advises, to a near-endless variety of rhetorical forms and social purposes, from stump speech to lab report to sympathy card. We could therefore imagine ways to apply the label "genre" to the graphic novel—for example, on the grounds of audience. However, labeling the graphic novel that way would invite confusion, not least because of the perceived antagonism between literature and so-called genre fiction.

17 Eddie Campbell, "In Depth: The Eddie Campbell Interview," by Milo George, *Graphic Novel Review* [September 2004], http://www.graphicnovelreview.com/issue1/campbell_interview.php. Web page no longer extant; last archived via archive.today on 4 April 2005, http://archive.today/BAiHl.

18 Campbell.

19 Dylan Horrocks, "Inventing Comics: Scott McCloud Defines the Form in *Understanding Comics*," *Comics Journal*, no. 234 (June 2001): 33–34. Also available on

Horrocks's website, http://www.hicksville.co.nz/Inventing%20Comics.htm, accessed 23 July 2018.

20 Thomas McLaughlin, introduction to *Critical Terms for Literary Study*, 2nd ed., ed. Frank Lentricchia and Thomas McLaughlin (Chicago: University of Chicago Press, 1995), 8.

21 This question is made more complicated by the very recent collection of the *Ganges* series as a formidable graphic novel, *The River at Night* (2019).

Part II
Cultures

7

Comics Industries

• •

MATTHEW P. MCALLISTER
AND BRIAN MACAULEY

The May 31, 2013, issue of *Entertainment Weekly* (*EW*), the magazine about popular media, was especially comics-heavy (fig. 7.1). Though in some ways a time capsule, with its specific 2013-released media artifacts, this issue represents the visibility of certain kinds of comics-oriented cultural products well past that year. Themed around "Your Summer Must List," the cover features a promotional photo of Hugh Jackman as Wolverine for a then-upcoming Hollywood blockbuster (*The Wolverine*, dir. James Mangold), followed by a five-page story inside. The issue also included substantial write-ups for the forthcoming *Man of Steel* movie and Marvel's *Agents of S.H.I.E.L.D.*, a fall 2013 ABC television series, as well as quick previews for the Lego Batman: DC Super Heroes smartphone/tablet app and the latest *Marvel Heroes* video game. A pullout section, "The 25 Greatest Superheroes Ever," prominently featured comics characters, while an insert on postcredit movie "stingers" cited examples from *X-Men: The Last Stand* and *Iron Man*. Even the advertisements were comics-influenced: a full-page tie-in with *Man of Steel* touted Gillette razors ("How does the Man of Steel shave?"), and a nine-page insert, "99 Ways to Spend 99 Days," was interwoven with a Target advertisement, "Save the Day with the Justice League," promoting the retailer's JL merchandise, including bedsheets, T-shirts, action figures, plush toys, and party supplies. While this issue's intense focus on the superhero was somewhat atypical, *Entertainment Weekly* routinely offered,

FIG. 7.1 *Entertainment Weekly*, May 31, 2013. This comics-heavy issue spotlights properties originating in comic books but does not mention comics as a reading medium at all.

and continues to offer, covers featuring comic book–themed films and television programs.

Today, perhaps more than ever before, comics properties are highly visible in popular culture; characters such as Batman and the Avengers are valuable licenses both for traditional media like movies, television, and magazines and for newer kinds like video games and apps. Two companies, DC Comics and Marvel Comics, own the most valuable properties (including twenty-two of *EW*'s twenty-five "Greatest Superheroes Ever"). That DC characters, rather than those from Marvel, occupy the two main advertising tie-ins in our opening example speaks to the corporate synergy of Time Warner (now WarnerMedia), which owns DC Entertainment and at the time owned *EW* (a fact that may also help account for the magazine's two Superman covers in 2013). Yet the cultural prominence of comics is selective: while *EW* spotlights characters originating in

comic books, it mentions characters from comic *strips* (and *bandes dessinées* and manga) not at all. Moreover, comic books as a reading medium are absent: current comic books do not appear in the issue *as comic books*.

The American comic book industry has, to say the least, unequal emphases, and while it shows signs of tremendous cultural and economic vibrancy, it also suggests a present (and future) in which incentives for certain kinds of cultural productions exist while others do not. The reality is that comic books are an industry that is somehow simultaneously both central and marginal to popular culture. With that in mind, this chapter reviews trends in the U.S. comics industries and their relationships to traditional media (and media trends) and discusses the industries' possible future. Of course, one chapter can hardly cover the entire range of global cultural industries relevant to comics, since such an undertaking would require the room to discuss myriad factors, including comics' degree of dependence on other media; the importance of serialization, adaptation, and cross-media promotion; the status of comics vis-à-vis national culture and the processes of consecration by which comics are valorized (or not) within that culture; the targeting of young audiences and the extent to which the comics are tied into regimes of education, literacy, and censorship; the role of imports and globalization; and the participation of fandom (see chapter 8 for more on this last subject). Certain patterns do recur across cultures: witness, for example, the commonality among anticomics campaigns in the mid–twentieth century[1] or the waxing and waning of serialization as opposed to book publication. This chapter, however, will focus on contextualizing industrial dynamics of the American comic strip and, especially, the American comic book.

Comics as Media Industries

Comic books and newspaper strips arguably inhabit the same form, one typically combining sequential art with words. Indeed (as chapter 2 describes), the United States' early comic books existed mainly to repackage and resell previously published comic strips. At certain historical moments, the two media have cross-pollinated on the basis of shared characters, as when newspaper strips have spun off from comic book properties such as Batman, Superman, Spider-Man, and Archie or, conversely, when comic book titles have been based on strip characters like Blondie and Dick Tracy. Yet from the perspective of political economy these two media have developed in vastly different industrial contexts. As discussed in chapter 1, strips in the United States have typically been anchored to the newspaper industry through a syndication system that supplies comics and other features to newspapers—a system that makes the comics pages of local newspapers across the country fairly uniform. Given the gatekeeping power of syndicates like King Features and Andrews McMeel (formerly Universal Press), this system has created significant barriers to entry for new strip creators. Historically, strips served to introduce young readers to the daily activity

of reading a local newspaper, and popular strips often influenced circulation figures. Newspapers also provided a stable economic home for comic strips until the double whammy of the global recession of 2008 and digital competition for revenue triggered a crisis in the financial stability of newspapers (and, arguably, journalism and print culture generally).

Throughout the twentieth century, meanwhile, comics magazines developed in many countries, notably in the United States, as a relatively independent medium and industry—in American parlance, the "comic book" (see chapter 2). In comparison to comic strips, this history has been especially turbulent, with enough drama to feed popular books about the early years of the superhero comic, the moral panic and self-regulation of the 1950s, and the Wall Street battle over Marvel in the 1990s.[2] The industry's primary revenue streams have shifted on more than one occasion, from an early emphasis on newsstand sales (relying on magazine distributors) with secondary revenues generated from advertising, to a later emphasis on the so-called direct market of specialized comic book shops, to the current emphasis on licensing revenue from film, television, and video games. Bart Beaty argues that, sales-wise, the industry has historically operated fairly independently from concurrent trends in both the media industries and the larger economy—until recently.[3] In fact, for decades, comic book shops, rather than other traditional media outlets such as magazine exhibitors or chain bookstores, have been responsible for most sales of new comic books and graphic novels, though numbers continue to shift.[4] While the direct market created a viable new exhibition system for comic books, it also arguably focused the medium on superhero comics and encouraged the movement toward ownership concentration in publishing.[5] Since the 1960s, the major U.S. comic book publishers have been Marvel and DC. After the consolidation of the direct market—as described here in chapter 2, a loose network of comic book specialty shops that purchase comic books on a nonreturnable basis—other companies, particularly Image and Dark Horse, have also been significant forces. However, like many media industries, comics have also bred alternative and even oppositional forms (notably, the underground comix of the 1960s) that offer more nakedly personal and politically charged content and sometimes radically different models of creative processes, ownership, production, and distribution (see chapter 3). Although graphic novels have become popular in chain and online bookstores, and the increase of self-publishing and digital options suggests that there is room for new voices in the comic book industry, in 2019, Marvel and DC still accounted for over 68 percent of the dollar market share in the direct market.[6]

Merchandising and Cross-media Licensing

Historically, both comic strips and comic books have relied heavily on licensing and merchandising.[7] Comics characters have very often been licensed to other

media: most obviously animation, film serials, and radio in the early twentieth century, then television programs, blockbuster movies, and video games in the late twentieth and early twenty-first century.[8] Conversely, comics have offered licensed versions of characters originating in other media (such as the publisher Dell's long-running Disney-based comics). Today, small- to midsized comic book companies such as Dark Horse and IDW specialize in publishing licensed comics including the popular *Alien*, *Buffy*, and *Star Trek* series (*Star Wars* comics are currently published by both Marvel and IDW). Merchandising includes toys, clothing, and other products branded with comics characters, such as the examples from Target in our introduction. Comic strip characters were once especially prominent via licensing and merchandising, including the very early example of the "Yellow Kid" (see chapter 1) as well as the Popeye cartoons (which first appeared in 1933), the *Blondie* film series (1938), and the *Dennis the Menace* TV series (1959). However, since the 1980s, comic book licenses have become more visible than comic strip licenses, apparently signaling the latter's rise as cultural artifacts (and the newspaper strip's decline). The recently adopted official names of the two largest comic book companies, Marvel Entertainment and DC Entertainment, suggest that today comics publishers are primarily in the character-licensing business as opposed to the comic book business.

While comic book sales have been largely autonomous from economic developments in other media, the industry's licensing activities are strongly connected to transformations in those fields.[9] This is especially visible in the current motion picture industry, where larger corporate-driven trends have converged with the characters and narrative worlds comic books offer. Specifically, comic books have provided the movies with raw material for visual effects–heavy blockbusters that are predictably successful in a global marketplace as well as with a steady stream of subsidiary licensing. For instance, DC's corporate ties to Time Warner (now WarnerMedia) meant that synergistic incentives strongly influenced efforts such as 1989's *Batman* film (dir. Tim Burton, distributed by Warner Brothers) and later television spinoffs like *Batman: The Animated Series* and *Batman: The Brave and the Bold*.[10] Marvel's licensing, until the 2010s, was less driven by ownership ties, although for a brief time (1986–1989) the company was owned by a movie studio, New World Pictures, and in the 1990s the company attempted to acquire subsidiaries ripe for cross-media synergy—a plan that backfired, greatly affecting the health and makeup of the comic book industry.[11] However, Disney's 2009 acquisition of Marvel ended the company's arm's-length relationship with larger media conglomerates and raised issues about the long-term independence of Marvel as a comic book publisher in the hands of an even more strongly branded company. Today, Marvel's greatest success flows through its film and TV division, Marvel Studios (a subsidiary of Walt Disney Studios), and Marvel characters appear at Disney theme parks.

The licensing of characters for comic book–based movies has become a major source of revenue that has shaped both the film and comic book

industries. Marvel's film licensing kept the company afloat during its tough economic times, and Disney's decision to buy Marvel was clearly based more on the licensing potential of Marvel's characters than its revenue from comic book sales per se. The extent to which the two biggest publishers consider themselves licensing companies rather than comic book companies will likely have long-term implications for comic books as both a print and (increasingly) a digital medium. The relationship between the two industries, comics and film, has also changed moviemaking, helping to shift the concept of a blockbuster toward more obvious "popcorn genres" such as superhero movies and making comics characters into important licenses for "tentpole" pictures and their marketing.[12] As of this writing, six of the twenty highest-grossing films of all time at the North American box office were based on comic book characters, and thirteen comic book–based movies have generated over $1 billion each in global revenues—two of which, *Avengers: Infinity War* and *Avengers: Endgame*, have grossed more than $2 billion. The heavy promotion of and financial investment in large-budget, effects-oriented, superhero-based movies has boosted the prominence of that genre in the larger culture, perhaps at the cost of further cementing the public perception of comics as a superhero-centered medium. Alternatively, Derek Johnson argues that Marvel's aggressive involvement as a film producer via Marvel Studios, before its acquisition by Disney, also shaped industrial and discursive strategies for such independent producers looking to maneuver in a studio-dominated industry.[13]

Comics and Labor

Labor issues associated with comics can be traced back to the emergence of the newspaper comic strip as an important cultural commodity. Early cartoonists routinely signed away ownership of their creations in their contracts with comic strip syndicates, and while contracts later improved for strip creators, comic book publishers retained some version of this work-for-hire model for decades (and indeed still retain it in many instances).[14] From the "factory"-like conditions and strict creative control endured by early comic book artists to the industry-standard work-for-hire contracts that nullified ownership claims and denied future compensation for their creations, the labor model of the comics industry reflects its historical and industrial origins.[15] Complicating the question of the ownership of licenses is the collaborative nature of much comics production (note the frequent division of responsibilities among writer, penciler, inker, and so forth), as well as its generally serialized nature, through which characters and story elements may be introduced later in a narrative that spans years (or decades). In addition, elements added to the narrative world in cross-media versions, such as in film and TV versions of superhero series, may become layered onto the comics versions, making the contributions of individual creators hard to trace (as is the case with the multimedia history of Superman).[16]

The relationship between DC and the creators of Superman, Jerry Siegel and Joe Shuster, has come to symbolize the battle between publishers and creators for proper credit and compensation. The pair sold Superman—which they had been trying to sell to comic strip syndicates without success for years—to Detective Comics Inc. in 1938 for the sum of $130. In so doing, they in effect acceded to an industry standard that transferred ownership of the character to DC and so relinquished any claims they might have had to what turned out to be millions of dollars in licensing revenue and potential residuals and royalties. The character reaped a fortune through its iterations in newspaper strips, radio, film, television, and licensed merchandise. Siegel and Shuster, fired from their creation in 1947, were never able to replicate their early success, and both were in financial trouble by the 1970s. Over the years, the two and their estates secured settlements through litigation and negotiations with DC.[17]

Similarly, in the early 1960s the creations credited to writer Stan Lee and artists Jack Kirby and Steve Ditko—including the Fantastic Four, the Avengers, and Spider-Man—revitalized a failing comic book line, now known as Marvel, and breathed new life into the superhero genre. Later, Kirby fiercely criticized Marvel, and Lee in particular, arguing that Lee's contribution to the creation of many characters was negligible and that Kirby had carried much of the creative load for the duo. Kirby and Ditko never received royalties for their contributions to the creation of Marvel's iconic characters and in fact had to lobby aggressively for minor concessions such as the return of their original art.[18] On the heels of this history, the underground comix of the 1960s (and later, their successors in alternative comics) offered different visions of creator rights and autonomy (see chapter 3).

The contentious nature of labor relations between publishers and creators shows not only in the discontent expressed by the creators of the some of the medium's most iconic and profitable characters but also in a so-called creators' rights movement that eventually led to some reform at the major publishers. This movement, seeking to improve working conditions for creative talent in the mainstream comic book industry, gained momentum during the 1970s. Artist Neal Adams, a fan favorite, played a pivotal role, lobbying on behalf of Siegel and Shuster with DC and working to establish a union for artists and writers, the Comics Creators Guild.[19] However, like earlier attempts to establish collective bargaining for comics workers in the 1950s and '60s,[20] the Guild was short-lived and only marginally successful. In the early 1980s, DC was the first of the big two publishers to offer artists and writers royalty payments on the sales of their titles, and Marvel immediately followed suit by offering creators "incentives." Tellingly, an internal memo from Marvel's lawyers details the rationale for using the word *incentive* rather than *royalty*: "Most definitions of [royalty] contain language which indicated that it is a payment to an 'owner' or 'author' for use of *his* work."[21] Using *incentive* allowed Marvel to appease creators financially without actually acknowledging them as creators. With this tactic, the company attempted to sidestep potential challenges to the ownership of characters.

The 1980s and early '90s saw the continued growth of creator-friendly independent publishers in the direct market, including Eclipse, Pacific, First, and Fantagraphics (as discussed in chapter 2). Indeed, these publishers' practices have been credited with spurring DC and Marvel toward royalty systems. In addition, the market provided outlets for self-published comics such as Dave Sim's *Cerebus* (1977–2004) and Kevin Eastman and Peter Laird's *Teenage Mutant Ninja Turtles* (1984–2015). In 1992, several of the industry's star artists (including Todd McFarlane, Jim Lee, and Rob Liefeld) left freelance positions at Marvel to establish Image Comics, an independent publishing cooperative initially dedicated solely to creator-owned work. Though Image's output in the 1990s did not venture very far from the superhero genre—indeed, the company sought to compete directly with Marvel and DC—its success demonstrated the importance of creators to fan culture (and therefore consumers) and set an important precedent for creators' rights in the industry. Many of the fledgling independent publishers folded during the industrial shakeups of the 1990s; however Image endured, and today Image and a number of other independent publishers—such as Dark Horse, Boom!, and Oni Press—offer homes for diverse creator-owned content. Even DC and Marvel have sought to capitalize on the seeming independence of creator-owned comics: from 1993 until 2020, DC maintained Vertigo, an imprint centered on creator-owned work, and Marvel has fielded creator-owned imprints, including the discontinued/dormant Epic and Icon. Properties like Mark Millar and John Romita Jr.'s *Kick-Ass* (Icon, 2008) demonstrate that creator-owned work can be done within the constraints of an exclusive contract with the big two. The industry at time uses "creator-owned" as a branding strategy to signal potentially more innovative comics.[22] Thus many comics professionals today view properties owned and controlled by creators as the industry's most viable option. On the other hand, it is common practice for creators to alternate between creator-owned projects and work-for-hire Marvel or DC projects.

Though the creators' rights movement helped to improve conditions for contemporary comics professionals, many of the pioneers of the medium were never able to benefit from these reforms. In 2000, a group of publishers banded together to create the Hero Initiative, a nonprofit dedicated to providing financial assistance to comics creators struggling after a lifetime of work in the comics industry.[23]

Comics Industries in the Digital Era

As with nearly all print media industries, the switch of comics to digital formats has been marked by doubt and anxiety—but also by cautious optimism regarding the development of alternative revenue streams and the power of online promotion. With the emergence of paywall-based websites, smartphones, and tablet computers, digital comics are widely assumed to be a key part of the

future of the form and a key to attracting new readers. Since comic strips are so closely tied to the newspaper industry, the revenue shifts in advertising and readership from newspapers to digital news and e-commerce sites means that strips may eventually need to find different industrial contexts or manage their creative output in an ever-changing (and not always optimistic) journalistic environment that struggles to monetize. Alternatively, comic books seemed to thrive in the early 2010s, with new digital formats and income influxes. While Darren Wershler, Kalervo Sinervo, and Shannon Tien offer fuller treatment of the impact of digital comics (see chapter 17), we should note here that the comic book industry as of this writing is still grappling with the digital transition. Concerns of format, distribution, piracy, pricing, and wide-scale industry transformation are at the forefront.

Digital comics represent a potential new source of income and publicity for publishers while also creating new revenue streams that can bypass brick-and-mortar shops and magazine outlets (and for comic strips physical newspaper sales). The prospect of bypassing shops has naturally alarmed many direct-market retailers. Consequently, the comic book industry has mobilized strategies to attract new readers without alienating the retailers who have sustained the industry since the end of the newsstand era. In comic strips, specific strip-branded websites and social media for works such as *Dilbert* compete with those created by syndicators. Andrews McMeel's GoComics and King Features' Comics Kingdom are websites supported by different revenue streams, including advertising and "premium" subscription options for full access to their archive or other specialized services. The extent to which such sites can monetize strips in a potentially postnewspaper age is unclear. In comic books, meanwhile, free downloads, subscription models, and "digital-only" or "digital-first" releases have all been used to revitalize a medium that once seemed on the verge of significant decline, especially with the shift of large-scale publishers to cross-media licensing. Since 2013, many large periodical comic book publishers have released new issues in digital and print editions simultaneously and at the same price. In addition, digital-comics publishers have emerged, such as MonkeyBrain and Lion Forge, but with mixed results. MonkeyBrain launched as all-digital in 2012 and later partnered with IDW to produce print comics but has published few titles since 2013, and Lion Forge launched as all-digital in 2011 but shifted the bulk of its output to print and later merged with Oni Press.

Aside from born-digital comics and digitized versions of print comics, the comic book industry is actively experimenting with alternative exhibition and production forms in order to attract new readers/users to comics and comics-related media. Digital versions of trade paperback compilations are available in various formats from the major online e-commerce retailers, with minor discounts from the print editions. Marvel's experiments with digital formats have included "motion comics"—that is, adaptations of print comics that feature kinetic elements, music, and voice acting. Marvel has also opened its back

catalog digitally: in 2013, Marvel Unlimited, a subscription service available on the web as well as for iOS and Android mobile platforms, offered paying subscribers access to an archive that at that time included more than thirteen thousand Marvel comics, with new issues added as soon as six months after print publication (as of this writing, Marvel Unlimited offers more than twenty-five thousand comics). Marvel's website now offers various membership plans that include access to comics that are downloadable to mobile devices, as well as special merchandise deals. DC too has experimented with digital reading options, including the short-lived DC² and DC² Multiverse formats launched in 2013, which offered different levels of interactivity (respectively, layered artwork with interactive pop-out features and a video-game-like choose-your-own-adventure format complete with soundtrack).[24] Later, in 2018, DC launched DC Universe, a multimedia streaming service that combined new TV series, vintage TV shows and films, and a select library of comics—in effect joining together the comics and their multimedia adaptations and offshoots into one subscription-based experience.[25] (DC Universe now reportedly offers more than twenty thousand comics.) *Shōnen Jump* moved to a digital subscription model in December 2018 that gave readers access to more than ten thousand manga chapters in their back-catalog.

Like other media industries, the comics industry has embraced digital rights management (DRM) technology to curtail the easy replication and pirating of digital data. Yet the adoption of proprietary DRM complicates the ownership of digital comics in ways that may alienate a generation of internet users with easy access to pirated content on BitTorrent or other file-sharing networks. For instance, when online manga retailer jManga (billed as a legal alternative to manga piracy) folded in May 2013, it left users with no access to previously purchased material on the streaming-only site. Viz's decision to move to a digital subscription model for *Shōnen Jump* was explicitly positioned as an attempt to undermine piracy by moving to simultaneous releases in English and Japanese.[26]

The major digital retailer in the comics industry is ComiXology, a cloud-based platform founded in 2007 (described in detail in chapter 17). Offering its own mobile application as well as branded apps for major publishers on the web and in major mobile formats (iOS, Windows, Kindle, and Android), ComiXology has thus far satisfied publishers' needs for reliable DRM and multiplatform access. Its proprietary Guided View technology is designed to facilitate comics-reading on both smartphones and tablets. Most of the major comics companies have partnered with ComiXology, which surpassed sales of one hundred million downloaded comics in fall 2012. By 2011, ComiXology was listed as one of the ten highest-grossing apps on iTunes.[27] Crucially, ComiXology's first product was a suite of web applications for brick-and-mortar comic shops, and the company continues to offer digital storefront tools for the direct market—a relationship that it was wise to cultivate before moving into digital comic sales.[28] (However, as of 2018 ComiXology has discontinued,

after a decade, its pull list service, which enabled brick-and-mortar shoppers to preorder upcoming releases from their local shops.) Indeed, the comic book industry frames its approach to digital comics as "additive,"[29] a claim seemingly supported by sales figures. While publishers have been reluctant to release digital sales figures, industry analysis website Comichron estimated digital sales at $75 million in 2012 and $90 million in 2017, with digital sales staying remarkably flat for the three-year period from 2015 through 2017.[30] Significantly, print comics saw a sales increase for several years, until 2017, suggesting that digital comics, rather than hurting the direct market, helped bring new readers into comic shops.[31] Although ComiXology does not quite have the monopoly that Diamond has in the direct market, its growing importance raises concerns that relying on any one outlet for distribution and exhibition may result in the censorship or suppression of ideologically challenging content.[32] An issue of Brian K. Vaughan and Fiona Staples's popular series *Saga* (2012–) was briefly pulled from ComiXology's app when the distributor believed that its "postage stamp-sized depiction of gay sex" would run afoul of iTunes content restrictions.[33] Concerns about ComiXology's preeminence were further stoked by Amazon's acquisition of the company in spring 2014 (again, see chapter 17).

International Markets and Flows

Comics is an increasingly global cultural form: comics art of course has international roots, and many cultures have contributed substantially to the development of its form and content (see chapters 4 and 5). Like most other forms of media in the digital age, comics are being disseminated around the world in unpredictable ways. Unfortunately, few resources track international comics sales. Similarly, international scholarship on comics, even in the mass communications-oriented *International Journal of Comic Art* (1999–), tends to focus on comics-as-texts rather than economic issues, though with notable exceptions.[34] Fortunately, a growing number of monographs on comics, especially comic books, highlights industrial histories and dynamics in such countries as Mexico, India, and France.[35]

Countries without a strong comics distribution and exhibition system (for example, Israel[36]) may experience significant change as stakeholders in print culture (such as magazines) are forced to adapt to new circumstances and as comics art becomes distributed more in book or digital forms, the latter again bringing the challenge of effective monetization. Even in the United Kingdom, with its long and vibrant comics tradition, the economic future of comics art is uncertain, as symbolized by the demise in 2013 of the *Dandy*, one of the longest-running anthology comics in the world, published by venerable Scottish newspaper and comics company DC Thomson (the print version discontinued in December 2012, succeeded by a digital-only version that lasted only six months).[37]

Aside from indigenous comics industries throughout the world, the global flow of American, European, and Japanese comics has turned certain types of comics into internationally familiar idioms. American comic strips, for example, have appeared in anthologies printed in various countries, and American comic books, especially from Marvel and DC, have been distributed widely (see chapter 4 on the growing presence of translated U.S. comics in European markets). The increasingly global reach of the U.S. comics industry was underscored in 2004 when Marvel developed a "glocalized" version of Spider-Man (featuring Peter Parker's Indian counterpart Pavitr Prabhakar) to appeal to Indian comics readers and to accompany its previously created Japanese version of the character.[38]

Certainly, manga is hugely popular in Japan and beyond, with the industry offering genres appealing to diverse age groups, genders, and tastes. It incorporates the influence of American and European comics and cartoons as well as indigenous influences (see chapter 5), yet has been referred to as "culturally odorless";[39] its cross-cultural character, as well as its thematic and aesthetic ties with anime, another transnational form, has made manga a globally friendly and economically powerful publishing force (even in the United States, a country often resistant to global imports). The graphic novel section of chain bookstores in the United States often consists mostly of manga titles, and at the turn of the millennium, manga was touted as "the fastest growing segment of comic-book publishing."[40] However, manga sales declined significantly with the 2008 recession, and as with American superhero comics, a large part of manga sales tends to be tied to a few very popular titles.[41] Of course manga is not the only example of such "contraflow" content popular in the United States. The international success of Marjane Satrapi's *Persepolis*, a French-published (2000–2003) autobiographical account of the author's childhood in Iran, and its animated adaptation (2007) demonstrates the importance of diasporic comics production. Many other creators whose voices were censored in more oppressive regimes have also found success by emigrating to countries with fewer restrictions on speech.[42]

This kind of circulation is not simply limited to comics works themselves; there is also a "contraflow" of talent going from other countries to the American comics industry. Britain's long-running weekly science fiction anthology *2000 AD* has been a particularly productive source of writing talent; many of the most respected and successful comic book writers in the United States—including Alan Moore, Grant Morrison, Warren Ellis, and Mark Millar—have contributed to the popular comics magazine since its debut in 1977.[43] And while the dominance of American, European, and Japanese comics can be a barrier to local comics production in a country like Brazil, Brazilian artists Ed Benes, Ivan Reis, and Mike Deodato became stars in the American superhero comics industry.[44]

Conclusion

This chapter paints a picture of the comics industries, the U.S. comic book industry in particular, with strokes of vibrancy and cultural visibility but also a continuing untapped potential for greater influence on the larger canvas. Marvel and DC's dominance in periodical comic book sales, cross-media licensing, and international box-office receipts will likely continue—and may even increase given Marvel's position in the Disney empire (certainly, the Marvel Cinematic Universe has been an enormously successful brand, and an aspirational model for other studios, since 2008). However, the integration of comic books in larger media industries like motion pictures may cause comics to be treated as a "loss leader"[45] rather than a direct-revenue generator, thus subverting the industry's autonomy and ability to develop new approaches, including nonsuperhero genres. Alternatively, in comic books, the transition to digital influences and revenues appears to have been smoother than it has been for comic strips, whose fortunes are still tied to the uncertain future of the newspaper industry. New digital players have emerged, most notably ComiXology, and others may follow, likely rising from both traditional media conglomerates and outside the system. Whether this digital evolution leads to diversification of genres and thematic content and freer, less constrained cultural argument in comics remains to be seen. Although the United States is still a transnational force in comics publishing (and movie licensing only solidifies this visibility), the growth of manga and other contraflow trends generally indicates the fluidity of comics' globalization. Comics scholars, to map such trends and understand their democratic, economic, and aesthetic implications, should continue to document and examine such industry dynamics as a key part of critical comics scholarship in addition to textual and audience-based scholarship. The political economy of comics industries both in the United States and worldwide remains an understudied area.

Notes

1. See John A. Lent, ed., *Pulp Demons: International Dimensions of the Postwar Anticomics Campaign* (Madison, N.J.: Fairleigh Dickinson University Press, 1999).
2. Comics-related popular books include the celebrated fiction best seller by Michael Chabon, *The Amazing Adventures of Kavalier and Clay* (New York: Random House, 2000); as well as nonfiction books such as David Hajdu, *The Ten-Cent Plague: The Great Comic Book Scare and How It Changed America* (New York: Farrar, Straus and Giroux, 2008); and Dan Raviv, *Comic Wars: How Two Tycoons Battled over the Marvel Comics Empire . . . and Both Lost* (New York: Broadway, 2002). More scholarly treatments of comic book history include Martin Barker, *A Haunt of Fears: The Strange History of the British Horror Comics Campaign* (Jackson: University Press of Mississippi, 1992); Amy K. Nyberg, *Seal of Approval: The History of the Comics Code* (Jackson: University Press of Mississippi, 1998); and Randy Duncan and Matthew J. Smith, *The Power of Comics: History, Form, and Culture* (New York: Continuum, 2009).

3 Bart Beaty, "The Recession and the American Comic Book Industry: From Inelastic Cultural Good to Economic Integration," *Popular Communication* 8, no. 3 (2010): 203–207.
4 Benjamin Woo, writing around 2011, states that comic book shops account for about 60 percent of new comic book and graphic novel sales. See Woo, "The Android's Dungeon: Comic-Bookstores, Cultural Spaces, and the Social Practices of Audiences," *Journal of Graphic Novels and Comics* 2, no. 2 (2011): 125–136. However, graphic novel sales have since been dramatically affected by an increase in the number of graphic novels aimed at children and young adults and offered outside of the direct market.
5 Woo, 127.
6 "Publisher Market Shares: February 2019," PreviewsWorld, 18 March 2019, accessed 10 June 2019, https://www.previewsworld.com/Article/227363-Publisher-Market-Shares-February-.
7 About comic strips, see Ian Gordon, *Comic Strips and Consumer Culture, 1890–1945* (Washington, D.C.: Smithsonian Institution Press, 1998); about comic books, see Mark C. Rogers, "Merchandising and Licensing," in *Encyclopedia of Comic Books and Graphic Novels*, ed. M. Keith Booker (Santa Barbara, Calif.: Greenwood, 2010), 412–415.
8 For a history of the relationship of graphic novels and film, see Matthew P. McAllister and Stephanie Orme, "Cinema's Discovery of the Graphic Novel: Mainstream and Independent Adaptation," in *The Cambridge History of the Graphic Novel*, ed. Jan Baetens, Hugo Frey, and Stephen E. Tabachnick (Cambridge: Cambridge University Press, 2018), 543–557.
9 Derek Johnson, *Media Franchising: Creative License and Collaboration in the Culture Industries* (New York: New York University Press, 2013).
10 Eileen R. Meehan, "'Holy Commodity Fetish, Batman!' The Political Economy of Commercial Intertext," in *The Many Lives of the Batman: Critical Approaches to a Superhero and His Media*, ed. Roberta E. Pearson and William Uricchio (New York: Routledge, 1991), 47–65; and Zak Roman and Matthew P. McAllister, "The Brand and the Bold: Synergy and Sidekicks in Licensed-Based Children's Television," *Global Media Journal* 12, no. 20 (2012).
11 Johnson, *Media Franchising*, chap. 2.
12 Matthew P. McAllister, Ian Gordon, and Mark Jancovich, "Art House Meets Graphic Novel, or Blockbuster Meets Superhero Comic? The Contradictory Relationship between Film and Comic Art," *Journal of Popular Film and Television* 34, no. 3 (2008): 108–114. See also Liam Burke, *The Comic Book Film Adaptation* (Jackson: University Press of Mississippi, 2015).
13 Derek Johnson, "'Cinematic Destiny': Marvel Studios and the Trade Stories of Industrial Convergence," *Cinema Journal* 52, no. 1 (2012): 1–24.
14 Robert C. Harvey, "How Comics Came to Be," in *A Comics Studies Reader*, ed. Jeet Heer and Kent Worcester (Jackson: University Press of Mississippi, 2009), 25–45.
15 Shawna Feldmar Kidman, "Five Lessons for New Media from the History of Comics Culture," *International Journal of Learning* 3, no. 4 (2011): 41–54.
16 Ian Gordon, "Comics, Creators, and Copyright," in *A Companion to Media Authorship*, ed. Jonathan Gray and Derek Johnson (Oxford: Wiley-Blackwell, 2013), 221–236. See also Gordon, *Superman: The Persistence of an American Icon* (New Brunswick, N.J.: Rutgers University Press, 2017). For further discussion of how different versions of characters manifest in different media, see Derek Johnson, "Will

17. the Real Wolverine Please Stand Up? Marvel's Mutation from Monthlies to Movies," in *Film and Comic Books*, ed. Ian Gordon, Mark Jancovich, and Matthew P. McAllister (Jackson: University Press of Mississippi, 2007), 64–85.
17. Gordon, "Comics, Creators, and Copyright."
18. Sean Howe, *Marvel Comics: The Untold Story* (New York: HarperCollins, 2012). See also Charles Hatfield, *Hand of Fire: The Comics Art of Jack Kirby* (Jackson: University Press of Mississippi, 2012).
19. Kidman, "Five Lessons."
20. Bradford W. Wright, *Comic Book Nation: The Transformation of Youth Culture in America* (Baltimore: Johns Hopkins University Press, 2001).
21. Howe, *Marvel Comics*, 246 (emphasis in original).
22. Shannon O'Leary, "Comics Retailers Upbeat on 2013 Sales, Digital, Indie Comics," *Publishers Weekly*, 10 July 2013, accessed 10 June 2019, http://www.publishersweekly.com/pw/by-topic/industry-news/comics/article/58161-comics-retailers-upbeat-on-2013-sales-digital-indie-comics.html.
23. The Hero Initiative, accessed 10 June 2019, http://www.heroinitiative.org.
24. Alan Kistler, "Jim Lee, Diane Nelson Introduce DC² & DC²: Multiverse Digital Comics," Comic Book Resources, 5 June 2013, accessed 10 June 2019, http://www.comicbookresources.com/?page=article&id=45889.
25. Adam Rowe, "What DC Comics' New Service Says about the Future of Digital Subscriptions," Forbes, 30 June 2018, accessed 10 June 2019, https://www.forbes.com/sites/adamrowe1/2018/06/30/what-dc-comics-new-service-says-about-the-future-of-digital-subscriptions/#6aa282d86cd4.
26. Brigid Alverson, "JManga Shuts Down: Robert Newman Answers Some Questions," *Publishers Weekly*, 1 April 2013, accessed 10 June 2019, http://www.publishersweekly.com/pw/by-topic/industry-news/comics/article/56617-jmanga-shuts-down-robert-newman-answers-some-questions.html.
27. "ComiXology Surpasses 180 Million Downloads of Comic Books and Graphic Novels Worldwide," Anime News Network, 22 July 2013, accessed 10 June 2018, http://www.animenewsnetwork.com/press-release/2013-07-22/comixology-surpasses-180-million-downloads.
28. Vaneta Rogers, "ComiXology Selling Digital Comics through Retail Stores," Newsarama, 27 January 2011, accessed 10 June 2018, http://www.newsarama.com/6920-comixology-selling-digital-comics-through-retail-stores.html.
29. Rogers.
30. John Jackson Miller, "Digital Comics: 40 Million Paid Downloads a Year?," *Comichron* (blog), 14 June 2013, accessed 10 June 2019, http://blog.comichron.com/2013/06/digital-comics-40-million-downloads-year.html; and Milton Griepp and John Jackson Miller, "Comics and Graphic Novel Sales Down 6.5% in 2017," ICv2, 13 July 2018, accessed 10 June 2019, https://icv2.com/articles/news/view/40845/comics-graphic-novel-sales-down-6-5-2017.
31. Press coverage of comics sales soon after the industry's shift to simultaneous day-and-date digital distribution tended to take an optimistic view of the synergy between print and digital. See, for example, Adam Carter, "Superheroes Smash Digital Sales Records," CBC News, 16 March 2013, accessed 10 June 2019, http://www.cbc.ca/news/arts/story/2013/03/15/hamilton-comic-book-sales-digital.html; and O'Leary, "Comics Retailers."
32. Matthew P. McAllister, "Ownership Concentration in the U.S. Comic Book Industry," in *Comics and Ideology*, ed. Matthew P. McAllister, Ian Gordon, and Edward H. Sewell Jr. (New York: Peter Lang, 2001): 15–38.

33 "Apple Homophobic? Company in Crossfire over *Saga* #12 Comic with 'Images of Gay Sex,'" *Queer Voices*, HuffPost, 10 April 2013, accessed 10 June 2019, http://www.huffingtonpost.com/2013/04/10/apple-homophobic-bans-saga-12-comic-gay-sex_n_3052783.html.

34 Among the articles in the *International Journal of Comic Art* that include industry information are, for example, Matthew M. Chew and Lu Chen, "Media Institutional Contexts of the Emergence and Development of *Xinmanhua* in China," *International Journal of Comic Art* 12, no. 2 (2010): 171–191; Iwan Gunawan, "Multiculturalism in Indonesian Comics," *International Journal of Comic Art* 15, no. 1 (2013): 100–126; and John Weeks, "Economics and Comics: Khmer Popular Culture in Changing Times," *International Journal of Comic Art* 13, no. 1 (2011): 3–31.

35 Examples of international work that discusses industrial issues include Anne Rubenstein, *Bad Language, Naked Ladies, and Other Threats to the Nation: A Political History of Comic Books in Mexico* (Durham, N.C.: Duke University Press, 1998); Bart Beaty, *Unpopular Culture: Transforming the European Comic Book in the 1990s* (Toronto: University of Toronto Press, 2007); Ann Miller, *Reading* Bande Dessinée*: Critical Approaches to French-Language Comic Strip* (Bristol, England: Intellect, 2007); and Karline McLain, *India's Immortal Comic Books: Gods, Kings, and Other Heroes* (Bloomington: Indiana University Press, 2009).

36 Uri Fink, "Comics in Israel—a Brief History," *International Journal of Comic Art* 15, no. 1 (2013): 127–145.

37 See the now poignantly dated Hugh Armitage, "'The Dandy' Publisher Reassures Fans on the Comic's Future," Digital Spy, 5 July 2013, accessed 10 June 2018, http://www.digitalspy.com/comics/news/a495942/the-dandy-publisher-reassures-fans-on-the-comics-future.html.

38 John A. Lent, "Comic Art in Asian Cultural Context," in *Medi@sia: Global Media/tion In and Out of Context*, ed. Todd Joseph Miles Holden and Timothy J. Scrase (London: Routledge, 2006), 224–242.

39 Wendy Siuyi Wong, "Globalizing Manga: From Japan to Hong Kong and Beyond," *Mechademia* 1 (2006): 23–45. See also Casey Brienza, "Books, Not Comics: Publishing Fields, Globalization, and Japanese Manga in the US," *Publishing Research Quarterly* 25, no. 2 (2009): 101–117. Brienza's more recent *Manga in America: Transnational Book Publishing and the Domestication of Japanese Comics* (London: Bloomsbury, 2016) offers an extended study of how manga has been shaped by Americanization.

40 Duncan and Smith, *Power of Comics*, 82.

41 Beaty, "Recession," 205.

42 Massimo Repetti, "African Wave: Specificity and Cosmopolitanism in African Comics," *African Arts* 40, no. 2 (2007): 16–35.

43 Chris Murray, "Signals from Airstrip One: The British Invasion of Mainstream American Comics," in *The Rise of the American Comics Artist: Creators and Contexts*, ed. Paul Williams and James Lyons (Jackson: University Press of Mississippi, 2010), 31–45. Regarding the history of *2000 AD*, see Pat Mills, *Be Pure! Be Vigilant! Behave! 2000 AD and Judge Dredd: The Secret History* (Bury, England: Millsverse, 2017); and David Bishop and Karl Stock, *Thrill-Power Overload: 2000 AD—the First Forty Years*, rev. ed. (Oxford: Rebellion, 2017).

44 Timothy Callahan, "The Boys from Brazil," Comic Book Resources, 12 July 2010, accessed 10 June 2019, http://www.comicbookresources.com/?page=article&id=27128.

45 Beaty, "Recession," 206.

8

Readers, Audiences, and Fans

●●●●●●●●●●●●●●●●●●●●●

BENJAMIN WOO

The word *comics* evokes a bundle of expectations about genre, format, and institutional context. Despite the fact that comics' iconography has been used in the fine arts and that there are "private" comics that languish unread, when we talk about comics, we are generally talking about a mass medium. Though historians may cite venerable antecedents, comics belong to the age of mechanical—and now digital—reproduction. As such, they do not communicate directly from the mind of the author to that of the individual reader; they communicate from the one (or more typically, several creators working within industrially coordinated processes) to the many.

However, this context is not apparent in most comics scholarship, which emphasizes the theoretically mediated interpretation offered by the lone critic over those of ordinary readers. These readings take up a view from nowhere, creating the impression of a popular art with no people. I am skeptical of any claim to a monopoly on "correct" interpretations, and if there are better and worse ones, they can only be evaluated in light of the whole range circulating among real readers. As Andrew Sayer has remarked, laypeople's beliefs confront us both as things to be explained and as rival explanations.[1] One way or another, then, we must account for the readers and audiences of comics.

This chapter therefore asks questions about comics' reception by their readers and, especially, their fans. It focuses on U.S.-published comic books and the

fandoms oriented toward them, although many of the arguments apply (mutatis mutandis) to other comics traditions (see, for example, those discussed in chapters 4 and 5). In the United States, the comic book's dramatic rise was followed by a sudden fall from grace and long decline. The industry adapted by focusing inward on a diminished but dedicated audience. That creators and critics alike are drawn from this fan culture problematizes the relationship between scholars' "ideal" interpretations and the many messy "empirical" ones out there in the audience.

Who Reads the *Watchmen*?

Unfortunately, we know relatively little about the readers of comic strips, comic books, and graphic novels. We don't even have reliable estimates of how many comics readers there are—although it is clear that readership has declined substantially since its mid-twentieth-century peak, when comics were not only a mass-produced form but part of the everyday cultural experience of the "masses."

In 1944, newspaper comic strips had an estimated readership of seventy million Americans; "well over half" of adults and two-thirds of children (ages six and up) read them.[2] Comic books had a public at least as large;[3] contemporary estimates suggest that newsstands and drugstores sold twenty million comics every month in 1944 and one billion per year by the mid-'50s.[4] Surveys revealed impressive readership rates across genders and age groups: Among children ages six to eleven, 95 percent of boys and 91 percent of girls were regular readers, and among twelve-to-seventeen-year-olds, 87 percent of boys and 81 percent of girls were. Upon reaching adulthood, 41 percent of men and 28 percent of women ages eighteen to thirty still read comics regularly, as did 16 percent of men and 12 percent of women age thirty-one and over.[5]

Comic books occupied a prominent place in the media landscape for such a new publishing format, but that didn't last. Their tremendous popularity among young people, who are with some justice viewed as a vulnerable audience,[6] provoked a vehement reaction from concerned parents, educators, and legislators. Some have blamed the 1950s anticomics furor for strangling the industry in its infancy. Certainly, the resulting regime of self-censorship perpetuated the understanding of comics as kids' stuff, undoubtedly shaping the form's development (see chapter 2). Even so, it is doubtful whether comics could have sustained their popularity in an expanding youth cultural market and, particularly, in competition with the new medium of television.

In contemporary comics publishing, publicly available figures only indicate sales to comic book stores, not how many comics those stores in turn sell to individuals. Nor do they include comics borrowed from libraries, loaned to friends, read through digital subscriptions, or pirated online. But there are obviously many times fewer new comic books in circulation today than at midcentury. For some, long-form graphic novels and manga sold in mass-market bookstores

represent the best hope for reaching new audiences. However, making and printing comics is expensive compared to prose literature, and both print runs and sales for graphic novel "best sellers" typically remain far below those of comparably successful prose books. Meanwhile, the much-vaunted manga boom in the United States (see chapter 5) has lost much of its momentum. Manga, as both a set of imported cultural commodities and a source of aesthetic inspiration for "domestic" creators, is here to stay, but it seems increasingly unlikely that it will save the comics industry by attracting massive new audiences. Observers of the webcomics scene may be more optimistic (see chapter 17); the most popular web series attract between one and ten million unique browser visits a month,[7] though how many unique webcomics readers there are remains anyone's guess.

Only so much can be inferred about comics-reading from sales and circulation data. If we want to know more about readers, we have to ask them. Quantitative surveys have been conducted, but they are usually funded by industry stakeholders for business reasons so their questions are limited and the data are proprietary. For example, following a line-wide relaunch in 2011 (the so-called New 52), DC Comics hired Nielsen NRG to study the response to their new titles by conducting surveys in selected comic book stores and online. The company shared key findings with retailers, which were posted online by the website Newsarama despite the "confidential and proprietary" warning on every slide of the PowerPoint presentation. The research seemed to confirm many stereotypes about comic book readers: most respondents were white, male, and between the ages of twenty-five and forty-four; described themselves as "avid" fans; and had been reading comic books for twenty years or more. But survey results like these cannot be generalized if the contours of the population as a whole are unknown, as is the case when taking convenience samples from comic book stores, and in any case, DC was only interested in people who directly purchased New 52 comics, not comics readers in general.[8] Small-scale qualitative studies conducted by academic researchers are perhaps more insightful, but there is no guarantee that their informants are typical either—indeed, many studies intentionally focus on readers who are *atypical* in some important way (for example, Jeffrey A. Brown's research on African American fans or Shari Sabeti's on young readers).[9]

Thus many of the claims made about comics' audiences are, at best, informed suppositions. It is clear that comics and characters derived from them remain key features of children's media culture (see chapters 9 and 16). However, simply visiting a contemporary comic shop should be sufficient to prove the old saw that comics aren't for kids anymore. But adults aren't comic books' primary audience either—if by *adult*, one means the "average" person.

From Fan-Addicts to Aca-Fans

By midcentury, American comic books were a ubiquitous if suspect part of global popular culture. Over the decades that followed, however, this mass

medium became a marginal one. Even as iconic comics characters appeared in films and television shows and on countless pieces of licensed merchandise, the audience for comic books themselves dwindled. In response, from the 1960s onward, publishers increasingly oriented their products toward a small, essentially subcultural audience, many of whom self-consciously identified as comic book fans.

Because comics fans were also, necessarily, collectors of ephemera, a market for old comic books emerged through the mail; at conventions, swap meets, and flea markets; and eventually in dedicated comic book stores. However, the earliest comics enthusiasts were not connected to long-lasting, self-aware communities of like-minded peers. As Ted White observes, "Comics fandom took a long time to develop and did so in fits and starts. [. . .] By 1960, comics had been around for over 25 years, but comics fandom was still in its infancy."[10] White is talking about "modern comics fandom" here, by which he means fans of U.S. superhero comics. This fandom began tentatively as an adjunct to the better-established culture of science fiction fandom, and it borrowed much from its older cousin: fanzines and letters of comment to professional magazines, conventions and masquerades (anticipating contemporary cosplay), and the veneration of detailed knowledge of and creative speculation about imaginary worlds. The first comics fanzine to emerge from under science fiction's shadow during this period was Dick and Pat Lupoff's *Xero* (1960), the comics history columns from which would eventually be collected as *All in Color for a Dime* (1970).[11] This was quickly followed by the nearly contemporaneous releases of Don and Maggie Thompson's *Comic Art* and Jerry Bails and Roy Thomas's *Alter Ego* in 1961. *Alter Ego* gave birth to two spinoffs, an "adzine" called the *Comicollector* and an industry news bulletin, *On the Drawing Board* (later rechristened the *Comic Reader*). The Thompsons would go on to take over the long-running *Comic Buyer's Guide*.[12] Bails, coeditor of *Alter Ego* and a powerhouse of early comics fan organizing, was the central mailer of a comics-oriented amateur press association, *CAPA-alpha*, which collated and distributed a selection of fanzines and other fan publications. The first meeting at Bails's home to count the ballots for the Alley Awards is often called the first organized meeting in comics fandom.[13] In 1965, Bails and Shel Dorf took over the fledgling Detroit Triple Fan Fair, which had been started the year before by Dave Szurek and Robert Brosch and was the earliest fan convention with a major focus on comic books. Dorf later moved to San Diego, California, where he and a committee of five teenagers organized the Golden State Comic-Minicon, the precursor to the world-famous San Diego Comic-Con, in 1970.[14] Even as comics declined in popularity in the 1960s and '70s, fandom grew into a social world with traditions, institutions, and a shadow economy to sustain and reproduce it over time.

But this ferment of activity was not merely an organic development from people's love of comics. Publishers also played a role in cultivating fandom. Although other comics had previously included letter columns, DC editor

Julius Schwartz (himself a former science fiction fan) began publishing the letter writers' complete addresses with 1961's *Brave and the Bold* #35, for which he had solicited letters of comment from "some of his better correspondents."[15] By providing evidence of others' responses to the comics and enabling fans to connect with one another, the letters pages helped knit readers together as a kind of community. Some took the further step of creating fan clubs, such as the EC Fan-Addict Club and the Merry Marvel Marching Society. EC's fans were mobilized defensively in the midst of the anticomics media panic to little effect,[16] but they had lasting consequences in the development of comics fandom.

With the emergence of a shared diegetic universe in the Marvel comics of the 1960s, reading comics became more demanding.[17] Whereas most earlier stories had been short and self-contained, returning the narrative to status quo in a few pages, readers now had to keep track of what had happened in previous issues and other series. This "problem" generated new paratextual apparatuses, such as footnotes directing readers to previous issues and Marvel's facetious "No-Prizes" for readers who wrote in to point out internal contradictions. In his captions and columns, Marvel's avuncular editor/ringmaster Stan Lee perfected a self-promotional discourse that interpellated readers as "True Believers," and this breezy address to fellow fans remains the dominant tone in the industry's communication with its publics. Indeed, the reader-as-fan became the basic axiom and article of faith in so-called mainstream comic book publishing. Creators, publishers, retailers, critics, and readers defined comic book fandom through shared tastes; deeply felt dedication to particular characters; a voracious appetite for continuity, trivia, homages, and intertextual references; and extensive collecting practices. This reorientation to the fan audience was both a symptom of and a contributor to the industry's political-economic transformations since the 1960s.

With shrinking circulation from the newsstand market, comics retreated into specialty comic book stores. Although such stores initially emerged from the collectors' shadow economy and the so-called head shops that distributed underground comix, comic shops were incorporated into a new "direct market" over the course of the 1970s and '80s (see chapters 2 and 7). The fan audience could be reached more efficiently through comic book stores than newsstands and drugstores. Moreover, publishers assumed much less risk for underperforming books, since within the direct-market system, comics were sold on a nonreturnable basis; unlike general interest magazines, unsold comic books could no longer be returned for a refund. As an unintended consequence, however, comic books became increasingly foreign to the everyday experience of most Americans. As Jean-Paul Gabilliet notes, "At the dawn of the 1980s, comic books were no longer a mass medium, but were a sector of the cultural industry that was increasingly structured around a 'fan' audience, in the strongest sense of that term. Comic book reading no longer belonged to the repertory of mass cultural activity shared by half the total population, as was the case

after the war."[18] Over time, many participants in comic book fandom sought to join the world of comics, pursuing creative and other work in the industry.[19] It is difficult to imagine anyone working at any level in the comic book industry today who is not, in some respect, a comic book fan, and as fans rose to decision-making positions in the industry, comics' content was increasingly oriented to the aesthetic concerns of dedicated readers like themselves. As Charles Hatfield puts it, "By 1980 the market was by and unquestionably for superhero fans."[20] So comics were not only sequestered from the media choices readily available to most people but also increasingly incomprehensible to anyone uninitiated into the culture of fandom.

Today, this kind of fan engagement is routinely taken as evidence of a sophisticated form of media literacy. The comic book medium is particularly praised for the ways it combines verbal and visual communication and for its ability to engage both gifted and struggling students in schools.[21] But this was not always the case. In the 1940s and 1950s, educators and librarians routinely portrayed comic book reading as pathological, and there was not yet a vocabulary for contesting these claims, let alone understanding fandom on its own terms.[22] However, in the 1990s, following John Fiske's accounts of popular culture as a battleground between "dominant" culture and "resistive" audiences, more scholars began investigating fan cultures. They not only argued that fans were paradigmatic "active" audiences but also identified with their subjects. Indeed, some scholars described themselves as "aca-fans" (short for "academic-fan"), suggesting, as Henry Jenkins puts it, a "hybrid identity that straddled two very different ways of relating to media cultures."[23] This rhetorical positioning enabled them to eschew academic pretensions to objectivity in favor of fannish advocacy and enthusiasm.

The growth of comics studies is also the work of fan scholars. On the one hand, much of what we know about the history of comic books and the careers of their creators is due to the efforts of the fans who documented it. Fan scholarship has occasionally promoted facts and interpretations that were subsequently debunked (for instance, the attribution of Outcault's "Yellow Kid" as the first comic), but some of our most knowledgeable and insightful critics have been autodidacts—and they certainly had no training in the perpetually nascent academic discipline of comics studies. At the very least, dedicated fans did yeoman's work in documenting the corpus, attributing authorship, and interviewing people involved long before anyone with a PhD got involved. On the other hand, notwithstanding the occasional dilettante, comics scholars working within the university system are generally lovers of the form. Indeed, many works of comics scholarship incorporate a confessional moment where the author outlines his or her fannish bona fides. It is doubtful if comics would have made their way into the academy—if a book like this one would even exist—without the efforts of fan scholars. If both lay and professional comics scholars tend to emerge from

the culture of comic book fans, then one might well ask how this background impinges upon their scholarship. To put it another way, how does comics culture affect our perception of comics as an art form, communicative medium, and social phenomenon?

Understanding Comics Culture

The seemingly straightforward notion of "comics culture" can mean very different things depending on which of those two words one emphasizes. *Comics culture* can refer to comics as cultural texts, expressing either their creators' genius or the zeitgeist within which they were conceived. But it can equally refer to the culture *of* comics: the constellation of beliefs, habits, and practices that take those texts as their object. Most comics scholarship is explicitly concerned with the former but deeply informed by the latter. As part of his critique of "pure judgement," Pierre Bourdieu enjoined sociologists to turn analysis back on themselves and explain how their own social position shaped their perspectives on the people they studied.[24] Similarly, I am suggesting—perhaps somewhat paradoxically—that comics scholars ought to be more concerned with, but less beholden to, the culture of comic book fans.

There are no naive readings, whether in academia or the comic shop. Our aesthetic standards, expectations, and tastes come from somewhere. I think there is good reason to believe many of them are learned through our interactions with other readers, much as Bourdieu suggests of cinema buffs and other pop-culture connoisseurs: "Where some only see 'a Western starring Burt Lancaster,' others discover 'an early John Sturges' or 'the latest Sam Peckinpah.' In identifying what is worthy of being seen and the right way to see it, they are aided by their whole social group (which guides and reminds them with its 'Have you seen ... ?' and 'You must see ...') and by the whole corporation of critics mandated by the group to produce legitimate classifications and discourse necessarily accompanying any artistic enjoyment worthy of the name."[25] Conversations like these focus our attention, training us to perceive objects differently. At the very least, we learn to express our taste in terms that are intelligible to significant others: Which preferences will earn knowing nods of approval? Which ones must be repressed or admitted only under the guise of "ironic appreciation" or the "guilty pleasure"?

Imagine a typical biography or career in comics fandom. In my own interviews with comics fans (and fans of other "geeky" cultural goods), most people told their "origin stories" in terms of some other person who got them started in the hobby—usually a sibling or friend, sometimes a parent or adult mentor. As mentioned above, young readers often supplement their own collections by swapping comics with or loaning them to their peers. Thus their tastes influence and direct one another's reading even if they do not talk about their preferences.

If they persist as "serious" readers, they may seek out news, commentary, and reviews on websites devoted to comics. Given the opportunity, they will probably spend some time in comic book stores and at conventions.

In these spaces, they will learn about the history of the form and further develop their aesthetics. Previous studies of comic book stores have emphasized that their role in fandom—and in individual fans' lives—extends far beyond their economic function as distributors of comic books and related merchandise: "The comic book shop is a meeting place, like the clubhouse at a country club or a small-town barbershop. It is a place for commerce, but, more importantly, it is a place for culture."[26] Indeed, the comic book store affords multiple uses for different customers: "The space is used as a commercial site, a lounge, a gaming hang-out, and a study hall."[27] Although open to the public, it serves as a "backstage" area, and shops deploy several techniques to keep dedicated fans apart in both space and time from casual shoppers.[28] It fosters interaction among its members, who tend to view chatting with staff and other customers as an integral part of buying comics. For example, Ofer Berenstein documents the "recommendations ceremony" that often occurs when comics fans meet one another for the first time.[29] Not only do they probe one another's taste, but this exchange of viewpoints also serves as aid to, or proxy for, socializing and building relationships. Through conversations in and around the comic shop, readers learn which creators and works are considered significant and which are laughable or passé, and they attach concrete examples to important aesthetic categories such as *good* and *bad*, *realistic* and *cartoony* (see chapter 11), and *mainstream* and *alternative*. Outside dedicated physical spaces like the comic shop or convention, similar conversations have been enabled by physical and electronic correspondence, fanzines and amateur press associations, online forums or chat rooms, and comment threads attached to relevant articles. And as Brown has noted, a significant number of fans routinely wear T-shirts that identify them as comics fans and occasion conversations with others about their fandom.[30]

All this suggests that a robust fan culture provides the ultimate ground of comics' reception for those readers who participate in it. Because the contemporary comic book industry is oriented to the fan audience at virtually every level, understanding and analyzing fandom as a social world and a regime of valuation are necessary components of comics scholarship. They are not, however, sufficient. A more thoroughgoing reevaluation of our assumptions—both *about* fans and *as* fans—is required.

Dash Fiction?

Jenkins refers to the aca-fan as a "hybrid identity," one that encompasses two different ways of relating to the object, simultaneously joined together and held apart by a dash. This suggests a productive tension between discrete entities, but I don't think it captures the tricky position of the "insider researcher" of fandom

in general and of comics in particular.[31] Indeed, the conflation of academic and fannish orientations has produced at least three distinctive and systematic distortions to comics scholarship.

First, casual references to comics fans by academics, industry professionals, and fans themselves too often assume we all know what being a fan means. There are, however, many ways to "do fandom." Some readers are careful collectors who maintain "want lists" to manage their acquisitions, whether for their own sake or with an eye to eventual return on investment. Others principally consume comics as a form of entertainment, perhaps archiving their purchases, perhaps disposing of them when finished. Some like comics in their "floppy" or periodical form, while others prefer to "trade-wait"—that is, to wait until those monthly installments are republished in collected editions ("trade paperbacks"). A growing contingent read digital editions (licit or otherwise) on screens, and others render their comics unreadable by "slabbing" them to preserve their condition.[32] Some "readers" aren't readers at all: for example, in a suggestive study of filmgoers at screenings of two "comic book" (that is, superhero) movies, Liam Burke discovered that many of the people who identified themselves as comics fans did not actually read comics, while some who denied being fans did.[33] Finally, the assumption of a fan identity may not account for the "hidden" audience alluded to above—those who borrow comics from others or the library, who read webcomics, or who are assigned graphic novels in the growing number of comics courses in schools and colleges.

Second, the tastes and priorities cultivated in comics fandom have distorted our picture of the field of comics. Superhero comics, "literary" graphic novels and memoirs, and especially quasi-literary superhero comics dominate the academic literature. Meanwhile, comics with much larger audiences have been relatively neglected by scholars: romance comics or Dell and Disney comics for children, to name only a few examples.[34] It is *theoretically* possible, though unlikely, that these comics are inherently less worthy of our attention, but it is hardly a coincidence that they are also comics that are/were not read by nerdy teenage boys and least resemble the consecrated forms of culture that it is hoped will enhance comics' reputation by association. They have not been legitimated by the "corporation of critics" that is comics fandom and tend to disappear from the description of what we mean by "the American comic book."

Even the history of superhero comics is warped by fannish common sense. Take, for example, the convenient but ultimately misguided metaphor of comic book "ages." This model of the history of comics originated in fandom around the start of what we typically call the Silver Age. At that moment, for a particular constituency of superhero fans, it made a great deal of sense, recalling the lost Golden Age of the late 1930s and 1940s and heralding their hopes for a superhero renaissance. But when this was extended into a "Modern" or "Bronze" Age and adopted as a general scheme for periodizing the history of comics, it started to show its weaknesses. Fan scholars and critics responded by proposing

a plethora of correctives to the system, from Mica to Mylar and Silicon to Silicone.[35] But as a mode of historiography, it is hopelessly nostalgic and imprecise, whatever labels we use. In a sense, however, these problems are paper tigers produced by a reluctance to let go of fan tradition, even a self-evidently incoherent one.[36]

Third, the development of research problems in comics studies has been distorted by what Joseph Witek calls "the problem of dual address."[37] The inclusion of academics, journalists, critics, fans, and comics professionals within the discursive community of comics scholarship ought to be commended for its democratic spirit. However, the varying backgrounds, priorities, interests, and especially vocabularies of interlocutors pose significant hurdles that cannot be wished away. Witek argues that too much comics scholarship reinvents the wheel, developing concepts or simply "applying" discipline-specific paradigms without reference to existing research on comics. This has subsequently been framed as a debate over jargon,[38] but linguistic usage is tied up in who we consider (and how we imagine) our interlocutors. In one study, for example, the rhetorical "moves" made in introductions to scholarly articles on comics showed limited awareness of an established field of debate and research.[39] These are typical problems of a field in its pretheoretical stage of development, and the intuitions developed in fandom are part of what is keeping comics studies there.

Marshall McLuhan famously quipped that while we may not know who first discovered water, we can be certain it wasn't a fish. Comic book culture is the water that comics readers—including professional and academic ones—swim in. What seem to us to be commonsense assumptions about comics and their audiences are products of the social worlds in which we encounter them—in the case of "mainstream" American comic book publishing, the world of comics fans and the broader universe of geek culture. When these assumptions go unacknowledged, we are likely to make mistakes.

Conclusion

Despite early roots in social-science fields like communication, education, and psychology, the field of comics scholarship today—whether interested in representation or formalism, in superheroes or autobiography—is dominated by scholars trained in literary studies, scholars for whom interpreting texts via close reading is the primary way of doing comics studies.[40] At its best, this mode of scholarship focuses our perceptual apparatus, enabling new appreciation of a comic's richness and complexity. But a close reading is really just an audience study with a sample size of one. It has no privileged status vis-à-vis other existing interpretations, and its difference from the everyday methods of reading employed by ordinary audience members is one of degree, not of kind.

In this chapter, I've emphasized the world of superhero-oriented comic book fandom. For much comics publishing, understanding this culture is absolutely essential, as it is the source of strategies, competencies, and knowledges that producers, readers, and academics alike use to make sense of comics. It is by no means the only such source, and others need to be investigated as well, but the larger point stands: comics are more than what is on the page. As Benedict Anderson has suggested of newspapers, mass media forge shared experiences—at the very least, of engaging with mass media—and an awareness of the others with whom you share them.[41] This, too, is the lesson of comics' audiences and fans. The meaning of any individual work of comics art, much less of comics as a field of cultural production, does not inhere in the text. Rather, its meaning is *made* in reception and its significance results from the various ways real people respond to it as it circulates through different sites and contexts.[42] Thus comics scholarship cannot merely *interpret* comics but must also *explain the production of interpretations*.

Notes

1 Andrew Sayer, *The Moral Significance of Class* (Cambridge: Cambridge University Press, 2005), 70.
2 Harvey Zorbaugh, "The Comics—There They Stand!," *Journal of Educational Sociology* 18, no. 4 (1944): 196.
3 Zorbaugh, 197.
4 Zorbaugh, editorial, *Journal of Educational Sociology* 18, no. 4 (1944): 194; and Dwight L. Burton, "Comic Books: A Teacher's Analysis," *Elementary School Journal* 56, no. 2 (1955): 73. Jean-Paul Gabilliet gives 1952 as the industry's peak, with estimated circulation between 840 million and 1.3 billion copies, depending on the source. Gabilliet, *Of Comics and Men: A Cultural History of American Comic Books*, trans. Bart Beaty and Nick Nguyen (Jackson: University Press of Mississippi, 2010), 46.
5 Zorbaugh, "Comics," 197–98.
6 Stephen Kline, "A Becoming Subject: Consumer Socialization in the Mediated Marketplace," in *The Making of the Consumer: Knowledge, Power and Identity in the Modern World*, ed. Frank Trentmann (Oxford: Berg, 2006), 199–221.
7 "Triumph of the Nerds: The Internet Has Unleashed a Burst of Cartooning Creativity," *Economist*, 22 December 2012, accessed 20 March 2019, http://www.economist.com/news/christmas-specials/21568586-internet-has-unleashed-burst-cartooning-creativity-triumph-nerds.
8 "The Full Nielsen: DC's Complete New 52 Consumer Survey," Newsarama, 12 April 2012, accessed 20 March 2019, http://www.newsarama.com/14637-the-full-nielsen-dc-s-complete-new-52-consumer-survey.html. Contains a PowerPoint presentation by the Nielsen Company, "DC Comics—the New 52 Product Launch Research Results," 21 October 2011.
9 Martin Barker, *Comics: Ideology, Power and the Critics* (Manchester: Manchester University Press, 1989); Jeffrey A. Brown, *Black Superheroes, Milestone Comics, and Their Fans* (Jackson: University Press of Mississippi, 2001); Matthew J. Pustz, *Comic Book Culture: Fanboys and True Believers* (Jackson: University Press of Mississippi,

1999); Shari Sabeti, "The Irony of 'Cool Club': The Place of Comic Book Reading in Schools," *Journal of Graphic Novels and Comics* 2, no. 2 (2011): 137–149; and Sabeti, "'Arts of Time and Space': The Perspectives of a Teenage Audience on Reading Novels and Graphic Novels," *Participations: Journal of Audience & Reception Studies* 9, no. 2 (2012): 159–179.
10. Ted White, "The History of Comics Fandom, Part Three," *Comics Journal*, no. 232 (April 2001): 99.
11. Ted White, "The History of Comics Fandom, Part Four," *Comics Journal*, no. 233 (May 2001): 108; and Dick Lupoff and Don Thompson, eds., *All in Color for a Dime* (New Rochelle, N.Y.: Arlington House, 1970). Bradley and Willits's 1947 *The Comic Collector's News* is believed to be the first fanzine solely focused on comics, and there was a great deal of fan activity around EC Comics in the 1950s. Sean Kleefeld, *Comic Book Fanthropology*, 2nd ed. (Hamilton, Ohio: Eight Twenty Press, 2011), 28.
12. White, "History of Fandom, Part Four," 109; and White, "The History of Comics Fandom, Part Five," *Comics Journal*, no. 234 (June 2001): 108.
13. A blog post by Philip Graves reproduces a photo from the first "Alley Tally" party in 1964. Graves, "Early Comics Fandom (Part 2)—after the Alley Awards," Examiner.com, 11 September 2009, http://www.examiner.com/article/early-comics-fandom-part-2-after-the-alley-awards. Web page no longer extant.
14. Dez Skinn, "Early Days of UK Comics Conventions and Marts," dezskinn.com (blog), 9 October 2011, http://dezskinn.com/fanzines-3/; and Albert Ching, "What Is Comic-Con? A Brief History of the Mega-event," Newsarama, 19 July 2010, http://www.newsarama.com/comics/what-is-comic-con-100719.html. See also San Diego State University Library's oral history project, *The Comic-Con Kids*, accessed 2 April 2020, http://comiccon.sdsu.edu.
15. White, "History of Fandom, Part Five," 109.
16. Jared Gardner, *Projections: Comics and the History of Twenty-First-Century Storytelling* (Stanford, Calif.: Stanford University Press, 2012), 98–99.
17. Charles Hatfield, *Hand of Fire: The Comics Art of Jack Kirby* (Jackson: University Press of Mississippi, 2011), esp. 103–104, 122–124.
18. Gabilliet, *Of Comics and Men*, 204.
19. Gabilliet, 264; and Ian Gordon, "Writing to Superman: Towards an Understanding of the Social Networks of Comic-Book Fans," *Participations: Journal of Audience & Reception Studies* 9, no. 2 (2012): 120–132. See also Gordon's *Superman: The Persistence of an American Icon* (New Brunswick, N.J.: Rutgers University Press, 2017).
20. Hatfield, *Hand of Fire*, 123.
21. James Bucky Carter, "Introduction—Carving a Niche: Graphic Novels in the English Language Arts Classroom," in *Building Literacy Connections with Graphic Novels: Page by Page, Panel by Panel*, ed. James Bucky Carter (Urbana, Ill.: National Council of Teachers of English, 2007), 1–25; Sabeti, "Irony of 'Cool Club.'"
22. Joli Jensen, "Fandom as Pathology: The Consequences of Characterization," in *The Adoring Audience: Fan Culture and Popular Media*, ed. Lisa A. Lewis (New York: Routledge, 1992), 9–29.
23. Henry Jenkins, *Fans, Bloggers, and Gamers: Exploring Participatory Culture* (New York: New York University Press, 2006), 4.
24. Pierre Bourdieu, *Distinction: A Social Critique of the Judgement of Taste*, trans. Richard Nice, Routledge Classics ed. (London: Routledge, 2010), 4.
25. Bourdieu, 20.
26. Pustz, *Comic Book Culture*, 6.

27. Brian Swafford, "Critical Ethnography: The Comics Shop as Cultural Clubhouse," in *Critical Approaches to Comics: Theories and Methods*, ed. Matthew J. Smith and Randy Duncan (New York: Routledge, 2012), 297.
28. Benjamin Woo, "The Android's Dungeon: Comic-Bookstores, Cultural Spaces, and the Social Practices of Audiences," *Journal of Graphic Novels and Comics* 2, no. 2 (2011): 125–136.
29. Ofer Berenstein, "Comic Book Fans' Recommendations Ceremony: A Look at the Inter-personal Communication Patterns of a Unique Readers/Speakers Community," *Participations: Journal of Audience & Reception Studies* 9, no. 2 (2012): 74–96.
30. Jeffrey A. Brown, "Ethnography: Wearing One's Fandom," in *Critical Approaches to Comics*, 280–290.
31. Paul Hodkinson, "'Insider Research' in the Study of Youth Cultures," *Journal of Youth Studies* 8, no. 2 (2005): 131–149.
32. Mark Rogers, "Political Economy: Manipulating Demand and 'The Death of Superman,'" in *Critical Approaches to Comics*, 153; and Benjamin Woo, "Understanding Understandings of Comics: Reading and Collecting as Media-Oriented Practices," *Participations: Journal of Audience & Reception Studies* 9, no. 2 (2012): 180–199.
33. Liam Burke, "'Superman in Green': An Audience Study of Comic Book Film Adaptations *Thor* and *Green Lantern*," *Participations: Journal of Audience & Reception Studies* 9, no. 2 (2012): 103–104.
34. Bart Beaty and Benjamin Woo, *The Greatest Comic Book of All Time: Symbolic Capital in the Field of American Comics* (London: Palgrave Macmillan, 2016).
35. A. David Lewis, "One for the Ages: Barbara Gordon and the (Il-)Logic of Comic Book Age-Dating," *International Journal of Comic Art* 5, no. 2 (2003): 296–311.
36. Benjamin Woo, "An Age-Old Problem: Problematics of Comic Book Historiography," *International Journal of Comic Art* 10, no. 1 (2008): 268–279.
37. Joseph Witek, "American Comics Criticism and the Problem of Dual Address," *International Journal of Comic Art* 10, no. 1 (2008): 218–225.
38. Craig Fischer, "Worlds within Worlds: Audiences, Jargon, and North American Comics Discourse," *Transatlantica: Revue d'études américaines*, no. 1 (2010): http://transatlantica.revues.org/4919, accessed 20 March 2019.
39. Phillip Troutman, "The Discourse of Comics Scholarship: A Rhetorical Analysis of Research Article Introductions," *International Journal of Comic Art* 12, nos. 2–3 (2010): 432–444.
40. Beaty and Woo, *Greatest Comic Book of All Time*.
41. Benedict Anderson, *Imagined Communities: Reflections on the Origin and Spread of Nationalism* (London: Verso, 1983).
42. Paul Willis, *Common Culture: Symbolic Work at Play in the Everyday Cultures of the Young* (Milton Keynes, U.K.: Open University Press, 1990).

9

Children and Comics

●●●●●●●●●●●●●●●●●●●●●●

PHILIP NEL

For as long as comics have been a recognized popular form of media, children have read them. However, in a bid for respectability over the past several decades, some comics creators and publishers have distanced themselves from younger readers, hoping to gain credibility by giving their works the more adult-sounding moniker *graphic novel* (see chapter 6). But comics, in the modern sense, arguably began as a literature for children. In 1827, Genevan schoolmaster Rodolphe Töpffer created the first of his pictorial narratives, *Les amours de M. Vieux Bois* (The loves of Mr. Vieux Bois), which was first published a decade later. As David Kunzle tells us, Töpffer wrote this early comic "under the eyes of and to the active applause of the boys, during evening 'prep' time."[1] While Töpffer's ambitions as a writer went beyond children, and his comics were satirical in aim (see chapter 1), it seems no accident that his whimsical tales grew out of his work with young people.

Granted, scholars have sometimes argued that comics began as an adult medium and only belatedly became tagged as a children's form. Thierry Groensteen, for example, argues that during the nineteenth century—Töpffer's century, thus for Groensteen comics' point of origin—the form was "intended for adults," only to be "relegated" to the children's press early in the twentieth, such that the "re-conquest of the adult readership" that came after underground comix marks the end of a long "historical parenthesis."[2] The question is debatable; data about child readers of comics in the nineteenth century are scarce,

while the twentieth-century explosion of comics for and about children is well documented. Yet even Groensteen acknowledges that comics retain "a privileged relationship with childhood" and that comics can give rise to "strongly nostalgic emotions" redolent of youth. It was in childhood, he assumes, "that each of us discovered [comics] and learnt to love them."[3] From this vantage point, the idea that the dominance of children's comics represents a mere anomaly, a "parenthesis," seems unsustainable. Suffice to say that comics and childhood are, and long have been, inextricably linked.

Comics as Children's Literature

The histories of comics and children's picture books are intertwined in ways most readers are unaware of. From 1900 to 1950, hundreds of popular comic strips found new life as children's books. Some publishers put out books that divided Sunday strips into two half-page segments; this was done for comics like Carl Emile "Bunny" Schultze's *Foxy Grandpa* (1900–1922), R. F. Outcault's *Buster Brown* (1902–1921), and Winsor McCay's *Little Nemo in Slumberland* (1905–1914, 1924–1926). Others published book versions with *one panel* per page (for instance, Chester Gould's *Dick Tracy* and, again, Outcault's *Buster Brown*), a layout that even more closely resembles the typical picture book format. Still others created new illustrated children's chapter books based on comics characters; Outcault wrote at least three such works: *Buster Brown Abroad* (1904), *Tige: His Story* (1905), and *Buster Brown's Autobiography* (1907).

In personally adapting his comics characters to the form of the chapter book, Outcault was unusual—and prescient (other such books appeared later: for example, Frank King's Skeezix chapter books of the mid to late 1920s, based on a character from his strip *Gasoline Alley*). After that, strips often appeared as books, albeit less artfully done. Following a format of text on the left page and image on the right, Whitman's Big Little Books and Better Little Books series (1932–1949, with sporadic revivals thereafter) included all the major comic book and comic strip characters: Dick Tracy, Alley Oop, Blondie, Mickey Mouse, Popeye, Li'l Abner. Unlike the carefully crafted adaptations of Outcault, however, these tended to be strips recycled into a book format, with text added by an employee of the press. But they were popular children's books.

Some of the best-known artists for children had fully developed careers in both comics and children's books. Tove Jansson wrote nine novels (1945–1970), five picture books (1952–1993), and six years of comics (1954–1959) about the Moomins. Crockett Johnson created the comic strip *Barnaby* (1942–1952) and seven picture books about Harold and his purple crayon (1955–1963). Syd Hoff, creator of the strips *Tuffy* (1939–1949) and *Laugh It Off* (1958–1977), wrote *Danny and the Dinosaur* (1958), *Sammy the Seal* (1959), *Stanley* (1962), and many other popular children's books. Wilhelm Busch, A. B. Frost,

W. W. Denslow, Palmer Cox, Lynd Ward, Jules Feiffer, Patrick McDonnell, Neil Gaiman, Marjane Satrapi, Mark Newgarden, and many others have had substantial careers in both fields.

Scholars of children's literature often point to Maurice Sendak's Winsor McCay homage *In the Night Kitchen* (1970) as an example of a picture book that uses a comics format. In fact, picture books have been using the storytelling techniques of comics since at least the 1940s. Virginia Lee Burton's *Calico the Wonder Horse* (1941), Margret and H. A. Rey's *Pretzel and the Puppies* (1946), David Wiesner's *Tuesday* (1991), Régis Faller's *Polo* books (2002–2010), Mark Newgarden and Megan Montague Cash's *Bow-Wow Bugs a Bug* (2007), Chris Raschka's *A Ball for Daisy* (2011), and JonArno Lawson and Sydney Smith's *Sidewalk Flowers* (2015)—all picture books—use the narrative art of the comics page: panels, juxtaposed in deliberate sequence. Some, such as the examples mentioned in the previous sentence, use panels throughout, while many others use panels more selectively. There's a single two-panel page in Hardie Gramatky's *Little Toot* (1939); Kevin Henkes uses panels for some pages, but not others, in *Owen* (1993); Ian Falconer uses borderless panels in *Olivia* (2000); and so on. Many authors of picture books speak the language of comics.

Children's Comics versus Adult Censors

Though they share elements of a common language, children's comics have historically ranked lower in our cultural hierarchy and inspired much more censure than picture books have. Claiming that naughty-kid comics like *Buster Brown* led to a decline in family values, Percival Chubb in 1911 founded the League for the Improvement of the Children's Comics Supplement. What Fredric Wertham would later be to horror and crime comics (see chapter 2), Chubb was to the Sunday comics page. According to him, "The child of the comic supplement is the 'smart kid.' The absolute abomination of American life is the 'smart kid.' . . . We must get rid of him. . . . Uncles and aunts, fathers and mothers, are alike made clowns in every comic supplement in order to make attractive to the American youth this ideal of the 'smart kid.'" He concluded, "The comic Sunday supplement must be banished from the American home. Harmless as it may seem, it is one of the most dangerous and degrading influences of our modern child's life."[4]

The reason that children's comics draw censure but children's books do not, Joe Sutliff Sanders suggests, is that "comics anticipate a child who reads without adult supervision; picture books anticipate an adult who will monitor and fix meaning in ways 'appropriate' for child listeners." According to Sanders, this distinction also explains why comics face regulation as a class of reading material, whereas picture books draw censure individually and relatively rarely. As he says, "Mid-century concern over comics led to the formation of the Comics Code Authority, a regulating body with enormous power to restrict the

distribution of comics," but the United States "has never had a Picture Books Code Authority."[5]

Since a newspaper comic strip cannot easily be read aloud (and thus cannot be supervised by a grown-up), these too face regulation. This is mostly a matter of internal editorial censorship but nonetheless curtails what can be said on the comics page. Though they later relented, for many years, Mort Walker's editors at King Features omitted the belly buttons on any woman in a bathing suit, and several newspapers censored a 1968 *Dick Tracy* strip that claimed, "Violence is golden, when it's used to put down evil" and showed the enemy being "vaporized."[6] On a number of occasions, *Doonesbury* has been moved to the editorial page for a week, and Walt Kelly drew alternate Sunday "bunny strips" for the newspapers too skittish to run his political Sunday *Pogo* comics. Because children read comic strips but adults monitor the content, a syndicate's editors may insist upon editorial changes—or the editor of a newspaper may make the decision to move *Doonesbury* for the week—if they do not consider the content benign.

Wertham's *Seduction of the Innocent* (1954) and the Senate hearings on comic books led the U.S. comics industry that same year to form the Comics Code Authority, regulating what content would be appropriate for young readers (again, see chapter 2). As John A. Lent has noted, parallel debates over the suitability of comics for children took place around the world, prompting, or at least helping to justify, Australia's ban on the importation of American comic books (1940–1959); Canada's Bill 10, a.k.a. the Fulton Bill, banning crime comics (1949); France's *Loi du 16 juillet 1949 sur les publications destinées à la jeunesse*, which forbade violent or lurid content; and Britain's Children's and Young Person's (Harmful Publications) Act, which banned the importation or reprinting of crime and horror stories (1955). Significantly, all such laws "dealt with what were perceived as the negative impacts of comics on children."[7] If these laws gave local comics artists (in the case of Australia) room to develop their work and (in the United States) aided children's comics and renewed interest in the superhero genre, they also curtailed what could be expressed in commercial sequential art.

Though Japan has had its own censorship regime for comics (based on statutes enacted in 1964), it has not experienced a comparably severe testing or crackdown but instead has enjoyed the growth of a wider range of comics with a greater variety of subject matter and a more diverse audience. While influenced by Western comics and cinema, Japanese manga of the past half century have not been dominated by masculinity, as Western comics have been until recently and as American comic book culture arguably still is (see chapters 5 and 16). Manga attract male and female readers in equal measure, though children's manga do split into shōjo (for girls ages ten to eighteen) and shōnen (for boys ages ten to eighteen), with genres typically divided along those gendered lines. Of course, shōjo and shōnen manga both have their prototypical, gender-specific genres,

but the range and subtlety of expression therein has vastly expanded since the explosion of extended-story manga in postwar Japan.[8] As they strive to encompass a wider variety of stories, contemporary American comics are just starting to catch up with Japanese manga, which have been offering more diverse stories for decades.

What Is and Isn't a Children's Comic?

Children's comics are not a genre so much as a medium that encompasses many genres. There are the funny animal stories of Walt Kelly or Sheldon Mayer, the nonsense of George Carlson, the character-driven comedy of John Stanley and Irving Tripp's *Little Lulu*, the imperialist adventure narratives of Carl Barks's Scrooge McDuck, the precise gags of Ernie Bushmiller's *Nancy*. A category containing a vast variety of narratives, children's comics defy attempts to simply label it a "genre."

And yet this claim evades the key question of audience. Although a child might be capable of reading Robert "R." Crumb's *Zap Comix* #1 (1967), very few people would label that work as "for children." The difficulty of defining that phrase, *for children*, has led scholars to note, for instance, that children are as heterogenous a group as adults are; that the notion of the child varies both historically and within given historical periods; that children vary by age, race, class, gender, sexuality, ability, region, and education; that works for children reflects adults' *ideas* of children; and so on.

That said, we can venture to identify some key traits of children's comics. Indeed, what Perry Nodelman says of children's literature might be said of children's comics as well: it is "literature that claims to be devoid of adult content that nevertheless lurks within it." The imagined child reader of children's literature, Nodelman notes, "is divided, both teachable and incorrigible, savage and innocent—eternally ambivalent. [Children's literature] possesses a double vision of childhood, simultaneously celebrating and denigrating both childhood desire and adult knowledge and, therefore, simultaneously protecting children from adult knowledge and working to teach it to them."[9] Such ambivalence pervades classic kid comics: the innocent but clever mischief of Bushmiller's *Nancy*, the hyperarticulate children of Charles Schulz's *Peanuts* (1950–2000), the ten-year-old radical black protagonist of Aaron McGruder's *The Boondocks* (1996–2003), a five-year-old's lush Art Nouveau dreamscapes in Winsor McCay's *Little Nemo in Slumberland* (1905–1927).

Likewise, Nodelman observes certain qualities of children's literature that children's comics typically share: stories tend to be "plot-oriented," to place "child characters in unchildlike situations," to be "hopeful and optimistic in tone," and to offer "what purport to be happy endings."[10] These elements feature in just about any episode of, say, Stanley and Tripp's *Little Lulu* (1948–1959), Jennifer and Matthew Holm's *Babymouse* (2005–2016), or even Hergé's *Tintin*

(1929–1976). One major theme Nodelman does not stress is the sometimes tricky boundary between imagination and reality, which is a frequent concern of children's books (Johnson's *Harold and the Purple Crayon*, Sendak's *Where the Wild Things Are*) and comics for children (Bill Watterson's *Calvin and Hobbes* [1985–1995], Sheldon Mayer's *J. Rufus Lion* [1944–1954]). Comics for children, then, share these features with children's books: exploration of the limits of imagination, an emphasis on action, child characters in unchildlike situations, and apparently happy endings.

Children's comics also exhibit traits that, while not absent, are less common in children's books. First, comics have more prominent roots in film comedies—Chaplin, Keaton, Laurel and Hardy, Abbot and Costello. Like their slapstick antecedents, comics go for sight gags more than children's books do and perhaps lean more heavily on stock characters (as opposed to three-dimensional characters) to populate those gags. Bushmiller's *Nancy* and Rudolph Dirks's *Katzejammer Kids* (1897–1913) are obvious examples, but visual humor is a mainstay even of more philosophical strips like *Calvin and Hobbes*, *Peanuts*, and Berkeley Breathed's *Bloom County* (1980–1989). Second, comics and not children's books are also the primary province of the superhero (off-screen, at least). Indeed, the influence of white male comedians and superheroes appears to have reinforced the historic dominance of the comic book industry by white men. That's changing, but comics have long reinforced patriarchal Western ideologies while denying or marginalizing women and people of color (regarding recent efforts to diversify the superhero genre, see chapter 14).

There is no definitive boundary between children's comics and comics for older readers, but there is a borderland—that area of the Venn diagram where the two intersect, making visible what they share and, by extension, where they diverge. The impulse to regulate locates some of those borderlands in sex and superheroes. When Art Spiegelman and Françoise Mouly write in the introduction to their *TOON Treasury of Classic Children's Comics* (2009) that they "focused on comics for the younger set, steering clear of the highly charged sexual and horrific content that once got comics in hot water," they are referring explicitly to the Comics Code adopted by publishers in 1954 to quell horror comics and crime comics. The Code stipulated, among other things, that

> policemen, judges, government officials and respected institutions shall never be presented in such a way as to create disrespect for established authority....
> Inclusion of stories dealing with evil shall be used or shall be published only where the intent is to illustrate a moral issue and in no case shall evil be presented alluringly nor so as to injure the sensibilities of the reader....
> Suggestive and salacious illustration or suggestive posture is unacceptable....
> Passion or romantic interest shall never be treated in such a way as to stimulate the lower and baser emotions.[11]

To conform to these rules, publishers abandoned horror and crime stories and, by the late 1950s, resurrected the superhero comic book, ushering in the genre's so-called Silver Age, which featured the Flash, the Justice League of America, the Fantastic Four, Spider-Man, the Hulk, the X-Men, and so on. These comics could *hint* at lurid or violent material (and they often did more than hint) but only if they did so tastefully and with a moral purpose. Where those publishers had to tone down their offerings, Dell—a publisher of children's comics that refused the Code but still thrived in the marketplace—only had to reaffirm what it already did. It began placing a Dell Pledge to Parents on each comic: "The Dell Trademark is, and has always been, a positive guarantee that the comic magazine bearing it contains only clean and wholesome entertainment. The Dell code eliminates entirely, rather than regulates, objectionable material. That's why when your child buys a Dell comic you can be sure it contains only good fun. 'DELL COMICS ARE GOOD COMICS' is our credo and our constant goal."[12] In this way, superhero comics, as they shifted from children's to adolescent fare, inhabited a borderland between kids' comics (such as those published by Dell) and comics that depicted "evil" and questioned "established authority." In superhero comics, children read of a violent, conflicted world beyond childhood—though, traditionally, with a kind of moral clarity that is rare in actual adulthood.

The partial revision and relaxing of the Code in 1971 signaled the shifting boundaries between childhood and adulthood and thus between what might qualify as "children's comics" and what might not. Coinciding with the rise of the young adult (YA) novel in the 1970s, superhero comic books began veering toward more realistic YA themes like death, drugs, racism, alcoholism, and pollution. If these later superheroes left childhood for adolescence, then subsequent superhero comics, influenced in part by the underground comics that (because they were typically self-published) had evaded the Code, moved toward even more serious, "adult" themes. In the late 1980s, Frank Miller's *Batman: The Dark Knight Returns* (1986) and Alan Moore and Dave Gibbons's *Watchmen* (1986–1987) helped speed the waning of the Code, which the industry ultimately abandoned in 2011 (see chapters 2 and 14).

If, in the West, superhero comics mark a borderland of children's comics, cuteness serves that function for children's manga and Western comics alike. Those large puppy-dog eyes of manga characters testify to Osamu Tezuka's enormous influence on the field (chapter 5). In these oversized "cute" eyes, Tezuka displays the influence of Disney cartoons: the doe eyes of Bambi and of the woodland creatures in *Snow White*. These signs have become conventional and part of the wider repertoire of Japan's cuteness culture: the so-called *kawaii* aesthetic. But just as not all children's comics are cute, nor does all cuteness function in the same way. As Sianne Ngai notes, cute is an aesthetic judgment "based on clashing feelings": tenderness and aggression, powerlessness and interpellative power, simultaneously containing child sexuality but also "bringing that sexuality

out."[13] Cuteness in children's comics, arguably, strives to limit or deny child sexuality but does not fully prevent desire's mischievous wink from registering in the reader's subconscious. Comics for older readers display much greater latitude toward cute's sexualization. In Western comics, an especially sharp example of these different "cutes" would be Harold Gray's *Little Orphan Annie* (1924–2010) versus Harvey Kurtzman and Will Elder's *Little Annie Fanny* (1962–1988). That said, there are also "cutes" that blur those lines, as in a lot of shōjo manga (see, for example, Aya Nakahara's *Lovely Complex* series [2001–2006]). In sum, cuteness is a boundary because it functions more covertly in work for children than it does in work for either adolescents or adults.

If the broader culture now merely acknowledges (instead of policing) the line between comics for children and comics for older readers, there remains a sense that there *is* a line. Though the Code is dead, comics rating systems persist. The precise terms vary from publisher to publisher, but in comic book shops, the "children's" line tends to be marketed to "everyone" or "all ages" rather than to children specifically.[14] Jeff Smith's *Bone* (1991–2004), Andy Runton's *Owly* (2004–2008), James Kochalka's *Johnny Boo* (2008–2013), and Luke Pearson's *Hilda* series (2010–) are all sold as "all ages" comics in the hopes that they will both attract young readers and not alienate older ones.

Commerce, Literacy, Literature

As has always been the case, many "all ages" comics today are tie-ins to other commercial properties (films, cartoons, TV shows, games, or other comics): *Walt Disney's Comics and Stories* (1940–, now *Disney Comics and Stories*), *Captain Marvel Jr.* (1942–1953), *Sonic the Hedgehog* (1992–), and *The Simpsons Comics* (1993–2018), to name but a few. What is different now is that rather than being excluded from libraries or school curricula, comics have been embraced by librarians and teachers.

The trend has been noticeable since at least 2002, when the Young Adult Library Services Association, a division of the American Library Association, held a comics-themed preconference, "Get Graphic @ Your Library," as part of the annual ALA conference.[15] However, it has been especially marked since 2005, the year Scholastic launched its comics imprint, Graphix.[16] Where once easy readers were at the vanguard of children's literacy, now it's comics. Founded in 2008 by Françoise Mouly, TOON Books publishes hardback comics by Art Spiegelman, Jeff Smith, Agnes Rosenstiehl, and others—all of which are labeled according to reading level and which, the publishers say, have been "designed to offer early readers comics they can read *themselves*."[17]

Meanwhile, a burgeoning professional literature describes motives and strategies for using comics in classrooms ranging from primary schools to universities. In 2013, *Publishers Weekly* noted that "a recent survey by test-prep publisher Kaplan showed a third of ESL teachers use comics to help teach English." The

same article found that "graphic novels are among the most circulated" items at public libraries, "right up there with teen paranormal romance and DVDs."[18] Children's author Raina Telgemeier, as of this writing, is America's best-selling graphic novelist, and her publisher, Scholastic, now one of the United States' leading comics houses. Reflecting all these trends, in 2018, the educational non-profit Pop Culture Classroom (founded in 2010) launched a new set of publication prizes, the Excellence in Graphic Literature Awards, with an explicit focus on "literacy, education, and academia" and an advisory board full of educators and librarians.[19] EGL organizers noted the "synchronicity that's happening across academia, library sciences, education, bookselling and comic creation" and frankly declared their ambition "to drive the sale of graphic novels" in the cultural mainstream.[20]

Though some still think of comics as merely a gateway to serious reading, many more people now consider them the thing itself. The midcentury *Classics Illustrated* comics introduced young readers to Melville's *Moby-Dick*, Cervantes's *Don Quixote*, Twain's *Huckleberry Finn*, and Dickens's *A Tale of Two Cities*, but each book ended with the injunction for readers to go to the library and read the original. In contrast, Hope Larson's graphic novel adaptation of Madeleine L'Engle's *A Wrinkle in Time* (2012) and Eric Shanower and Skottie Young's reenvisioning of *The Wonderful Wizard of Oz* (2009), though they might inspire readers to pick up the prose novels on which they are based, have won acclaim as works of art in their own right.

While the term *graphic novel* often serves merely as a highfalutin way of saying *comics*, the persistence of both implies a continuing divide between "culturally important comics" and "trashy comics." Beverly Lyon Clark has pointed out that early twentieth-century critics canonized Mark Twain's *Huckleberry Finn* (1884) as the Great American Novel and relegated his *Tom Sawyer* (1876) to the lower status of boys' book;[21] just so, late twentieth-century critics elevate Art Spiegelman's *Maus* (1986 and 1991) to great Graphic Novel, and relegate Sheldon Mayer's *The Three Mouseketeers* (1956–1960) to the junk heap of funny animal comics.

Yet without funny animal comics, there would be no *Maus*. Spiegelman's first, three-page version of *Maus*, which was published in 1972 in the underground anthology *Funny Aminals* (sic) and details his father's experience in Hitler's death camps, rests upon the premise of animal characters who behave like humans—a notion developed in funny animal comics (Barks's Scrooge McDuck, Jim Davis's *The Fox and the Crow* [1951–1968]). Spiegelman's attempt to explode the stereotype builds upon this understanding. He represents his Jewish protagonists as mice and the Germans as cats to refute Hitler's claim (used as the book's epigraph) that "the Jews are undoubtedly a race, but they are not human." As Spiegelman has said, "My anthropomorphized mice carry trace elements of Fips' anti-Semitic Jew-as-rat cartoons for *Der Stürmer*, but, by being particularized they are invested with personhood; they stand upright and affirm

their humanity. Cartoons personalize, they give specific form to stereotypes."[22] It is easier for readers to grasp the concept of anthropomorphic mice as people if they've already experienced funny animal comics. Comparably, readers of *Huckleberry Finn* can better understand the text as *both* Great American Novel *and* boys' book if they read it as a sequel to, and further development of, *Tom Sawyer* rather than dismissing the latter as inferior "kids' stuff."

For comics scholars to fully understand their object of study, they must recognize its historic dependence on children—as both readers and characters. If we don't read funny animal comics, we cannot fully appreciate *Maus*; if we neglect superhero comics, we deprive ourselves of better understanding *Watchmen*.

But that's not the only reason that comics for young readers merit our attention. As works read by people who are still very much in the process of becoming, children's comics have the potential to be among the most influential books in a young person's life. These comics give children some of their earliest aesthetic experiences. They introduce small humans to art, language, graphic design, and ideas. Finally, even though comics have found their way into educational institutions, they are still as likely to be found in children's bedrooms as in classrooms; the advantage is that comics are still books that children can *choose* to read themselves. As Jon Scieszka has said of his own childhood reading of comic books, "No one I knew ever picked up *Archie* or *Lulu* or *Dennis the Menace* because it was Required Reading. We read comics because we wanted to see what was going to happen. We wanted to take that unexpected turn."[23] Comics have much to teach us about how good books create avid readers—not only teaching literacy but fueling the desire to keep reading, outside of the classroom and long after formal education has ceased. Children's comics are where children begin the journey to an adulthood of reading, thinking, and dreaming.

Notes

Thanks go to Mark Newgarden for offering advice, drawing on his expertise in children's comics. This essay is dedicated to him.

1. David Kunzle, "Chronology," in *Rodolphe Töpffer: The Complete Comic Strips*, by Rodolphe Töpffer, comp. and trans. David Kunzle (Jackson: University Press of Mississippi, 2007), xiii.
2. Thierry Groensteen, "Why Are Comics Still in Search of Cultural Legitimization?," trans. Shirley Smolderen, in *A Comics Studies Reader*, ed. Jeet Heer and Kent Worcester (Jackson: University Press of Mississippi, 2009), 4.
3. Groensteen, 11. Bart Beaty echoes Groensteen, asserting that "European comics have their origins in publications for adults" and were only later "reconceptualized as material for children," but also acknowledges that "the vast majority of commercially successful work [is] aimed at a young audience" (see chapter 5).
4. Quoted in Lara Saguisag, "The Child of the Comic Supplement Is the 'Smart Kid': Early Twentieth Century Comics and Their Child Readers" (lecture, Annual

Conference of the Children's Literature Association, Biloxi, Miss., 14 June 2013). See also Saguisag, *Incorrigibles and Innocents: Constructing Childhood and Citizenship in Progressive Era Comics* (New Brunswick, N.J.: Rutgers University Press, 2019), 86–88; and Amy Kiste Nyberg, "Percival Chubb and the League for the Improvement of the Children's Comic Supplement," *Inks* 3, no. 3 (1996): 31–34.

5 Joe Sutliff Sanders, "Chaperoning Words: Meaning-Making in Comics and Picture Books," *Children's Literature* 41 (2013): 72, 70.
6 Mort Walker, *Backstage at the Strips* (New York: Mason/Charter, 1975), 48, 56.
7 John A. Lent, "The Comics Debate Internationally," in *Comics Studies Reader*, 73.
8 See, for example, Paul Gravett, *Manga: Sixty Years of Japanese Comics* (London: Laurence King, 2004); Jennifer S. Prough, *Straight from the Heart: Gender, Intimacy, and the Cultural Production of Shōjo Manga* (Honolulu: University of Hawai'i Press, 2011); and the *Comics Journal*'s special issue on shōjo manga, no. 269 (July 2005), with notable contributions from Rachel Matt Thorn and editor Dirk Deppey.
9 Perry Nodelman, *The Hidden Adult: Defining Children's Literature* (Baltimore: Johns Hopkins University Press, 2008), 341, 243.
10 Nodelman, 243.
11 "Comics Magazine Association of America Comics Code (1954)," reprinted in Amy Kiste Nyberg, *Seal of Approval: The History of the Comics Code* (Jackson: University Press of Mississippi, 1998), 166–169. The text of the original Code has been reprinted in various places; as of this writing, for example, it can be found online at WikiSource ("Comic Book Code of 1954," accessed 1 January 2020, https://en.wikisource.org/wiki/Comic_book_code_of_1954).
12 Quoted in Art Spiegelman and Françoise Mouly, eds., *The TOON Treasury of Classic Children's Comics* (New York: Abrams, 2009), 13.
13 Sianne Ngai, *Our Aesthetic Categories: Zany, Cute, Interesting* (Cambridge, Mass.: Harvard University Press, 2012), 44, 11, 60.
14 DC has used a video-game-like rating system, with *E* for "Everyone," *T* for "Teen," *T+* for "Teen Plus" (fifteen years and older), and *M* for "Mature" (seventeen and older); however, as of this writing, they have ostensibly replaced this with a simpler age-banded labeling scheme: *DC Kids* (readers eight to twelve), *DC* (thirteen-plus), and *DC Black Label* (seventeen-plus). Marvel, meanwhile, has *All Ages*, *T* ("appropriate for most readers"), *T+* (thirteen and up), *Parental Advisory* (fifteen and up), and *Explicit Content* (eighteen-plus). BOOM! Studios' "KaBOOM!" line of comics fall into the all-ages category that signals appropriateness for children.
15 Amy Kiste Nyberg, "How Librarians Learned to Love the Graphic Novel," in *Graphic Novels and Comics in Libraries and Archives*, ed. Robert G. Weiner (Jefferson, N.C.: McFarland, 2010), 26–40; and David Serchay, "The Day Comics Won," Diamond Bookshelf [14 June 2012], accessed 26 July 2018, http://www.diamondbookshelf.com/Home/1/1/20/630?articleID=121866.
16 See Charles Hatfield, "Comic Art, Children's Literature, and the New Comics Studies," *The Lion and the Unicorn* 30, no. 3 (September 2006): 360–382.
17 Françoise Mouly, "Our TOON Books Mission," TOON Books [2 November 2007], accessed 26 July 2018, http://www.toon-books.com/our-mission.html. For academic analysis of TOON's output, see Charles Hatfield and Joe Sutliff Sanders, "Bonding Time or Solo Flight? Picture Books, Comics, and the Independent Reader," *Children's Literature Association Quarterly* 42, no. 4 (Winter 2017): 459–486.
18 Heidi MacDonald, "How Graphic Novels Became the Hottest Section in the Library," *Publisher's Weekly*, 3 May 2013, accessed 20 March 2019,

https://www.publishersweekly.com/pw/by-topic/industry-news/libraries/article/57093-how-graphic-novels-became-the-hottest-section-in-the-library.html.

19 "Excellence in Graphic Literature Awards," Pop Culture Classroom [5 December 2017], accessed 26 July 2018, http://popcultureclassroom.org/excellence-in-graphic-literature-awards. Due to a redesign of popcultureclassroom.org, this EGL web page is no longer available; last archived via Internet Archive: Wayback Machine (archive.org) on 19 September 2018. As of this writing, a new EGL page is viewable at https://classroom.popcultureclassroom.org/programs/excellence-in-graphic-literature but absent detailed descriptions of the advisory board and judging process.

20 Alex Dueben, "'We Know This Will Drive Book Sales': A Conversation about the EGL Awards," *Comics Journal*, 16 January 2018, accessed 26 July 2018, http://www.tcj.com/we-know-this-will-drive-book-sales-a-conversation-about-the-egl-awards.

21 Beverly Lyon Clark, *Kiddie Lit: The Cultural Construction of Children's Literature* (Baltimore: Johns Hopkins University Press, 2003).

22 Art Spiegelman, *Comix, Essays, Graphics and Scraps: From* Maus *to Now to* Maus *to Now* (Palermo, Italy: Sellerio Editore—La Centrale dell'Arte, 1999), 17–18.

23 Jon Scieszka, introduction to *The TOON Treasury of Classic Children's Comics*, ed. Art Spiegelman and Françoise Mouly (New York: Abrams, 2009), 7.

10

Difference

• •

THERESA TENSUAN

In weekly installments that occasionally took the form of encyclopedia entries or tear sheets from how-to guides, Lynda Barry's serial *Ernie Pook's Comeek* (1978–2008) provided its readers with a running critical commentary on issues ranging from the social construction of gender to the nature of prejudice. While the strip's tips on "how to draw girls" and its educational asides on the wonders of the small intestine are most often cast from the perspective of Marlys Mullins, a self-proclaimed "gifted child" whose elliptical eyeglasses and anarchic pigtails make her an easily identifiable character, "Fine Dining" (fig. 10.1), from 1986, is drawn from the perspective of Marlys's more reticent cousin, Arna Arneson. In "Fine Dining," Arna reveals that she has a predilection for "the delicate taste of fried baloney and mayonaise [*sic*] on Sunbeam bread"—a declaration that accompanies an image of a slice of luncheon meat puffing into an arc as the casing contracts on the hot surface of a frying pan. Arna herself dishes out the fact that "at everyone's home, their family ate at least one thing that was scary," an announcement that introduces a panel crowded with the outlines of six near-identical houses. The cookie-cutter images frame descriptions of the fare consumed behind closed doors, ranging from "jelly on spaghetti" to "fried pigs' guts" to "bagoung" [*sic*], a substance that is helpfully (if ungrammatically) glossed as a "scary pink fish condiment that the smell would make you start running."[1]

The wormlike lines that squiggle between the houses suggest a stench of a particularly strong order or, perhaps, the psychedelic effects brought on by the chemical compound created by combining "sardines and coolwhip," as one

FIG. 10.1 Lynda Barry questions what constitutes common culture and the conventions of good taste. "Fine Dining," *Ernie Pook's Comeek* (1986), from *The! Greatest! Of! Marlys!* (2000, rev. ed. Drawn & Quarterly, 2016). Copyright © and used by permission of Lynda Barry. All rights reserved.

neighborhood boy does as an act of bravado. The descriptions of the food consumed in the different homes reveal which families are living low on the hog and name concoctions that cannot easily be fit into the "food groups" that constitute the cornerstones of a square American meal. Over the course of its four panels, "Fine Dining" offers an insight into the performative practices, familial rituals, and cultural conventions that delineate individual and collective differences, and raises the question of what constitutes common culture and the conventions of good taste. *Difference* is key to what this strip notices and articulates.

Arna's observations can help us decipher the complex set of codes that establish mainstream mores: the third panel of the strip offers a still life composed of a Dixie cup, a paper napkin, and an iced cupcake with sprinkles, a vision encapsulated in a penumbra that suggests that the treat generates its own incandescent light. In the overarching commentary, Arna informs her audience that: "Our main opinions, however, regarded the world of desserts. For example everyone

agreed anything tasted the best when you ate it in your class room during a Halloween or Valentines party. Even the worst Kool-Aid was simply delicious if it was in a paper cup on your desk with a cupcake. (Especially if the cupcake was in a *blue* paper holder. The worst cupcake holder was the yellow.) (Yellow was always bad due to P.)" Arna's explanation of the chain of associations between primary colors, bodily waste, and alphabetic homonyms speaks to the complicated dynamics that establish aesthetic standards. In moving from the locus of her own preferences to the nexus of collective disgusts and desires, Arna shows how one's tastes, whether for the visual effect of a monogrammed chicken pot pie or for the savor of pig meat that has been simmered in its own blood, make manifest one's place in—or displacement from—a social order. That is, Arna shows us socially fraught examples of difference.

This essay explores how comics register difference, in particular how the represented *bodies* in comics manifest hierarchies of difference. I take my cue from Tobin Siebers's characterization of aesthetics as a conceptual framework that "tracks the sensations that some bodies feel in the presence of other bodies"[2] and also Mark Chiang's assertion that "the concept of the aesthetic emerges out of discourses of politics and economics in the eighteenth century, and only subsequently became separate and indeed opposed to those other spheres of social activity."[3] I argue that comics draw out and explore the generative tension between bodies—bodies cast as seemingly invulnerable men of steel, as human-animal hybrids, as figures subjected to repeated acts of violence—that not only make difference manifest but also show the possibilities for transforming social constructions, ranging from playground pecking orders to the aesthetic and ethical frameworks that denote what fits and what, or whom, is *mis*fit.

For example, throughout works such as *Palestine* (1993–2001), *Safe Area Goražde* (2000), and "Complacency Kills" (2005), Joe Sacco's depictions of people making their lives in zones of conflict ranging from the Gaza Strip to the gentrifying neighborhoods of Cleveland's Southside call to mind the fulsome corporeality and fleshy gravity of Robert Crumb's disturbing underground comix icons, such as Mr. Natural and Angelfood McSpade. Sacco's approach draws attention to the ways in which bodies—in their sweaty, spittle-spewing, and pockmarked glory—are made vulnerable to the ravages of war, imperialism, and poverty. As Erica Cho argues, comics tell "the small story hidden within larger contexts of history and politics, war and displacement, global migrations, family separation, racism and genocide, sexism and heterosexism."[4] This potential is made manifest in the drawn-out desires of teenaged girls for authentic Levi's 501 jeans in Sacco's account of Muslims fighting and fleeing genocide in *Safe Area Goražde* or in the way Art Spiegelman's *Maus* (1986 and 1991) pays careful attention to a technique for resoling boots, one of the practices that enabled Vladek Spiegelman to stay alive in Auschwitz. The importance of such moments is not self-evident: comics actively enlist their viewers in the practice of making meaning, engaging their readers in a dynamic that Gillian Whitlock

has characterized as the "process of imaginative production whereby the reader shuttles between words and images, and navigates across the gutters and frames, being moved to see, feel, or think differently."[5] Sacco's use of text boxes to encapsulate his running commentary and direct the reader's gaze across his crowded and exuberantly detailed pages is but one example of the myriad compositional possibilities that a cartoonist can deploy, ranging from the layout of a page to the selection of lettering to the decision to invoke the visual iconography of, say, fourteenth-century Italian altarpieces or of nineteenth-century editions of the Sears, Roebuck and Co. catalog. Comics renegotiate the dichotomies created between high and low, news and entertainment, self and other as a means of tracing circulations of power and reverberations of violence and of recasting a reader's understanding of how certain narratives and visions gain cultural currency while others are cast to the margins.

Comics such as Alison Bechdel's *Fun Home* (2006), or Chris Ware's "Thrilling Adventure Stories" (1991) and *Jimmy Corrigan: The Smartest Kid on Earth* (2000), delineate the ways in which cultural expectations are encoded in the form's visual idioms and narrative conventions, and how comics make visible the ideologies that frame experiences, script actions, and shape identities. Bechdel reproduces the biting social satires of Charles Addams's cartoons in her "family tragicomic" so as to reconsider the stability of the heteronormative nuclear family; *Fun Home*'s attention to the concrete properties of type as well as to carnal bodies of knowledge focus the reader's attention on the surface of the text, the vulnerability of flesh, and the power of word and image in giving shape and form to desire, action, and vision. Ware, throughout his work, reconfigures the familiar figure of the superhero to delineate the obsessions catalyzed by such icons; his antiseptically clean lines make manifest the structural flaws in those seen as men of steel. By showing the nuclear family to be a source of radioactive decay or subverting the expectations that cast a caped crusader as a model of heroic individualism, these works compel their viewers to refocus the perspectives that construct, mediate, and authorize concepts of common culture and to reframe practices of reading and interpretation. They illustrate Jared Gardner's assertion that "the comics form retains that which cannot be reconciled to linear narrative—the excess that refuses cause-and-effect argument, the trace that threatens to unsettle the present's narrative of its own past (and thereby of itself)."[6] Through such excess, comics can show how narrative tropes and visual codes both assemble a recognizable world and challenge assumptions about the world beyond the comic frame.

Comics may seem an unlikely medium in which to find challenges to cultural convention, given the ample documentation of the strips, editorial cartoons, and comic book serials that have inscribed and amplified racial, ethnic, and gendered stereotypes. Comics art has an ugly history of spectacularizing and exploiting difference. Novelist and cartoonist Charles Johnson puts forward the query, "How [can] a black person respond to a parade of generic,

dancing silhouettes: savage, cannibalistic Africans; language-mangling Boskos; and bubble-lipped, buffoonish sidekicks like *The Spirit*'s Ebony?"[7] Similarly, Sheng-mei Ma reveals how midcentury adventure comics delineated heroic American masculinity against figurations of Orientalized others such as the diabolical Ming the Merciless in Alex Raymond's *Flash Gordon* and the rapacious Dragon Lady of Milton Caniff's *Terry and the Pirates*.[8] As I argue elsewhere, Caniff's most enduring creation may not be the stalwart Steve Canyon or the resolute Pat Ryan but the stocky, simian creature who stands in as a representative Japanese officer in Caniff's guide to "How to Spot a Jap," which was published in the U.S. War and Navy Departments' 1942 *Pocket Guide to China* (fig. 10.2).[9] Caniff's comic represents a particularly virulent example of the ways in which cartoonists can encode ethnic and national differences. Such images, as John Berger writes in *Ways of Seeing*, show "by implication how [their subjects] had once been seen by other people," and this is not simply "documentary" evidence, for "the more imaginative the work, the more profoundly it allows us to share the artist's experience of the visible," an experience both personal and ideological.[10] Yet to become critically alert to this dimension takes work. As Ralph E. Rodriguez asserts,

> The only way to make race legible in a medium that is merely black and white marks on a page is to employ the language, social conventions, and biological fictions we use to read race in our daily lives.... Reading race requires a particular vocabulary for reading race, but we have so naturalized that vocabulary that we take the social construction of race as a given. If, however, we were really to pay attention to the racial/textual form ... we could possibly have our eyes opened to the everyday racial reading habits we have naturalized and which we therefore no longer recognize as reading.[11]

"How to Spot a Jap," an imaginative if also hateful work, offers an anatomy of the anxieties, expectations, presumptions, and conventions that were put into play at a specific historical and cultural moment and shows the medium's ability to bring social questions of identity and difference to the fore.

Such legacies create a peculiar inheritance for cartoonists who actively contend with issues of racism, sexism, or imperialism, given the aesthetic frameworks that have cast as grotesque, hypersexualized, primitive, and/or animalistic those who fall outside what Audre Lorde has defined as "the mythic norm." In her essay "Age, Race, Class, Sex: Women Redefining Difference," Lorde writes that the mythic norm is "usually defined as white, thin, male, young, heterosexual, christian [sic], and financially secure. It is within this mythical norm that the trappings of power reside within this society."[12] Lorde's insight resonates with W. J. T. Mitchell's call for critical purviews that "would treat visual culture and visual images as go-betweens in social transactions, as a repertoire of screen

Difference • 143

FIG. 10.2 A virulent example of the ways cartoonists can encode ethnic and national difference: Milton Caniff, "How to Spot a Jap," *Pocket Guide to China* (U.S. War and Navy Departments, 1942).

images or templates that structure our encounters with other human beings." Mitchell posits that "stereotypes, caricatures . . . mappings of the visible body, of the social spaces in which it appears"—these images—"are the filters through which we recognize and of course misrecognize other people." Thus, he argues, "the social construction of the visual field has to be continuously replayed as the visual construction of the social field"; even our seemingly "unmediated or face-to-face relations" are filtered through "an invisible screen or latticework" of received images.[13] Comics have had disconcerting ways of bringing "the visual construction of the social field" to light.[14]

Archetypes, Stereotypes, and a Located Politics of Difference

In his essay "Comics" in the catalog for the Museum of Modern Art's 1990 *High and Low* exhibition, Adam Gopnik offers a view of newspaper funny pages as

> a coral reef of modernity, a slowly accumulated deposit of the [twentieth] century's styles and preoccupations and proprieties. . . . If the comics page is a mirror of modern life, it is a mirror of a curiously retentive kind, in which a reflection lingers in the glass long after its original has vanished form the world. . . . The comic strip has endured by inventing completely self-sustaining secondary worlds, where evil and suffering are either banished altogether or else are represented in unambiguously simplified and comprehensible form—so stylized and heightened that they transcend the moral muddle of caricature to attain the timeless clarity of a myth or folk tale.[15]

Gopnik speaks to the ways in which newspaper comic strips have created visual idioms that can crystallize experience, emotion, insight, and desire through a creative shorthand that is legible to art historians and armchair readers alike. Dagwood's towering sandwiches speak to appetites not fully met in the neat confines of Blondie's suburban home or the clockwork demands of Mr. Dithers's office; Lucy's psychiatric help stand plays with the conceit that a customer with a nickel can benefit from Lucy's two cents on issues ranging from depression to unrequited love; the dotted line that traces what Glen Weldon describes as the "carefree peregrinations" of the *Family Circus* siblings "through the privet-lined, strangely carless, possibly post-Rapture streets of [the] neighborhood" delineates childhood as a time and space unhampered by self-disciplining drives toward efficiency and conjures "a pang of nostalgia for a time before stranger-danger and Amber Alerts."[16] Chic Young, Dean Young, and John Marshall and their colleagues' *Blondie* (1930–), Charles Schulz's *Peanuts* (1950–2000), and Bil and Jeff Keane's *Family Circus* (1960–) each provides a different vision of the protocols and inanities of modern middle-class life, at times tweaking the presumptions and expectations that structure it and at other times echoing and amplifying those frameworks.

For example, over the course of *Blondie*'s run, the strip's eponymous heroine has developed from a feckless flapper who defied class-bound mores into the very nucleus of a modern nuclear family, a woman who can easily slip between her roles as wife, mother, and entrepreneur without having to change out of her high heels. Cartoonist and comics historian Brian Walker notes that *Blondie* "was the most successful strip in postwar America" and that "Young had developed a strict set of rules for the comic strip. Certain taboos were followed, including avoidance of physical infirmities, politics, religion, liquor, and other subject matter that might offend or confuse readers."[17] In 1990, the strip shocked some fans when Blondie conveyed her skills as a housewife into a catering business with her friend Tootsie, thus embodying and enacting—a couple of decades after the heyday of the movement—an organizing vision of middle-class second-wave feminism. Given the parameters of the *Blondie* universe, it seems highly unlikely that Blondie will ever announce to Dagwood, Alexander, and Cookie that she is leaving the family to become a labor organizer for undocumented immigrants or to engage in a domestic partnership with Tootsie (outside of the pages of a Tijuana bible). Alison Bechdel satirizes such conventions in a 1995 calendar illustration that casts Mo, the central character of Bechdel's long-running serial *Dykes to Watch Out For* (1983–2008), into the frames of Cathy Guisewite's *Cathy* (1976–2010), Mort Walker's *Hi and Lois* (1954–), and Ed Dodd's *Mark Trail* (1946–) to highlight how, despite their drastically different styles and story lines, these comics all circulate in the same heteronormative space, thus showing how practices of representation both arise from and contribute to ideological frameworks as well as aesthetic traditions.[18]

In an essay entitled "Little Orphan Annie's Eyeballs" that appeared in the *Nation* in 1994 and reappears in the compendium *Comix, Essays, Graphics and Scraps* (1999), Art Spiegelman offers an etymology of the term *stereotype* and an overview of the process that produced the earliest newspaper comic strips: "*Stereos*. Greek, meaning solid, and *typus*, late Latin, meaning form. The stereotype was invented early in the eighteenth century as a way of making relief-printing plates from paper pulp molds. It's the way newspaper comic plates were made until new technologies overtook the business in the 1960s. So comic strips were literally as well as figuratively generated from stereotypes."[19] Spiegelman's *Maus*, by making material the Nazi characterization of Jews as vermin, enacts a number of stereotypes: the asymmetrical power relationship between predator and prey, the anti-Semitic caricatures that cast Jews as subhuman, and even the iconic image of Disney's Mickey Mouse, a character that has its own roots in the highly racialized representations of early animation. *Maus* both thematizes and theorizes the potential and the problems posed by a medium that derives much of its power from its ability to invoke and play upon the visual and social shorthand of stereotype, made manifest at such moments as a conversation between the narrator and his French-born wife, whose conversion to Judaism creates the conundrum of whether she is to be represented in the text as a frog or a mouse.[20]

Maus, then, uses racist iconography to challenge racist thinking; it rather aggressively makes "invisible screens" visible. Thus it operates much like certain works by Gene Luen Yang, Adrian Tomine, and Derek Kirk Kim in which, as Jared Gardner observes, "sequential comics destabilize racist logic." Racism, Gardner notes, "may share with comics some fundamental grammatical elements: caricature, stereotypes, condensation. But racism requires precisely what sequential comics makes impossible: unequivocal meanings, and a stable definition of us and them."[21] Indeed, comics provide a particularly generative framework in which we can, as Gardner says elsewhere, "theorize and practice new ethical and affective relationships and responses" by refiguring the visual iconographies and narrative conventions that shape our understanding of social relations, cultural practices, and political discourses.[22]

Mapping Difference in *Finder*

Indeed, comics have long foregrounded figures outside of the frame of social visibility, cultural intelligibility, and political agency, from the motley crews of the Lower East Side streets in Richard F. Outcault's *Hogan's Alley* and related strips (1895–1898) to the genetic constructs and nomadic "sin eaters" who populate Carla Speed McNeil's epic science fiction series *Finder* (1996–). *Voice*, a *Finder* story line finished in 2008 and compiled into graphic novel form in 2011, traces the missteps of a character who risks being cast out of the pageant that determines membership and status in her clan as she renegotiates the terms

on which the clan assesses and exploits her and her cohort. It takes place in an urban center in which social and economic hierarchies are literally mapped out in tiers: only the First Families get access to sunlight, while the poor and transient inhabit lower levels subject to rolling brownouts and repositories of the detritus from the upper realms. *Voice* was first published as the U.S. housing bubble burst, as North American and European financial markets plummeted, and as some key corporate ledgers became newly understood as creative fiction.

Anvard, the domed, multilayered city that serves as a locale for several of the interrelated stories in the *Finder* series, is just one example of the many dystopic urban landscapes that can be found in comics, ranging from the streetscapes of Gotham in Frank Miller's *Batman: The Dark Knight Returns* (1986), to the visual cacophonies of Warren Ellis and Darick Robertson's *Transmetropolitan* (1997–2002), to the congested *ligne claire* cities of Moebius (Jean Giraud)—all iconic settings that have influenced design in comics and beyond. *Finder* brings to this tradition a strict attention to social geography, including urban boundaries, borders, and divisions.

As Michael Sorkin observes, the history of cities "is embedded in the ways their elements are juxtaposed, the structures of art and regulation that govern urban amalgamation. Questions both of what goes with what and what yields to what are at the basis of urban form-making"; further, cities are sites that have "historically mapped social relations with profound clarity, imprinting in [their] shapes and places vast information about status and order."[23] Social geographer Geraldine Pratt, given what she sees as her field's "long history of studying the ways in which urban space orders grids of social difference," calls upon her colleagues to chart the "histories of social and economic inequalities." To "disrupt" boundaries and "build toward multicultural spaces of radical openness and radical politics," she argues, we must first "understand the multiple processes of boundary construction"; that is, we must understand the logics of difference that literally shape the cityscape.[24] Similarly, Ruth Fincher and Jane Jacobs call for a "located politics of difference," observing that power, identity, and place are inextricably linked. If "persistent power structures can unevenly shape urban lives," then such structures "are, in turn, shaped by the contingent circumstances of specific people in specific settings," and that very specificity can shake those structures: "Oppressed groups can, through a politics of identity and a politics of place, reclaim rights, resist, and subvert."[25] Comics, through the juxtapositions embedded in their very form, can convey the complexities and unexpected congruences revealed by a located politics of difference—difference that McNeil's *Voice* thematizes in the tensions between those who enjoy the privileges of unimpeded mobility and those for whom movement is both plotted and policed. In this way, McNeil extends and enriches a long comics tradition.

Voice opens with a scene from "the five hundred and fifty-seventh annual Llaverac Clan Conformation Competition" in which Rachel Grosvenor, a peripheral character in earlier *Finder* story lines, literally as well as figuratively

takes center stage.[26] Rachel is the granddaughter of a Llaverac media magnate; her mother, Emma, herself a full-fledged Llaverac clan member, married outside the clan, and Rachel is the sole child of their three offspring who embodies the physical attributes common to Llaveracs that make her a viable candidate in the conformation competition. The youngfolk of the twelve dominant multifamily clans that control commerce, politics, and culture in Anvard "must compete for entry according to [their respective] clan standards"; as McNeil further explains in an author's note, "Lejeb clan kids have to pass rigorous mental math marathons. Medawar girls have to graduate medical school. Milos must present and defend their doctoral theses in history. Each clan follows what it values, and the Llaveracs are, among other things, drama queens."[27] Those who are culled from the competition face uncertain social and economic futures. *Voice* deals with such a crisis and raises the question of how much any one actor can rearticulate the cultural scripts made manifest in socially sanctioned ritualized performances such as beauty pageants or dissertation defenses. As Rachel's perambulations through the various levels and layers of Anvard society bring her into contact with those who literally as well as figuratively deal in underground economies, readers begin to see that her fortunes are intimately tied to the fates of two Ascians, members of a tribal nomadic group that have no official status in the clan hierarchies of Anvard. These unnamed Ascians first appear as seemingly marginal figures in the background of Rachel's story, but their deaths are a direct result of what seems to be Rachel's sole act of good citizenship.

A key sequence in *Voice* (fig. 10.3) uses Rachel's silhouette—literally, the outline of her body—as a gutter in a series of panels that convey her impressionistic and naive sense of her surroundings, ushering readers to a highly charged sequence marked by contrasting visual cues that conjure visions of violence and displacement.[28] Recalling Scott McCloud's characterization of the gutter as a gap that invites readers into acts of active imagination and open interpretation (see chapter 12), this passage implicates Rachel in the politics of place, signaling a turning point in the story. Indeed, this becomes a moment of transformative opportunity for both Rachel and members of the Ascian community, as what could have been a cycle of vengeance instead becomes a circuit of restorative justice. Through this unexpected resolution, *Voice* offers a vision of justice that challenges the material, social, and political economies in which Anvard society is framed. Thus *Voice* reworks the visual conventions and narrative frames through which social, economic, and gendered differences are coded and questions the structural security of the storied 1 percent. Bodies, places, differences: all are mapped by McNeil, by comics.

Conclusion

If comics have historically been a loaded, sometimes brutal, means of social discrimination—indeed, a spectacular art of difference—then at their most

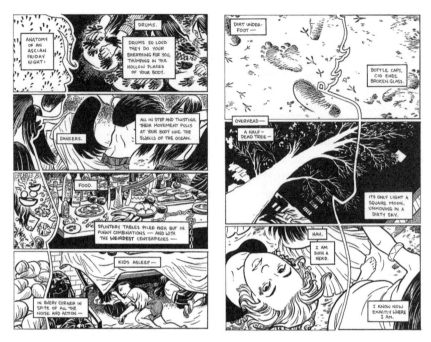

FIG. 10.3 Disrupting boundaries in a city marked by difference: the politics of place in Carla Speed McNeil, *Finder: Voice* (Dark Horse, 2011), pages 146–147.

generative, they challenge a reader to see the world differently in a better sense: to realize how a frame both focuses and delimits one's vision; to discern, through the interplay of words and images, how specific iconographies shape and are shaped by particular ideologies; to see how seemingly marginal and empty space can be a site of creative possibility; to imagine the unthinkable. A single comics panel can encompass different moments in time, competing registers of reference, and multiple points of view; the composition of frames on a page can open up trajectories that intersect and crosscut one another as well as visual idioms that create their own matrices of meaning. Comics thus open an avenue of inquiry through which one can begin to address the systems and structures of violence that have constituted collective histories of degradation. They offer their audiences the power to give shape and form to emerging subjectivities as well as to engender new visions.

Notes

1. Lynda Barry, *The! Greatest! Of! Marlys!*, rev. ed. (Montreal: Drawn & Quarterly, 2016).
2. Tobin Siebers, *Disability Aesthetics* (Ann Arbor: University of Michigan Press, 2000), 1.
3. Mark Chiang, "Autonomy and Representation: Aesthetics and the Crisis of Asian American Cultural Politics in the Controversy over *Blu's Hanging*," in *Literary*

Gestures: The Aesthetic in Asian American Writing, ed. Rocío G. Davis and Sue-Im Lee (Philadelphia: Temple University Press, 2006), 18.
4 Erica Cho, "Taps and Scratches" (unpublished manuscript, 2008).
5 Gillian Whitlock, "Autographics: The Seeing 'I' of the Comics," *Modern Fiction Studies* 52, no. 4 (Winter 2006): 978.
6 Jared Gardner, "Archives, Collectors, and the New Media Work of Comics," *MFS* 52, no. 4 (Winter 2006): 800.
7 Charles Johnson, *I Call Myself an Artist: Writings by and about Charles Johnson*, ed. Rudolph P. Byrd (Bloomington: Indiana University Press, 1999), 8.
8 Sheng-mei Ma, *The Deathly Embrace: Orientalism in Asian American Identity* (Minneapolis: University of Minnesota Press, 2000), chap. 1.
9 Theresa Tensuan, "Comics," in *The Routledge Companion to Asian American and Pacific Islander Literature*, ed. Rachel Lee (New York: Routledge, 2014), 420.
10 John Berger, *Ways of Seeing* (London: Penguin Books, 1972), 10.
11 Ralph E. Rodriguez, "In Plain Sight: Reading the Racial Surfaces of Adrian Tomine's *Shortcomings*," in *Drawing New Color Lines: Transnational Asian American Graphic Narratives*, ed. Monica Chiu (Hong Kong: Hong Kong University Press, 2014), 90.
12 Audre Lorde, *Sister Outsider: Essays and Speeches* (Berkeley: Crossing Press, 2007), 116.
13 W. J. T. Mitchell, "Showing Seeing: A Critique of Visual Culture," *Journal of Visual Culture* 1, no. 2 (August 2002): 175.
14 Contemporary comics studies has decisively, if belatedly, turned toward comics' visual construction of the social field, exploring the form's historical reliance on stereotype, its assumed norms and challenges to assumed norms, and the work of minoritized creators and readers to claim space in the comics world. Book-length landmarks would include (but would not be limited to): Abate, Grice, and Stamper, eds., "Lesbian Content and Queer Female Characters in Comics," special issue of *Journal of Lesbian Studies* (2018); Alaniz, *Death, Disability, and the Superhero* (2014); Aldama, ed., *Multicultural Comics* (2010); Aldama and González, eds., *Graphic Borders* (2016); Chiu, ed., *Drawing New Color Lines* (2014); Chute, *Graphic Women* (2010); Foss, Gray, and Whalen, eds., *Disability in Comic Books and Graphic Narratives* (2016); Gateward and Jennings, eds., *The Blacker the Ink* (2015); Hall, ed., *No Straight Lines* (2013); Heimermann and Tullis, eds., *Picturing Childhood* (2017); Howard and Jackson, eds., *Black Comics* (2013); Køhlert, *Serial Selves* (2019); and Scott and Fawaz, "Queer about Comics," special issue of *American Literature* (2018). See this book's bibliography for further information.
15 Adam Gopnik, "Comics," in *High and Low: Modern Art, Popular Culture*, ed. Kirk Varnedoe and Adam Gopnik (New York: Museum of Modern Art, 1990), 153.
16 Glen Weldon, "Bil Keane's Dotted Line: An Appreciation," *Pop Culture Happy Hour*, National Public Radio, 11 November 2011, accessed 7 June 2019, https://www.npr.org/blogs/monkeysee/2011/11/11/142218444/bil-keanes-dotted-line-an-appreciation.
17 Brian Walker, *The Comics since 1945* (New York: Abrams, 2002), 22.
18 Alison Bechdel, *The Indelible Alison Bechdel: Confessions, Comix, and Miscellaneous Dykes to Watch Out For* (Ithaca, N.Y.: Firebrand Books, 1998), 157.
19 Art Spiegelman, *Comix, Essays, Graphics and Scraps: From* Maus *to Now to* Maus *to Now* (Palermo, Italy: Sellerio Editore—La Centrale dell'Arte, 1999), 17.
20 Art Spiegelman, *The Complete Maus* (New York: Pantheon, 1996), 171–172.
21 Jared Gardner, "Same Difference: Graphic Alterity in the Work of Gene Luen Yang, Adrian Tomine, and Derek Kirk Kim," in *Multicultural Comics: From* Zap

to Blue Beetle, ed. Frederick Luis Aldama (Austin: University of Texas Press, 2010), 141–142.
22. Jared Gardner, "Autography's Biography, 1972–2007," special issue, *Biography* 31, no. 1 (Winter 2008): 1.
23. Michael Sorkin, ed., *Variations on a Theme Park: The New American City and the End of Public Space* (New York: Hill and Wang: 1999), xii.
24. Geraldine Pratt, "Grids of Difference: Place and Identity Formation," in *Cities of Difference*, ed. Ruth Fincher and Jane M. Jacobs (New York: Guildford Press), 44.
25. Ruth Fincher and Jane M. Jacobs, introduction to *Cities of Difference*, 2.
26. Carla Speed McNeil, *Finder: Voice* (Milwaukie, Ore.: Dark Horse Comics, 2011), 8.
27. McNeil, 202.
28. McNeil, 146.

Part III

Forms

11

Cartooning

••••••••••••••••••••••

ANDREI MOLOTIU

Cartooning can be defined as the graphic simplification of figurative shapes for purposes of communication, humor, and so on in comic strip and comic book rendering (as well as, of course, in gag cartoons, animation, and other visual media).[1] However, the use of the term and its cognates in the comics field is ambiguous. On one hand, its derived form, *cartoonist*, is being increasingly employed as a general term for *any* comics artist, implicitly subsuming under *cartooning* all rendering for purposes of comics illustration; on the other hand, the term is often contrasted with more naturalistic rendering styles, the most extreme of which have traditionally been dubbed "photo-realist" (not to be confused with Photorealism in the fine-arts world). In this second acceptance of the term, only *some* comics artists (such as, say, Ernie Bushmiller on *Nancy*, Carl Barks on *Uncle Scrooge*, or Dan DeCarlo on *Betty and Veronica*) engage in cartooning, while others (such as Neal Adams on *Green Lantern / Green Arrow* or Alex Ross on *Kingdom Come*) do not.

A question then arises: Is *cartooning* only one style within comics rendering, or does it describe the entirety of the field? If the latter, our opening definition still stands: even apparently realistic comics such as those rendered by Adams or Stan Drake (creator of the newspaper strip *The Heart of Juliet Jones*) are drastically simpler than not only photographic depiction but even many other graphic styles—such as might be seen, for example, in drawings of the Beaux-Arts academic tradition. While a traditionally trained artist might render facial features through variations in charcoal or ink-wash shading, indicating the play

of light on a nose or brow, even the most naturalistic comic strip artists have historically been restricted to a relatively small number of lines for depicting the shape of a character's nose and nostrils, say, or for outlining an eye and its eyelid.

An intrinsic factor in the stylization of comics has been the technology of comic book and comic strip reproduction. The reason that Drake or Adams worked with relatively few lines rather than smooth variations of gray shading had to do with the fact that they were drawing for either daily newspaper strips—printed in pure black and white—or Sunday strips and comic books. Though the latter were usually printed in four colors, the contribution of the narrative artist was often restricted to the line art and thus equally needed to be in pure black and white (coloring came later in the production process, typically done by others). This technological requirement brought about the very notion of "line art" (as opposed to, say, "shading art") and created the job of inker—whether, as in many newspaper strips, that was just one of the functions fulfilled by the strip's sole artist or, as in much mainstream comic book production, a different artist was assigned that role.

Furthermore, both newspaper strips and comic books allotted a relatively small area to the finished product as reproduced, and reproduction techniques tended to thicken the lines from the original art. For purposes of legibility, artists simplified the rendering into clearly defined, discrete lines that would not blur or blend together in print (crosshatching and other line-heavy traditional techniques for indicating tone tended to reproduce poorly). At its most extreme, this imperative for clarity and simplification resulted in comic strips such as Bushmiller's *Nancy* (1938–1982), where the eponymous character's eyes are simple black spots, each eyebrow a single semicircle, and the shapes of the characters' faces and bodies are indicated primarily by outlines with rarely any rendering of texture or shadow.

Besides technology, another determining factor needs to be taken into account: economics. On a tight schedule requiring the production of a newspaper strip a day or of dozens of comic book pages a month, developing a simplified style that could fill up panels more quickly was for most artists clearly an economic necessity.

We can analyze the effects of these determining factors in three contrasting examples of art representing, respectively, the genres of gag cartoon, comic strip, and comic book. An 1898 cartoon by Charles Dana Gibson for *Punch* captioned "They are only collecting the usual fans and gloves" (fig. 11.1) renders the winding down of a dinner party with the techniques of traditional graphic arts: the image is constructed mainly out of black and white tones achieved through hatching and crosshatching. Objects and figures in it are defined by the play of light on their surfaces, creating highlights and areas of shadow; they not only exist within a well-constructed, perspectivally convincing space but have a concrete existence within and under the light that reveals that space. Chiaroscuro, or the contrast of light and dark tones, is used not only to give the objects

FIG. 11.1 Charles Dana Gibson, "They are only collecting the usual fans and gloves," a cartoon for *Punch*, 1898.

shape and texture but also to make the image's narrative readable: its "battle of the sexes" gag is effectively diagrammed by having the two contrasting groups framed against the image's two principal white areas—the women framed against the bright doorway, the men, in their black suits, against the white of the tablecloth. Areas of the image that are of lesser narrative importance, such as the sideboard in the background, are constructed out of less strongly contrasting tones.

Such a technique could be effective and economically efficient in rendering a single-panel gag in a journal printed with reproductive techniques that were sophisticated enough to keep the hatching from turning into an illegible jumble. However, early American newspaper strips differed in their use of multiple panels and often cruder, less-precise printing.

Winsor McCay developed a new method of rendering that allowed panel after panel to be drawn and to communicate without the time-consuming hatching of Gibson. (Interestingly, McCay always reverted to hatching when drawing single-panel editorial cartoons.) Both in his black-and-white strips such as *The Dream of the Rarebit Fiend* (1904–1925) and in the line art for his color *Little Nemo in Slumberland* (1905–1927) Sundays (fig. 11.2), McCay constructed his figures and objects almost entirely out of contour lines, with little to no shading except for areas of darkness, which he would render in flat black. McCay tended to use two different pen nib thicknesses in his inking: a thinner one to delineate most elements in each panel and a thicker one to outline the

156 • Andrei Molotiu

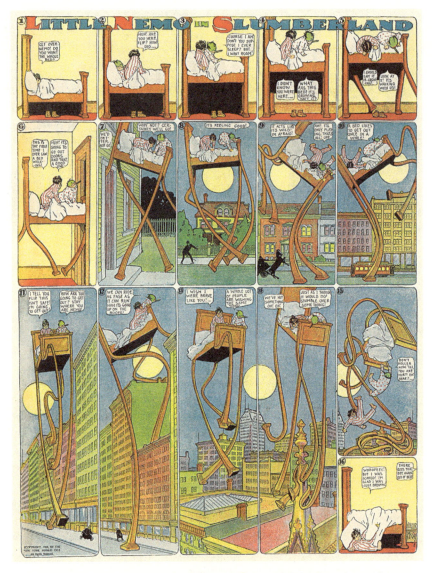

FIG. 11.2 Winsor McCay's distinctive rendering: figures and objects are made out of contour lines with little shading; thicker lines serve a semiotic rather than representational purpose. *Little Nemo in Slumberland*, July 26, 1908. Restored image courtesy of Peter Maresca and Sunday Press.

principal figures or groups that carried the narrative forward. Surfaces, at this point, no longer respond to or are constructed out of light and shadow. McCay's thicker lines especially have a semiotic rather than representational value: they indicate which elements of each picture we need to focus on in order to follow the narrative. That this function trumps the representational one can be seen in the fact that the thick outline indifferently moves from figure to figure or

from object to object in a group, its only rationale being to delimit and highlight shape, with no regard for the three-dimensionality of the entities that compose it. Such use of contour lines is one of the first "mistakes" one is warned against when drawing from life; it is clear that McCay's narrative art puts the line to a wholly different use.

Replacing McCay's use of distinct line thicknesses, the principal tool of mainstream American cartooning became, beginning in the 1920s, the inflected line—that is, a line that can thicken or taper, an effect achievable either with dip pens outfitted with flexible nibs or with brushes. A masterful use of the inflected line technique can be seen in a 1968 drawing by Dan DeCarlo for *Josie*, probably inked by Rudy Lapick (fig. 11.3). Here, the differentiation between figure and background, which McCay had achieved through the contrast of thick and thin lines, is attained by constructing the background—indeed, the entire built environment—out of uninflected lines drawn with technical pens, while the principal figures are constructed out of inflected lines drawn with a brush (for the thicker passages) or a flexible-nib pen (for smaller elements of the drawing, such as fingers). DeCarlo/Lapick's lines communicate significantly more than McCay's. Not only does inflection denote organic life, as opposed to the inorganic quality of the walls and the pavement. It is also used to suggest perspective by having the larger figure of Socrates, closer to the viewer, drawn with lines that are on average thicker, while thinner lines are used for Melody and Clyde Didit in the middle ground. Looking at the sleeve of Socrates's T-shirt, we also notice that lines can vary thickness in keeping with the shape of the object they enclose: the outlines of the sleeve taper toward the top, where the sleeve itself tapers. Perhaps most importantly, the inflected line provides visual interest: it brings life to the design of the comics page. Such visual interest is achieved much more quickly this way than with the labor-intensive practice of hatching; economic causes can once again be seen to have informed the formal choices of the cartoonists.

Alongside the simplification of the line work, one of the most typical aspects of cartooning is foregrounded by a comparison of Gibson's drawing to DeCarlo and Lapick's: the reduction of facial features, as well as of other aspects of the figure such as hands and feet, to conventionalized formulas. Whereas Gibson's drawing, for the most part, attempts to capture each head as a volumetric object defined by light and shadow—and therefore to render a visual impression of the facial features—in the *Josie* drawing, pupils and irises are reduced to black ovals and the shape of the eye is exclusively defined by the upper eyelid—a single curved brushstroke, to which, on the female characters, a few thin outward strokes to suggest eyelashes are added (though in a configuration never seen on any human). Melody's nose is indicated by a single upturned *v*, and Socrates's, seen in profile, is a circular knob jutting out in front of his face. Such formulas, besides simplifying the act of rendering and thereby helping artists create narrative art on deadline, also define the visual stylization of the strip (or that of the

FIG. 11.3 A masterful use of the inflected line: Dan DeCarlo (probably with inker Rudy Lapick), original art for "Endsville," *Josie* #36 (Archie Comics, September 1968). Script by Frank Doyle.

company—the conventions described here guide the rendering in most stories set in the Archie universe). They function much like trademarks to differentiate that look from those of other comics.[2]

"Cartoonism"

Given the technological and economic limitations that determine the development of comic illustrations, the rise of cartooning as the dominant graphic mode of sequential art may seem a contingent development, not one essential to the medium's act of communication. That is, one can easily imagine a scenario where, but for such limitations, comics might have developed quite differently—for example, rendered as naturalistic oil paintings. Many writers on comics, however, implicitly or explicitly see cartooning as a *necessary* part of sequential art and believe there is an intrinsic, not contingent, relationship between graphic simplification and the act of narrating in sequential panels. According to such theories, the ease of reading necessitated by sequential storytelling is only or mainly provided by simplified renderings such as those in cartoons.

In English-language studies, perhaps the best-known discussion of cartooning appears in chapter 2 of Scott McCloud's *Understanding Comics* (1993). The ambiguity inherent in the term *cartooning* with which we began our discussion also figures in McCloud's argument. McCloud opens the chapter by describing a sliding scale of representational options that are available to the comics artist, from the most photo-realistic drawing to the most simplified smiley face; he closes it with a call that no such option (including abstract combinations of nonrepresentational shapes) be left off the table.[3] However, the bulk of the chapter is devoted to "the cartoon," by which McCloud means the more simplified art belonging, in his diagram, on the right-hand side of the sliding scale. The cartoon then, in the narrow definition of the term, is given a privileged position among the options available for comics rendering. This is made clear by the implied premises of the questions with which McCloud begins his analysis: "Why are we so INVOLVED? Why would ANYONE young or old respond to a cartoon as much or more than a REALISTIC IMAGE? Why is our culture SO in THRALL to the SIMPLIFIED REALITY of the CARTOON?"[4]

Why does McCloud privilege the cartoon? For him, as for many others, it is an image overflowing with significance, purified of any element that does not contribute to its semiotic mission. Describing the cartoon as a form of "iconic abstraction," McCloud sees it as "a form of amplification through simplification" in which the removal of (secondary) information, or noise, allows the essential meaning of the image to shine through: "When we abstract an image through cartooning, we're not so much eliminating details as we are focusing on specific details. By stripping down an image to its essential 'meaning,' an artist can amplify that meaning in a way that realistic art can't."[5]

A number of McCloud's assumptions can be questioned here: how does one define an image's "essential meaning"? On what basis do we even know that an image *has* such a thing? Is amplifying that meaning always necessary or desirable? Isn't there a danger that the stripping away of secondary characteristics might remove much of an image's *connotative* abilities in favor of a monosemic *denotative* function? Couldn't that removal of connotation be at least one of the reasons that for a long time, cartooning and, by extension, comics in general were seen as simplistic children's fare and unable of addressing more complex themes?[6]

McCloud's passage has become a locus classicus in defining and popularizing what might be called an ideology of *cartoonism* (a term formed by analogy to the concept of "rockism" in music criticism). This ideology is also formulated in the pronouncements of artist Chris Ware, who sees cartooning not only as inherently tied to sequential narration but as a practice apart, different not just in degree but in essence from *drawing*—a term that he seems to reserve for what we might call "fine-art" drawing. Ware simplifies McCloud's sliding scale from "reality" to "meaning" into a black-and-white dichotomy, fully reifying its two poles. In his "Whitney Prevaricator" poster (2002), in a sidebox headlined "Did YOU Know..." and reminiscent of similar rubrics in children's magazines, Ware writes, "CARTOONING is not really DRAWING at all, but a complicated pictographic language intended to be READ, not really SEEN!"[7] While the statement may seem inflected with the irony that pervades most of the prose matter in his comics, Ware has made similar declarations unironically in interviews and other texts.[8] Furthermore, important commentaries on Ware's work have made good use of the cartooning/drawing and reading/seeing distinctions in discussing his "pictographic" language, and the statement was quoted by Ivan Brunetti as one of the mottos to his 2007 book, *Cartooning: Philosophy and Practice*, a pedagogical text written from a similar theoretical position.[9]

Ware's argument certainly seems to apply to his own artistic practice, helping explain the radical difference between the nearly typographical rendering style in his comics ("cartooning") and the hatching-rich, more light-and-shadow-inflected style ("drawing," in Ware's acceptance) he uses in many of the sketches published in the volumes of the *Acme Novelty Datebook*. However, Ware does not seem to be discussing his own work exclusively. In his pronouncement as well as in similar views held by Brunetti, Seth, and others, we again run up against the ambiguity of the term *cartooning*. Are they referring only to the more simplified style of rendering they practice or to the wide range of art made for comics? Are they merely describing how the simplified style of rendering functions, or are they prescriptively arguing that this is how the best comics art functions or *should* function?[10]

Such questions arise because evidently comics *can* function otherwise. One need only look at cultures such as Italy's, where one of the dominant modes of sequential art has been photocomics: while using photographs in sequential

narration is economically efficient in its own way, the richness of detail in photographs is the exact opposite of cartoony simplification. Similarly, in American comics, the photo-realistic painting style of Alex Ross in comics such as *Kingdom Come* (1996) or *Marvels* (1994) has found great commercial success. Clearly, the readers of such works do not feel that their ability to read sequential art is impeded by the lack of "amplification through simplification." Given such evidence, we should be wary of stipulating an essential connection between cartooning and sequential art. Rather, the centrality of the cartoon in comics needs to be seen as contingent, while the aesthetic ideology that tries to establish such an essential connection needs be investigated historically and its causes sought, perhaps, in the sociology of the comics world.

Töpffer and the Theory of Cartooning

And yet. As contingent as cartooning's connection to sequential art may be, it remains a dominant mode of comics rendering. It has become a complex visual language, developing means of expression not available elsewhere in visual art. The best analysis of how cartooning functions, and probably the best theoretical argument for the aesthetic of cartoonism, was formulated long before terms such as *comics* or *cartooning* even existed. In his *Essai de physiognomonie* of 1845, trying to make sense of his own artistic procedures as well as to recommend them to other would-be storytellers working in images, Rodolphe Töpffer discussed the relationship between graphic simplification and sequential art in terms that not only prefigured the arguments of McCloud or Ware but also built a philosophical argument for this position that is more complex than that of any recent studies. To understand Töpffer's points, we first need to understand his terminology; as no term for comics yet existed, Töpffer refers to the art form he helped found as "literature in prints," defined as "a series of sketches in which [representational] correctness counts for nothing and, on the contrary, the clarity of the idea, expressed in an elementary, cursory manner, counts for everything."[11] It is hard not to hear in that combination of "clarity" of meaning and "elementary" or even "cursory" handling McCloud's argument for the centrality of cartooning, with its "essential meaning" and elimination of details. Töpffer even draws the same connection we have drawn here between cartoony simplification and the material conditions of the chosen graphic medium when he associates that "cursory manner" of rendering with the "*célerité*," or speed of rendering, in autography, the simplified form of lithography he used for his sequential narrations, which largely prefigured the technological conditions of early comics printing (280).

Just as he needed to invent a word for his art form, Töpffer also needed to invent one for his procedure of graphic simplification. He called it "the technique of the simple graphic trait" (le procédé du simple trait graphique), which, throughout his writings, we can hear as standing in for "cartooning." Töpffer

argued that, for the rendering of "literature in prints," this technique "presents manifest advantages":

> As a matter of fact, even though it is a purely conventional means of representation, in that it does not exist in nature and that it disappears in the complete imitation of an object, the graphic trait is nevertheless a procedure that satisfies and, indeed, transcends all the demands of expressiveness and clarity. In terms of clarity, especially, its bare simplicity helps to make meaning more luminous and more easily understood by the simplest of minds. This comes from the fact that it gives only the most essential features of the object and suppresses the ones that are only accessory, so that, for example, a young child who, when looking at a painting rendered according to all the demands of a complex and advanced art, would have a hard time discerning in it the shape of a man, of an animal or object, will immediately recognize that shape when, isolated by means of the simple graphic trait, it offers itself to the child's gaze without accessories and reduced to its essential characteristics. (281)

Here we can also see the roots of the (at times unfortunate) association of cartooning with infantilization; the "simple graphic trait" removes complexity, therefore making itself readable to the youngest and least trained readers.

Even Chris Ware's distinction between the seen and the read can be found in Töpffer when the latter contrasts the technique of the graphic trait to the acceptable rendering methods of the period's academic painting:

> This ease, offered by the graphic trait, of suppressing certain imitative traits that will not fit the object, in order to use only the ones that are essential to it, makes it thereby resemble written or spoken language, a property of which is the ability to suppress with even more ease, in a description or a tale, entire parts of the described scenes or narrated events, so as only to give of them those expressive traits which contribute to [the intended representation of] the object. In other words, the graphic trait, by very reason of the fact that meaning is clear in it without imitation being complete, admits and demands enormous ellipses of accessories and details, such that, while in a finished painting the least discontinuity bothers us and suggests incompleteness, in the graphic trait, to the contrary, enormous discontinuities neither bother us nor suggest incompleteness. (283)

It is fascinating to find in Töpffer the attempt to create a theory of cartooning from scratch. While some of his phrasings are contorted and awkward, they are so only due to his attempt at analyzing for the first time, and with the highest precision, what such rendering could accomplish. The "ellipses" and "discontinuities" that Töpffer mentions refer to all the elements that, in the process of graphic simplification, have been removed from what we might imagine began as a mimetically perfect rendering of the depicted scene. Superfluous

information can, unproblematically, be left out; in the same way that a sentence such as "he walked to the store" contains no description of, say, the street along which the subject walked, a panel depicting the same action may show only the (cartooned) figure in the action of walking, with no environment to detract from the panel's central meaning. This is especially true if that environment has already been depicted, perhaps in a larger establishing panel: further depictions of that sequence of actions, as long as they share an environment, can be abbreviated. This was a technique, used frequently in later comic strips and comic books, that Töpffer innovated and used repeatedly in his "literature in prints" and that he also theorized: "The graphic trait . . . in a sequential story serves to draw cursory sketches which . . . as but links in a series, often figure in it only as reminders of ideas, as symbols, as rhetorical figures strewn through the discourse and not as integral chapters of the subject" (283).

The *discontinuity* Töpffer refers to also approximates the discrete quality of signs in writing, as opposed to the plenitude without gaps of the seen world. Again, he argues that the graphic trait "does not exist in nature and . . . it disappears in the complete imitation of an object." While the world as seen is a *continuum*, in which, for example, outlines that indicate the boundaries of three-dimensional shapes have no actual existence, cartooning, like language, abstracts it and cuts it up into individual concepts that are then made to follow upon or interact with each other as words do. "The graphic trait" thus offers a world already intellectualized (a term that, from a negative perspective, could be paraphrased as "predigested"), facilitating its comprehension by the reader's mind.

Cartooning and "Comics Acting"

It is such concept-images that we find in the formulas of cartooning simplification—in the eyes and noses of Archie characters, for example. Facial features, in cartooning, are no longer simply iconic (in the Peircean meaning of the term)[12] depictions that try to approximate a singular visual perception; they are also conventionalized symbols, components of a restricted vocabulary that can be manipulated and combined to construct the emotions and attitudes of characters—indeed, the entire panoply of means required for comics acting. As Töpffer puts it,

> Another advantage of the graphic trait is the full freedom it allows as to which traits to indicate, a freedom that is not possible at a higher degree of imitation. If I want to express, when drawing a head, stupefied fear, sharp disagreeableness, stupor, or simple-minded, indiscreet curiosity, I restrict myself to the graphic signs that express those affections, freeing them from all others that might accompany them and which, in a more complete imitation, might distract [from the expression we are trying to represent]. . . . The graphic signs by means of which can be

rendered the varied and complex expressions of the human face turn out, in the end, to be few in number; consequently, the procedures of expression are made powerful not by the multiplicity of these signs, but by the numerous easy modifications that they can be subjected to. (282, 286)

How such "acting" functions can easily be seen in a *Peanuts* strip by Charles Schulz, whose narrative technique seems to be thoroughly described—more than a century in advance—by Töpffer's analysis (fig. 11.4). In the Sunday strip for August 14, 1960, in which Charlie Brown and Lucy listen to Linus's elaborate description of the pareidolia he sees in clouds, Charlie Brown's features consist, as always, of a curved pen stroke for the nose, a single curly line for his lock of hair (out of which occasionally one or two strokes jut out to indicate the eyebrows), two dots for the eyes, and a line segment, sometimes straight, sometimes curved or wavy, for the mouth. This is the basic vocabulary of the character's face; other, subsidiary signs come and go as needed. As the conversation proceeds, Charlie Brown's features move up and down what we might call his "head sphere," to indicate the head tilting up or down. In panel 5, in response to Linus's identification in a cloud of "Thomas Eakins, the famous painter and sculptor," Charlie Brown's hair curl draws closer to his nose and the line segment of his mouth gets slightly longer and turned down at one corner; with this slight change in the configuration of the facial-feature vocabulary, we immediately read his new expression as a frown of concentration, as he tries to see for himself what Linus sees. By panel 6, a pair of additional signs has appeared: parenthetical lines on either side of his eyes to indicate his bafflement. In panel 8, the mouth line becomes a black oval to indicate that he is speaking.

A very small repertoire of signs, then, can be manipulated to construct a wide variety of expressions. The concept-images, as we have called them, do not function exactly like words. To begin with, they are not arranged linearly; rather, the gestalt of their configuration needs to be taken into account. Each sign (for example, a dot for an eye) is perhaps closer to a conventionalized symbol than a mimetic copy of the feature it stands for; however, our reading of the expressions is not equally formulaic. In contrast to some of the diagrammatic faces with which Töpffer illustrates his argument, which indicate happiness or sadness with the schematism of theater masks, Schulz is a master of in-between emotional states, of ambiguity. For example, in other strips—such as the heartbreaking one of November 19, 1961, in which a lonely Charlie Brown, eating his lunch by himself, nevertheless rejoices in the games of the other kids, from which he is excluded (fig. 11.5)—the same basic vocabulary can create a sequence of fleeting expressions worthy of the subtlest actor. Sometimes the line of Charlie Brown's mouth gets longer and wavier to indicate uncertainty or shyness; his lock curl moves up and down as he thinks; and the wavy mouth curves up to construct a hesitant smile as he remarks, "That little girl with the red hair is a good runner..."

FIG. 11.4 A small repertoire of signs can be manipulated to create a wide variety of expressions: Charles Schulz, *Peanuts*, August 14, 1960. PEANUTS © 1960 Peanuts Worldwide LLC. Dist. by Andrews McMeel Syndication. Reprinted with permission. All rights reserved.

FIG. 11.5 A master class in comics acting: Schulz, *Peanuts*, November 19, 1961. PEANUTS © 1961 Peanuts Worldwide LLC. Dist. by Andrews McMeel Syndication. Reprinted with permission. All rights reserved.

While the vocabulary of a cartooned face, then, can be close to symbolic, the "graphic acting" is iconic. There is no dictionary definition for these intermediate, liminal emotional states, as there is for the basic configurations of smiley or frowny faces. Schulz's faces are not simply emoticons; this is where Chris Ware's comparison of cartooning with written language and typography breaks down. We read Charlie Brown's expressions through our experience with the richness of human emotions; subtle, infinitesimal changes in the length or angle of a line can signify equally subtle psychological transformations. From this point of view, a visual "continuum" still dominates cartooning: the cartooned human face may be a system of discrete signs, but we process our understanding of it in ways that are quite different from the reading of written words. Schulz demonstrates that the possible configurations of these signs are close to infinite.[13]

Cartooning and Emanata

The logic of Töpffer's analysis can easily be extended to other characteristics of comics art—characteristics that he did not address simply because, at the time of his writing, they had not yet been invented.

An important aspect of cartoony styles of rendering is the ability to incorporate conventionalized graphic symbols to convey information that emphasizes or goes beyond what can be perceived visually in the diegesis, such as psychological or emotional states (for example, a light bulb representing a new idea or sweat beads suggesting fear or anxiety), sounds, smells (wavy "stink lines"), physical impact (star shapes, for example, at the place where a punch lands on a jaw), and so on. Such signs have come to be referred to as *emanata*.[14] Emanata function primarily as symbolic signs added to the iconic signs that denote the visual diegesis. Other such symbolic signs, which are occasionally also categorized as emanata, include motion lines—graphic signs that can indicate an object's or figure's momentum or path of movement.[15]

(While all these signs are by now conventionalized, it is important to note their different origins: while momentum or motion lines seem to be representational, derived from the visual perception of something moving quickly as a blur, trajectory motion lines most likely come from diagrams or maps. A bulb standing in for an idea is purely metaphorical, playing on the notion of "enlightenment." Sweat beads, on the other hand, suggest a generalization and exaggeration of phenomena that occur in only a small percentage of cases of anxiety; we do not feel that we need to take the figure shown "emanating" sweat beads as *actually* sweating.)

More simplified, "cartoony" styles tend to include significant quantities of emanata within the image. Photo-realistic styles, on the other hand, such as that of Alex Ross, include none. Neither do, obviously, photocomics, except when the emanata have been added by hand over the photographs for humorous effect,

as in some of the photocomics published in *Punk Magazine*—but in those cases, the humor comes specifically from the incongruity of such signs with the photographic rendering.[16] The point can easily be demonstrated by comparing any *Nancy* daily by Ernie Bushmiller with, say, a page from Kurt Busiek and Alex Ross's *Marvels*. The concept-images in Bushmiller's cartooning—the simplified facial features, for example—sit comfortably side-by-side with purely symbolic graphic signs; this is because the iconic signs that visually depict the diegesis already share some of the conventionalized quality of symbols. On the other hand, every panel in *Marvels* is rendered as a fully painted, photo-realistic view of a scene. As Töpffer would have said, in such a ("more perfect") representation, there are no discontinuities, and therefore no space is left open that emanata can occupy. It may well be that Ross's choice to avoid emanata came from a desire for his art to look more mature, avoiding the cartooniness associated with children's comics. Yet the painted art is also fundamentally different—in its representation of surfaces, not lines—from the essentially *graphic* quality of emanata. It would be difficult to integrate the two stylistically very different modes of visual representation. The iconic "photo-realism" of Ross's art does not allow a symbolic regime of signs; as demonstrated by the *photo-* prefix, it relates to light and therefore to only one sense, sight.

More cartoony work such as Bushmiller's shows that comics, even beyond their use of language in word balloons, need not evoke only a visual impression of the world (even though, of course, the reader receives the comics themselves visually). The diegesis of a cartoony comic also comes with sounds (indicated by sound effects), smells, and even a sense of touch (suggested by crash emanata). While a photo-realistic comic can only show the exteriors of things, in more cartoony work, psychological emanata, such as the aforementioned sweat beads or dark depression clouds, also indicate the thoughts and inner lives of the characters. So, of course, do thought balloons, which themselves tend to be more easily integrated into cartoony comics. (One of the main developments in the 1980s, when graphic novelists such as Alan Moore or Frank Miller tried to make the world of their comics a more "realistic" one—though, in this case, realistic in a wider sense than that of visual, representational realism—was to eliminate thought balloons, as can be seen in both *Watchmen* [1986–1987] and *Batman: The Dark Knight Returns* [1986].)

We are describing, then, two very different aesthetics that accomplish their task of sequential narration in very different ways. Photo-realist images that cannot easily accommodate conventionalized symbols end up being reduced to a pure visual experience. Consequently, they may have a harder time bridging the gap from word to image, and word balloons often appear superimposed (as they often are in the actual production of such comics), without as organic a connection to the image. Because cartooning goes beyond simple visual mimesis, it can supplement the visual experience with evocations of elements perceptible only by other senses than sight—or by the mind's eye.

A further difference between these two modes is their treatment of temporality. Because of its approximation of a photograph, a photo-realistic panel can seem close to a snapshot—that is, a representation of only the fraction of a second in which that photo was taken. It is not able to suggest a longer duration; therefore photo-realistic panels with particularly lengthy word balloons, which suggest the lengthy duration of the utterance, seem particularly self-contradictory, imbued with a paradoxical time dimension. Temporality also seems to flow more "realistically"—or, rather, more convincingly—*between panels* in more cartoony comics. A cartooned image that incorporates motion lines is granted at least the duration of the motions represented in it, avoiding the suggestion of the photographic instant. Sequences of panels with more cartoony renderings, therefore, do not have the staccato quality of photo-realistic ones, which appear to jump, across gaps of time, from snapshot to snapshot. A temporal flow, or *continuum*, seems, paradoxically, better suggested by *discontinuous* art, while images that tend more toward the visual continuum give the impression of moments in time that are themselves discontinuous, discrete.

Conclusion

The last sections of this chapter should not be construed as an argument, after all, for the "superiority" of the cartoon aesthetic or its higher suitability for the purposes of sequential art. Though it is beyond the scope of this article, an analysis of how photo-realistic comics and photocomics function formally could easily show why they are preferred by many over more simplified art. We are rather dealing with (at least) two different answers to the question of what rendering is suitable for sequential art, two different aesthetics, each of which finds its enthusiastic proponents and reaches significant audiences. However, through its particular treatment of graphic simplification (and the consequent "amplification" of meaning that McCloud attributes to it), cartooning is significant inasmuch as it creates new solutions for "graphic acting" and for the incorporation of nonvisual sensations and temporality into the visual image—solutions found in no other branch of the visual arts.

Notes

1 Cartooning should not be confused with the notion of caricature, which I have elsewhere defined as "the exaggeration of specific traits in the depiction of an individual, a social or ethnic type, etc., in order to facilitate recognition and to convey character or the artist's (often ideologically-influenced) perception of the depicted figure." Andrei Molotiu, "List of Terms for Comics Studies," Comics Forum, 26 July 2013, accessed 27 July 2018, https://comicsforum.org/2013/07/26/list-of-terms-for-comics-studies-by-andrei-molotiu. Caricature always has an empirical referent; furthermore, it need not imply graphic simplification: facial features can be distorted for the purpose of caricature in the medium of painting while retaining all signifiers

of volume and light, as can be seen in the work of William Hogarth, and even in sculpture, as for example in busts by Honoré Daumier. This distinction is muddied in David Carrier, "Caricature, or Representing Causal Connection," in *The Aesthetics of Comics* (University Park: Pennsylvania State University Press, 2000), 12–26. On caricature, see especially Werner Hofmann, *Caricature: From Leonardo to Picasso* (London: John Calder, 1957).

2 An important qualification to this discussion is that the level of cartooning simplification need not be homogenous within a comic—or even within a panel. An instance of this is Scott McCloud's notion of the "masking effect," in which cartoony figures are paired with realistic backgrounds; see McCloud, *Understanding Comics: The Invisible Art* (New York: HarperCollins, 1994), 43. The level of simplification can also vary from character to character (as, for instance, in the work of Jaime Hernandez, where children are often rendered more "cartoonishly" than adults) and between different renderings of the same character in different panels (a traditional device in manga).

3 "For comics to mature as a medium, it must be capable of expressing each artist's innermost needs and ideas. But each artist has different inner needs, different points of view, different passions, and so needs to find different forms of expression." McCloud, *Understanding Comics*, 57.

4 McCloud, 30.

5 McCloud.

6 A partial solution to the latter concern can be found in Alex Toth's oft-repeated dictum, "Throw out everything in the way of the storytelling, then draw the hell out of what's left!" For one instance of this sentiment, see Alex Toth and John Hitchcock, *Dear John: The Alex Toth Doodle Book* (n.p.: Octopus Press, 2006), 179; Toth there attributes the maxim to Roy Crane, though he often also repeated it as a piece of advice without further attribution. As exemplified by many of Toth's drawings, the "draw the hell out" injunction—that is, the contribution of the artist's hand—can add to the image a whole new poetic dimension that makes up for the stripped-away elements. However, most arguments in support of cartooning, such as McCloud's, focus mainly or exclusively on the iconic reduction and not on the compensatory contribution of the artist's graphic style.

7 Chris Ware, "The Whitney Prevaricator" (poster for the Whitney Biennial, Whitney Museum of American Art, New York, 2002), reprinted in Chris Ware, *The Acme Novelty Library* (New York: Pantheon, 2005), 8.

8 For example, "To this day Ware equivocates that his cartooning is not drawing per se: 'it's more like typography, a mechanical sort of "picture lettering," which is why I guess some people hate it and say that my stuff is unemotional. I think it's probably the same sort of approach that Daniel Clowes and Charles Burns have taken—their stuff was a real inspiration, obviously, along with Ernie Bushmiller—though I doubt they were anywhere near as ridiculously self-conscious about it.'" Steven Heller, "Smartest Letterer on the Planet: Chicago's Comic Book Hero Has a Finely Tuned Gift for Hand-Lettering," *Eye Magazine*, autumn 2002, accessed 15 February 2019, http://www.eyemagazine.com/feature/article/smartest-letterer-on-the-planet.

9 See, for example, Daniel Raeburn, *Chris Ware* (New Haven, Conn.: Yale University Press, 2004); and Ivan Brunetti, *Cartooning: Philosophy and Practice* (New Haven, Conn.: Yale University Press, 2011), front matter. A similar sentiment was expressed by the Canadian cartoonist Seth: "Cartooning is not drawing—it's more about moving shapes around on the page than it is about trying to replicate the seen world." Sean Rogers, "Q&A: Seth," *Walrus Magazine* (blog), 21 August 2008, accessed 18

March 2014, http://walrusmagazine.com/blogs/2008/08/21/an-interview-with-seth-part-one. Web page no longer extant; last archived via Internet Archive: Wayback Machine (archive.org) on 8 August 2012.

10 Some scholars have gone so far as to attempt to ground a preference for cartooning in perceptual psychology—that is, in preconscious cognitive universals that are essentially hardwired into us. For example, Stuart Medley argues that the distinctive features of cartooning, including "abstraction away from realism, clear outlines, flat colours, reliance on closure, [and] a tendency towards caricature," correspond to "innate" tendencies in the psychology of seeing; the human visual system, he argues, "prefers less-than-realistic images." See Medley, "Discerning Pictures: How We Look at and Understand Images in Comics," *Studies in Comics* 1, no. 1 (2010): 68; 56. Medley's work presents two difficulties: first, by his own admission, it "suspend[s] discussion of narrative" (55), seeking to understand the "look" of comics without reference to storytelling; second, it is essentially ahistorical. (Note suggested by the editors.)

11 Thierry Groensteen, *M. Töpffer invente la bande dessinée* (Brussels: Impressions Nouvelles, 2014), 280. My translations throughout. Further references to this edition appear in parentheses in the text.

12 In the theory of signs developed by Charles S. Peirce, an *icon* (or likeness) is a sign that functions by resemblance, such as a portrait; a *symbol* is a sign that functions strictly by convention, such as a word; and an *index* is a sign that functions by causal or physical connection or closeness to the thing it signifies, such as a fingerprint taken as evidence of someone's past presence. For fuller definitions of these terms, see Molotiu, "List of Terms." Peirce introduced these concepts in his paper "On a New List of Categories" (1867), which can be found in *Writings of Charles S. Peirce: A Chronological Edition*, vol. 2, *1867–1871*, ed. Edward C. Moore et al. (Bloomington: Indiana University Press, 1984), or via the Peirce Edition Project website at http://peirce.iupui.edu, accessed 20 March 2019.

13 This complexity is acknowledged by Töpffer when he discusses a series of roughly similar faces he drew, all in profile and all constructed from the same graphic elements:

> Here is ... the human head in as elementary a form as possible, as unsophisticated as one could wish. Well then, what is it that strikes us in this figure? It's that, unable not to have an expression, it indeed has one. It is that of a rather stupid, stammering individual, though one who is not particularly displeased with his station in life. It is not easy to say what it is that makes us see this expression; but finding it through a comparison is easy for anyone curious about it. Because, making a new head, I see that it looks less stupid, less stammering, even endowed, if not with intelligence, at least with some capacity for concentration. It's not hard to notice that this has to do with the fact that I drew out its lower lip, diminished the space between the eyelids, and brought the eye closer to the nose. I will multiply the heads, so as to multiply the comparisons. (285)

14 The term was first introduced by cartoonist Mort Walker in *The Lexicon of Comicana* (Port Chester, N.Y.: Museum of Comic Art, 1980), 28–29, and is so named because emanata usually seem to "emanate" from a character or object.

15 Joseph Witek, for example, includes motion lines under the category of emanata: "Typical conventions in the cartoon mode include the extensive use of the icons called 'emanata,' such as the sweat beads, dust clouds, speed lines, and many other symbols that have become closely associated with traditional humor cartooning." Witek, "Comics Modes: Caricature and Illustration in the Crumb Family's *Dirty Laundry*," in *Critical Approaches to Comics: Theories and Methods*, ed. Matthew J.

Smith and Randy Duncan (New York: Routledge, 2012), 29. My own usage of the term is more restricted, hewing closer to Walker's.

16 Of course, many comics inhabit an in-between space, where rendering is simpler than in a photo-realistic comic but more naturalistic than in *Nancy* or even *Archie*. In this wide middle ground, the use of emanata tends to vary greatly; for example, while Curt Swan's Superman stories of the sixties and Dave Gibbons's *Watchmen* art can be said to be at roughly the same degree of abstraction from reality, Swan uses a good amount of emanata and motion lines, while Gibbons uses virtually none.

12

Design in Comics

• •

Panels and Pages

MARTHA KUHLMAN

When approaching a comic, our first impulse may be to read for the content of the story *as* a story (what narrative theory calls the *récit*) and pass over its visual form. Yet to do so is to miss some of the most fascinating and rewarding aspects of comics. We stand to gain something essential by reading the graphic text more slowly and deliberately, looking for the visual intricacies of *how* the story is conveyed. In comics, form and content are not separate but fundamentally complement one another; visual patterns and design strategies literally make up the narrative. Therefore, this chapter focuses on formal aspects of comics, with reference to American and Franco-Belgian sources, in an effort to show how, in comics, design serves story.

Where to begin? We can analyze comics in progressively larger units of meaning as if we were looking through an ever-expanding lens, noting applicable critical terms along the way. Since there is no ironclad consensus about this terminology—comics critics have drawn upon diverse fields such as film theory, cognitive theory, semiology, and narratology, as well as the discourse of comics artists and fans—whenever possible, I will cite diverse approaches and techniques. Despite these differences in approach, discussions of comics form often start with the *panel* as a basic unit of meaning; from there, a next logical step is to consider relationships and transitions between *panels in sequence* and

then to expand our view to analyze the layout of *panels on the page*. We can also analyze *pages in relation to each other* and observe what patterns emerge. Finally, we can consider the *entire design* of the comic as a physical object: the dimensions of the book, the quality of the paper, and how the haptic experience of handling the book may influence the experience of reading.

The Panel

When we read a comic, we are following specific conventions that are "historically contingent and evolving," as Joseph Witek reminds us.[1] Basic components of comics design, including panels, the sequencing of images, gutters (the spaces between panels), and word balloons, all came together in the late nineteenth and early twentieth century, concurrently with innovations in printing and film.[2] The panel is an image that represents a narrative unit: either a moment or series of moments in time, or an idea. It is typically bordered by a line that marks out a square or a rectangle, although it does not have to be. In European accounts, Switzerland's Rodolphe Töpffer is generally the first author credited with routinely using multiple panels on one page, in a form recognizably close to modern comics.[3] This view conflicts with that of the many historians who cite Richard Outcault's *Hogan's Alley* (1895–1898), an American newspaper serial featuring the "Yellow Kid," as the first comic.[4] That argument, however, confuses history, because there were many sequential, multipanel comics prior to Outcault, and in any case, his broadsheet-sized depictions of rambunctious immigrant children did not initially include panels or even a sequence of actions (see chapter 1). Not until 1896 did the Yellow Kid appear in a multipanel time sequence, wherein the character participates in a humorous self-referential dialogue with a phonograph.[5] Both the Töpffer and the Outcault arguments, however, converge around the notion of a panel as narrative episode, with or without borders, that tells a story.

Debate has swirled around the expressive possibilities of the panel and whether a comic can consist of one panel alone. Robert C. Harvey argues that the gag cartoon, which is in effect a single panel, should be considered a comic because, he maintains, the combination of word and image is the defining aspect of the medium.[6] Following David Kunzle, Harry Morgan also asserts that a single image can "narrate" as long as it can represent temporality and the notion of cause and effect. Thus even though the cartoon—a static image—is not literally sequential, some theorists emphasize its potential to suggest a story. This expanded definition would encompass anything from a fifteenth-century engraving by Dürer (cited by Kunzle) to single-panel cartoons such as Hank Ketcham's *Dennis the Menace*.[7] In *Comics and Narration* (2013), Groensteen takes issue with Morgan, arguing that conjecture about what precedes or follows a panel is not the same as *showing a sequence*.[8] Similarly, Scott McCloud's

and Will Eisner's definitions of comics both insist on a literal sequence of images; according to McCloud, comics are essentially "juxtaposed" images in "deliberate sequence."[9]

On the other hand, one can imagine a single panel that encompasses several moments in time, thus comprising a sequence. Charles Hatfield describes a single-panel page from Bill Watterson's *Calvin and Hobbes* (1985–1995) in which the pair of characters appears three times careening through a forest landscape, suggesting that their journey is unfolding over time.[10] Even without representing the main character more than once, a panel can convey a sense of duration: in Marjane Satrapi's autobiographical *Persepolis* (2004), Marjane is shown at a party in Austria where she feels culturally out of place (fig. 12.1), and the caption reads, "In Iran, at parties, everyone would dance and eat. In Vienna, people preferred to lie around and smoke."[11] The single panel, which occupies the full page, depicts Marjane sitting uncomfortably in the upper right corner of a dark room, gazing directly at the reader, while other teenagers are smoking, laughing, and making out around her. This represents not an instant in time, but the general prevailing scene at the party as it unfolds over the course of an evening, a situation in which the protagonist/narrator feels ill at ease. Moreover, the written text reinforces the sense that this scene happened again and again—indeed, was typical.

Whether one considers a single panel a comic or not, from a design perspective, the one-panel cartoon takes us only so far. Multipanel comics open new possibilities: a panel may exist in relation to other panels in a strip, other panels on the page, and other pages of panels in the context of an entire work. Representations of time and sequence become more involved and complex at the level of the page layout (or *mise-en-page*, as Franco-Belgian comics theory calls it).

From Panel to Panel

McCloud argues that we bridge the logical gap between two panels in sequence—a gap marked spatially by the gutter between them—through the cognitive process of "closure," a concept implicitly owed to Gestalt psychology. "Closure," writes McCloud, "allows us to connect [disparate moments] and mentally construct a continuous, unified reality." McCloud urges readers to pay attention to the potentially complex transitions between panels and even offers a typology of transition types, starting with "moment-to-moment" (conveying brief, incremental advances in time) and "action-to-action" (conveying cause-effect relations, for instance, action/reaction or move/countermove). The remaining types suggest increasingly distant or complex transitions: subject-to-subject, scene-to-scene, aspect-to-aspect, and finally, the seemingly illogical non sequitur.[12] As soon as one tries to apply these categories, however, problems arise from the degree of overlap between them.[13] Moreover, McCloud's categories do not address the way the interplay of text and image may further complicate panel-to-panel relations.[14]

Design in Comics • 175

FIG. 12.1 A single panel that encompasses an ambiguous span of time: Marjane Satrapi, *Persepolis*. The *Complete Persepolis* (Pantheon, 2007), page 185.

Nor do they take into account the overall layout of the page; thus they may miss other significant networks and correspondences among panels.[15]

To see how panel transitions may work in practice, consider a famous example: a page from *Action Comics* #1 (1938), the first appearance of Jerry Siegel and Joe Shuster's "Superman" (fig. 12.2). After being unsuccessfully submitted for newspaper syndication as a comic strip (see chapter 14), "Superman" finally

FIG. 12.2 Tension between the linear strip and the layout of a whole comic book page: Jerry Siegel and Joe Shuster, "Superman," *Action Comics* #1 (1938). Reprinted in Siegel and Shuster, *The Superman Chronicles*, vol. 1 (New York: DC Comics, 2006), 12.

found a home at comic book publisher Detective Comics Inc. in 1938, but the strip samples had to be edited to fit the comic book format.[16] The resulting page demonstrates the tension between panel transitions seen in linear sequence and a more expanded field of vision that considers the page layout as a whole. The plot goes as follows: a pushy character named Butch takes revenge on Lois for refusing to dance with him by kidnapping her in his massive car, accompanied

by his thuggish friends. Naturally, Superman punishes the villains and rescues Lois. The location, a deserted road dotted with a single telephone pole and a house, remains constant despite the shifts between panels; thus we can identify the transitions, in McCloud's terms, as "subject-to-subject"—that is, transitions that show "different elements yet [stay] within a scene or idea."[17] But the most salient feature of these transitions is the heroic *action* of Superman, who lifts the car (panel 1), shakes out the occupants (panel 2), crashes the car (panel 3), and then pursues the unfortunate Butch (panels 4–6). Thus all the transitions could qualify as "action-to-action." In terms of perspective, the characters appear at a distance, such that we can see their full figures in a long shot, with the exception of panel 4, which shows the panicked Butch in the foreground, fleeing Superman.

On closer examination, the panels in the last row appear truncated; Butch's arms are cropped out of the right-hand side of panel 4. Even more striking is the cropping of panel 5, which almost clips the beginning of Superman's sarcastic comment "Do you mind?" as he grabs his victim.[18] Originally the story was not intended to be presented on one page, but rather in a series of daily strips; Shuster, however, has done his best to create a page layout using panels from those strips. That page consists of three rows, with two panels in the first, one larger page-wide panel in the second, and three smaller panels in the third. In a strictly panel-to-panel analysis, the awkwardness of the last row makes no sense, but that row does lend a touch of balance and symmetry to the page; the center of the middle bottom panel, for instance, nearly aligns with the gutter in the first row.

This transformation of strip to comic book page reveals a basic tension. Pierre Fresnault-Deruelle has argued that the strip emphasizes the temporal—that is, a linear sequence—while the page (*planche*) operates according to a spatial logic.[19] What is arresting about Shuster's page is not the logic of the transitions, but his effort to crop and squeeze one format into another: strips *into* page, an elegant illustration of why layout or mise-en-page matters. If Shuster had started from the premise of the whole page, his selection of what to place in each panel (that is, the narrative *breakdown*) and how to frame it (that is, Fresnault-Deruelle's *découpage* or Will Eisner's *encapsulation*) might have been quite different. The minor flaws in the breakdown of the last row of panels demonstrate the conflict between strip and page, or in Hatfield's terms, *sequence* and *surface*.[20]

From Panel to Page

The comics page allows for myriad relationships between the relative size, shape, and positioning of panels and their placement on the overall page surface. Because we glimpse all the elements that make up a page simultaneously, comics faces a separate set of formal issues from film, which is typically viewed as a continuous stream of images.[21] We therefore need ways to describe and analyze the overall design of the page (the French term *planche*, literally board, reminds us that we are talking about not only the material page—that is,

a sheet of paper—but also the page as design unit).[22] Benoît Peeters has developed a typology of page layouts[23] that raises important questions and provides a basis for further elaboration.[24] This typology consists of four types of layouts, based on the varying relationship between the story (*récit*) and page surface (*tableau*). For a mise-en-page in which the story commands our entire attention and the page surface is discreet or understated, there are two possibilities: either an unchanging *conventional* layout, typically based on a grid (often nicknamed *le gaufrier*, meaning "waffle iron") or a *rhetorical* layout, where the size and shape of panels dynamically adjust in response to the logic, pacing, and drama of the story. Sometimes the conditions of production require a conventional grid layout; this is the case for artists drawing serial strips that may be published in configurations they cannot control, or ones that are subsequently reissued in book form (Charles Schulz's *Peanuts* [1950–2000], for instance).[25] Peeters describes the relation between story and design in a conventional layout as *neutral*. Contemporary alternative comics artists such as Seth, James Sturm, and Jason have often used layouts based on a nine-panel or six-panel grid, which would meet this definition.[26] A rhetorical layout, on the other hand, supports the narrative by expanding or contracting panels to accommodate action and dramatic developments. Peeters declares this the most common type of layout. He cites a sequence from Hergé's Tintin adventure *The Castafiore Emerald* (1963) in which the butler slips as he is descending the stairs; the panels gradually widen to show the butler's figure as he struggles to regain his balance. Superhero and other adventure comics tend toward this type of layout, in combination with cinematic framing, to dramatize the action. In this instance, Peeters asserts that the primary function of the layout is to *express* the story rather than draw attention to itself.

By contrast, comics in which the page surface commands our attention are classified by Peeters as falling into the remaining two categories, *decorative* or *productive*. Decorative layouts are aesthetic attention-grabbers that may not work to further or reinforce the story in any obvious way, while productive layouts appear to determine and control the very action of the story itself. The design of a decorative layout can be quite elaborate and may precede the story; Peeters mentions, for example, stylized pages that resemble Art Nouveau windows in Jacques Tardi's *The Arctic Marauder* (*Le démon des glaces*; 1974). Some of George Herriman's *Krazy Kat* (1913–1944) Sunday pages could also qualify, given the simplicity of the strip's recurrent plot and his unusual and inventive graphic design. Productive layouts go further, not only preceding but actually motivating or accounting for the story's action; that is, a design conceit overtly determines what will happen in the story, often in a self-reflexive way. Critics often cite pages from Winsor McCay's *Little Nemo in Slumberland* (1905–1927) in which the characters comment upon or react to the fluctuations in panel size and perspective, the most famous instance being the Befuddle Hall sequence of 1908 (fig. 12.3), in which, for example, the characters appear squashed or

Design in Comics • 179

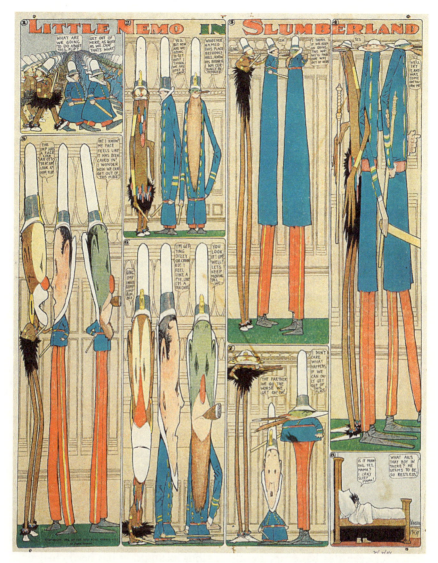

FIG. 12.3 A classic example of productive layout: a strip from the Befuddle Hall sequence in Winsor McCay's *Little Nemo in Slumberland*, February 2, 1908. Woody Gelman Collection, The Ohio State University Billy Ireland Cartoon Library & Museum.

stretched by funhouse mirrors; their shapes morph over the series of panels, expanding and contracting as if in response to the shifting panel dimensions that contain them. Here, as in some pages of *Krazy Kat*, the design dictates the action of the story as the characters scramble to make sense of their topsy-turvy world.[27]

Perhaps the most extreme examples of productive layout are found in constraint-based experimental comics. Most famous in this category are the

works of the collective Oubapo, the Workshop of Potential Comics (L'Ouvroir de bande dessinée potentielle), started by a group of French cartoonists in 1992 in response to the literary movement Oulipo, the Workshop of Potential Literature (L'Ouvroir de littérature potentielle). The idea behind this approach is that a constraint—that is, a specific rule of composition—can have the productive and creative potential to generate a story. Thus one can have a palindrome comic that begins and ends in the same way (such as Étienne Lécroart's *Cercle vicieux* [2000])[28] or a crossword-style comic that can be read in horizontal or vertical strips.[29] Matt Madden, an American member, is the author of the playful *99 Ways to Tell a Story: Exercises in Style* (2005), inspired by Oulipo cofounder Raymond Queneau's *Exercises in Style* (1947).[30] Each of Madden's pages is an exercise that conforms to a given rule or question: Can there be a comic without panels? If a comic is broken into its constituent parts, is it still a comic? What about a comic with no text, or text with no images? Since page design dominates Madden's experiments, they are all in some sense *productive*, but within these possibilities, there are grids that would also qualify as conventional layouts, as well as more dynamic rhetorical layouts that imitate the different styles of artists such as Jack Kirby, Hergé, and even Scott McCloud.

Peeters's typology boasts an elegant simplicity in the abstract but runs into the same limitations as all formalist projects: it applies well to cases at one extreme or another, but cannot easily account for the nuances that get lost among the various categories. How can we distinguish, for example, a decorative from a rhetorical layout?[31] Who is to say whether the layout advances the story or is only gratuitously aesthetic? Since the layout influences the reading process, the two are inescapably interconnected; however, Peeters's categories assume a dichotomy between form and content. In any case, there are other crucial aspects of layout—sequence, simultaneity, and surface—that evade Peeters's system.

Sequence, Simultaneity, and Surface

According to Western conventions, a page is read from left to right, top to bottom. Yet even this basic, apparently obvious assumption has been challenged from the very beginning of the history of American newspaper comics. Early twentieth-century cartoonists such as George Herriman, Winsor McCay, and Lyonel Feininger pushed the medium with playful experiments in form. Feininger, an American artist living in Berlin, was one of the founding members of the Bauhaus and had a gifted eye for design.[32] The broadsheet-sized compositions of his serial *Wee Willie Winkie's World* (1906), reminiscent of Cubism and Expressionism, represent the third-person narration of a boy's naïve and dreamy visions, in which natural forms are personified. In one example from September 30, 1906 (fig. 12.4), oddly shaped geometric panels are arrayed in a clockwise spiral with small numbers appended to aid the reader.[33] According to Peeter's typology, this mise-en-page might be categorized as decorative, for clearly the

Design in Comics • 181

FIG. 12.4 A zigzagging layout creates an unusual rhythm of panels: Lyonel Feininger, *Wee Willie Winkie's World*, September 30, 1906. Reprinted in Brian Walker, ed., *The Comics: Before 1945* (Abrams, 2004), 63.

design dominates the story. However, this classification alone would miss the unusual rhythm established by the sequence of panels, which leads the reader from left to right (panels 1–3), but then skips a beat and jumps to a panel on the far left-hand side (4) before turning right again to focus on the largest, central panel (5). The layout creates a surprising zigzag effect that echoes the idiosyncratic nature of the boy's musings as he gazes about his surroundings. Moreover,

the panels defy two-dimensional space and appear as if they are constructed out of successive layers or planes; a harlequin peeking mischievously over the top center panel at the little boy adds to this three-dimensional effect.

Inspired by these early comics, contemporary cartoonists such as Art Spiegelman, Chris Ware, and Seth manipulate sequence to support the unusual architecture of their narratives.[34] In "A Day at the Circuits" (from *Breakdowns* [1977, reissued 2008], Spiegelman's collection of experimental comics) panels are linked by a nonlinear sequence of arrows that loop through variations on a bar conversation: a barfly alternately complains that he "only drink[s] to keep from getting so damn depressed" and that he's "depressed because [he] drink[s] so much."[35] Depending upon which path one follows, the character ends in suicide and despair or merely progresses to the next bar. Nonlinear layouts also dominate Spiegelman's *In the Shadow of No Towers* (2004), expressing his confusion and trauma in the aftermath of the September 11 attacks.[36] To convey "that all-at-onceness" of 9/11, Spiegelman uses what he terms "a vivid kind of collaging" to represent several simultaneous narrative sequences that do not follow a predetermined order; readers must negotiate this bewildering landscape on their own. Spiegelman's pages can overwhelm and confuse the reader, much as he himself was overwhelmed and confused at the time.[37]

Chris Ware, in many ways inspired by Spiegelman, is one of the most sophisticated cartoonists in his use of nonlinear—or perhaps it would be more accurate to say multilinear—page layouts. In his early issues of *ACME Novelty Library* (1993–), some pages of which were later collected in *Quimby the Mouse* (2003), pen-and-ink characters reminiscent of Herriman's style are propelled around in panels with arrows that direct us through switchbacks and loops as we follow slapstick sequences of cause and effect.[38] Critics have commented on the intricate multilinear layouts in Ware's *Jimmy Corrigan: The Smartest Kid on Earth* (2000), especially in the opening "instructions" section, the diagrams that depict Amy Corrigan's complex interracial heritage,[39] and the history of the Corrigan family's immigration from Ireland to America. In the book's hardback edition, the last of these takes the form of a map that serves as the dust jacket, which one can unfold. There is no obvious beginning or end to this comic, for we can read the family history from any corner and follow the arrows as we traverse time and space through the Irish immigration, the Atlantic slave trade, the Great Chicago Fire, and the individual lives of the Corrigan men.[40]

Building Stories (2013), Ware's boxed narrative consisting of fourteen separate books in various sizes and shapes, contains an impressive example of multilinear narration in the form of a four-leafed playing board. Without using text, the four sections represent how the various residents of a three-story building interrelate. We learn, for example, that the man who lives with his girlfriend on the second floor has entertained lustful fantasies about the young woman on the third floor and that the old landlady on the first floor remembers her lonely youth, when she refused suitors in order to care for her ailing mother.

Ironically, these intricate networks of relationships are apparent only to the reader, not the characters, thus underscoring their isolation from one another. Ware sees this manipulation of layout not as decorative but as an integral part of his stories, explaining that he rarely makes comics "just for the sake of experimentation" but rather tries "to get at some feeling."[41]

Contemporary cartoonists have picked up layout techniques from earlier comics, carrying on an experimental tradition. Take for example the split panel, a type of polyptych in which multiple panels together form a larger image with a continuous background. In his strip *Gasoline Alley* (1918–1959), Frank King would occasionally superimpose a regular grid onto a continuous landscape to affect the reader's perception of time. Transitions between panels might be simple moment-to-moment changes or might span seasons of the year to produce a patchwork-quilt effect. Ware's *Jimmy Corrigan* uses split panels to startling purpose by juxtaposing past and present, as when James Corrigan and the McGinty girl are playing hide-and-seek around a house. Intermingled with this scene are panels that depict the original wooden frame of the house—and the silent figure of a Native American on a horse, the one poignant reminder of a population displaced by settlers.[42] Charles Burns's "Tunnel Vision" (1991) offers a virtuoso commentary on this type of page design, superimposing not one but *two* split panel grids over a nightmarish and fantastical skull adorned with snakes (fig. 12.5).[43] Each cell of this elaborate checkerboard of panels is rendered in a different texture; below them, the captions express the narrator's frustration with the rigid framework of the panels, and his desire to "pierce the surface and see a richer, more complex structure below." Our gaze oscillates between the fragmented panels and the page as one simultaneous horrific image.

We cannot help, then, but see the page as an entire surface. Cartoonists and theorists have invoked various metaphors to describe the page: a mosaic, a puzzle, a many-storied building. Spiegelman engages the third possibility in the introductory comic in *Breakdowns*, suggesting a connection between *story* (as in narrative) and the story of a house. Many artists (for example, Spiegelman, Ware, Ivan Brunetti, and Jeff Zwirek[44]) have played with this notion by representing individual strips on a page as floors of a building, as if the page represented the building's "façade."[45] In this conception of the page, panels physically abut each other, like blocks in a wall, and gutters function almost as the grout or cement that holds the narrative together. This lends the layout a solidity and material presence; the viewer becomes accustomed to seeing tiers of panels support each other almost as if by the force of gravity. But we can also think about panels on a page as successive layers that float over a plane, allowing artists to manipulate effects of foreground and background; Will Eisner terms this the *metapanel*.[46] Panels can be brought forward, or recede into the landscape, depending on where cartoonists choose to place their emphasis. This type of design—the "multilayer," as Groensteen calls it—emphasizes "the penetration of space by means of superimpositions and encroachments that create

FIG. 12.5 A virtuoso example of the split panel (and self-reflexive comment on the comics form): Charles Burns, "Tunnel Vision" (1991). From *ArtForum* 29, no. 7 (March 1991). Reprinted in Paul Candler, ed., *Raw, Boiled and Cooked: Comics on the Verge* (San Francisco: Last Gasp, 2004), 13. Copyright © and used by permission of Charles Burns. All rights reserved.

the illusion of a staggering of elements from surface to depth."[47] Both manga and superhero comics often use these techniques to support the dynamism and drama of story (in this sense, the multilayer is rhetorical). For instance, in Frank Miller's *Batman: The Dark Knight Returns* (1986) and Miller and David Mazzucchelli's *Batman: Year One* (1987), panels shaped like television screens hover over complex backgrounds, creating a counterpoint between what is happening in the "depth" of the page and the media coverage of that same action.

Even the negative space of the gutters can be a meaningful design element. Mazzucchelli and Paul Karasik's graphic novel adaptation of Paul Auster's *City of Glass* (1994) reverses the conventional figure/ground perception of a page to transform a regular nine-panel grid into a set of prison bars, thus to represent the character Peter Stillman's psychological suffering and confinement.[48]

David B.'s *Epileptic* (English trans. 2005) creates a striking variation on the outer gutter of the page—also called the hyperframe—when he draws the body of his brother, Jean-Christophe, curling snake-like around a series of panels about his brother's life as an adult with epilepsy. Sometimes a hand, foot, or part of Jean-Christophe's head will overlap onto the space of the panels, underlining his physical presence and suffering as he struggles with his condition.[49] However the page surface is used, artists have exploited its creative potential such that it can function not simply as background but also as a crucial element of design.

From Page to Pages

Just as a panel takes on significance in relation to other panels, comics can establish design patterns and rhythms over the course of an entire work. Eisner compares the comic strip to "Morse Code or a musical passage" and describes his own pages as having a "beat" or "tempo."[50] Following Eisner, others have borrowed terms from music to express what happens in a page or across pages. Ware, who quotes Goethe's dictum that "architecture is frozen music," describes the process of reading comics in musical terms: "What you do with comics, essentially, is take pieces of experiences and freeze them in time. The moments are inert, lying there on the page in the same way that sheet music lies on the printed page. In music you breathe life into the composition by playing it. In comics you make the strip come alive by reading it."[51] Critics have also applied poetic terms to comics: for example, when describing how various panels or pages "rhyme" with each other.[52] Groensteen devotes a chapter of *Comics and Narration* (English trans. 2013) to analyzing "rhythm," a word that applies equally to music and verse. Whether the point of reference is music or poetics, critics use these terms to identify patterns in page and book design that may be subtle and difficult to perceive upon the first reading. In both poetry and music, *repetition* and *variation* are key elements of expression—and in comics, the two provide a starting point for analyzing relationships across pages.[53]

Repetition

A two-page spread from Alison Bechdel's *Fun Home* (2006) deploys the technique of repetition to stunning effect (fig. 12.6). At first glance, these pages appear not at all daring from a graphic design perspective: each page is divided into a twelve-panel grid, and the figures depicted in each panel—Bechdel and her father sitting in a car together, facing forward—are in almost the exact same position in every panel. According to Peeters, this would be classified as a conventional grid layout, yet, as Groensteen argues, what is important is how these pages appear *in relation to other pages*. In the larger context of *Fun Home*, these pages depart from the book's established pattern of three-tiered layouts with rectangular panels of different sizes and proportions. Most of the book's layouts would

FIG. 12.6 A conventional grid layout used to stunning effect: Alison Bechdel, *Fun Home* (Houghton Mifflin, 2006), page 221.

be, in Groensteen's terms, irregular yet discrete,[54] but this sequence stands out for its oppressive regularity. Alison, an out lesbian, is paired and contrasted with her closeted gay father over the course of the narrative as she tries to make sense of their relationship and her father's untimely demise. The design change in this sequence, from three tiers to four, heightens our sense of tension and claustrophobia as father and daughter at last attempt to have a sincere talk about their sexual identities during a car trip. Suspense builds as the reader's hopes are raised that the two will come to some mutual understanding, but this expectation is dashed when the father, Bruce, ends the conversation abruptly and we are left with six silent panels of Bechdel's internal monologue. The poignancy of this moment is heightened by, ironically, Bechdel's parental feelings toward her father's "shamefaced recitation" of his first homosexual experience, one of many such reversals that occur throughout.

Repetition of identical or nearly identical panels can imply short spans of time that expand, as in an awkward car ride, or can expand to encompass much longer, less defined time frames. In *Shenzen: A Travelogue from China* (2006), Guy Delisle shows the banality and monotony of travel when he represents five almost identical hotel rooms he stayed in from different Chinese cities: Nanjing, Shenzen, Canton, Shanghai, and Canton again.[55] Robert Crumb also uses repetition ironically, as in his three-page comic "Mr. Natural's 719th Meditation" (1970), in which Mr. Natural stays still throughout, even as chaos erupts around him in the form of urban development, the intrusion of police, and natural calamities. As the chaos subsides, the final panel finds him in the same

position as in the first. Groensteen analyzes the regular rhythm established by this story's grid layout, in combination with the repeated image of Mr. Natural, and notes that the duration of the story—that is, the amount of time that is supposed to pass in it—fluctuates and is ultimately ambiguous.[56]

Patterns and Variations

Repetition can be powerful, but has limited expressive potential, rather like the sound of the same note again and again; variation can add greatly to the depth and richness of comics. In Franco-Belgian theory, two terms describe the appearance of a visual motif with variations over the course of a multipage comic: translinearity and braiding (*tressage*). Jan Baetens and Pascal Lefèvre note that comics demand "a reading capable of searching beyond linear relations" to certain aspects or details that can be "networked" with aspects or details of other panels. *Translinearity*, then, refers to "a distant relationship between two or more non-contiguous units."[57] Groensteen acknowledges and builds on this concept by coining the term *braiding*, which he describes as "a game of formal analogies" through which "a powerful semantic network is put into place that will later be revealed as rich in narrative consequences and symbolic implications."[58] The most famous illustration of this concept of *translinearity* or *braiding* is found in *Watchmen* (1986–1987) by Alan Moore and Dave Gibbons. Baetens and Lefèvre note how *Watchmen*'s page layout and color are skillfully orchestrated to establish patterns and rhythms that subtly reinforce the narrative. The novel's chapter 5, "Fearful Symmetry," deploys symmetry in its layouts through the repetition of a checkerboard grid of panels and then in a remarkable two-page spread at the center of the chapter in which the facing pages reflect each other.[59] In fact the entire chapter is laid out symmetrically so that the last page mirrors the first, the penultimate page mirrors the second, and so on; the spread at the center is the point of convergence. Indeed, in those central pages, reflection and doubling can be found on a number of levels: the letter V shape that bisects the two-page spread, the joining of the two central contiguous panels, and the reflection in the pool below Ozymandias as he is poised to strike the supposed assassin. Beyond this chapter, a number of motifs—such as the smiley face, the clock, and the repeated image of the Comedian falling out of the window—form a semantic network that unites the work graphically and symbolically. As Groensteen notes, in *Watchmen*, "symmetry becomes an abstract category" that ultimately raises questions about "the moral equivalence between criminals and heroes, since they use comparable methods."[60]

Not surprisingly, the kind of translinear analysis that seeks patterns, variations, and networks is most effective for longer-form comics that are sometimes a decade or more in the making, such as Spiegelman's *Maus* (1986 and 1991), Ware's *Jimmy Corrigan* and *Building Stories*, and Burns's *Black Hole* (2005).[61] An exceptional example of the meticulous braiding together of form and narrative

is found in Mazzucchelli's *Asterios Polyp* (2009),[62] which uses patterns of color and variations in line work, texture, and layout to evoke the perspectives and personalities of different characters, particularly the pompous architect Asterios (rendered in aqua blue) and his artist-wife Hana Sonnenschein (magenta pink). Using repeated visual signals to underscore the dialectical tug-of-war between characters, Mazzucchelli achieves an almost fugue-like structure, weaving together themes and variations that continually enrich the story.

The Book as Object

Historically, the publication formats of comics have often been simply a consequence of the conditions of production. Early strip cartoonists scaled their pages to fit papers or supplements; today, periodical comic books in the DC and Marvel vein have a standard size of about seven by ten inches (see chapter 2). In Europe, the hardcover album has been the norm, and so children read their *Astérix* and *Tintin* in colorful books that are larger and more durable (nine by twelve inches). Publishers have often dictated dimensions to the cartoonists, who have been obliged to work within those parameters. However, with the turn toward alternative comics publishing, cartoonists began to see format—binding, paper, covers, endpapers—as components of design that could be more expressive, that the interior and the exterior of a book could be complementary and function as a cohesive whole. In France in the 1990s, the independent publishing house L'Association deliberately rebelled against the standard "48CC" (forty-eight-page cardboard cover) format, and produced more understated, monochromatic covers on heavier, higher-quality paper to signal their difference from the mainstream (see chapter 4). Around the same time, Ware became one of the first American cartoonists to take control of the entire format of his books as an integral part of his comics' designs. His *ACME Novelty* series, initially published by Fantagraphics but later self-published, includes books in diverse formats, ranging from digest-sized mini-comics to large, broadsheet-sized pieces such as those found within *Building Stories*. Ware's work clearly shows that material choices such as paper and binding can contribute importantly to story. Volume 20 of *ACME Novelty Library* (2010), devoted to Ware's character Jordon Lint, has a tactile brocade cloth cover with a filigree title embossed in gold on heavy blue stock; the book resembles a photo album. This beautiful presentation is painfully ironic in light of the life story of Lint, a selfish and brutal man.[63] Charles Burns's trilogy *X'ed Out* (2010), *The Hive* (2012), and *Sugar Skull* (2014) is printed in a large hardcover format to evoke the "48CC" albums of Hergé's *Tintin*. The books' invocation of the innocent boy adventurer mixes disturbingly with Burns's nightmarish tale of a drug-addled underground punk, showing how the book-as-object can have complex connotations and resonances.

All media, not simply comics, are moving in the direction of dematerialization—tablets, e-readers, smart phones, and laptops have changed the way we consume culture (see chapter 17). Even in this digital age, though, comics are often defiantly material—that is, objects with physical weight and heft, though varying in scale from 2008's bookshelf-defying *Kramer's Ergot*, volume 7 (21.25 by 16.5 inches) to minicomics that fit in the palm of one's hand. What may be lost or gained when comics are reformatted for different platforms and read on screens? How will this change the experience of appreciating the panel in the context of a page or a two-page spread, or the patterns that develop over a number of pages? Perhaps new approaches to layout and design will accommodate these altered modes of reading and bring new insights.[64] But there is still something to be said for the haptic as well as visual experience of reading a material book. As Ware states on the back of *Building Stories*, "It's sometimes reassuring—perhaps even necessary—to have something to hold on to."[65]

Notes

1 Joseph Witek, "The Arrow and the Grid," in *A Comics Studies Reader*, ed. Jeet Heer and Kent Worcester (Jackson: University Press of Mississippi, 2009), 149.
2 Jared Gardner, *Projections: Comics and the History of Twenty-First-Century Storytelling* (Stanford, Calif.: Stanford University Press, 2012), 1–28.
3 Thierry Groensteen and Benoît Peeters cite Töpffer as the inventor of comics. See also Thierry Smolderen, "Of Labels, Loops, and Bubbles: Solving the Historical Puzzle of the Speech Balloon," *Comic Art* 8 (Summer 2006): 98–99.
4 For detailed discussion of this comic, see N. C. Christopher Couch, "The Yellow Kid and the Comic Page," in *The Language of Comics: Word and Image*, ed. Robin Varnum and Christina Gibbons (Jackson: University Press of Mississippi, 2001), 60–74.
5 Harry Morgan, *Principes des littératures dessinées* (Angoulême: Editions de l'an 2, 2003), 79–80.
6 Robert C. Harvey, "Comedy at the Juncture of Word and Image," in *Language of Comics*, 75–96.
7 Morgan, *Principes*, 40–45.
8 Thierry Groensteen, *Comics and Narration*, trans. Ann Miller (Jackson: University Press of Mississippi, 2013), 23.
9 Scott McCloud, *Understanding Comics: The Invisible Art* (New York: HarperCollins, 1994), 20–21.
10 Charles Hatfield, *Alternative Comics: An Emerging Literature* (Jackson: University Press of Mississippi, 2005), 53.
11 Marjane Satrapi, *The Complete Persepolis* (New York: Pantheon, 2007), 185. *Persepolis* was first published in French as a series of four volumes (Paris: L'Association, 2000–2003). Pantheon then published the work in English in two volumes (translated by Mattias Ripa and Blake Ferris, respectively) in 2003–2004; the one-volume *Complete* edition followed in 2007.
12 McCloud, *Understanding Comics*, 67–72.
13 Bart Beaty, "The Search for Comics Exceptionalism," *Comics Journal*, no. 211 (April 1999): 70.

14 Hatfield, *Alternative Comics*, 44.
15 Beaty, "Search for Comics Exceptionalism," 72.
16 Les Daniels, *Superman: The Complete History* (San Francisco: Chronicle Books, 1998), 22, 31.
17 McCloud, *Understanding Comics*, 67–72.
18 Jerry Siegel and Joe Shuster, *The Superman Chronicles*, vol. 1 (New York: DC Comics, 2006), 12.
19 Pierre Fresnault-Deruelle, "Du linéaire au tabulaire," *Communications* 24 (1976): 7.
20 Hatfield, *Alternative Comics*, 48.
21 In Franco-Belgian comics theory, the peripheral field of vision that informs and influences our reading of the page is called the *périchamp*. See Benoît Peeters, *Case, planche, récit* (Paris: Casterman, 1998), 17.
22 Hatfield, *Alternative Comics*, 48.
23 There are actually three versions of his evolving conceptions of page layout: the first was published in 1983, and then the first edition of *Case, planche, récit* came out in 1991, followed by the 1998 edition, to which I am referring.
24 See, for example, Ann Miller, *Reading* Bande Dessinée (Bristol, England: Intellect, 2007), 86–88; Thierry Groensteen, *The System of Comics*, trans. Bart Beaty and Nick Nguyen (Jackson: University Press of Mississippi, 2012), 93–101; and Jesse Cohn, "Mise-en-Page: A Vocabulary for Page Layouts," in *Teaching the Graphic Novel*, ed. Stephen Tabachnick (New York: MLA, 2009), 44–57.
25 Peeters cites Jean-Michel Charlier's *Spirou* and Hugo Pratt's *Corto Maltese* as examples of serial strips that are published in book form. Peeters, *Case, planche, récit*, 42.
26 See, for example, Jason, *The Iron Wagon* (Seattle: Fantagraphics, 2003); or Seth, *It's a Good Life, If You Don't Weaken* (Montreal: Drawn & Quarterly, 2003), which was originally serialized in *Palookaville* (1993–2003).
27 Peeters, *Case, planche, récit*, 53.
28 Étienne Lécroart, *Circle vicieux* (Paris: L'Association, 2005).
29 See François Ayroles, "Consécution Aléatoire," *Oubapo* 2 (2003): 18. This four-by-four grid can be read in 256 different ways.
30 Matt Madden, *99 Ways to Tell a Story: Exercises in Style* (New York: Chamberlain Bros., 2005).
31 Groensteen, *System of Comics*, 93.
32 Brian Walker, "Lightning at the Crossroads," in *Masters of American Comics*, ed. John Carlin, Paul Karasik, and Brian Walker (New Haven, Conn.: Yale University Press, 2005), 190, 192.
33 Joseph Witek, "Arrow and Grid," 150–151. Witek explains that although numbered panels may seem odd to us, this was common around the turn of the twentieth century. He cites several examples of Herriman's *Krazy Kat* that play with this convention.
34 Jeet Heer, "Inventing Cartooning Ancestors: Ware and the Comics Canon," in *The Comics of Chris Ware: Drawing Is a Way of Thinking*, ed. David M. Ball and Martha B. Kuhlman (Jackson: University Press of Mississippi, 2010), 5–6.
35 Art Spiegelman, *Breakdowns: Portrait of the Artist as a Young %@&*!* (New York: Pantheon, 2008), n.p.
36 Art Spiegelman, *In the Shadow of No Towers* (New York: Pantheon, 2004).
37 For more detailed close readings of these pages, see Martha Kuhlman, "The Traumatic Temporality of Art Spiegelman's *In the Shadow of No Towers*," *Journal of Popular Culture* 40, no. 5 (2007): 849–866.

38 See Chris Ware, *Quimby the Mouse* (Seattle: Fantagraphics, 2003). Pages 10 and 16 exemplify the antic energy of these multilinear layouts. For an analysis of how this work relates to the author's life, see Benjamin Widiss, "Autobiography with Two Heads: *Quimby the Mouse*," in *Comics of Chris Ware*, 159–173.

39 See, for example, Isaac Cates, "Comics and the Grammar of Diagrams," in *Comics of Chris Ware*, 90–104.

40 For a detailed analysis of this map in the context of immigration and race relations, see Joanna Davis-McElligatt, "Confronting the Intersections of Race, Immigration, and Representation in Chris Ware's Comics," in *Comics of Chris Ware*, 135–145.

41 Quoted in Daniel Raeburn, *Chris Ware* (New Haven, Conn.: Yale University Press, 2004), 11.

42 Ware's layering of different time periods in a single layout appears to be an homage to cartoonist Richard McGuire, whose experimental comic "Here" (*Raw* 2, no. 1 [1989]) maintains a grid layout but skips across time, revealing moments in the vast history of a single locale as seen from a fixed point in space. Ware has made his debt to McGuire clear: see Chris Ware, "Richard McGuire and 'Here': A Grateful Appreciation," *Comic Art* 8 (Summer 2006): 5–7. McGuire expanded the comic to a full graphic novel in 2014.

43 Charles Burns, "Tunnel Vision," in *Raw, Boiled and Cooked: Comics on the Verge* (exhibition catalog), ed. Paul Candler (San Francisco: Last Gasp, 2004), 13.

44 Jeff Zwirek's *Burning Building Comics* (Chicago: Imperial Comics, 2012) uses this premise to represent the intertwined stories of residents in a building in which a drama unfolds on each "floor" (strip) as a fire threatens to engulf them all.

45 Chris Ware quoted in Raeburn, *Chris Ware*, 25.

46 Will Eisner, *Comics and Sequential Art* (Tamarac, Fla.: Poorhouse Press, 1985), 63–64.

47 Groensteen, *Comics and Narration*, 63.

48 Paul Karasik and David Mazzucchelli, *City of Glass*, 2nd ed. (New York: Picador, 2004), 22. *City of Glass* was adapted from the novel by Paul Auster and first published in 1994 by Avon.

49 David B., *Epileptic*, trans. Kim Thompson (New York: Pantheon, 2005), 296–301.

50 Eisner, *Comics and Sequential Art*, 28–36.

51 Quoted in Raeburn, *Chris Ware*, 25.

52 Peeters notes how the image of the watch on each chapter division in Moore and Gibbons's *Watchmen* establishes a sequence or "rhyme" that unites the first and last title pages. Peeters, *Case, planche, récit*, 62.

53 Groensteen creates three categories: repetition, alternation, and periodic alternation (I am collapsing the last two categories into one discussion of variation). For more detail, see his chapter on "The Rhythms of Comics," in *Comics and Narration*, 144–145.

54 Groensteen, *System of Comics*, 97.

55 Guy Delisle, *Shenzhen: A Travelogue from China* (Montreal: Drawn & Quarterly, 2006), 8.

56 Groensteen, *Comics and Narration*, 139–143.

57 Jan Baetens and Pascal Lefèvre, *Pour une lecture moderne de la bande dessinée* (Brussels: Centre Belge de la Bande Dessinée, 1993), 72, 7.

58 Groensteen, *System of Comics*, 158.

59 Baetens and Lefèvre, *Pour une lecture moderne*, 73.

60 Groensteen, *System of Comics*, 100.

61 As Hatfield notes, serialization can produce works with the complexity of *Watchmen*, but understandably, "the breakneck scheduling of periodicals usually discourages the exploitation of this potential." Hatfield, *Alternative Comics*, 157.

62 David Mazzucchelli, *Asterios Polyp* (New York: Pantheon, 2009).
63 Ware reprints, revises, and recontextualizes the story of Jordan Lint in his graphic novel *Rusty Brown* (New York: Pantheon, 2019), significantly changing its material presentation.
64 Regarding the impact of e-books and other digital reading platforms on comics (and comics-reading), see Aaron Kashtan, *Between Pen and Pixel: Comics, Materiality, and the Book of the Future* (Columbus: The Ohio State University Press, 2018). Kashtan points out that, far from diminishing the importance of materiality, digital-age comics have experimented with materiality in self-conscious ways that may foretell the future of the printed book.
65 Chris Ware, *Building Stories* (New York: Pantheon, 2012).

13

Words and Images

• •

JAN BAETENS

It should be stressed from the start that comics, though often defined as a hybrid form that combines words and images, can be wordless. As argued by David Beronä, the wordless woodcut novels of the 1920s and 1930s (for instance Frans Masereel in Europe or Lynd Ward in the United States) can be seen as important predecessors of the contemporary graphic novel (see chapter 6).[1] Also, most historical overviews of the comics medium rightfully emphasize the seminal role of engraved image sequences in works such as William Hogarth's *A Harlot's Progress* (1732).[2]

The absence of words in such works, however, is never complete. First, a comic, even a wordless one, is only rarely presented without any verbal accompaniment—that is, without what Gérard Genette calls a "paratext."[3] These paratexts or supplements—titles, blurbs, indicia, editorial apparatus, packaging, and so forth—inevitably shape the comic's interpretation. There is a difference, after all, between calling a woman "a harlot" or "a country girl"; also, the use of the word *progress* in Hogarth's title ironically recalls John Bunyan's *Pilgrim's Progress*.

Second, words are never completely absent from a comic, because the reading of visual signs is never limited to the strictly visual realm. Visual semiotics has demonstrated that we tend not only to categorize but also to "verbalize" what we perceive, even if this verbalization is not always easy or possible, given the tension between the limits of our vocabulary and the infinite forms and nuances of visual stimuli.[4] More generally, it has been argued by W. J. T. Mitchell that

"there are no visual media,"[5] since all forms of sign perception involve a broad range of senses: we see and hear texts as much as we read them, we project words onto images, and so on. If the "pure" image is one "liberated" from all verbal culture, then *im*purity is the rule—though the concept of (im)purity carries such negative connotations that it would be better to suggest multimodality or complexity as a more neutral term to cover the intertwining of words and images, both in comics and elsewhere. In the examples that follow, it is precisely the interaction, or "dialogue," of the verbal and the visual that proves key to better understanding how comics work, even when that dialogue is far from self-evident.

From a classical point of view, the discussion of words *and* images is a discussion of words *versus* images, for in Western culture, it is the differences rather than the analogies that have been stressed. Culturally and ideologically, word and image have never been equal partners: our Western history is deeply rooted in *logocentrism* (which considers language more valuable than images), the corollary of which is *iconoclasm* (which tends to mistrust or devalue the image in favor of language).[6] According to Gotthold Ephraim Lessing, whose *Laocoön* (1766) continues to be a major reference in the comics debate, words belong to the field of the arts of *time*, whose signs are read consecutively, whereas images belong to the arts of *space*, whose signs are processed simultaneously. From this general observation, the German philosopher also infers the (highly contentious) idea that words are a more appropriate medium for the representation of actions, while (fixed) images should focus on the representation of descriptions. These and other issues are still crucial in art-historical controversies on the relative status of verbal and visual media and the supposed qualities or disadvantages of "impure" media.

Comics clearly transcends this opposition between arts of time and arts of space. Yet despite the medium's intimate interrelation of words and images, some authors and scholars of the form have taken a decidedly antiverbal stance. If the cultural resistance to comics (as the epitome of lowbrow literature) reveals the persistence of iconoclasm in Western culture, the defense of comics, which often implies the defense of images as such, expresses the opposite fear: that of text dominating the image or, conversely, of seeing the image reduced to the mere role of illustration (a position not unlike that of movie lovers who criticize sound films for being an impoverished form of the "pure visuality" of silent cinema). In contemporary culture, however, the respective roles of words and images have changed dramatically, through the propagation of what is called (though the term is admittedly vague and general) the *visual turn*—that is, the shift from a word-dominated culture to an image-dominated one. It is in this context that one should understand Roland Barthes's famous statement that "the image no longer *illustrates* the words; it is now the words which, structurally, are parasitic on the image."[7]

This paradigm shift has enabled a different approach to word and image relationships: not only a more complete understanding of how verbal and visual elements jointly contribute to the building and unfolding of a story world but also a more visual, though not exclusively so, approach to the role and place of words in comics. For comics, this means that images can no longer be considered a mere supplement to an underlying story—that is, a funny and easy way of telling stories that are first verbally scripted and then translated in a visual form that does not affect their verbal "essence."

What follows will take a post–"visual turn" approach to word-image relationships in comics, with a focus on two major elements: one, the interaction of words and images on the page; and two, the visual, spatial, and architectural aspects of the various words and text types one can find in comics.

Conflicts, Overlaps, Correspondences

Equality of words and images of course does not mean *identity* in all respects. Granted, both may share the same space, follow the same sequential arrangement, refer to the same objects, display the same stylistic features and connotations, and even, to a certain extent, exchange their "proper" characteristics (in cases where words are "drawn" like images or where images substitute for words). Yet words and images also continue to be very different signs whose encounters can take many different forms.

These differences involve issues of, on the one hand, narrative content and, on the other, order and rhythm. Although words and images can refer to the same meaning, the two can also have different if not opposite significations, and the same applies to the stylistic features of linguistic and pictorial elements, which can converge or instead diverge. Additionally, though it is possible to read the linguistic information of a comics page in a random order, the sequential, consecutive structure of text is much more constrained than that of visual information (after all, words form "strings"). In contrast, the visual information on the page is almost impossible to process in a strictly linear way; this is why comics scholars often use the concept of "tabularity," as defined by Pierre Fresnault-Deruelle, to refer to the nonlinear composition of the panels and tiers on a page taken as a whole.[8] Comics readers "browse" panels in various directions, just as they see various panels at the same time, including the very last panel of the page. Conversely, the reading pace of the text is more regular than that of images, which can be looked at for a longer or shorter time according to the interests of the reader. In light of these options, it is important to distinguish which general approach, or regime, determines the encounter of words and images on the page.

Theoretically speaking, the possibilities are endless, but two major regimes emerge. The first privileges the desire for *symmetry* (or if one prefers,

convergence): that words and images refer to the same objects and that they do so in the same style. Moreover, the symmetrical page is constructed so that the reader is invited to read words and images at a more or less similar pace and in more or less the same order. The second regime privileges the pursuit of *tension* (or *divergence*): here, words and images refer to different objects, and the stylistic instruments used are different. The page is, in this case, constructed so that words and images can only be read in different rhythms and perhaps also in different orders. In practice, many comics use a creative mix of both regimes. There are many examples of such mixing in visual theory as well: Roland Barthes's notion of *relay*[9] and the more recent notion of the *imagetext*[10] imply both divergence (words and images do not offer the same kind of information but do complete each other) and convergence (words and images do collaborate in shaping one global meaning, even if that meaning can be dramatically complex and multilayered).

Dave McKean's graphic novel *Cages* (1998) offers many examples of the permanent tension between convergence and divergence.[11] The carefully constructed minimalist page layout, with its variations on the traditional nine-panel grid, reproduces, often in painful detail, the characters' conversations (monologues or dialogues). Words and images move forward together at a slow pace with few readily discernible gaps. Very quickly, however, the seeming vacuity of many utterances invites the reader to look in the images for what the words hint at but fail to convey fully (yet suggest indirectly, by their very failure), and vice versa, the subtlety of the verbal variations urges the reader to seek the hidden meanings of the images.

Contemporary and adult-oriented comics often prefer tension to symmetry, as tension prompts a stronger degree of writer-reader interaction, active involvement, and freedom of interpretation, which are seen as forms of added aesthetic and cultural value. Yet this preference has nothing essential or absolute about it. Both types can be applied in degrees: the maximal form of symmetry would be tautology, in which case it would suffice to read either the text or the image alone to grasp the whole. The minimal form of tension would be mere juxtaposition, in which case we are probably close to illustrated works in which texts and images can almost be read separately (recent work in the artist's book genre offers examples of such a juxtaposition). The application of both tension and symmetry, and the many possible variations in their interaction, need not stay stable throughout the course of a work (in fact, the absolute and unvarying use of a single regime is nearly unthinkable in practice). Whatever the system employed in a given work, a description in terms of symmetry/tension and variability/invariability should prove an easy and efficient tool to chart the ways in which word and image interactions function at various levels: panel, tier, page, chapter, book, series.

Thus far, we have examined word and image relationships mainly in terms of how information is dispatched. However, we may also consider a second

perspective: the ways in which the dispatched information is presented. Within that context, issues of point of view (whose standpoint is filtering what we are seeing and reading?) and of voice (who is actually telling and showing?) are of crucial concern. Often inspired by or derived from debates in literature, the scholarship on these aspects—for instance, by Thierry Groensteen and Charles Hatfield—is quite impressive.[12] The most interesting scholarly discussions have rightfully foregrounded the complex nature of narration in comics and study said nature from both a linguistic and a visual point of view.

A number of trends have emerged within this doubly oriented scholarship. First, the work of the narrator has been split into a verbal and a visual aspect, the narrative act being the combination of both, at a metalevel, by a "meganarrator."[13] Second, and more importantly, images themselves—or rather, the styles in which they are drawn—are more and more frequently analyzed in narrative terms. Storytelling is also a matter of drawing, and the storyteller is not only a *voice* (in the literal or metaphorical sense of the word) but also a *hand*. Images not only communicate information but also contain revealing traces of one or more (embedded) narrators. Narrative theory traditionally recognizes that the presence of a verbal narrator can vary according to the number and the nature of the subjective elements that he or she includes in the narrative utterance: in the classic "telling" modus, these subjective elements will be overwhelmingly present; in the classic "showing" modus, the narrator will try to create the illusion of invisibility. Just so, the presence of a visual narrator—or as Philippe Marion says, "graphiator"[14]—varies between two extreme positions. On the one hand, an "objective" or "transparent" graphiation style encourages the reader to "look through" the images (typical examples include the *ligne claire* [clear line] aesthetic as developed by Hergé in *Tintin* [1929–1976], the minimalist style of Schulz's *Peanuts* [1950–2000], and the sleek, diagrammatic drawings of Chris Ware). On the other hand, a more subjective or self-reflexive graphiation style calls for the reader to "look at" the images (for example, Eddie Campbell's violently expressionist strokes in *From Hell* [1991], the punkish *horror vacui* of postcomix authors such as Julie Doucet, and the multicolored collage and scrapbook style of Lynda Barry). The written text within comics typically shares in these variations of style.

Once again, these distinctions are far from absolute and invariable. What matters most, in the context of the discussion of words and images, is to see whether there is or isn't a significant symmetry or tension between the workings of the verbal and the visual. Crucial in this regard is the analysis of the drawn "line" proposed by Jared Gardner. As Gardner argues, comics and graphic novels probably constitute the medium that best matches our age-old craving for the storyteller's actual physical connection to the artisanship of (written/printed) storytelling, which has been lost by the progressive spread of machines overtaking the role and place of the embodied storyteller (we no longer hear the storyteller, we read his or her text, and this text, which is no longer handwritten, fails

to bear any physical relationship with the body of its maker). Gardner states, "In fact, alone of all of the narrative arts born at the end of the nineteenth century, the sequential comic has not effaced the line of the artist, the handprint of the storyteller. This fact is central to what makes the comic form unique, and also to what makes the line, the mark of the individual upon the page, such a unique challenge for narrative theory."[15]

A given work can always shift from one position to another, and the changes in graphiation that such a shift entails can generate meaningful narrative information, including information about the graphiating instance. The inclusion of photographs in Spiegelman's *Maus* (1986 and 1991), for example, is not only a sign of increased veracity (*If you don't believe my drawings, look at these pictures!*) but also a way of suggesting a higher degree of emotional involvement: the narrator seems to withdraw from his story by replacing his subjective drawings with objective pictures at a moment when the story threatens to tip over into the unspeakable. The photos, after all, show us haunted survivors of the Nazi concentration camps: first Spiegelman's mother, then his father. The same effect can be observed when the book incorporates an older short story by the same author, "Prisoner on the Hell Planet" (1972), drawn in an expressionistic, heavy-on-pathos style that not only aims at creating sympathy for the narrator's difficult youth (the story describes his mother's suicide) but also, and perhaps more prominently, serves to amplify the emotional charge of the dryer, less subjective style of *Maus* itself, whose detachment is all the more impressive since the reader sees the hypersubjective pretext that Spiegelman had to put aside in the making of the final book.[16] In most cases, shifts in graphiation style are limited to local interventions: the degree of objectivity or subjectivity changes in order to highlight certain key moments of the story, as with *Maus*.

When applied on a larger scale, as in David Mazzucchelli's *Asterios Polyp* (2009), the transformations follow clearly defined rules.[17] Mazzucchelli shifts point of view and style according to his subject matter: the two protagonists, Asterios and Hana, male and female, are not drawn in the same way, and neither is their view on the world represented with the help of the same stylistic elements (see fig. 13.1). In all these examples, the shifts in visual graphiation draw the reader's attention to similar changes at a textual level, which often tend to go unnoticed (Asterios and Hana "speak" in different scripts and within different styles of word balloon).

The changes in visual style, in other words, are not just a way of stressing this or that local expressive or narrative detail. They force the reader to focus on the ever-shifting relationship between the style of the images and *the visual representation of the textual elements*, which are crucial to grasping the position of the narrative voice and hand.

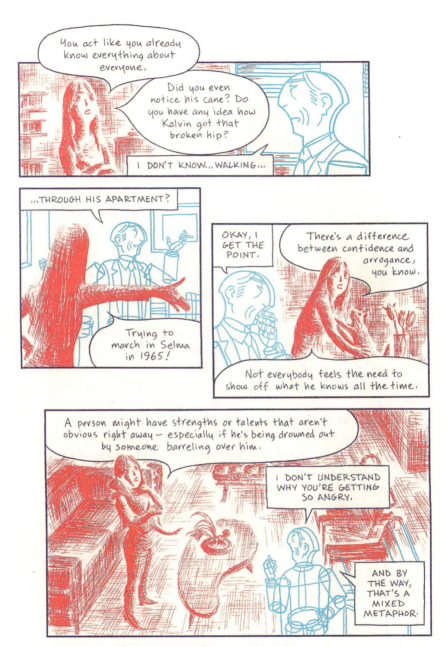

FIG. 13.1 Deliberate shifts in graphiation style and the visual presentation of text may imply different worldviews and personalities: David Mazzucchelli, *Asterios Polyp* (Pantheon, 2009).

Comics Language as Visible Speech

The uniqueness of comics results not only from the intertwining of words and images but also from the systematic visualization of speech. Even if not all relevant words are physically present in the drawn work (as stated earlier, the reader "translates" verbally what he or she perceives on the page) and even if the words are as much "heard" as they are read (Francophone *Tintin* scholars like to repeat the anecdote of the young fan who did not "recognize" Captain Haddock's voice in the film adaptations of the series), the words that do appear in a comic have a strong visual dimension, which is dramatically important for the meaning of the work. We can analyze this visual dimension in terms of two different but strongly intertwined phenomena.

First of all, it bears repeating that the verbal elements of a comic can take up multiple spatial positions in relation to the visual elements to which they are connected. For one, they can be presented as captions, clearly separated from the drawings. Often, captions are placed under the panels or the drawings, but it is always possible to diverge from this option, as for instance in Eddie Campbell and Daren White's *The Playwright* (2010), where the narrative voice is most often placed on top of the images, a choice that contributes to the subtle distortion between what we see and what we read.[18] Alternately, the verbal elements can be inserted into the text, where they can be either free-floating or "framed"—that is, distinguished from other visual elements by a speech or thought balloon. Though the distinction between caption and balloon may seem uneventful, its implications are far-reaching. On the one hand, the difference has clear ideological underpinnings, for historically the balloon-strip has been seen as typically American, whereas the captioned strip has been seen as typically European (it is known that Mussolini, who was a great Disney fan, forced the Italian publishers of Mickey Mouse to shift from the balloon modus to the caption modus). Even today, captions have an aura of "literariness" that is exploited by authors eager to stress the singularities of their verbal style as well as the purely visual qualities of their drawings. The use of speech balloons, not to mention the words they contain, has symbolic and narrative consequences of its own. From a visual point of view, a balloon can have a seriously invasive and disruptive influence on the composition of a panel, jeopardizing for instance the search for symmetry between words and images as sketched above. However, the use of captions can result in symbolic and narrative frustration as well, as the physical separation of words and images that the caption engenders may dampen the provocative tension between words and images.

On the other hand, the use of balloons may also serve to emphasize the autonomy of the single panel. Captions may be stretched out over a whole tier and may refer freely to the various images that compose the tier. Balloons, on the contrary, are more often tethered to one single image and, for that reason, tend to limit the storytelling ambitions of an author who craves a less linear, less

segmented way of storytelling. Not only are images "anchored" by the semantic content of the words that accompany them; they are also "chained" by the balloons that (if only partially) prevent them from interacting with the other panels. Therefore, the reaction against the commercial stereotypes of panel and strip as basic units of composition is often accompanied by an analogous suspicion toward the balloon, as can be seen for instance in Will Eisner's late-career attempts to transcend the grid-structure of the conventional comic book.

Great authors always manage to achieve great things no matter the system they choose to work with. The form of a balloon can be used in a variety of ways, and each of its parameters—its contour line, its color, its position in the panel, its graphic resemblance or lack of resemblance to other elements of the drawing, the parts of the drawing that it hides or highlights, its relationship with other balloons, its very presence or absence—can be the starting point of a fascinating exploration of the opportunities of the medium. Of course, the same applies to captions, not to mention works that very consciously mix both regimes (*Cages*, for instance, is definitely not a book that opts for the speech balloon as its overall model).

A second aspect of the visualization of speech has to do with the material form and size of letters, words, punctuation, and more generally, the segmentation of each respective unit. In literary scholarship, the wide range of aspects and phenomena that have to do with the visual dimension of the word is called *grammatextuality*.[19] In contrast to the plain, unmarked text, the visually highlighted grammatext, though commonly associated with the typographic experimentalism of certain literary genres (for example, concrete poetry), is absolutely crucial to the great majority of comic books. This primacy manifests in the often emphatic visual presence of the letterforms (for example, the use of **boldface** to foreground the key information of a sentence), in the configuration of the words in the speech balloons (a rhythmic effect may be created by the presentation of a sentence in shorter or longer lines), in the insertion of these balloons into the panels, in the presence of letters and other written symbols within the fictional world (for language can also appear as part of the fictional world or diegesis), and in the presence of onomatopoeia (*wham, whoosh, whap*). A good example of grammatextuality can be found in chapter 6 of *Cages* (fig. 13.2), where we can see the plain lettering of the speech of a lonesome and abandoned old lady (in reality, a monologue addressed to her parrot) shift suddenly to a more expressive style that makes the old lady's words resemble those of her violently screeching yet fully noncommunicative interlocutor, in a raw parody of what a dialogue is supposed to be like.

The use of grammatextual devices is not restricted to avant-garde or abstract comics, which often make a point of blurring the distinction between the verbal and the visual. It is also used by mainstream comics. Although these comics typically aim for mimetic transparency and ease of reading, they also play with the visual dimensions of their paratexts—in particular, with their title sequence,

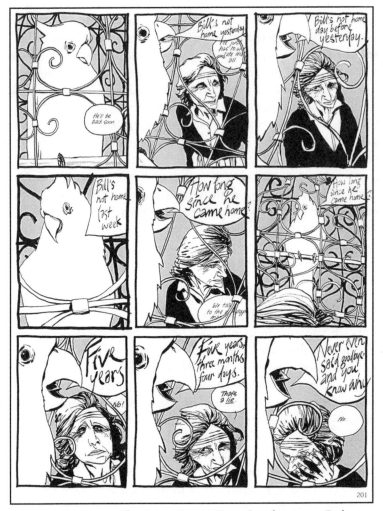

FIG. 13.2 Grammatextual variation: Dave McKean, *Cages* (1998; repr., Dark Horse, 2010), 201.

as that element is familiar to the reader and hence less likely to cause communicative errors. In *Little Nemo in Slumberland* (1905–1927), Winsor McCay thoroughly integrates the title words of his weekly comic, which are always clearly visible in the upper tier of the page, with the adventures of his young protagonist.[20] The interaction between paratext and text is twofold. First, there is a semantic correspondence between the date of publication (a key item in the building of an imagined community through newspaper reading) and the protagonist's dream. For example, in the installments of August 26 and September 2, 1906 (figs. 13.3 and 13.4), the connecting theme is definitely that of the summer holidays and of going swimming in an exotic-looking resort. Second,

Words and Images • 203

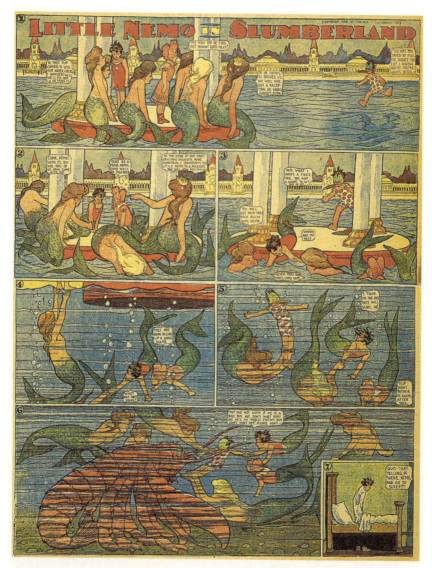

FIG. 13.3 Interaction between paratext and text: Winsor McCay, *Little Nemo in Slumberland*, August 26, 1906. San Francisco Academy of Comic Art Collection, The Ohio State University Billy Ireland Cartoon Library & Museum.

the shape of the title letters is manipulated in order to further stress the link between the building blocks of the author's imagination and the final result on the page. In both weekly comics, we see Nemo play with mermaids who take him underwater to show him the horrors of life below (in this case, the monster is a giant, threatening lobster). The installments form one continuing story so that the second page, published one week after the encounter with the lobster, starts under the sea. This narrative situation changes the form of the letters,

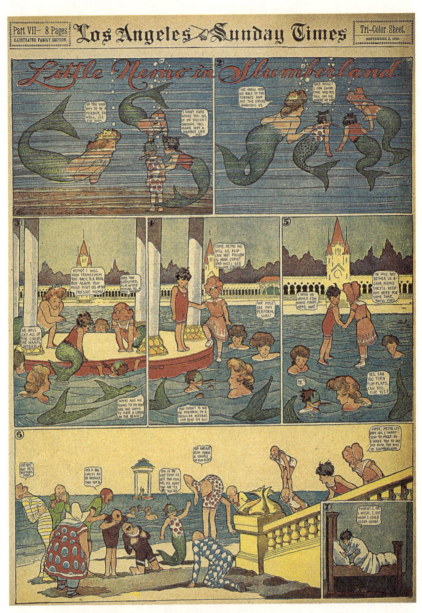

FIG. 13.4 Interaction between paratext and text: Winsor McCay, *Little Nemo in Slumberland*, September 2, 1906. San Francisco Academy of Comic Art Collection, The Ohio State University Billy Ireland Cartoon Library & Museum.

which are drawn in a different, less angular style, in order to evoke the slightly distorted underwater perception of the protagonist.

More radical is what George Herriman does in the later period of *Krazy Kat* (1913–1944).[21] In the 1936 installments, for instance, each page opens with a title panel that displays endless new variations on the form of the words "Krazy Kat," which the reader is invited to use as a thematic "key" (almost in the musical sense of the word) to the text. In one special case, that of November 22 (fig. 13.5), the whole comic revolves around an expansion of that basic principle. The page is divided into three panels. In the first one, we see the words of the title projected onto a black backdrop (smoke?), and in the rightmost part of this image, we spot Krazy (the cat), Ignatz (the mouse), and Joe Stork (yes, the stork), smoking a pipe that Ignatz has prepared for him. In panels 2 and 3, Herriman shows us the consequences of the pipe-smoking bird's flight, first in daylight and then by night: in the second image, the stork writes an electoral slogan in smoke ("Elect Ignatz Mouse"), while in the third and last image, a new constellation, seemingly formed of "fire flies," has appeared in the night sky, displaying a new slogan ("Illekk Krezy Ket"). The whole comic can be seen as a series of grammatextual variations, with great thematic impact of course, on the very idea of words on the page.

Obviously, the difference between (unmarked) text and grammatext bears some relationship to the difference between objective and subjective modes of graphiation. However, one should not overhastily conclude that these couples neatly coincide. *Maus*, for instance, which does not at first sight appear to be a work that puts a strong emphasis on grammatext, succeeds in establishing a very subtle and touching connection between the absolute tragedy that it narrates and the restrained use of the visual possibilities of the text, the slightly awkward, slightly wooden aspect of which offers an interesting analogy to the tone of the nonnative English spoken by Spiegelman's father. Translators (and letterers, editors, and publishers involved in the translation process) face the challenge of having to drop or modify visual elements of the original work in order to capture such analogies. This challenge provides indirect but convincing proof of the importance of these minimal yet decisive grammatextual elements.

The distinction between handwritten and machine-printed words plays an important role in this regard, although their opposition is also relative. Not all hand-lettering systems aim at displaying a personal touch; in fact, the contrary is true for traditional lettering, which aspires to be just as neutral and transparent as the classic mimetic drawing style. Conversely, not all machine-lettered texts are deprived of strong grammatextual effects, as can be observed in the systematic use of visual highlighting or in the handwritten origins of many machine-printed conventions (which are frequently evoked by Chris Ware in his manual *redrawing* of machine-printed models). Special mention should be awarded to the specific subfield of what we might call "the words in the image"—that is the representation of words on or as objects within the drawn

FIG. 13.5 Grammatextual variation: George Herriman plays with the very idea of words on the page. *Krazy Kat*, November 22, 1936. *Krazy Kat* © 1936 King Features Syndicate, Inc., Hearst Holdings, Inc. Used by permission. All rights reserved. The Ohio State University Billy Ireland Cartoon Library & Museum.

story world: for example, images of books, papers, or signboards that appear as important objects within the narrative. Such diegetic texts are usually hand-drawn, though it is always possible to insert machine-printed, photographed, or scanned sources (one could, for instance, depict a character reading a newspaper article, followed by a scanned close-up of the printed text that he or she is reading). And of course, the very drawing of these elements is never a neutral operation but an opportunity to add a supplementary layer of forms and meanings to the work, be it in the perspective of increased realism (so-called local color) or, more interestingly perhaps, in order to provide the reader with special interpretive keys. Alison Bechdel's *Fun Home* (2006), for instance, abounds in hand-drawn re-creations of literary texts, dictionaries, and other printed forms, as well as of handwritten letters, and these re-creations of textual objects have been interpreted as significant.[22]

Finally, the narrative and structural levels that define the comics form pose challenges to the verbal-visual dynamic. Just as a comic's text, graphically, follows the principle of functional differentiation by dividing into different strands and levels (paratextual information, the narrator's voice, dialogues between characters, verbal elements within the fictional diegetic world, and so on), all these differences in text category coincide with a difference in place as well as in form. That is, the major categories of text occupy different sites spatially: we find them in the margins of the book (paratexts), in the margins of the panel (the narrator's voice), within the speech balloons (dialogues between characters), and inside the story world (verbal diegetic elements). Moreover, these differences in position can be underscored by formal differences. In traditional comics, one can easily notice the differences between the grammatextual features of the author's (or the publisher's) voice in the paratext, the narrator's voice in a caption, the character's voice in a speech balloon, and the object's voice (so to speak) in the diegetic world of the drawings. Some authors, however, take advantage of the grammatextual dimension of a text to pursue a different ambition—not one of separating but of *intertwining* layers and voices. Chris Ware's *Jimmy Corrigan: The Smartest Kid on Earth* (2000) is a good case in point, for in this book, the principle of functional differentiation alternates with another principle we could call "visual crisscrossing." Here, the paratext tends to become a real part of the text, the text includes a large number of paratextual elements, the text is drawn in the same style as the images, the grammatextual characteristics of the narrator's comments are sometimes the same as those found in the dialogues, and last but not least, it is hard to differentiate stylistically between the texts visible inside the story world and the speech visible in the captions and balloons.[23]

Words and images working together have always been considered a decisive feature of comics. But their complex relationships have often been reduced to narrowly formal discussions on the role and place of speech balloons, captions, and various types of onomatopoeia, on the one hand, or ideologically biased

critiques of the negative influence of comics on reading culture. Recent scholarship has contributed to a more balanced and richer approach to the interaction between words and images, taking into account issues of authorship and narrative structure and offering new perspectives on the visuality of the text in comics, as both a print medium and a cultural practice with its own traditions and conventions.

Notes

Thanks go to Charlotte Pylyser for her careful and critical rereading of a first version of this text.

1. David Beronä, *Wordless Books: The Original Graphic Novels* (New York: Abrams, 2008).
2. For an in-depth analysis of these issues, see Thierry Smolderen, *The Origins of Comics: From William Hogarth to Winsor McCay*, trans. Bart Beaty and Nick Nguyen (Jackson: University Press of Mississippi, 2014), which is currently the best cultural history of early comics available in English.
3. Gérard Genette, *Paratexts: Thresholds of Interpretation*, trans. Jane E. Lewin (New York: Cambridge University Press, 1977).
4. The most detailed overview of this issue can be found in Groupe Mu, *Traité du signe visuel* (Paris: Seuil, 1993).
5. W. J. T. Mitchell, "There Are No Visual Media," *Journal of Visual Culture* 4, no. 2 (2005): 257–266.
6. W. J. T. Mitchell, *Iconology. Image, Text, Ideology* (Chicago: University of Chicago Press, 1985).
7. Roland Barthes, "The Photographic Message," in *Image, Music, Text*, trans. Stephen Heath (London: Fontana, 1977), 25.
8. Pierre Fresnault-Deruelle, "Du linéaire au tabulaire," *Communications* 24 (1976): 7–23.
9. Roland Barthes, "The Rhetoric of the Image," in *Image, Music, Text*, 32–51.
10. *Imagetext* was coined by W. J. T. Mitchell in his book *Picture Theory* (Chicago: University of Chicago Press, 1992).
11. Dave McKean, *Cages* (1998; repr., Milwaukie, Ore.: Dark Horse, 2010).
12. Thierry Groensteen, *Comics and Narration*, trans. Ann Miller (Jackson: University Press of Mississippi 2013); and Charles Hatfield, *Hand of Fire: The Comics Art of Jack Kirby* (Jackson: University Press of Mississippi, 2011).
13. On the concept of meganarrator, see André Gaudreault, *From Plato to Lumière: Narration and Monstration in Literature and Cinema*, trans. Timothy Barnard (Toronto: Toronto University Press, 2009).
14. Philippe Marion, *Traces en cases* (Louvain-la-Neuve: Académia, 1993). For a discussion of the graphiation concept, see Jan Baetens, "Revealing Traces: A New Theory of Graphic Enunciation," in *The Language of Comics: Word and Image*, ed. Robin Varnum and Christina T. Gibbons (Jackson: University Press of Mississippi, 2001), 145–155.
15. Jared Gardner, "Storylines," *Substance* 40, no. 1 (2011): 56.
16. Art Spiegelman, *The Complete Maus* (New York: Pantheon, 1996).
17. David Mazzucchelli, *Asterios Polyp* (New York: Pantheon, 2009).
18. Eddie Campbell and Daren White, *The Playwright* (Marietta, Ga.: Top Shelf, 2010).

19 The notion of grammatextuality was coined by the French critic Jean Gérard Lapacherie; see his article "De la grammatextualité," *Poétique* 59 (1984): 283–294. For a transfer of this concept to the field of digital studies, see Terry Harpold, *Ex-foliations: Reading Machines and the Upgrade Path* (Minneapolis: University of Minnesota Press, 2008).
20 Winsor McCay, *The Complete Little Nemo in Slumberland*, vol. 1, *1905–1907* (Seattle: Fantagraphics, 1998).
21 George Herriman, *Krazy Kat: The Complete Full-Page Comic Strips, 1935–1936* (Seattle: Fantagraphics, 2005).
22 Regarding Bechdel's hand-drawn re-creations of printed texts within *Fun Home*, see, in particular, Hillary L. Chute, *Graphic Women: Life Narrative and Contemporary Comics* (New York: Columbia University Press, 2010), chap. 5.
23 Chris Ware, *Jimmy Corrigan: The Smartest Kid on Earth* (New York: Pantheon, 2000).

Part IV

Genres

14

Superheroes

MARC SINGER

More than any other genre, superheroes are indelibly associated with comic books in America. Almost as old as the comic book format itself, their fortunes have waxed and waned from their debut in the 1930s to their near-disappearance in the 1950s, and most recently, their domination of popular film in the twenty-first century. Now more visible than ever, superhero stories continue to present the same characters, conventions, and ideological conflicts to audiences worldwide. As champions of the oppressed who break the law in order to defend society, superheroes promote a contradictory mythology that mingles heroic individualism, civic responsibility, and redemptive violence. Other elements of the genre animate our most potent fears and desires about masculinity and femininity, science and technology, urbanity and modernity. With their continued expansion into other media and other markets, superheroes now play out these anxieties not just in the American comics industry but across global popular culture.

Origins of the Superhero

Although the superhero genre is almost universally recognized as beginning with the first appearance of Superman in *Action Comics* #1 (1938), its origins predate any comic book. The first superhero creators drew upon multiple influences, including science fiction, Westerns, swashbuckler films, the pulps, and comic strips.[1] The elements that constitute the genre would not come

together, however, until two young science fiction fans named Jerry Siegel and Joe Shuster created Superman. They had already collaborated on "The Reign of the Superman" (1933), a self-published short story about an unemployed man who receives tremendous psychic powers and exploits them for personal gain.[2] Unlike this tyrannical figure, however, the Superman who appeared in *Action Comics* used his powers to serve the public good, even if that meant defying the rule of law or the will of the public itself; in his earliest adventures, he saves a wrongly convicted woman from the electric chair and breaks up a lynch mob. This new Superman was the last survivor of an alien planet, placed in a rocket by parents he would never know. He wore a skintight costume, modeled on a circus strongman's outfit, that advertised his physical prowess, yet he also concealed his remarkable abilities under the guise of Clark Kent, the mild-mannered newspaper reporter.

Individually, these elements had appeared elsewhere—Doc Savage, Tarzan, the Phantom, the Scarlet Pimpernel—but collectively, they established a new genre and a new kind of adventure hero. Peter Coogan distills the superhero down to three traits: a mission to fight evil and injustice, superpowers and abilities, and a "secret" or dual identity, with one identity emblematized by a costume.[3] Richard Reynolds adds other elements, including a contrast between the extraordinary superhero and mundane society, a desire to reach atonement with absent or dead parents, and a depiction of science as a form of magic.[4] However, semantic definitions such as these typically overlook the social and institutional contexts that also shape genres, such as superheroes' publication in the new medium of comic books.

Siegel and Shuster originally conceived Superman as a newspaper comic strip, but after repeated rejections, they settled for the ancillary format of the comic book. The first successful comics published in magazine or pamphlet format were generally reprinted newspaper strips or promotional giveaways; by the mid-1930s, comic books were publishing original material, but the content was still derivative of newspaper strips (see chapter 2). Superheroes were the first distinct genre original to comic books, and they were a runaway success—vendors reported that children were coming up to newsstands and asking for "the magazine with Superman in it."[5] Publishers began churning out imitations by the truckload. Newsstands were soon filled with the adventures of Batman (1939), the Human Torch (1939), the Sub-Mariner (1939), Captain Marvel (1939), the Green Lantern (1940), Captain America (1940), Plastic Man (1941), Wonder Woman (1941), and dozens of other costumed heroes.[6] These comics were frequently hurried and crude, produced under an industrial-style division of labor that separated the roles of writer, penciler, inker, letterer, colorist, and editor in order to increase the pace and volume of production—a system that persists to this day.[7] However, some artists refined their techniques for the new medium: Captain America creators Joe Simon and Jack Kirby animated their pages with raucous battles, extreme perspectives, and dynamic figures that exploded

outside the panel borders.[8] Artists began to treat the page as their unit of composition, moving away from their comic strip inspirations. Comic books continued to publish across a range of popular genres, from funny animals to jungle queens, but superheroes fueled their expansion and helped establish them as a viable mass medium in their own right.

This sudden popularity sparked an equally immediate backlash. In May 1940, *Chicago Daily News* literary editor Sterling North wrote an editorial decrying comic books for targeting children with lurid images of sex and violence.[9] The column triggered the first moral panic over comic books, and publishers wasted no time in responding to North's accusations. DC Comics sought to defend their heroes as healthy, wholesome figures by assembling an editorial advisory board of credentialed experts (one of whom, psychologist William Moulton Marston, went on to create Wonder Woman). DC also adjusted their characters to match this new image. Batman stopped shooting criminals and became an honorary member of the police; he also took on a more genial and paternal role as mentor to Robin, the Boy Wonder, who had been introduced a few months before North's editorial.[10] Superman, who began his career fighting crooked arms dealers, corrupt politicians, and other greedy capitalists as a two-fisted reformer, abandoned his quest for social justice and started fighting mad scientists.[11] At DC Comics, at least, the superheroes were no longer outlaws or social crusaders. They had become morally upstanding defenders of the very laws they had once broken.

The explosion of superhero comics in the late 1930s and early 1940s initiated a period remembered by the fans and collectors of a later generation as the Golden Age of comics. (Such labels applied primarily to superhero comics, offering an incomplete and overly nostalgic history of comics as a whole.[12]) During the Second World War, the most popular heroes, such as DC's Superman and Fawcett's Captain Marvel, regularly sold more than a million copies an issue—copies that were often passed around to multiple readers. More than 90 percent of American children (boys and girls alike) read comic books.[13] America's entry into the war only boosted their popularity. Comic book covers showed superheroes doing battle against German and Japanese soldiers (the latter usually represented in racist caricatures) and exhorted readers, or their parents, to buy war bonds. The prohibitions that had barred Superman from fighting Nazis were quickly dropped, and superheroes became enthusiastic supporters of the war effort. (Not every publisher had issued such prohibitions: at Timely Comics, Jack Kirby's cover for *Captain America Comics* #1 [1940], released almost a year before Pearl Harbor, had shown the good Captain punching Adolf Hitler in the jaw.) Comic books were shipped overseas to provide reading material for servicemen, and the adult readership would only grow in the postwar years.[14]

Sales of superhero comics, however, collapsed after the war's end. All but a handful of superhero titles were canceled, supplanted by crime, horror, war,

Western, and romance comics. Comic book sales soared, yet the moral panic that had flourished briefly after North's editorial returned in full force, fanned by newspaper campaigns, decency crusades, and fears over juvenile delinquency (see chapters 2 and 9). These populist protests were accompanied by criticisms from intellectuals such as Walter Ong, Gershon Legman, and most notably, Fredric Wertham.[15] Wertham, a psychiatrist who studied child development, criticized comic books for their violence, racism, and sexual imagery and maintained that they contributed to juvenile delinquency. He publicized these criticisms first at a psychotherapy symposium in 1948, then in a series of articles in popular magazines such as the *Saturday Review of Literature*, *Reader's Digest*, and *Ladies' Home Journal*. These articles led to his testimony before the New York state legislature and the U.S. Senate Subcommittee on Juvenile Delinquency, as well as the publication of *Seduction of the Innocent* (1954), the most famous and incendiary attack on comic books. This pressure from intellectuals, legislators, and activists led the majority of comics publishers to form the Comics Code Authority, which attempted to placate critics by regulating the content of comics. The Comics Code banned graphic violence and sexuality, prohibited horror comics, and insisted that comics promote respect for parents, police, and other authority figures. Wertham regarded industry self-regulation as inadequate, little more than a public-relations move; nevertheless, the adoption of the Code in 1954 (as chapter 2 here recounts in detail) cemented comic books' image as a juvenile art form marketed solely to children.[16]

The Second Generation of Superheroes

While superhero fans and creators have reviled Wertham for his criticisms of the genre—particularly his insinuations that Superman was a fascist, Wonder Woman a lesbian, and Batman and Robin "a wish dream of two homosexuals living together"—superhero comics only received a minor portion of his criticism, as most of his attention was directed at the lurid crime and horror comics of the postwar years.[17] Arguably, the anticomics crusade did the superheroes a favor: after the Comics Code all but eradicated the crime and horror comics and drove several smaller publishers out of the comics business, superheroes returned to fill the void. In the mid to late fifties, DC Comics editor Julius Schwartz began reviving his company's canceled Golden Age heroes in updated versions that replaced the magical origins of the thirties and forties with science fiction elements better suited to the age of the space race and the atomic bomb. The Flash (reintroduced in 1956) was now a police scientist with a new streamlined costume; Green Lantern (1959), who had previously received his powers from a mystical Chinese lamp, was now a dashing test pilot who worked for an intergalactic corps of lawmen; Hawkman (1961), previously a reincarnated Egyptian prince, was now an alien police officer. Featuring clean, polished art

and clever (if formulaic) plots, the comics sold well, and DC brought back more superheroes in a revival that fans would later term the Silver Age.

DC was not the only company to capitalize on the resurgent interest in superheroes. Reportedly, after Marvel Comics publisher Martin Goodman noticed the healthy sales of *Justice League of America* (1960), a team book that united DC's top superheroes, he ordered Stan Lee, his editor and head writer, to come up with an imitation.[18] Lee turned to veteran artist Jack Kirby to launch *Fantastic Four* (1961), about a team of explorers transformed by cosmic radiation. But the Fantastic Four were no mere knockoffs of DC's establishment heroes. They included among their number a scientist and his self-effacing fiancée but also a teenaged hothead and a surly bruiser who lamented his transformation into a rocky monster. The Thing, as he was called, regarded his powers as more curse than blessing, setting a pattern followed by other Marvel outcast heroes, most notably the Hulk (1962), Spider-Man (1962), and the X-Men (1963). Other heroes such as Iron Man (1962) and Daredevil (1964) were distinguished by the physical disabilities that came with their powers. Marvel's focus on teenagers and outsiders came to inflect its politics as well; while it initially trafficked in a gung ho anticommunism, as the Vietnam War escalated, the comics gradually shifted first to a liberal humanism and then later to overt sympathy with the antiwar movement, other protest movements, and the sixties counterculture.[19]

These changes were the result of a generational shift within the comic book industry as older creators were replaced by younger ones. The transition was not always amicable; when several longtime DC freelancers attempted to organize in demand of royalties and benefits, DC stopped giving them work and hired younger creators instead.[20] Veteran writers, who often came from other fields or harbored other ambitions, were replaced by young fans who had grown up on superhero comics. Many of these writers came from the fanzines—that is, the self-published magazines and newsletters that emerged from science fiction fandom—and from the letter columns published in the comics themselves. Roy Thomas exemplified their career trajectory: after first writing to letter columns in the early 1960s, Thomas soon graduated to helping Jerry Bails publish the fanzine *Alter Ego*, the first dedicated solely to superheroes. Hired as Stan Lee's editorial assistant in 1965, Thomas also wrote scripts and ultimately succeeded Lee as editor in chief of Marvel Comics in 1971, barely a decade after his first letters were published.[21] Thomas and the host of other fans who became writers, artists, and editors were invested in exploring the characters' histories and exploiting the connections between different comics set in the same shared universe—a web of intertextual narratives that fans would term *continuity*. These continuities would ultimately develop into vast narratives with decades of history created by hundreds of writers working in dialogue with one another.[22] As more fans entered the comics profession, these continuities became ever more elaborate.

The superhero revival of the 1960s attracted other publishers such as Tower, Charlton, and even Archie Comics, particularly after the overnight success of the *Batman* television series (1966–1968).[23] The Batman fad soon ended, however, and sales began to fall once again. The genre entered a period of retrenchment and consolidation in the 1970s as the surviving publishers attempted politically relevant approaches to the superhero and experimented with other genres, such as monster comics (made possible by a revision of the Comics Code in 1971), fantasy, and kung fu. Sales continued to decline. The neighborhood convenience stores that had sold comics were disappearing, replaced by supermarkets that weren't interested in stocking such low-profit items. (In 1972, most comic books still cost just twenty cents, only a dime more than they had in the 1930s.) The industry also suffered from the punishing economics of newsstand distribution. As much as three-quarters of a print run could be returned to the publishers unsold—or shady distributors could claim the comics were unsold while moving them on the black market, pocketing the money, and receiving credit from the publishers. For these reasons, the comics industry began a gradual shift toward direct distribution, selling to a growing network of comics specialty stores that bought comics at wholesalers' discounts but could not return unsold copies (see chapters 2 and 7). The direct market reduced overprinting, moving the risk from publishers to retailers; it also catered to a fan audience, resulting in more comics published by and for superhero fans.[24]

One of the most successful superhero comics to emerge in the 1970s was Chris Claremont and Dave Cockrum's revival of *X-Men* (1975). Claremont, Cockrum, and Cockrum's successor, John Byrne, turned an unpopular title into a fan favorite by focusing on complex (if melodramatic) characterization, long-running story lines, an elaborate continuity, and a diverse, multinational cast of heroes.[25] Claremont had a penchant for writing assertive and powerful women, although his feminism had its limits: the mutant Phoenix's corruption and eventual destruction by her own powers was tied to her sexual gratification. Less troubling was Claremont's evolution of Magneto from a typical supervillain to a morally ambiguous character, a Holocaust survivor who wanted to protect mutants like himself from further persecution. The X-Men were depicted as objects of fear, prejudice, and oppression, leading readers to interpret them as free-floating metaphors for African Americans, gays, Jews, and other marginalized groups—not to mention adolescents, particularly those outcasts who read comic books. Turning his mutant heroes into a mutable allegory, Claremont created a powerful vehicle for reader identification by conflating a conditional social ostracism with systematic and institutional oppression.[26]

Superhero Revisionism

While Claremont, Cockrum, and Byrne were building the X-Men into Marvel's most popular characters and setting the tone for most mainstream superhero comics in the 1980s and beyond, another movement was forming on both sides of the Atlantic. American and British creators, most notably Frank Miller, artist and writer on *Daredevil* (1979), and Alan Moore, writer of *V for Vendetta* (1982) and *Marvelman* (1982, reprinted and continued in the United States as *Miracleman*, 1985), began crafting superhero comics that featured cynical social commentary, mature sexuality, and graphic violence. These comics cultivated an audience of older readers and began a trend toward revisionist superheroes, culminating in Miller's *Batman: The Dark Knight Returns* (1986) and Moore and Dave Gibbons's *Watchmen* (1986–1987).[27] The revisionist comics represented superheroes as morally ambiguous or suspect figures, although they critiqued the genre from a broad range of ideological positions. Moore tended to adopt a self-critical left-wing perspective: his comics represented some superheroes as archconservative thugs, others as liberal dictators, and still others as anarchist revolutionaries, but they ultimately condemned anyone who attempted to impose their ideals through violence. Miller, on the other hand, celebrated his tough-guy vigilantes as he pitted them against corrupt civic authorities. When Miller's Batman seized control of Gotham City at the head of a mob and then battled the government that allowed the city to fall into chaos, he was both an antiauthoritarian rebel and a fascist leader.

The revisionist comics exerted a powerful influence on the genre. After Moore's initial work for the American comics industry on *Swamp Thing* (1983) proved successful, publishers recruited other British writers and artists such as Neil Gaiman, Grant Morrison, and Dave McKean.[28] These creators generally regarded superheroes with no small amount of skepticism, particularly the superhero's role as a defender of law and order who enforces social norms through righteous violence. The revisionists also broke new ground commercially. Together with Art Spiegelman's Holocaust narrative *Maus* (1986 and 1991), *Watchmen* and *The Dark Knight Returns* found significant audiences among noncomics readers when they were collected into book form and sold in bookstores. This format of comics, written as finite works and published under one cover, would be marketed to adult readers as "graphic novels" (see chapter 6).[29] However, for many creators, the easiest and most financially rewarding way to emulate the revisionists' success was simply to increase the sex and violence in other superhero comics. These changes were made in the name of realism or maturity, though they more often resulted in grotesque excesses such as the crippling of Batgirl or the murder of Robin—which happened after readers voted to kill him in a telephone poll (1988).[30] Flooded with cheap and exploitative imitations, the vogue for adult comics would fizzle out in the early 1990s.

Graphic novels would have to wait another decade to gain a widespread adult audience through their exposure in bookstores and classrooms—and when they did, they would garner it primarily for work outside the superhero genre.

The superhero publishers instead continued to focus on periodical comic books distributed through the direct market. By the end of the 1980s, the bulk of comics publishing and sales had shifted over to comics stores. The growth of the direct market reversed the sales slump of the 1970s and supported new publishers such as First, Pacific, and Eclipse, but it also caught the comics industry in a new cycle of booms and busts driven by speculation and overproduction.[31] A glut of independently published black-and-white comic books sought to duplicate the success of Kevin Eastman and Peter Laird's *Teenage Mutant Ninja Turtles* (1984) but only left retailers stuck with boxes of unsellable, nonreturnable comics. The longest and largest boom took place in the late 1980s and early 1990s, driven by a confluence of factors: the popularity and media attention given to the revisionist comics, the growth of the comic book collector's market, the collapse of the market in baseball cards (which led to an influx of speculators searching for new collectibles), and the formation of Image Comics, founded by seven artists who left Marvel to start a new company where they would have full ownership of the characters they created. Image titles such as Rob Liefeld's *Youngblood*, Jim Lee's *WildC.A.T.s*, and Todd McFarlane's *Spawn* (all 1992) amplified the intense violence and exaggerated sexuality of the revisionist superheroes while dropping their social critiques and subversion of genre conventions. They were also wildly successful, although their sales were inflated by speculators who bought and stored multiple copies as investments, not realizing their comics were unlikely to become rare collectibles when every other collector was also buying and storing multiple copies. When the speculator bubble collapsed in the mid-1990s, falling sales drove thousands of comics stores and several publishers out of business. In 1996, even Marvel Comics—loaded with unwise acquisitions and high-yield junk bonds courtesy of its then-chairman, Ronald Perelman—went bankrupt.[32] Sales recovered in the 2000s, particularly in the expanding sector of graphic novels, but have not sustained the artificial heights they reached during the speculator bubble.

The Metatextual Superhero

Comic books have not been a truly mass medium for decades; once read by nearly every child in America, they now cater primarily to a core audience of a few hundred thousand fans, mostly adults, who buy comics at specialty stores or through digital downloads or cloud-based apps (see chapter 17).[33] Superhero comics written for that audience have become increasingly self-referential and metatextual, obsessively revising their own narrative continuities in multititle crossovers such as *Crisis on Infinite Earths* (1985) or *Infinite Crisis* (2005) while

celebrating their history in titles such as Kurt Busiek and Alex Ross's *Marvels* (1994), Busiek's *Astro City* (1995), or Alan Moore's *Supreme* (1996). Caught between traditionalist fans and risk-averse publishers, superhero comics have been captured by their past. The most popular heroes were created between the late 1930s and the early 1970s; even the few relatively new characters such as Warren Ellis and Bryan Hitch's *The Authority* (1999) tend to be pastiches of older, more familiar heroes. The major publishers provide no incentive to develop new superheroes, however, as they hold the copyrights to any characters created for them as work for hire. This has been standard practice in the industry ever since Jerry Siegel and Joe Shuster sold Superman to DC in exchange for a flat rate of ten dollars per page.[34] By the 1980s, the comic book companies had instituted royalties, but they still hold the copyrights and reap most of the profits (see chapter 7). Some independent publishers such as Image and Dark Horse allow creators to retain the copyrights, and titles like *Spawn* and *Hellboy* (1994) are owned by their creators; even in those cases, however, creators may contract other artists under work for hire.

Ironically, while the comics market was shrinking, the superhero genre was expanding its audience through adaptations in other media. Superheroes have always been popular sources for adaptation: Superman almost immediately became the star of a successful newspaper strip (1939), followed by a radio show (1940), animation (1941), movie serials (1948), a live-action television series (1952), and eventually major studio films (1978). Batman also enjoyed success in adaptations as diverse as the campy William Dozier–produced television show (1966) and the moody Tim Burton films (1989, 1992), and other superheroes made the leap to television and video games. In the first decades of the twenty-first century, however, superheroes became one of the dominant genres in popular culture following the success of *X-Men* (2000), *Spider-Man* (2002), and other film franchises. Many of these films have used the language and conventions of the superhero genre to respond to the terrorist attacks of September 11, 2001, and the wars in Afghanistan and Iraq. The makers of *Spider-Man* removed footage of the World Trade Center but added a scene of Spider-Man posing in front of an American flag, transforming the social pariah into a patriotic New Yorker; *Iron Man* (2008) depicts its hero, both a product and a living embodiment of the military-industrial complex, destroying terrorists in Central Asia with precision strikes that leave innocent civilians unharmed. Numerous reviewers and pundits identified *The Dark Knight* (2008), in which Batman resorts to illegal surveillance, rendition, and torture to combat the Joker's terrorist attacks, as an allegory for the post-9/11 war on terror, although they quarreled vigorously over whether Christopher Nolan's film endorses or criticizes these practices.[35] Film scholar David Bordwell cautions against any simple "zeitgeist readings" that attribute these films' success purely to their political allegories, identifying a number of other material and cultural factors

behind the rise of the superhero movies, including improvements in digital special effects, the increasing legitimacy and profitability of fantasy genres, and movie studios' preference for proven franchises with built-in merchandising opportunities.[36] Nevertheless, movies remain the most visible form of the superhero genre in the twenty-first century.

Superhero films, along with television adaptations and the comics industry's expansion into bookstores and online sales, have reached new audiences outside the direct market. Those audiences have in turn contributed to a belated diversification of the genre, which has often struggled with the politics of representation. Studies of gender, sexuality, race, and disability in superhero comics have found depictions ranging from the most entrenched stereotypes to more sophisticated and inclusive figures.[37] Early efforts at creating more diverse superheroes such as the Black Panther (1966) or Luke Cage (1972) could rely on exoticizing clichés, while later projects such as Milestone (1993), a comics imprint with a multicultural ethos run by black creators, proved short-lived.[38] In more recent years, publishers have promoted new superheroes, such as G. Willow Wilson, Sana Amanat, and Adrian Alphona's Kamala Khan, a Pakistani American Muslim teenager who assumes the identity of Ms. Marvel (2014). Like Ms. Marvel, most of these heroes use the names or branding of preexisting characters controlled by the publishers, a strategy for attracting readers but also a means of extracting value from otherwise abandoned or exhausted properties through the commodification of cultural diversity. However, all of these efforts have generated characters who broaden the representation in superhero comics, reaching out to previously underserved audiences while expanding the opportunities for a more diverse pool of creators.

Interpreting the Superhero

As these examples should indicate, the superhero genre has demonstrated a wide (though not unlimited) range of meanings and inspired equally varied critical interpretations. One approach, particularly popular in comics fandom, defines superheroes as a modern mythology and attempts to trace their lineage back to the gods and heroes of the ancient world, although some scholars have noted that superhero comics do not typically perform the sacred cultural work done by religious mythologies.[39] Other scholars view the genre's "myths" through more strictly ideological terms: critics such as John Shelton Lawrence and Robert Jewett argue that superhero stories are fundamentally antidemocratic for their celebration of powerful individuals who maintain or restore the existing social order through violence.[40] Like Lawrence and Jewett, Thomas Andrae argues that the genre promotes passivity in its audience, both through the spectacular superhuman violence of its protagonists and through the lack of any temporal progression or change in its serialized, never-ending

stories.[41] These assertions dovetail with Umberto Eco's observation that long-running superhero stories create an "oneiric climate" in which progress and change are impossible because the narrative always resets itself to the status quo at the beginning of each new story; for Eco, this stasis is connected to the superhero's ideology as a defender of capitalism and protector of private property.[42]

Other scholars see the genre as more complicated or ambivalent. Richard Reynolds argues that superheroes contain and resolve multiple contradictions, including more oppositional or satirical readings that cut against the superhero's typical role as a defender of the status quo.[43] Charles Hatfield similarly argues that the genre conventions are themselves in conflict, playing out tensions between violent individualism and social responsibility, between the meek secret identity and the flamboyant heroic identity, between personal and public modes of justice.[44] These contradictions lie at the heart of the genre and have been present since its inception: the Superman of the 1930s protected ordinary citizens from unscrupulous industrialists and crooked politicians, but he also exerted his power without limit or consequence. When he wrecked factories or abducted corrupt mine owners, he had no more legal authority than the lynch mob he battled in one of his first acts of vigilante justice. Like other popular genres and formula stories, superheroes are built around the reconciliation of irreconcilable tensions and desires.[45] They are champions of the oppressed who impose their values through physical dominance and heroic individuals who promote passivity and escapism—although some of the genre's most eloquent defenders, notably novelist Michael Chabon, have championed escapism as both a sane response to the pressures of everyday life and the impulse that inspires all art.[46]

This variety of ideological interpretations highlights a disparity between readers such as Reynolds, Hatfield, and Chabon, who view the genre as the work of specific creators, and those such as Lawrence and Jewett, who only look at the genre in the abstract. Indeed, their focus is so abstract that they discuss few actual superhero texts, instead applying "superhero" as an archetypal, ahistorical label that describes everything from American presidents to Disney movie characters. When archetypal critics do address superhero comics, they tend to focus on characters published under the type of long-running, open-ended serialization that favors stability and familiarity over change. More auteurist examinations of specific creators, especially those who work on finite stories freed from the pressures of continuous serialization, tend to look at works with alternative meanings and oppositional or idiosyncratic ideological positions; the most radically revisionist works such as *The Dark Knight Returns* and *Watchmen* were produced under such conditions.

On the other hand, so long as the superheroes are owned by their publishers and not their creators, there is no guarantee that any story will be finite.

DC Comics enticed Frank Miller to produce two belated sequels, *The Dark Knight Strikes Again* (2001) and *Dark Knight III: The Master Race* (2015), and published *Before Watchmen* (2012) over the vocal objections of Alan Moore. Corporate owners have a financial incentive to extend any successful title in perpetuity and to maintain the characters in their most familiar and marketable forms. These practices have constrained the development of the genre just as they have deprived its creators of compensation. Of all the tensions that animate the superhero, this is perhaps the cruelest: a genre built on characters who fight for justice and defend the common man was also built by artists who lost the rights to control their work and share in its rewards.

Notes

1. Peter Coogan, *Superhero: The Secret Origin of a Genre* (Austin, Tex.: MonkeyBrain Books, 2006), 126–174.
2. Aldo J. Regalado, *Bending Steel: Modernity and the American Superhero* (Jackson: University Press of Mississippi, 2015), 89–94.
3. Coogan, *Superhero*, 30–39.
4. Richard Reynolds, *Super Heroes: A Modern Mythology* (1992; repr., Jackson: University Press of Mississippi, 1994), 12–16.
5. Jean-Paul Gabilliet, *Of Comics and Men: A Cultural History of American Comic Books*, trans. Bart Beaty and Nick Nguyen (Jackson: University Press of Mississippi, 2010), 7–12, 197.
6. Comic books are typically postdated for two or three months after their actual release. Where there is a discrepancy between the cover date and the release date (as in *Captain America Comics* #1, on sale in December 1940 but dated March 1941), I have used the actual year of publication.
7. Mark Rogers, "Understanding Production: The Stylistic Impact of Artisan and Industrial Methods," *International Journal of Comic Art* 8, no. 1 (2006): 509–517.
8. R. C. Harvey, *The Art of the Comic Book: An Aesthetic History* (Jackson: University Press of Mississippi, 1996), 31–35.
9. Amy Kiste Nyberg, *Seal of Approval: The History of the Comics Code* (Jackson: University Press of Mississippi, 1998), 3–6.
10. Will Brooker, *Batman Unmasked: Analyzing a Cultural Icon* (New York: Continuum, 2000), 56–66.
11. Ian Gordon, *Comic Strips and Consumer Culture, 1890–1945* (Washington, D.C.: Smithsonian Institution Press, 1998), 133–135.
12. Benjamin Woo, "An Age-Old Problem: Problematics of Comic Book Historiography," *International Journal of Comic Art* 10, no. 1 (2008): 268–279.
13. Gabilliet, *Of Comics and Men*, 198.
14. Gabilliet, 197–201.
15. See Bart Beaty, *Fredric Wertham and the Critique of Mass Culture* (Jackson: University Press of Mississippi, 2005).
16. Nyberg, *Seal of Approval*, 166–169, 156–158.
17. Fredric Wertham, *Seduction of the Innocent* (New York: Rinehart, 1954), 190.

18. Sean Howe, *Marvel Comics: The Untold Story* (New York: HarperCollins, 2012), 1–2.
19. Bradford W. Wright, *Comic Book Nation: The Transformation of Youth Culture in America*, rev ed. (Baltimore: Johns Hopkins University Press, 2003).
20. Gabilliet, *Of Comics and Men*, 180–183.
21. Howe, *Marvel Comics*, 58–60, 121.
22. Pat Harrigan and Noah Wardrip-Fruin, eds., *Third Person: Authoring and Exploring Vast Narratives* (Cambridge, Mass.: MIT Press, 2009), 1–9.
23. Howe, *Marvel Comics*, 69–70; and Gabilliet, *Of Comics and Men*, 57–60.
24. Gabilliet, 72–79, 140–141, 143–146.
25. Howe, *Marvel Comics*, 153–155, 196–198, 223–228.
26. Neil Shyminsky, "Mutant Readers, Reading Mutants: Appropriation, Assimilation, and the X-Men," *International Journal of Comic Art* 8, no. 2 (2006): 387–405.
27. Roger Sabin, *Adult Comics: An Introduction* (London: Routledge, 1993), 87–95; and Sabin, *Comics, Comix & Graphic Novels* (London: Phaidon, 1996), 160–171.
28. Chris Murray, "Signals from Airstrip One: The British Invasion of Mainstream American Comics," in *The Rise of the American Comics Artist: Creators and Contexts*, ed. Paul Williams and James Lyons (Jackson: University Press of Mississippi, 2010), 31–45.
29. Gabilliet, *Of Comics and Men*, 98–101.
30. Sabin, *Comics, Comix*, 167.
31. Gabilliet, *Of Comics and Men*, 146–152.
32. Dan Raviv, *Comic Wars* (New York: Broadway, 2002).
33. Gabilliet, *Of Comics and Men*, 208.
34. Wright, *Comic Book Nation*, 7.
35. Will Brooker, *Hunting the Dark Knight: Twenty-First Century Batman* (London: I. B. Tauris, 2012), 199–204.
36. David Bordwell, "Superheroes for Sale," *Observations on Film Art* (blog), 16 August 2008, http://www.davidbordwell.net/blog/2008/08/16/superheroes-for-sale/. See also Liam Burke, *The Comic Book Film Adaptation* (Jackson: University Press of Mississippi, 2015), esp. chap. 1.
37. Carolyn Cocca, *Superwomen: Gender, Power, and Representation* (London: Bloomsbury, 2016); Jill Lepore, *The Secret History of Wonder Woman* (New York: Knopf, 2014); Adilifu Nama, *Super Black: American Pop Culture and Black Superheroes* (Austin: University of Texas Press, 2011); and José Alaniz, *Death, Disability, and the Superhero: The Silver Age and Beyond* (Jackson: University Press of Mississippi, 2014).
38. Jeffrey A. Brown, *Black Superheroes, Milestone Comics, and Their Fans* (Jackson: University Press of Mississippi, 2001).
39. Hatfield, *Hand of Fire*, 124–125.
40. John Shelton Lawrence and Robert Jewett, *The Myth of the American Superhero* (Grand Rapids, Mich.: William B. Eerdmans, 2002).
41. Thomas Andrae, "From Menace to Messiah: The History and Historicity of Superman," in *American Media and Mass Culture: Left Perspectives*, ed. Donald Lazere (Berkeley: University of California Press, 1987), 124–138.
42. Umberto Eco, "The Myth of Superman," trans. Natalie Chilton, *Diacritics* 2, no. 1 (1972): 17, 21–22.

43 Reynolds, *Super Heroes*, 74–83.
44 Hatfield, *Hand of Fire*, 109–110.
45 John Cawelti, *Adventure, Mystery, and Romance: Formula Stories as Art and Popular Culture* (Chicago: University of Chicago Press, 1976).
46 Michael Chabon, *The Amazing Adventures of Kavalier & Clay* (New York: Random House, 2000), 582.

15

Autographics

●●●●●●●●●●●●●●●●●●●●●

GILLIAN WHITLOCK

Autographics is, historically speaking, a relatively new genre in the field of graphic narrative—a sign of the rapid transformations rippling through comics over the past three to four decades. Its arrival as a critical concept is foreshadowed in the first edition of Sidonie Smith and Julia Watson's *Reading Autobiography: A Guide for Interpreting Life Narratives* (2001), where "graphic life narrative" is viewed as a latent possibility in the changing contours of the field. By the second edition (2010), "autographics" could stake a powerful claim for recognition as a dominant form in the contemporary mapping of life narrative.

This rapid change in what had been a largely unexplored relationship between graphic narrative and autobiography is noticed elsewhere during this period. In *Alternative Comics: An Emerging Literature* (2005), Charles Hatfield recognizes graphic autobiography as "emergent" in his cultural history of comics and includes symptomatic case studies; his work follows the early example of Joseph Witek's monograph on historical and autobiographical comics, *Comic Books as History* (1989), an island of influence in a field that was slow to be recognized. Elsewhere, recognition of generic shifts at the intersections of autobiography and the comics medium is less assured. Stephen Tabachnick introduces a collection of essays about teaching graphic novels in college classrooms with the observation that "a new genre," the graphic novel, is appearing "before the excited gaze of teachers of both literature and the visual arts." Yet despite the book's attention to works like Art Spiegelman's *Maus* (1986 and 1991) and Lynda Barry's *One Hundred Demons* (2002), Tabachnick does not address the

particular and distinctive claims of memoir, its narrating "I," and their implications in memory, history, and autobiography, aspects that make memoir quite different from the novel.[1] In the introduction to a 2011 collection of essays on autobiographical comics, Michael Chaney remarks that a "cottage industry of autobiographical graphic novels has rapidly sprung up, populating in its wake new outgrowths of criticism on the subject."[2] Chaney's wording too suggests that the graphic memoir remains domesticated and is contained within the confines of the graphic novel.

Contrary to these assertions, I would argue, rather, for the provenance and usefulness of *autographics* as a critical concept specific to graphic memoir: an offspring of both life narrative and the comics but one with its own history, genealogy, and "generic fix" apart from what distinguishes it from the graphic novel. If genres are dynamic "frames" constantly transformed through use, this insight is crucial to grasping the dynamism of the graphic memoir now and its distinctive aesthetic, political, and ethical work.

Hatfield points out that academic comics study is a self-conscious field notable for an "anxious throat-clearing about how to define its object."[3] One of its key texts is, after all, a formalist primer cast in the personal form of an autographic nonfiction: Scott McCloud's *Understanding Comics* (1993) is sometimes itself considered, in the words of Eddie Campbell, a "great" graphic novel—that is, "a great work of fiction in which [McCloud] is the protagonist."[4] What is often lost in this talk, Hatfield reminds us, is the recognition that definitions are not merely analytic but tactical: they enable critical advocacy.[5] "Working" definitions generate ways of reading texts and shaping literary histories. The turn to "autographics" in the revised edition of Smith and Watson's *Reading Autobiography* should be read in this way. This turn contests the appropriateness of the all-encompassing label "graphic fiction" for comics that gesture toward "the autobiographical pact" and sets out to make a case for the distinctiveness of graphic memoir. In academia, autobiography too, like the comics, is notorious for "throat-clearing" anxiety: in particular, the mere mention of Phillipe Lejeune's phrase "autobiographical pact"[6] yields a pause and a hunt for scare quotes—imagine a McCloudian speech balloon encapsulating a cough. Questions of truth and authenticity in autobiography, the relationship among the narrator and the narrating and the narrated "I" of the text, are a theoretical minefield, but autographics, as we will see, has, in its own inimitable way, much to show and tell us about these issues.

An important thing to remember is that autographics, as a working concept, is both theory and practice, both a unique remediation of the signature of autobiography and a sophisticated and compelling critique of self-possession and authorization on the page. *Autographics*, though a neologism, already boasts a history and genealogy, a canon of classic narratives, and substantial scholarship located in a series of critical monographs and several special journal issues. It is articulated in and through the association of memoir and graphic

narrative, and in intimate and creative ways of imagining and performing the self in and through memory. The neologism *autographics* results from the recent convergence of graphic narrative and autobiography, denoting a hybrid that is self-reflexive yet definitively nonfiction. Autographics is both creative and theoretical, visual and textual, thriving in multiple modes and genres, and its definition acknowledges the productive tensions between *auto* and *graphics*: "Autographics: Life narrative fabricated in and through drawing and design using various technologies, modes, signs and materials. A practice of reading the signs, symbols and techniques of visual arts in life narrative. See also autobiography, biography, testimony, comics, self-portrait, avatar."[7]

The remediation of Art Spiegelman's *Maus* into *MetaMaus* in 2011 is symptomatic, indicating a cluster of characteristics that we might, tactically, describe as "autographic." *MetaMaus* is born (again) out of a "rat's nest of files, archives, artwork, notebooks, journals, books." It revisits *Maus* collaboratively through a series of conversations between Spiegelman the artist and comics scholar Hillary Chute that respond to the three main questions that readers constantly ask in the wake of *Maus*: Why comics? Why mice? Why the Holocaust? *MetaMaus* is a work of art that extends the original into a new multimedia format, with "The Complete *Maus* Files" incorporated as an archive on a DVD that is integral to the book's jacket design—a DVD whose plastic lens reveals, one more time, the unique iconography of "Mauschwitz."[8] *Maus* is on the move, mutating yet again through new technologies, and it grasps the "generic fix" of autographics *now* with its intense self-reflexivity, its immersion in history and postmemory, its dialogic response to the reader/viewer/witness it creates, and the meshwork of politics, ethics, and aesthetics that are revealed in every facet of this artifact.

The idea of "generic fix" suggests that although reality seems to be singular and independent of the forms through which we apprehend it, genres are "fixes" or frames on the world that have formative power: "Genres create effects of reality and truth that are central to the ways the world is understood."[9] For graphic narrative, this approach is particularly potent; the idea of "framing" reality comes alive in the unique verbal and visual art of the comics, where it gestures to the distinctive symbolic and semiotic resonance of the comics page.

Canonizing

How is autographics set to work? What are the consequences of this tactical shift toward a new concept? What does the new concept produce by way of reading graphic memoir, and how does it recognize the unique affective work of life narrative in comics, which may well be novel but is decisively not *a* novel? We can answer these questions now by reviewing the uptake of this concept, recent though it is, and considering the emergence of a canon: texts and readings that both formulate and legitimate the concept and translate the neologism

into critical practice through a process of selection, connection, and interpretation that creates the kinship network of graphic memoir.

Digital humanities research—that is, studies that use quantitative evidence, often large-scale evidence, derived from digital technologies—provides some conceptual maps for the dissemination and practice of autographics in the scholarship of (roughly) the past decade, a period I take as both the moment of the concept's arrival and a distinctive conjuncture for reading autobiography. Using the ProQuest database, Craig Howes has tracked recent trends in autobiography criticism, analyzing data on the circulation of articles published in *Biography*, a premier international journal in autobiography studies.[10] With this resource, Howes has mapped preferences for specific articles quantitatively and, on this basis, can map trends in the fields of life narrative. Like the shift in Smith and Watson's *Reading Autobiography*, Howes's interpretation of the data registers the arrival of autographics as a new concept in the field, with a rapid uptake that was both recognized and accelerated in a special issue of the journal in 2008. The ProQuest data indicates that Julia Watson's essay "Autographic Disclosures and Genealogies of Desire in Alison Bechdel's *Fun Home*" was the most downloaded article of *all* those published in *Biography* during the decade between 2002 and 2012. Digital data from Google Scholar generates a citation index that confirms the preeminence of this article in recent scholarly work on life narrative.[11] Quantitative evidence suggests, then, that this is an influential reading that demonstrates and shapes autographic criticism and its canon and indicates burgeoning interest in this field of life narrative.

Hatfield's cautionary remark on tactics is important here: as a neologism and a critical practice, "autographics" produces an aggregation of texts and a form of taxonomic classification that, as Wai Chee Dimock reminds us, is not given but made, brought forward as a willed intervention in the field.[12] Special issues of journals such as *Biography* and *Modern Fiction Studies* do not simply reflect changes occurring elsewhere but rather are themselves agents of change in the dissemination of criticism and the canonization of particular texts as symptomatic—and this is contested, as we have seen, in the persistence of "graphic novel" as a category for books that present an autobiographical signature graphically.

Watson's article both canonizes *Fun Home* (2006) as autographic narrative and uses Bechdel's tragicomic to further define the generic "fix" of autographics through a process of selection and interpretation that is fundamental to canon formation. Autographic reading is dramatized here as a "reflexive and recursive reading practice" that negotiates the intertextual and cross-discursive aesthetics of graphic memoir. This reading of *Fun Home* emphasizes the multiple autobiographical genres that are engaged in the memoir—the coming-out story, the coming-of-age story, the *Künstlerroman*, the domestic ethnography, the trauma story—to create the "richly embodied subjectivity" that is the art of graphic memoir.

An active interface between literary criticism and autobiographical comics comes alive: the reader and critic work to interpret the unique visual and verbal, symbolic and semiotic, language of the comics, which translates the promise of the autobiographical signature into a vivid embodiment. The comics make ethical demands of the reader; for example, in *Fun Home*, the visual presence of the hand of the narrating "I" at work on the page reaches out and transforms the autobiographical signature: "The signature or autograph of the autobiographical becomes an autographic juxtaposition discoverable in acts of looking, drawing, embodying and comparing, in an ongoing spiral of reflection."[13] Autographic reading and its process of "ongoing reflection" are at work in *MetaMaus* too, where Spiegelman's graphic memoir, which began to emerge as a work in progress in 1972 and whose "first volume" became a book in 1986, is a canonical text of graphic memoir that continues to generate an extensive imagined community of readers that seek every opportunity to convene around remediations of *Maus*. The dialogue of artist and critic, Spiegelman and Chute, produces a metacommentary that extends the long tail of the *Maus* corpus and dramatizes the reflexive and recursive reading that graphic memoir demands.

Watson's compelling "snout to tail" study of *Fun Home* elaborates the aesthetics, ethics, and politics of Bechdel's memoir. Reading for aesthetic effects includes, for example, the materiality of this book as a beautiful artifact and work of art, with a fastidious attention to detail: the distinctive black line art and gray-green wash; the elegant design of the hardback edition with the jacket's embossed silver tray and cutouts revealing the contrasting orange binding beneath; and endpapers featuring green-shaded white chrysanthemums on a silvery teal background, imitating the William Morris wallpaper design in Bruce Bechdel's funeral home. Autographic reading requires a multidisciplinary literacy on the part of the reader: the book is grasped as a material object from cover to cover; the particular power of cartoon drawing (see chapter 11) to activate the reader's desire affectively is observed from page to page. An elaborate intertexuality recurs in Bechdel's memoir: artistic, mythic, and literary precursors circle around and through the narrative, appealing to cosmopolitan readers familiar with James Joyce and Marcel Proust and able to interpret the significance of a glimpse of Leo Tolstoy's *Anna Karenina* in this unhappy family history. This book enacts an intimate connection between aesthetics and sexual politics in representations of embodiment and sexuality. Watson's reading draws out the subtlety and sophistication of the social, cultural, and familial history of same-sex desire in *Fun Home*: the "tricky reverse narration that impels our entwined stories," capturing the links between Bruce Bechdel's closeted homosexuality and his daughter Alison's "coming of age" story of discovering her own sexuality; the sociocultural context of these personal histories in the postwar United States; the extraordinary vision of sexual kinship, "a legacy both genealogical and chosen," that is imagined in the final frame depicting the graphic "dance" of father and daughter.[14] This elaborates the generic "fix" of

autographics: the capacity of what Spiegelman calls "picture writing" to make an inspired intervention at great risk in representations of identity, specifically gender and sexuality (in Bechdel's case, a speculation on the "inheritance" of same-sex desire).

That autographics could draw on feminism, queer theory, and poststructuralism to produce this audacious and (for some) confronting memoir indicates its historicity: at this moment in life narrative studies, *Fun Home* and autographics generally invite us to theorize subjectivity, genre, and the reader's engagement with the autobiographical in new terms.[15] Bechdel's risky intervention in ways of thinking about social identity occurs elsewhere in graphic memoir. Consider, for example, *Embroideries* (2003, English trans. 2005), Marjane Satrapi's bawdy and gossipy autographic that focuses on a single afternoon's conversation about sex and sexuality among a group of three generations of Iranian women in the Satrapi living room in Tehran in 1991. When the talk turns to the taboo subject of female circumcision, Satrapi dispenses with frames and speech balloons, and the talk expands and occupies all the available space, uncontained and unregulated. In *Maus*, the substitution of animals for humans and the questioning of the species divide that follows stage a controversial intervention in debates about race, ethnicity, and representations of the Holocaust—one that not only triggered "postmemory" as a concept but also transformed debates about representations of genocide more generally.[16]

Embodiment—the presence of a somatic body, its senses, consciousness, and memories, its very anatomy—is the heart of autographics. Figuring the self in the frame of memoir is an intimate art that draws attention to how cultural and ideological discourses shape when the body becomes visible and what this visibility of the body and its parts means. *Fun Home*, for example, depicts the corpse in the embalming room scene with surgical precision, as Bechdel highlights the act of looking at it and its genitalia and animates the relationship between Alison and her father.[17] Elsewhere, autographic cartooning often presents the body in a highly abstracted way, "stripping" an image to focus on specific body parts—for example, the focus on the face of the very cartoonish figure of Marji in Satrapi's *Persepolis* (2000–2003, English trans. 2003). Satrapi uses cartooning and the minimalism of stark monochromatic frames to draw the reader close to its veiled subject. In David B.'s *Epileptic* (1996–2003, English trans. 2005) the monochromatic panels are invaded by creatures and specters that open this book to the irrational and fantastic dreamworlds of mental illness, the monsters and dreams that break loose there, and the violent physical transformation produced by his brother's seizures, which are visualized graphically on the page.

Comics has a unique repertoire in representations of the human body and psyche. This inheritance includes the depictions of explicit sexuality found in the underground comics, the anthropomorphized animals of comics and animated cartooning, and the exuberant transformations of the superhero; all this

remains active in the gene pool of autographics. The transformation of the comics into "a vehicle for the most personal and unguarded of revelations" conveying "an unprecedented sense of intimacy, rivaling the scandalizing disclosures of confessional poetry but shot through with fantasy, burlesque, and self-satire," draws on this heterogenous ancestry.[18] As Spiegelman insists in his memoir of the September 11 attacks, *In the Shadow of No Towers* (2004), the ephemeral art of the comic strip and its capacity to elude censorship and grasp what cannot be photographed or filmed remains alive in autographics' generic mix. The boundaries of the human body are not secured in the panels of the comics, which remain open to monstrous, abject, liminal bodies that are not quite self or other. Graphic memoirs take pleasure in the abjection of the body, in explicit and shameless representations of bodily functions, and in, for example, the alien and vulnerable bodies that populate graphic illness narratives. The boundaries between self and other are porous, and cartooning remains inherently open to the carnivalesque and grotesque[19] or to the cross-species imaginaries that Terry Zwigoff, Justin Green, and their colleagues gesture toward in their comic book *Funny Aminals* (sic), in which Spiegelman published the first version of the story "Maus" in 1972. Such forms of embodiment are positively posthuman in the sense of calling the very boundaries of the human into question.

This posthuman embodiment is fundamental to the politics, aesthetics, and ethics of autographics and to the intervention that graphic memoir makes in life narrative. If anxiety surrounds autobiography and its putative claims to truth and authenticity, and if references to the "autobiographical pact" are necessarily hedged by parentheses, graphic memoir troubles the individualism and singularity of the autobiographical signature anchored by the title page. In fact, it undermines the authority and integrity of autobiography's traditional humanist subject: the autonomous individual and universalizing life story that became definitive for life writing in the West. Autographics reformulates the signature of the narrating "I" in all its complexity. Satrapi and Bechdel draw the hand on the page, at work with its own distinctive "handwriting" in captions and balloons, drawing on the devices of panels and gutters to prompt the readerly work of closure that the comics demand (part of the distinctive combination of reader and spectator stressed by formalist interpretations of the comics page à la McCloud—see chapter 12).

Fun Home's near-life-sized drawings of the hand on the page are self-reflexive, emphasizing the handcrafted work of composition and reflecting the reader's touch that holds its subject close. Elisabeth El Refaie characterizes this as "drawing in the reader," and it highlights the embodied presence and proximity of both artist and spectator.[20] In the second volume of Satrapi's *Persepolis* (2004), Marji's hand appears on the page grasping a thick black crayon, gesturing to the political and cultural practice of portraiture, as in the Islamic republic of Iran, where she is required to represent politically correct martyred subjects (which she does by creating a pastiche of Islamic and Christian iconography).

In *MetaMaus*, Spiegelman's "working process" details the laborious frame-by-frame construction of what he calls the "I-thou" intimacy of memoir, where the production incorporates the authenticity of his hand tremor as a signature in its final frame. Part of the generic "fix" of autographics is this reworking of the "signature" of autobiography to deconstruct the authority and singularity of the "pact" and to place something more tremulous and contingent in its place—an intimate craft, with an alchemy that survives mass reproduction.[21]

"How do we theorize this difference of autographics?" asks Watson, and in response, she cites the cartoonist Ariel Schrag's comments to Hillary Chute: the connection between autobiography and comics "has to do with *visualizing memory*. Every writer incorporates their past into their work, but that act becomes more specific when you're drawing."[22] Watson's reading of *Fun Home* follows a "perverse itinerary" that moves in a recursive fashion from the center of the book outwards, a to-and-fro movement shaped by Bechdel's ongoing spiral of reflection and memory work. G. T. Couser reminds us that memoir is a genre named after a faculty: the French word for memory.[23] To insist on attaching *memoir* to graphic autobiography recognizes a crucial component of the "fix" of autographics: it draws the past into the present, and it does so through the unreliable and highly selective frameworks of cultural memory.

This returns us to the "historicity" of autographics, which questions how the genre works to bring the past into the present and what political and ethical work follows from this. Consider for example *Maus*, where the father's traumatic memory of the Holocaust produces as its legacy a generational "postmemory," a concept that has in large part been theorized in and through Spiegelman's memoir.[24] Or feel the weave of *Persepolis*, which shuttles back and forth across the narrator's childhood recollections of the Islamic Revolution in Iran, using Marji's memory to make a decisive intervention in debates about representations of the veil. In *Epileptic*, the memory of childhood is also traumatic; it reveals a family history of suffering and loss when the author's brother is diagnosed with epilepsy, which extends to a cross-generational account of war and traumatic memory. *Fun Home*, suggests Watson, is a memoir about memoirs, memory, and storytelling; Bechdel's drawings are "memory mirrors" that are continuously shaped and refracted by the self-engagement of the narrating "I."

The response to the question of what graphic memoirs do differently constantly returns to cultural memory in this way. The rise of autographics coincided with the memoir "boom" of the 1990s and early 2000s and a turn to thinking about memory as a self-reflexive construction of the past that is cultural, social, and historical. At a time when concepts of cultural memory, and traumatic memory in particular, produce new interdisciplinary ways of thinking about history, subjectivity, and representation, autographics feasts on the opportunity to be perverse. Just as Watson suggests, *Fun Home* is a memoir about memoir and storytelling; *Maus* also, in Jared Gardner's words, "bears witness to the process of bearing witness."[25]

To say that genres are representational "frames" or "fixes" that are dynamic, performative, and actively engaged in theorizing subjectivity challenges conventional ways of thinking about life narrative, and productively so. It reroutes the discussion from an anxious emphasis on fixed ideas of genre, and a preoccupation with the truth and authenticity of the autobiographical pact, toward a focus on genre as social action. From this, it follows that the autobiographical is read, as Couser says, for what it *does*, not for what it *is*.[26] Or, as John Frow remarks, rather than asking "What kind of thing is this text?," we should be asking something like, "What kind of world is brought into being here? . . . Who represents this world to whom, under what circumstances and to what ends?"[27]

We can answer these questions by returning to the question of how autography is set to work in recent academic criticism. For example, the editors of a special issue on the topic of "Witness" were taken aback by the number of submissions they received on graphic narrative and especially the multiple proposals to analyze *Fun Home*.[28] This reinforces the evidence of the *Biography* case study: autographics is, as Ann Cvetkovich says, an "insurgent genre" thriving in contemporary criticism,[29] and Bechdel's memoir is a canonical text that exemplifies and reproduces the brand. The concept of *witness* clarifies how autographics draws the past into the present: it focuses on the witnessing "I," and the panels and gutters of the comics are reconfigured to "bear" witness to history, memory, and subjectivity. The recursive and reflexive art of graphic memoir produces a unique space of witness, and it is this discovery of comics' unique ability to represent the demands of trauma, memory, and narration, and to foreground memory and subjectivity so graphically, that makes this an urgent and dynamic medium in contemporary life narrative. As Gardner argues of *Maus*, autographics "challenge[s] the authenticity of any memory even as [it] insists on the vital truth of the story."[30]

Autography's Biography

What is the history and provenance of this generic "fix?" Jared Gardner argues that the early 1970s, and 1972 in particular, were a watershed moment in the life story of autobiographical comics and also that the first decade of the twenty-first century, the very period that embraces a generation of bestselling and critically acclaimed graphic memoirs and the emergence of autographics as a neologism and critical practice, is another. Gardner presents a genealogy in which "bloodlines . . . connect very different personal stories across generations."[31] His account of autography's heritage and genealogy draws together a group of texts into a kinship network.

In 1972, Justin Green's pioneering graphic memoir *Binky Brown Meets the Holy Virgin Mary* appeared, born out of the avant-garde underground comix scene in the United States. The autobiographical turn to confession and testimony begins with *Binky Brown* and its visceral and sacrilegious primal "scene"

of autography: the overwrought image of the author himself, half blind and hogtied over an inverted sword of Damocles, forced to listen to "Ave Maria" while penning his memoirs with his mouth, dipping into ink that is his life's blood. This image of the self-obsessed Binky is in every sense "graphic," confrontational, and sexually explicit, beginning both the history and the genealogy of autographics with an account of childhood trauma that stresses the links among trauma, memory, and comics. The unique capacity of comics to show the processes of mental illness from the perspective of the ill, to externalize and give "visual body" to psychic suffering, is *Binky*'s legacy, which appears most obviously in contemporary illness memoir. "Without *Binky Brown* there would be no *Maus*," declared Art Spiegelman. "Justin turned comic books into intimate secular confession booths."[32] In her history of "graphic women," Hillary Chute concurs with Gardner's canonization of *Binky* as the inaugural text of autobiographical comics (a status also suggested by Witek and Hatfield): it established a mode of comics narrative that explored the self seriously, "delv[ing] into and forcefully pictur[ing] non-normative sexuality." Thus autography from the outset "len[t] itself to feminist concerns about embodiment and representation." The first generations of "graphic women"—Aline Kominsky-Crumb, Lynda Barry, Phoebe Gloeckner—also turned to graphic memoir to tell traumatic histories, and Chute argues these women epitomize a distinctive *idiom of witness*, "a manner of testifying that sets a visual language in motion with and against the verbal in order to embody individual and collective experience, to put contingent selves and histories into form."[33]

Binky's place as an ancestor in this transnational kinship network is germinal: in the DNA of autographics post-*Binky* is the turn to confession, the risky revelation of the most personal and neurotic experiences, particularly on issues of sexuality and childhood trauma, in a medium that allows the autographer to maneuver in the spaces of gutters, panels, captions, and balloons as both traumatized victim and detached observer. The first panels of what would become the mighty *Maus* were contemporaneous with *Binky Brown*, and Spiegelman was inspired by the sight of Green's artwork, just as, in turn, Bechdel and Satrapi acknowledge the formative influence of *Maus*. Spiegelman's memoir, as we have seen, has helped to establish memory studies, and numerous articles testify to its canonical heft in studies of cultural memory, the Holocaust and genocide, trauma studies, and narrative theory.

Within the larger history of comics, 1972 stands as a key moment in the history of autographics, for what was triggered then was a new pattern of associations and affiliations that established a generic "fix"—that is, formulated how graphic memoir "understands the world" and frames its reality. This is vividly exemplified in its canonical texts. Both Chute and Gardner identify a testimonial turn as a vital component of "autography's biography," and the idea of an "idiom of witness" underscores autography's focus on the ethical and political work of testimony. All this suggests a convergence: between the reflexive,

recursive reading that autographics demands and the testimonial narrative's imperative that its reader "bear" witness—that she carry the weight, the ethical and political responsibility, for this "bleeding through" of history into the present. The self-obsession of *Binky Brown* initiated a turn to childhood trauma that recurs in canonical autographic memoir but with a matching emphasis on historical witness.

The genealogy—which, as Dimock reminds us, is not given but made—that connects Green to Spiegelman and, via *Maus*, to Satrapi and Bechdel and a now-proliferating literature, has many outlets, ripples, and cascades that elude national, chronological, and formal bounds. Autographics is not a national story; it migrates through a world republic of letters. Although the West Coast of the United States had a formative influence on the roots of graphic memoir, autography's routes are global, encircling Japanese, Francophone, and other sources as well as Anglophone ones.[34] For example, David B.'s *Epileptic*, Satrapi's series of graphic memoirs starting with *Persepolis*, and Julie Doucet's *365 Days* (2004, English trans. 2007) were all originally published in French by L'Association and influenced by the traditions and debates in *bandes dessinée* culture there (see chapter 4). These complicate any suggestion that autographics is a national product—or that North America itself has a singular tradition, given the transatlantic Francophone connections of Canadian autographers like Doucet.

The ripples of autographics are unpredictable. For instance, in his Baghdad blog of December 7, 2003, Salam Pax writes, "I spent most of the day at home reading *Persepolis* . . . a comic book written by Marjane Satrapi. It is scary how much we have in common, Iraqis and Iranians I mean. . . . It was my third attempt to go thru that 'comic book,' I tried once right after I bought it but it made me wince. . . . It is a beautiful book. I had the urge to start translating it and throw copies of it on the streets of Baghdad. Why can't we learn from other people's mistakes?"[35] This testifies to the cross-cultural dissemination and potency of autographics now, and its speed, for the English translation of *Persepolis* was published just that year, and as we see here, it inspires further translation.

This capacity to travel across cultures and languages and open new ways of thinking about communicative ethics, cultural difference, and representations of self and other draws autographics into political and ethical issues of the first importance. For example, when graphic memoirs engage with traumatic memory they are a piercing reminder of our tenuous grasp on the self and its place to speak humanely.[36]

I have been using *autographics* here tactically, as a concept that sets to work a canon, a history, a genealogy, and a critical apparatus. Another way of reading this chapter is as an extended argument for attaching the word *memoir* to *graphic* to recognize the distinctive alchemy that began when autobiography discovered comics (or did comics discover autobiography, in San Francisco

forty-some years ago?). In any case, graphic memoir produces beautiful books that make us wince. Why attach these evocative and affective words—*alchemy*, *beautiful*, and *wince*—to graphic memoir? To recognize the distinctive investment that the graphic memoir requires of its reader/spectator and its affective impact. The signature of autobiography is transformed in autographics' touch on the page, and memoir makes demands that draw deeply on the provenance of the comics in return. Here, autobiography escapes the rigid confines of truth, authenticity, and a singular coherent subject and discovers the potential of comics' multimodal visual/verbal pyrotechnics to transform self-representation. For its part, comics draws on its long association with metamorphoses of the human and the abject—the superhuman, the subhuman, "aminals," the posthuman—to bring to the panels of autographics metamorphoses that produce risky "tragicomic" associations of mice and men, the living and the dead. There is a brilliant transformation of both life narrative and the comics occurring here, through the synergy and energy generated by the kinship of graphics and memoir.

Notes

1. Stephen Tabachnick, *Teaching the Graphic Novel* (New York: MLA, 2009), 1. I concur with G. Thomas Couser, who remarks, "It doesn't help that *graphic novel* has come to be the accepted term for any narrative, fictional or not, that is drawn in the manner of a comic book. To my dismay, even the Modern Language Association has adopted this misleading usage for the title of a volume of essays on *Teaching the Graphic Novel*. Several of the narratives in question—such as Art Spiegelman's *Maus* and Marjane Satrapi's *Persepolis*—are better thought of as memoirs, because they concern real people and historical events." Couser, *Memoir: An Introduction* (New York: Oxford University Press, 2012), 16. Couser suggests that the novel and memoir can be thought of as siblings "that grew up together, often borrowing each others' clothes" (8). For a rather different take on the expansiveness of the term *graphic novel*, see chapter 6.
2. Michael Chaney, ed., *Graphic Subjects: Critical Essays on Autobiography and Graphic Novels* (Madison: University of Wisconsin Press, 2011), 5. Among the recent "outgrowths" of scholarship on the subject is Andrew J. Kunka's monograph, *Autobiographical Comics* (London: Bloomsbury, 2017), which, as it sets out to orient new readers to the genre, notes the "enormous amount of critical attention" it has garnered (1).
3. Charles Hatfield, "Defining Comics in the Classroom, or The Pros and Cons of Unfixability," in *Teaching the Graphic Novel*, 19.
4. Eddie Campbell, interview by Dirk Deppey, *Comics Journal*, no. 273 (January 2006): 114. Also quoted in Hatfield, "Defining Comics," 20.
5. Hatfield, "Defining Comics," 20.
6. The *autobiographical pact* refers to Phillipe Lejeune's concept of the negotiated relationship of author, reader, and publisher, which has been a very influential characterization of what is distinctive to autobiographical representation in its relation to truth and authenticity.
7. Gillian Whitlock and Anna Poletti, "Self-Regarding Art," introduction to "Autographics," special issue, *Biography* 31, no. 1 (Winter 2008): v.

8 This is the second multimedia presentation of *Maus*. *The Complete Maus* of 1992 consisted of a CD-ROM that, as Eakin points out, is now technologically obsolete.
9 John Frow, "'Reproducibles, Rubrics, and Everything You Need': Genre Theory Today," *PMLA* 122, no. 5 (October 2007): 1632.
10 Craig Howes, "Editing Twenty Years On: Biography, Life Writing, and the Future of 'Publication'" (paper presented at "Auto/biography across the Americas: Reading across Geographic and Cultural Divides," International Auto/biography Association, San Juan, Puerto Rico, July 2013). The use of metrics such as this to trace the dissemination of criticism via downloads and citations of academic articles will become increasingly influential in digital humanities research. For example, Taylor & Francis Online offers access to "My Authored Works" at their website, which presents article metrics (how many times articles have been viewed), citation data, and "a chronological history of the key dates in the life of [the] article" for articles published in Taylor & Francis journals. See Taylor & Francis, https://authorservices.taylorandfrancis.com/my-authored-works, accessed 16 February 2020.
11 The citation data on Google Scholar includes a reprint of this article in Chaney's *Graphic Subjects*.
12 Wai Chee Dimock, "Introduction: Genres as Fields of Knowledge," *PMLA* 122, no. 5 (October 2007): 1377–1388.
13 Julia Watson, "Autographic Disclosures and Genealogies of Desire in Alison Bechdel's *Fun Home*," special issue, *Biography* 31, no. 1 (Winter 2008): 52.
14 Alison Bechdel, *Fun Home: A Family Tragicomic* (Boston: Houghton Mifflin, 2006), 232; and Watson, "Autographic Disclosures," 35.
15 Watson, "Autographic Disclosures," 133.
16 See, for example, Chaney's essay "The Animal Witness of the Rwandan Genocide," in *Graphic Subjects*, 93–100.
17 Hillary L. Chute, *Graphic Women: Life Narrative and Contemporary Comics* (New York: Columbia University Press, 2010), 197.
18 Charles Hatfield, *Alternative Comics: An Emerging Literature* (Jackson: University Press of Mississippi, 2005), 7.
19 Elisabeth El Refaie, *Autobiographical Comics: Life Writing in Pictures* (Jackson: University Press of Mississippi, 2012), 71.
20 El Refaie, 179.
21 "I suggest, then, that what feels so intimate about comics is that *it looks like what it is*; handwriting is an irreducible part of its instantiation. The subjective mark of the body is rendered directly onto the page and constitutes how we view the page.... The bodily mark of handwriting both provides a visual quality and texture and is also extrasemantic, a performative aspect of comics that guarantees that comics works cannot be 'reflowed': they are both intimate and *site specific*." Chute, *Graphic Women*, 11.
22 Quoted in Watson, "Autographic Disclosures," 52.
23 Couser, *Memoir*, 19.
24 Marianne Hirsch, "Mourning and Postmemory," in *Graphic Subjects*, 17–44.
25 Jared Gardner, "Autography's Biography, 1972–2007," special issue, *Biography* 31, no. 1 (Winter 2008): 17.
26 Couser is paraphrased in Sidonie Smith and Julia Watson, *Reading Autobiography: A Guide to Interpreting Life Narrative*, 2nd ed. (Minneapolis: University of Minnesota Press, 2010), 19.
27 Frow, "Reproducibles," 1633. Frow is drawing on Rosalie Colie's work on genre theory here.

28 Kathryn Abrams and Irene Kacandes, eds., "Witness," special issue, *Women's Studies Quarterly* 36, nos. 1–2 (Spring/Summer 2008): 15.
29 Ann Cvetkovich, "Drawing the Archive in Alison Bechdel's *Fun Home*," special issue, *Women's Studies Quarterly* 36, nos. 1–2 (Spring/Summer 2008): 112.
30 Gardner, "Autography's Biography," 17.
31 Gardner, 1.
32 Cited in Gardner, 8.
33 Chute, *Graphic Women*, 19, 3.
34 See, for example, the discussion of Keiji Nakazawa in Hillary L. Chute, *Disaster Drawn: Visual Witness, Comics, and Documentary Form* (Cambridge, Mass.: Belknap Press of Harvard University Press, 2016); and El Refaie's attention in *Autobiographical Comics* to European, particularly francophone, traditions of graphic memoir.
35 Salam Pax, "I Spent Most of the Day at Home Reading [*Persepolis*]," *Where Is Raed?* (blog), 7 December 2003, accessed 16 February 2020, http://dear_raed.blogspot.com/2003/12/i-spent-most-of-day-at-home-reading.html.
36 This is an argument I develop further in *Soft Weapons: Autobiography in Transit* (Chicago: University of Chicago Press, 2007), using work on communicative ethics by Seyla Benhabib and Iris Marion Young.

16

Girls, Women, and Comics

• •

MEL GIBSON

Though comics has often been wrongly identified as an exclusively masculinist field, close attention to its history reveals that comics for girls and women have played a significant role in the medium's development. Such comics have often been innovative and have arguably formed part of the mainstream. This chapter addresses the history of comics produced for girls and women in an international context by focusing on diverse case studies, including the rise of girls' comics in the United Kingdom, the importance of romance comics post–World War II, the burgeoning of specifically feminist comix in the underground era, and the central role now played by shōjo manga internationally.

Of course, girls' comics are not the only titles girls and women read. Female readers enjoy comics of all kinds, even in genres that are seen as addressing male audiences specifically.[1] Though this chapter does not focus on the larger issue of readership across gender, it's important to note that girls' comics, while broadening the range of options for all readers (including boys and men), are not the only part of the medium that women and girls engage with. Publishing strategies may be strictly gendered, but readership is not.

Girls' Comics in Britain

Between the 1950s and 1980s in Britain, there were over fifty comics titles for girls. Most were weekly anthologies in series, every issue of which contained two or three pages each of several narratives that would continue from issue to issue,

often for months, offering a cliffhanger at the end of every week. Some weeklies were accompanied by pocket-sized versions that came out once or twice a month. All had accompanying hardback annual editions. Some were also hybrids containing text-based narratives, problem pages, and a range of other features in addition to comic strips.

Even before the Second World War, there were a number of "story papers" for girls featuring text-based narratives, including *School Friend* published by Amalgamated Press (AP), which ran between 1919 and 1929 but also reappeared in comic form from 1950 to 1965 (as part of an expansion of publishing that followed the postwar relaxation of paper rationing regulations).[2] These comics retained elements of the old model in the new format. For example, *The Silent Three*, which ran in *School Friend* from 1950 to 1963 and featured boarding school girls who solved mysteries, had been a staple of the prewar papers in prose form, as were "endlessly successful school themes, 'tales of bygone days', ghost stories, mystery and detection, exploits of gypsies in disguise, poor little rich girls and rich little poor girls."[3] However, the new comics titles also contained innovations, including stories focused on family life, ballet, and ice-skating.

These new publications proved very popular, with *School Friend* achieving a circulation of around one million in the early 1950s.[4] However, the most significant girls' comic of that era is generally thought to be *Girl* (1952–1956), the sister comic to the *Eagle* (1950–1969). *Girl* had high production values, glossy paper, and four-color rotogravure printing and was edited by clergyman Marcus Morris. The aim was to create a middle-class comic inculcating sound Christian values, as *Eagle* did for boys. With a focus on what were seen as exciting and attractive jobs such as nursing and working as an air hostess or in television, the stories offered aspirational, yet also conventionally "appropriate," role models. The ideological work of the title had a very specific model of the "girl" in mind, not unlike that seen in romance comics in the United States.

The late 1950s saw a burst of British comics aimed at preteens that further divided the market by age, driven particularly by publisher DC Thomson. *Bunty* (1958–2001) contained several innovations and had a circulation, at peak, of around eight hundred thousand per week. It became the longest-running girls' comic title. While its stories continued to focus on schoolgirls, most notably through *The Four Marys*, the narratives reflected the changing experience of school in the 1950s, by, for instance, making one of the Marys a working-class scholarship pupil.[5] *Bunty* also differed in that many of its school stories focused on the working-class outsider and her struggle to deal with the snobbery of, and bullying by, both staff and pupils in private schools.

After the success of *Bunty*, DC Thomson and rivals expanded their publishing in this area. DC Thomson also developed *Twinkle* (1968–1999), aimed at girls under eight years old, a group comparatively untargeted as consumers in the 1960s and 1970s. However, the initially strong sales of these titles began to fall in the 1970s. This led to further innovation in the shape of *Tammy* (IPC,

1971–1984), which comics writer Pat Mills has identified as "the beginning of what could be called the 'new wave' comics," thus making way for titles like *Action* (IPC, 1976–1977) and *2000 AD* (1977–).[6] Indeed innovations in girls' titles have had an impact upon other comics. Regarding *Tammy*, girls ages eight to thirteen involved in market research for that comic generally confirmed the editors' assumptions about preferred content, but the readers' enjoyment of stories that made them cry came as a surprise.[7] Consequently, *Tammy* and the titles that followed, like *Jinty* (IPC, 1974–1981), distinguished themselves from the comics of the 1960s through their heavy emphasis on central characters learning from difficulties and suffering. There was also humor in the new wave comics, albeit of a rather bleak kind at times. In *Tammy*, for instance, the serial *Bella at the Bar* (IPC, 1974–1984) featured a working-class orphan gymnast whose guardians attempt to persuade her to become a criminal.[8] The story, far from being miserable, is about the wit and resilience of the central character.

The impact of *Tammy* forced DC Thomson to produce harsher stories as well, but despite changes in narrative, girls' comics continued to decline. The Royal Commission on the Press linked this to publishing practices, suggesting that "it is possible that publishers' own expectations, and the approaches built upon them, have become self-fulfilling prophecies."[9] The tendency to combine rather than cancel titles when one dropped below the break-even point was seen as evidence of a lack of commitment. Attempts were made to stop the erosion of the market, including such innovations as the use of photo-strips as well as notable changes in the content of the drawn stories. If the former, given the photographic medium, encouraged a social-realist edge, the latter drew on horror and melodrama. The theme of cruelty intensified throughout the 1980s—for instance, in the popular *Nothing Ever Goes Right*.[10] Here, the heroine ends up buried anonymously in an unmarked grave. Further, the supernatural took on increasing importance again in another attempt to refresh the genre. *Spellbound* (DC Thomson, 1976–1978) was a bold experiment, the first British horror title since the 1950s. IPC took up the idea, launching their own horror title, *Misty* (IPC, 1978–1980). Both *Spellbound* and *Misty* were short-lived but foreshadowed what was to become a major type of publishing in novels for girls.

This is a narrative of success and innovation, which, all the same, ended in publishers simply reducing their involvement with comics for girls and investing, instead, in developing noncomics magazines for them. Though romance comics and feminist comix (discussed below) made appearances, it was not until the growth of manga in translation that girls became a major target audience for comics in Britain again.

Romance

In Britain and the United States alike, romance comics were a significant genre for female readers. In the American context, Trina Robbins and Catherine

Yronwode flag up the genre's relationship to the teen comics of the 1940s, stating that "love was nothing new to the world of comics. After all, that's what prompted Betty and Veronica to fight over Archie.... [However] nobody ever kissed, and nobody ever cried—until 1947. That was the year that two ex-GIs named Joe Simon and Jack Kirby created a comic book called *My Date*."[11] The most innovative element of this short-lived title was the inclusion of love stories told in the first person that were modeled on "true confession" magazine stories. This led to the launch of a dedicated romance title by Simon and Kirby, *Young Romance* (Prize Comics / Feature Publications, 1947–1963; DC, 1963–1975). Given its huge success, other publishers followed suit, and by 1950, over a quarter of the comics published in the United States were on that theme. Roger Sabin says that by 1949, there were 120 romance titles on the market but concedes that few had the same "intelligent storytelling and finely-wrought art."[12] These titles specifically tried to court adult readers and distance themselves from younger audiences, although as Robbins points out, the readership typically ran from early teens into adulthood.[13]

Such romance comics often contained stories that were generic hybrids in that they included Western, wartime, and career-based subgenres. However, most shared a cautionary approach, in which the female protagonists admitted the dangers of female independence, their incompleteness without men, and the importance of domesticity. At the same time, promiscuity or the aggressive pursuit of men was very much discouraged—or punished. Passivity and self-denial were ideals, and tolerance of men's shortcomings was encouraged in that light. Bradford Wright links these narratives explicitly with the culture of the Cold War, arguing that the "preservation of the traditional family and prescribed gender roles meshed with concerns of national security and resulted in a sort of domestic containment policy."[14] In this context female independence was problematic, so narratives showed domestic stability as more important than passion, and careers as making women unhappy and unfulfilled. (This contrasts sharply with the emphasis on career in British girls' comics, as discussed above.)

The American romance genre fell into decline in the 1960s in the wake of the Comics Code, which amounted to a regime of self-censorship. Consistent with the overall decline in U.S. comic book sales, which has been traced to various causes—including the Code, loss of stable distribution, and competition from television—romance comics languished (see chapter 2). Attempts to refresh the genre by giving female protagonists more exciting roles as air stewardesses, college students, or rock stars were unsuccessful. Robbins points out that student protests became a theme and that the comics attempted, often desperately, to link in with popular culture in other ways.[15] Despite these attempts at updating, the genre's own golden age came to an end when *Young Romance* and its companion title *Young Love* (also founded by Simon and Kirby) ceased publication in 1975 and 1977, respectively.[16]

The American titles proved influential in Britain, particularly in the form of reprints. British romance comics per se began with *Marilyn* (1955–1965), *Romeo* (1957–1974), *Roxy* (1958–1963) and *Valentine* (1957–1974). These comics were innovative in many ways, from the use of a girl's name as the title and their advertising (for clothes and jewelry rather than toys) to their links with popular culture—a strategy apparent in the way the comics frequently based romantic stories on popular songs.[17]

Although British romance comics from the start targeted adults and older teenagers alike, younger teens were *not* part of the envisioned audience. However, as the Royal Commission on the Press reports, *Mirabelle* (1956–1977) "was originally intended as a 'romance comic' for girls of 18 and upward, but its publishers later were surprised to discover that it was most popular with 13–16 year olds."[18] In the late 1950s to early 1960s, the realization that there was a younger audience for romance comics caused a shift in production. *Jackie* (1964–1993) was aimed squarely at younger teens and became a hugely popular title. With an eye on parental concerns about *Jackie*'s younger audience, publishers DC Thomson reinforced their strong moral line on marriage and "true love." In effect, romance comics in Britain and America shared a common view of female readers, though in Britain this view stemmed more nearly from concerns about the age of readers and notions of protecting "innocence" than from Cold War ideology in the American sense.

However, many features in *Jackie* were generated *by* young women, which allowed for variation within the comic rather than a single monolithic ideology determined by the publishers. While Angela McRobbie has argued that the publishers "attempt[ed] to win consent to the dominant order—in terms of femininity, leisure and consumption," Martin Barker counters that *Jackie* readers formed a community and that the title opened up spaces for communication and collective understanding.[19]

While *Jackie* grew from the romance comics, it also differed from them, as it applied the format of the woman's magazine to material for younger readers. Although it began with a large number of comic strips, these were phased out over time. This shift was reported by various commentators, such as Cynthia L. White, who remarked in 1970, "While the story monthlies have generally been putting on circulation, the 'romance comics', the staple fare of the secondary modern school-girl in the fifties[,] have lost popularity. Since 1958 *Boyfriend* (City, 1959–1967), *Marilyn*, *Marty* (C. Arthur Pearson, 1960–1963) and *Roxy* have all folded, although *Mirabelle* is managing to hold its own, and *Jackie*, a more recent entrant put out by DC Thomson[,] is doing well."[20] The magazine became a dominant medium for girls in Britain starting in the mid-1960s when romance comics for both teens and adults began to fail, mirroring the experience of the American market. At this point the magazine sans comics became the primary mode of address to women in their twenties and above, and slowly came to dominate the market for younger readers too.

The decline of the romance comic in both Britain and America testifies to what McRobbie has identified as a "generic crisis" in romance. She argues that readers increasingly rejected stereotypical romantic behavior and the stories that promoted it. McRobbie notes that publishers claimed to have moved beyond treating teenage and younger readers "with amusement if not downright ridicule," partly by getting rid of romance, which was seen by the 1980s as clichéd and silly.[21] Both British and American romance comics, then, came to seem redundant to politicized audiences.

Feminism

During the 1970s, attempts to make the girls' and romance comics relevant coincided with the emergence of adult, feminist-inflected work in comics. While romance comics had occasionally engaged with feminism, it was only to insist that the movement would lead to unhappiness. British comics, with their very specific girls' market, offered aspirational narratives but rarely moved beyond what the largely male producers saw as appropriate. Thus the comics were seen by feminists as limited and limiting, although, as Sabin argues, "there are differing opinions on what constitutes positive and negative images—and, moreover, such categorizations tend to change with time."[22]

The development of specifically feminist comics was, however, predominantly a response to a very different kind of comic altogether. American underground comix were generally the stimulus. The underground boom lasted from around 1968 to 1975, and (as described in chapter 3) the comix produced were sold mainly via a network of hippie shops, or "head shops." Typically self-published and creator-owned, underground comix could take on any topic—indeed, the content would generally prevent mainstream shops from stocking them. Feminist titles that "purposely concern[ed] themselves with the articulation of women's experience"[23] first appeared in the 1970s. Major pioneers in this area were Trina Robbins, Willy Mendes, and Lee Marrs. Robbins, talking about her experience, says that she was inspired by strips in the *East Village Other* but also that "underground comics in the 1960s were an almost exclusively male field," adding that "most of the male underground cartoonists understood as little about the new women's movement as the newspapers did and reacted to what they perceived as a threat by drawing comix filled with graphic violence directed mostly at women. People . . . who criticized this misogyny were not especially welcome in this alternative version of the old boys' club and were not invited into the comix being produced."[24] These titles, then, were not central to the underground market as commercial trend but a response to its perceived sexism.

The spaces for women to create comics were, instead, located in the growing field of feminist underground newspapers. Robbins joined the women's liberation newspaper *It Aint Me Babe* (*sic*) in 1970, drawing covers and comic strips.

This, in turn, led to the creation of the all-woman anthology of the same name, published by Last Gasp (1970). This represented the first time in comic book history that women had claimed full creative control. Creating comix was a good way of getting across ideas about feminism, whether through parodies of mainstream sexist imagery or through the discussion of major issues such as rape and abortion. There was also a great deal of autobiographical work, thus setting in motion an aspect of women's work in comics that continues today. (The first overt example of work in this field was by Aline Kominsky-Crumb in *Wimmen's Comix* #1.)[25]

The initial key titles, besides *It Aint Me Babe*, are usually identified as *All Girl Thrills* (1971) from The Print Mint, by Robbins and Mendes, and a number of anthologies, including *Wimmen's Comix* (1972; later *Wimmin's Comix*), *Tits & Clits* (1972), and *Wet Satin* (1976). *Wimmen's Comix*, a continuing all-woman anthology, ran (through various publishers) for about twenty years and took a different theme for each edition; *Tits & Clits* featured a lot of humor as well as sex; and *Wet Satin* was about women's erotic fantasies. In addition, Lee Marrs also published the first edition of *Pudge, Girl Blimp* in 1974 with Last Gasp. What these titles did was stimulate further work, thus drawing in new female creators. One edition of *Tits & Clits* from 1973, as noted by Robbins, carried an advertisement for "thirteen other feminist underground comics, thereby launching the heyday of women's comics."[26] This included the growth of lesbian comics, notably Roberta Gregory's *Dynamite Damsels* (1976) and Mary Wings's *Dyke Shorts* (1978). While Robbins wrote the first overtly lesbian story in comics for *Wimmen's Comix* #1, Wings responded to what she saw as its heterosexual view of lesbianism by creating the self-published *Come Out Comix* (1973).

The development of the underground in Britain echoed that of the United States but with specifically British twists. Sabin notes that despite the absence of a recognized "women's scene" such as there was in America, several notable feminist comix "served the same twin purposes of providing a platform for women creators, and a venue for women's issues to be aired."[27] This was very much the case in the creation of *Heröine* (1978), a feminist and punk-informed one-off from the Birmingham Arts Lab edited by Suzy Varty, the best known of the British women creators. This comic in part satirized the British girls' comic, with reference to the vacuous nature of some of the characters in the mainstream titles. Other titles included *Sourcream* (1979–1982). However, the number of U.K. female creators being much smaller meant that single editions rather than series tended to be the rule.

The impact of punk upon the British underground moved comic creators away from the concerns of the 1960s. The resulting style tended to be more aggressive and confrontational. For example, *Shocking Pink*, published in the 1980s by a collective of young women, was based on *Jackie* and teen magazines but pastiched them mercilessly.[28] The work of these younger creators served as a rejoinder to British girls' comics and magazines and shared their mixed

format. Another example, Erica Smith et al.'s *GirlFrenzy* (1992), analyzed and commented upon the British "riot grrrl" scene using a range of formats from photo-stories to hand-drawing, along with text-based features. The relationship between feminism and comics also continued in the creation of "girl comics" in the United States in the 1990s, including *Girlhero* by Megan Kelso (1991–1996) and the anthology *Action Girl* edited by Sarah Dyer (1994–2000). Further, a number of the underground stars, including Robbins and Marrs, were able to move into the mainstream and independents; for example, Cath Tate and Carol Bennett's imprint Fanny, published in Britain by Knockabout, spotlighted a number of women creators. Feminism, then, as a focus, motivated women to become creators in the 1960s and 1970s and opened up spaces, especially through the genres of autobiography and fantasy, for self-expression that continues today.

Shōjo Manga

The growth in comics for girls and women is a global phenomenon. In recent years (as noted in chapter 5), manga has become an important Japanese export, and though that phenomenon may have peaked and somewhat subsided, manga in translation remains an established international staple. In particular, shōjo manga, comics for girls, have helped to mainstream Japanese comics worldwide. In 2004, Paul Gravett noted that there were four hundred women *mangaka* (comics creators), among them top industry figures, and their significance has enabled the development of a diverse yet female-centered body of texts.[29] These have proved popular in many countries. In fact, the narratives, artwork, and philosophy of shōjo manga are complex and appeal to diverse girls and women globally, as shown by robust sales in America and beyond. For instance, Natsuki Takaya's *Fruits Basket* (1998–2006), licensed in English by Tokyopop, was the most popular manga in America circa 2007, selling millions of copies, and helped fuel an American shōjo boom.

According to Casey Brienza, the U.S. market for translated shōjo exploded from 2002 to 2007,[30] and to this day, that surge remains an important milestone in discussions of comics, readership, and gender. Given the small number of comics aimed at girls in the United States and Britain in the late twentieth century—indeed, a kind of gendered vacuum in the comics of both countries—shōjo manga reinvigorated the relationship between girl readers and comics. This connection happened despite stereotypic images of manga (such as the big-eyed female and the big-bodied or comedic male) that have dominated Western perceptions of these titles and may have limited readers' engagement, even though those stereotypes represent only a fraction of the narratives on offer.

While tentative attempts at translating manga were made in the 1970s, interest was limited. The initial perception of manga was that it would need to be not

only translated for a Western audience but also adapted by visually "flipping" its pages, at substantial cost. Animation did not make such demands, and perhaps partly for that reason, anime rather than comics made Japanese popular culture's first impact internationally. (The trend of developing manga and animation simultaneously had been pioneered by Mitsuteru Yokoyama's *Mahōtsukai Sarī* [Sally the witch] in 1966, after which employing cross-media synergy became a standard tactic.) However, by the 1990s, as it turned out, Western readers were happy to read "unflipped" work. Indeed, reading manga in this "authentic" manner became a rebellious form of reading, simply given these reversals.[31]

Globalizing manga has been a gradual process that began with, as Gravett notes, the Italian and Spanish industries taking an early interest in the 1980s. In the United States, manga became a regular feature of comic bookstores starting in 1987, and one of the first U.S. publishers to move in that direction was Eclipse, a small independent house known for its engagement with feminist comics. Since then, Gravett observes, shōjo has played a particularly significant role in the process of spreading manga internationally; Tokyopop targeted girls and young women with shōjo translations, such that as of 2004, about 70 percent of their readership was girls ages eleven to seventeen.[32] Gravett also notes that the expansion of manga into European markets was, in the mid-2000s, huge. The length, complexity, and themes of shōjo manga—in effect, their differences from homegrown national comics—made them attractive.

In Japan, the recognition of shōjo manga emerged in the 1970s, long before the export of titles took off. Before the 1960s, shōjo manga was much like Western romance comics in setting passivity and marriage as aspirations for the reader, though there were narratives that offered considerable adventure before that end was reached. A key example would be *Princess Knight* (*Ribon no kishi*) by Osamu Tezuka, serialized in *Shōjo Club* (first series, 1953–1956). The central character of *Princess Knight*, the cross-dressing Sapphire, acts, in Gravett's words, as "a prototype for the magical girls and sexual ambiguities that would become central to Shôjo manga."[33]

In the 1960s, the success of artists like Machiko Satonaka and Yoshiko Nishitani heralded the arrival of women creators in shōjo manga. Satonaka, like many who followed, came into the industry by winning a talent competition. This tactic was also used in launching manga internationally, resulting in various firms developing "native" manga talent. In the 1990s and early 2000s, "manga" in effect became a label for work that did not fit in with stereotypes of what a comic could be in any given country; as such, it freed younger creators internationally and resulted in the creation of a wider range of works, even though, as Gravett acknowledges, "whether any of these non-Japanese versions can strictly be called manga is a matter of contention."[34] Notably, the spread of shōjo manga encouraged an upsurge of women creators both in print and online, in the blossoming digital comics culture. Further, talent competitions urged fans to start creating, again following the Japanese model, wherein *dōjinshi*, comics

by amateur creators, are significant. Many female creators originally made contributions to this field, again boosting women's presence as creators as well as readers of comics.[35]

The female mangaka of the 1970s changed the subjects, layout, and symbols of shōjo manga. The 24 *Nengumi* (Year 24 Group, also known as the Fabulous or Magnificent '49ers) had a significant impact (as chapter 5 here discusses in detail). They extended shōjo's range of genres into social problems, science fiction, history, and other areas, much as women's comix had in America and elsewhere. Also, they innovated aesthetically, using ornate graphic symbols (for example, stylized flowers) and "halos" around characters' heads to fashion new ways of representing emotional states outwardly. Further, they used panels in fluid and expressive ways, moving beyond a rigid grid. As Gravett observes, "They overlapped or merged sequences of panels into collages. A borderless panel could now permeate the page, often beneath flotillas of other panels sailing across it, or it could expand or 'bleed' off the edges of the printed page itself and imply an even bigger picture beyond the paper.... Characters too were no longer always contained within panels, but could stand in front of them, making them more vivid and showing off their body language and fashions."[36] All these changes and nuances—aesthetic refreshments in a perhaps overfamiliar medium—served to give shōjo manga a stronger appeal to female readers. A key example of such work would be Riyoko Ikeda's popular *Berusaiyu no bara* (*The Rose of Versailles*; 1972–1974).

In addition, a number of shōjo creators, notably Moto Hagio and Keiko Takemiya, deepened shōjo's treatment of gender nonconformity (harking back to *Princess Knight*) by exploring themes of homosexuality and gender fluidity, and thus began another major innovation: the subgenre of *shōnen-ai* (boys' love) narratives, pioneered in key titles such as Takemiya's *Kaze to ki no uta* (The song of the wind and the tree; 1976). Although the search for love remained a theme, these comics shifted away from social and gender conformism. Shōnen-ai, as Dru Pagliassotti, Kazume Nagaike, and Mark McHarry assert, "attracts a large number of Japanese female readers, and it has also had large transnational impact."[37] In particular, they pinpoint Tokyopop's 2003 publication of *Gravitation* in the United States as a landmark, noting that translated shōnen-ai "met an enthusiastic reception."[38]

The appeal of these titles for readers everywhere comes through immersion in complex worlds that, whether in science fiction or shōnen-ai, offer a deep emotional resonance. In addition, the sheer length of the stories means that a reader may spend years growing up with a title, often developing a lifelong affection for creator and narrative. Even when titles are compressed for Western readers, they still offer a significant, sustained engagement with the comics form.

Conclusion

Various genres and movements have produced comics for girls and women; this brief chapter can summarize only a few strands. These case studies indicate the range of engagement women and girls have had and do have with comics. If British girls' comics can be seen as victims of publishers' lack of commitment in favor of male audiences, they still offered important spaces of aspiration and inspiration. Romance comics, largely written to support masculine perceptions of traditional power relations, failed to address shifting understandings of gender and culture but, again, offered for a time sets of texts that addressed girls' and women's concerns (in part through the transgressions of the female characters before their eventual conformity). In contrast, women's underground comix spotlighted politics and personal experience and so had an influence much wider than their immediate circulation and established a number of major female creators. While these were often short-lived, they had a huge impact on comics and on women's relationship with the medium. Finally, shōjo manga, in tapping once more into topics of interest for girls and women and in challenging, often fantastically, gender norms, reshaped women's relationships to comics on an international scale, enabling new generations of female readers to access comics they enjoy and offering women creators another space in which to work.

Notes

1. Mel Gibson, "'You Can't Read Them, They're for Boys!' British Girls, American Superhero Comics and Identity," *International Journal of Comic Art* 5, no. 1 (Spring 2003): 305–324.
2. Dennis Gifford, *The British Comic Catalogue, 1874–1974* (London: Mansell, 1975), 141.
3. Mary Cadogan and Patricia Craig, *You're a Brick, Angela! The Girls' Story 1839–1985* (London: Gollancz, 1986), 233.
4. Penny Tinkler, *Constructing Girlhood: Popular Magazines for Girls Growing Up in England 1920–1950* (London: Taylor & Francis, 1995), 60.
5. Mel Gibson, "What Bunty Did Next: Exploring Some of the Ways in Which the British Girls' Comic Protagonists Were Revisited and Revised in Late Twentieth-Century Comics and Graphic Novels," *Journal of Graphic Novels and Comics* 1, no. 2 (December 2010): 121–135.
6. Martin Barker, *Comics: Ideology, Power and the Critics* (Manchester: Manchester University Press, 1989), 17.
7. Anonymous, *Mum's Own Annual* (London: Fleetway/IPC, 1993), 13.
8. Mel Gibson, "*Bella at the Bar*," in *1001 Comics You Must Read before You Die: The Ultimate Guide to Comic Books, Graphic Novels and Manga*, ed. Paul Gravett (New York: Universe Publishing, 2011), 354.
9. Royal Commission on the Press, *The Women's Periodical Press in Britain, 1946–1976*, CLW Working Paper No. 4 (London: HMSO, 1977), 39.
10. Barker, *Comics*, 234–238.
11. Trina Robbins and Catherine Yronwode, *Women and the Comics* (n.p.: Eclipse, 1985), 49.

12 Roger Sabin, *Adult Comics: An Introduction* (London: Routledge, 1993), 152.
13 Trina Robbins, *From Girls to Grrrlz: A History of Women's Comics from Teens to Zines* (San Francisco: Chronicle, 1999), 50.
14 Bradford W. Wright, *Comic Book Nation: The Transformation of Youth Culture in America*, rev. ed. (Baltimore: Johns Hopkins University Press, 2003), 127.
15 Robbins, *From Girls to Grrrlz*, 70.
16 Marvel Comics also abandoned romance after 1976. Of all the long-lived U.S. comic book publishers, only Charlton persisted in publishing romance titles into the 1980s, and these were but marginal, low-selling remnants of a once-thriving genre.
17 Penny Tinkler, "'A Material Girl'? Adolescent Girls and Their Magazines, 1920–1958," in *All the World and Her Husband: Women in Twentieth-Century Consumer Culture*, ed. Maggie Andrews and Mary M. Talbot (London: Cassell, 2000), 106.
18 Royal Commission on the Press, *Women's Periodical Press*, 11.
19 Angela McRobbie, *Feminism and Youth Culture: From* Jackie *to* Just Seventeen (London: Macmillan, 1991), 87; and Barker, *Comics*, chaps. 8 and 11.
20 Cynthia L. White, *Women's Magazines 1693–1968* (London: M. Joseph, 1970), 177.
21 McRobbie, *Feminism*, 136.
22 Sabin, *Adult Comics*, 221.
23 Sabin.
24 Robbins, *From Girls to Grrrlz*, 85.
25 Regarding the rise of women's autobiographical comix, and Aline Kominsky-Crumb's essential role in particular, see Hillary L. Chute, *Graphic Women: Life Narrative and Contemporary Comics* (New York: Columbia University Press, 2010), 21–24, 34–37.
26 Robbins, *From Girls to Grrrlz*, 89.
27 Roger Sabin, *Comics, Comix and Graphic Novels* (London: Phaidon, 1996), 111.
28 Regarding the complex history and influence of *Shocking Pink*, see Cazz Blase, "A Shocking Shade of Pink," The F-word: Contemporary UK Feminism, 13 August 2011, accessed 16 February 2020, https://thefword.org.uk/2011/08/shocking_pink/.
29 Paul Gravett, *Manga: Sixty Years of Japanese Comics* (London: Laurence King, 2004), 74.
30 Casey Brienza, "Books, Not Comics: Publishing Fields, Globalization, and Japanese Manga in the United States," *Publishing Research Quarterly* 25, no. 2 (2009): 101–117.
31 Mel Gibson, "'So What Is This Mango, Anyway?' Manga and Younger Readers in Ireland and Britain," *Inis Magazine*, Children's Books Ireland, no. 22 (Winter 2007): 10–15.
32 Gravett, *Manga*, 154, 156.
33 Gravett, 77.
34 Gravett, 157.
35 Dru Pagliassotti, Kazumi Nagaike, and Mark McHarry, "Boys' Love Manga Special Section," editorial, *Journal of Graphic Novels and Comics* 4, no. 1 (2013): 2.
36 Gravett, *Manga*, 79.
37 Pagliassotti, Nagaike, and McHarry, "Boys' Love," 1.
38 Pagliassotti, Nagaike, and McHarry, 3.

17

Digital Comics

• • • • • • • • • • • • • • • • • • • •

DARREN WERSHLER,
KALERVO SINERVO,
AND SHANNON TIEN

On October 15, 2012, Google celebrated the 107th anniversary of the first appearance of Winsor McCay's comic strip *Little Nemo in Slumberland* with one of its now-familiar Google Doodles. Since 1998, Google has made over 2,000 such alterations to its logo (which can be found at https://google.com/doodles/about), but "Little Nemo in Google-Land" was one of the most elaborate (figs. 17.1 and 17.2). The doodle team debated whether to follow McCay's vertical composition or the horizontality of the computer screen. They finally settled on an animated series of frames that "reads" left to right, as a print comic strip would... but then, after reaching a hard right-hand margin, reveals a small arrow. Clicking the arrow reveals another row of animated frames below and then another arrow, which does the same. The action continues in this manner until Nemo finally "tumbl[es] out of bed."[1]

"Little Nemo in Google-Land" was a watershed moment for digital comics. It points simultaneously to the history of comics as well as to the present and future of the form. Digitization adds a number of formats and subgenres to the already complex history of comics, making use of not just motion and animation but also "infinite plane" comics, hypercomics, "zooming" comics, and other techniques such as those Scott McCloud describes in *Reinventing Comics* (2000) and on his website (https://scottmccloud.com).[2] However, the history of digital

FIG. 17.1 "Little Nemo in Google-Land," screen shot, Google Doodle, October 15, 2012. Clicking on the arrow at the end of each tier reveals further tiers of panels below, one after another; thus the comic invites reader interaction. As new tiers open up, elements of the drawing (Nemo, the ball, the bed, and so on) are animated, moving from left to right.

comics is as haphazard and complex as is *Little Nemo*—a comic strip that has had a long history of intermediality that stretches over the last century, including several film versions, a stage production, and a video game (see chapter 1). Digitization itself might be relatively new, but comics have always been intermedial and interactive. As such, a discussion of the digitization of comics needs to focus on more than formal concerns if it is to distinguish what has changed.

There are strong family resemblances between digital comics and the graphic adventure games produced by companies like On-Line Systems (later Sierra) in the 1980s. Comics served as the subject matter for games like *BC's Quest for Tires* (Sierra, 1983) and *Spy vs. Spy* (First Star Software, 1984), both playable on the Commodore 64, Apple II, and other platforms. But are these early video games "really" digital comics? In *Comics versus Art*, Bart Beaty contends

FIG. 17.2 "Little Nemo in Google-Land," screen shot, Google Doodle, October 15, 2012. The comic ends with Nemo's long vertical "fall" across several tiers of panels and out of bed, as per McCay's famous strip formula. (Compare with McCay's original in fig. 11.2.)

that it makes the most sense to think of comics as "the products of a particular social world, rather than as a set of formal strategies."[3] For Kevin G. Barnhurst and John Nerone, form always includes the social world from the outset, so the notion of form retains its usefulness for description as long as we bear that in mind.[4] However, Beaty's point is to attempt to avoid the sorts of erasures and omissions that always result from the policing of formal concerns. What should matter to scholars and historians is not some elusive and chimeric formal essence but what particular communities say about and do with the things that count as comics to them. A detailed analysis of these early computer programs is one of the many components of the history of digital comics that remains to be written.

It's far from clear what "digital comics" actually references, because comics are at once a medium, a set of genres, and a series of different "formations" that combine a system of production and circulation, a cultural and ideological component, and physical format.[5] Digitization involves shifts in all these levels, affecting how comics are produced, circulated, and consumed. This chapter considers three separate digital comics formations: digital print production, removable media, and networked digital media. These overlap in interesting ways, and none has become completely obsolete. With the rise of smartphones and tablets and the accompanying drive toward cloud computing and leasing rather than retail business models, digital comics on removable media might prove to be the most fragile of these systems because they are a transitory form.

Print Comics Created with Digital Tools

The vast majority of new comics are "digital" to some extent. Even if the original art is made with pencil, pen, and brush rather than a graphics tablet, virtually all printing companies have moved away from process cameras to flatbed scanners and from analog plate production to digital workflows. Even before comics appeared on computer screens, they were being produced with the help of computers.

Anecdotes about the earliest use of a computer at a major comics publishing house place it at Marvel in 1989. Marvel's computer was primarily used for the business side of production but apparently was also employed in some initial forays into digital typesetting.[6] The earliest examples of digital print comics were produced by artists and writers with a history of working for Marvel but appeared outside the major publishers, in the pages of a British magazine for computer hobbyists (yet another reason to consider the Sierra and similar games as part of the history of digital comics).

Illustrator Mike Saenz and writer Peter B. Gillis's *Shatter* is usually cited as the first print comic to make total use of digital illustration. Test pages of the tentatively titled "Project Zero" were exhibited at Chicago Comicon in July 1984 and subsequently featured in a short article in the sixth issue of *Big K* magazine.[7] A four-page spread, retitled "Shatter," appeared in the twelfth issue and was supposed to continue monthly, but this was the magazine's final issue.[8] *Shatter* was then published as fourteen issues from First Comics Publishing in Chicago in 1985 and 1986 and later released as a trade paperback. Drawn with a mouse on an Apple Macintosh Plus with one megabyte of RAM and twin floppy drives, using the computer program FullPaint, *Shatter* was printed on a dot-matrix printer, retouched by hand, then photographed with a process camera to make plates. Artist Charlie Athanas (who joined the project with issue 8) writes that the hardest part of working with the hardware was drawing with the boxy mouse on the computer's tiny screen, which revealed only two-thirds of a page at a time.[9]

Other experiments, like Pepe Moreno's *Batman: Digital Justice* (1990), followed on *Shatter*'s heels. Moreno has proudly described the book as "the first ever of its kind," indeed a landmark in "the desktop digital revolution," one that inspired "hundreds of articles . . . all over the world." Moreno owned early computers from Amiga and Apple and worked with software companies to help develop applications like PixelPaint, Letraset's Image Studio, and EA's Studio 32.[10] *Digital Justice* was produced on an eight-bit Mac II with 256 indexed colors, eight megabytes of RAM, a removable forty-five-megabyte hard disk drive, and a Trinitron monitor.[11] Where *Shatter* was produced as a bitmap, pixel by pixel, *Digital Justice* made use of early vector drawing software, three-dimensional modeling tools, and page-layout software.[12] *Digital Justice*, a futuristic, high-tech, and dystopian spin on the Batman mythos, remains of interest to the extent that it represents the state-of-the-art digital production methods of the era as well as the emergence of the cyberpunk ethos in the late 1980s.

Removable Media and Comics Distribution

The earliest effort at producing a digital platform for comics was also the most experimental. In 1988 and 1989, Infocom's Infocomics released four titles for the Apple II, Commodore 64, and PC. While unimpressive in terms of their visual design and writing, "many scenes scaled, panned and rotated from one scene to the next," making use of the structural and narrative possibilities of hypermedia.[13] Infocomics each had several plots, allowing readers to switch points of view and requiring multiple readings to experience the entire story.

The first two Infocomics, Steve Meretzky's *Lane Mastodon vs. the Blubbermen* and Amy Briggs's *Gamma Force in Pit of a Thousand Screams*, both released in 1988, drew their inspiration from pulp heroes like Captain Future and comic characters like the Fantastic Four.[14] Meretzky's previous work, the Flash Gordon pastiche text adventure *Leather Goddesses of Phobos* (1986), had included a small print comic as supplementary material. As their titles suggest, the last two Infocomics titles, Elizabeth Langosy's *ZorkQuest: Assault on Egreth Castle* (1988) and *ZorkQuest II: The Crystal of Doom* (1989), instead of hearkening to comics, drew their content and inspiration from the *Zork* computer adventure games that were already a decade old. Importantly, though the Infocomics project only lasted two years, it serves as an early example of using removable computer discs for comics storage and distribution, which became common in the late 1990s.

Experiments with hypermedia soon fell away, and digital discs began to serve as delivery mechanisms for digital content. In the late 1990s, *Wizard: The Guide to Comics*, a monthly price-guide publication, began including free America Online (AOL) floppy disks in the back covers of its magazines. In this case, print comics served as a link to the rapidly developing internet rather than as

material to be adapted to digital display constraints. This was a turning point in the history of digital comics, as the disk in the back of the price guide suggests a substantial overlap between comics collectors and early users of the internet.

While the AOL disks in *Wizard* did not contain any comics themselves, the AOL network did. Around 1996, Marvel began to produce Cybercomics for America Online.[15] A hybrid, "slightly interactive" form that fell somewhere between comics and animation, Cybercomics were probably the first entirely digital Marvel product. Like most emergent technologies, they were marginal and clunky, and they were certainly at odds with the print comics that were still the sustaining technology of the Marvel media empire. AOL users received free access to Cybercomics as part of their subscription packages. Beginning in 1997, Cybercomics were available on MarvelZone.com, and in 1999, NextPlanetOver.com republished a dozen previously released Cybercomics. In 2002, Marvel licensed GIT Corporation to release complete scanned collections of its backlisted comics on multiplatform CD-ROMs and DVD-ROMs.[16] The disks contained series of PDF files, one per comic, each of which consisted of a front-to-back, high-resolution scan of a single issue of a print comic book, including ads, editorials, letter columns, and sometimes even rubber stamps or scribbles. The idea was to use digital media as the basis for reprint economy—a fairly novel concept, since it was not yet common for full runs or even partial runs of comics titles to be available in collected and published form.

Marvel halted production of Cybercomics in 2001, but simultaneously launched Marvel dot.comics, Flash-based motion comics that functioned in a similar way to Cybercomics, suggesting that the minimally interactive form still dominated the notion of what digital comics might be at the House of Ideas. Readers of the dot.comics also could access them on DVD-ROM or download them to their hard drives. With the dot.comics, Marvel was also beginning to develop a digital business model. Some of their content was drawn from back issues and some came from recent releases. In both cases, the added labor of producing original content from scratch was gone—another important difference from their Cybercomic predecessors. Marvel monetized dot.comics in a fashion similar to the early nineties shareware model, where the first few levels of a video game might be available free of charge as a demo, but then players had to purchase the full product to continue the game they had begun to enjoy.

At the turn of the millennium, Marvel was clearly hedging its bets with digital technology. In 2003, it penned a licensing deal with Intec Interactive to launch another version of motion comics called Digital Comic Books (DCBs): cross-platform DVDs that displayed "digitally enhanced" versions of classic Marvel titles.[17] Enhancements included "professional voice-overs, original music, stunning effects and high-end sound design . . . previews, character biographies, original sketches, a documentary about how comics are made, and bonus chapters (including classic first appearances of the main characters)"—more than one hundred minutes of content per DVD. Though their name suggests that

DCBs were closely related to comic books, Intec's own press releases repeatedly use the language of cinema to describe them, suggesting that they were designed to appeal to audiences other than regular comics readers. GIT's and Intec's collections were more likely to be found in video stores and general retailers than comics stores, evidence that their producers still did not conceive of these products as "comics," per se. This conception of comics on discs as a tool to expose new markets to old material probably contributed to their short life span. The nail in their coffin, though, was the shift in marketing philosophy that arose with networked digital media, which eschews selling digital files as products in favor of leasing them as services on a subscription basis.

From Product to Service

The current model of selling digital comics as a service associated with apps for hardware such as tablets and mobile phones also began with the use of digital media to distribute print comics. The most successful example of digital distribution of English-language comics has been ComiXology, a cloud-based digital comics platform founded in 2007 and acquired by Amazon in April 2014. While Comics by ComiXology is easily the best-known comics app, it was not the first. An independent concern called Carnival Comics beat it to the mark in April 2009.[18] So did Dark Horse's digital rerelease of 1998's *Terminator: Death Valley* in June 2009 in anticipation of the *Terminator: Salvation* film.[19]

At its genesis, ComiXology was an online community that allowed users to develop pull lists of upcoming print titles and to review already-released books; it also offered retailers a suite of tools to optimize their online presence. In summer 2009, ComiXology released the Comics by ComiXology app, which acted as both store and reader for devices ranging from home computers to mobile devices. Branded versions of the app quickly became the default platform for the major commercial comics publishers. It rose to prominence without generating its own content but instead through a patented technology called Guided View, which atomizes the comic book page into individual panels for easier viewing on mobile digital devices. Guided View provides for varying degrees of dynamic animation within a panel, which actually allows for a degree of formal innovation (see, for example, the digital version of Jeff Loeb and Tim Sale's *Daredevil: Yellow* [2001–2002], which uses Guided View to make the viewing frame follow Daredevil's acrobatics within large panels). However, it is primarily a concession to small screen sizes; it will sometimes cut visual or textual information out of a panel, presumably to reduce complexity. Guided View fundamentally alters the way a comic is read, changing the basic unit from page to panel (though in recent builds of apps that use Guided View, such as Marvel Infinite, the page has returned as a vestigial thumbnail view).

The key difference between comics on removable media and cloud-based digital comics is that ownership and attendant rights like first sale (the right to

resell goods like books and CDs) disappear. A digital title may cease to exist if and when its publisher stops offering a particular digital comics service. Readers that change phone models or change service providers may also lose their cloud-based comics collections, which are not downloadable. Other risks include server crashes, data erasures, and errors in the electronic sale process. While some print comics now come with digital redemption codes (so that readers can have access to a digital version when they purchase the print edition), no such service exists going in the other direction. In short, the digitization of print into nonremovable cloud-based formats impacts not only the content of the comics themselves but also the politics of distribution, ownership, and collecting.

The purchase of ComiXology by Amazon in 2014, and the immediate dismantling of the ability to make in-app purchases, brought howls of outrage from comic readers and writers alike. Gerry Conway, cocreator of The Punisher and other popular comics characters, claims, "[Amazon has] deliberately degraded the iPad and iPhone Comixology app so that users of the Kindle will have a better reading and purchasing experience.... They've destroyed the future of digital comics to give an advantage to their hardware platform—and, in passing, to leverage their control of digital comics distribution to do to comic book stores what they've already done to brick-and-mortar book stores."[20] The story of the World Wide Web has been one in which a dream of decentralized, democratic publishing has become a history of increasing concentration and monopolization. Are there still alternatives to Amazon and Apple's cloud services on the open web?

Webcomics

The history of webcomics runs parallel to but is distinct from that of mainstream digital comics. Because the web is an open publishing medium with relatively few barriers to entry, webcomics have always included opportunities for independent authors. However, webcomics have also become a platform for self-sustaining business models, properties for games, and a route into print publication.

The beginnings of webcomics are relative rather than absolute. Eric Monster Millikin's *Witches and Stitches* actually predates the existence of the web: its author began distributing *Witches and Stitches* in 1985 through CompuServe. *Witches and Stitches* bears little resemblance to today's webcomics; an unauthorized take on *The Wizard of Oz*, it was a hand-produced long-form narrative. Millikin was followed in 1991 by Hans Bjordahl's strip *Where the Buffalo Roam*, which claimed to be "The Internet's First Comic Strip."[21] It was distributed through File Transfer Protocol (FTP) and Usenet, and it made an attempt to update regularly. Then, in late 1993, the first online comic published on the internet appeared: a panel gag comic titled *Doctor Fun*, produced by David Farley.[22]

New webcomics began to appear with some frequency—for those who knew where to find them. Because many webcomics were roughly done and avoided most kinds of censorship, they seemed to inherit the aesthetics of the comix and zines that came before them. A great many articles (many of them now dated) already exist that offer to delineate the "best of" webcomics.[23] However, it may be helpful to note a few webcomics that signaled the growing viability of webcomics creation as a profession.

In much of the existing literature on webcomics, three strips appear again and again as milestones in the form: *Penny Arcade* (1998–), a largely nonnarrative gag strip about video games by Mike Krahulik and Jerry Holkins; *Goats* (1997–2010), a narrative-driven comedic fantasy/science fiction strip by Jonathan Rosenberg; and *PvP* (1998–), a comic by Scott Kurtz about games that evolved into character-driven comedy. All three have been around since the late 1990s, and their creators have managed to make their creative work their primary source of income through the implementation of a variety of business models. Rosenberg was one of the first webcomics creators to experiment with micropayments as a revenue generator (generally critiqued as a failed experiment).[24] Kurtz was an early self-publisher of collected editions of his work but also one of the first to move his webcomics property over to a prominent print comics publisher (in 2003, Image Comics began publishing a monthly *PvP* series that combined old strips with new material to turn online story arcs into single issues in print). Krahulik and Holkins produced print collections but also grew their webcomic into a company that develops games, sells merchandise, produces both animated and reality show webseries, and runs successful if divisive gaming culture festivals (Penny Arcade Expo, or PAX) and a children's charity (Child's Play).

Most webcartoonists looking to carve an income from their creations have focused on the sale of merchandise. John Allison of *Scary Go Round* (2002–2009) is exemplary. An early webcomic creator now making a living from his art, Allison designs and sells T-shirts, tote bags, and prints from his site, as well as collected print editions of his regularly updated comic. He has blogged extensively about the process of earning a living from comics, writing that shirtmaking was a vital component of the webcomic moneymaking ecosystem and that a combination of "merchandise sales, advertising, and freelance work" comprises how webcomics creators make the bulk of their money.[25] (More recently, Allison has focused on working for print.) But while it may be difficult to sell the print version of content that's available online for free, success in print is by no means inaccessible to webcartoonists. Kate Beaton, creator of *Hark! A Vagrant* (2007–2018), has managed to make a living in print by publishing collections of her work with the boutique press Drawn & Quarterly and has channeled her reputation into work on publications like Marvel's *Strange Tales* and the *New Yorker*. (Most recently, Beaton has focused on picture book and graphic novel work.)

Webcomics have produced a number of innovations in form and technique. Every now and again, a webcartoonist like Randall Munroe of *xkcd* (2005–) will publish a comic that pushes the boundaries of the "infinite canvas" that Scott McCloud describes in *Reinventing Comics* (2000).[26] Such examples represent the aesthetic and narrative potential of webcomics, but like mainstream print comics, webcomics for the most part appear to have settled into a comfortably static model. The webcomics form presents few controversies or departures from print conventions beyond basic HTML functions such as additional scrollover text that modifies the comic's punchline or external links that put the comic in conversation with a larger discursive community.

Though the webcomics field is dominated by dedicated independent creators, industry interests have made a show of trying out the format as well. The most notable of these has been DC's webcomics imprint Zuda. Launched in 2007, it was conceived of as a breeding ground for curated webcomics that would compete with each other for renewal by popular vote. A DC editorial board would select competitors from open calls held each month and leave ten up to be voted among by users. The most popular would receive a short-term contract, at the end of which popularity would once again determine the viability for another contract. The imprint ran into criticisms that its curatorial process favored work that more closely resembled traditional print comics aesthetics rather than that of common webcomics. In 2010, DC Comics began expanded digital distribution of their print content and folded Zuda into this service, effectively ending the imprint and closing competitions. The most popular comics of the Zuda line were repackaged for print. As has been the case historically, corporate interests have largely aimed to harness digital technologies in order to produce or distribute traditional print properties or to act as supplementary, transmedial arms of intellectual property empires.

Digital Distribution and Funding Models

Digital media have not only transformed the ways both corporate and independent comics are produced but also changed the distribution and funding models for comics. Most of the large mainstream comics publishers now support the day-and-date digital distribution model. Day-and-date is a simple concept: it has become the policy of the large publishers to release digital versions of their comics in all forms on the same day that the print edition of the comic hits the store shelves. While Wednesdays have long been "new comics day," readers no longer even have to travel to their local comics store to pick up their favorite titles. The first publisher to take on day-and-date digital distribution for all their flagship titles was Archie Comics, who began making their weekly comics output available online in April of 2011.[27] However, it was DC Comics that made the bigger splash by timing their strategy to coincide with the launch of the continuity-cleaning "New 52" DC Universe reboot event in September

of 2011.[28] Other major North American publishers followed suit shortly after. This industry-wide change points to the born-digital nature of the vast majority of comics now being produced but also speaks to a shift toward seeing digital as equal in importance to print. The prevalence of day-and-date is a massive indication that mainstream comics interests now take digital media seriously.

Meanwhile, independent self-publishing comics creators have turned toward networked electronic media as a source of financing. Crowdfunding has fundamentally changed the way that indie comics can be produced, with sites like Kickstarter and Indiegogo now boasting scores of successfully funded comics-related projects, with more new campaigns every day. Representative of this new movement toward crowdfunding in comics, perhaps unexpectedly, is a major figure in comic history: Dave Sim.

Sim is a giant in the world of comics: over the course of a quarter century, he self-published all three hundred issues of his magnum opus *Cerebus* (1977–2004) through his own publishing firm, Aardvark-Vanaheim; helped to revolutionize the direct-market comics distribution model in the 1980s by cutting out distributors and communicating directly with comic shop owners; and arguably popularized the graphic novel form through his outsize *Cerebus* reprint volumes, nicknamed "phone books." In May 2012, Sim turned his attention toward both digital comics and crowdfunding with the launch of a Kickstarter campaign. The project was successfully funded a month later, by which point it had met more than 1,000 percent of its six-thousand-dollar goal. *Cerebus: High Society—Special Audio/Visual Digital Edition* promised just what the title indicates: a digital repackaging of one of Sim's best-received *Cerebus* collections as a high-end digital audiobook with scans of every page, commentary tracks, and attached footage of Sim's notebooks and studio (also accompanied by audio narration from Sim). The campaign was launched as an experiment to test the feasibility of *Cerebus* Digital 6000, a larger project to digitize and electronically redistribute all six thousand pages of Sim's epic.

This effort epitomizes the way crowdfunding is changing how comics work as a form, community base, and business: comics creators have always been among the most accessible entertainment professionals to their fan communities, and now readers are able to express their support in concrete dollar amounts. But as Sim has noted, crowdfunding also has its limits. He predicted a "built-in drop off in Kickstarter sales" for ongoing large scale projects like the *Cerebus* Archive.[29] (While IDW eventually published the *Special Audio/Visual Digital Edition* of *High Society* in 2015, the larger project of digitizing *Cerebus* continues as of this writing.) Going cap-in-hand to one's audience plays all too easily into the neoliberal desire to dismantle government grants to artists, writers, and presses and should by no means be viewed as a magic solution to the rapid centralization of digital sales.

Pushing the Form

Digital technology has shifted the foundations of what we mean when we talk about comics. There are simply too many formal innovations to list, each of which comes with its own promise of revolution in terms of the ways comics are produced, distributed, and consumed. But none of them represent *the future of comics*. Creators like Scott McCloud, Jason Shiga, and Randall Munroe have been experimenting with the "infinite canvas" on and off for years now, and while their comics are beautiful, innovative, and important works, they are also anomalies. For every dynamic strip Munroe produces, he produces fifty static ones. This is because most of the available innovative techniques and technologies for digital comics creation compound the energy and resources necessary for an already time-consuming process. If every comic were to suddenly require augmented reality, independent comics would disappear almost entirely, and mainstream titles would only be published on a quarterly basis.

The other reason to avoid talking about the "potential" of these experimental works is because to use such language would elide two facts: comics have always been intermedial and formally experimental, and digital media have *already* changed the way comics are made, circulated, and experienced. It is unlikely that any one digital expression of comics will soon become dominant, and maybe that's for the best. But one major topic of conversation about digital technology and comics needs to be the economic stakes of turning new audiences into markets—not just for the publishers but from the perspective of, and for the sake of, comic creators and readers alike.

Notes

1. Jennifer Hom, "107th Anniversary of *Little Nemo in Slumberland*," Google Doodles, 15 October 2012, accessed 10 June 2019, http://www.google.com/doodles/107th-anniversary-of-little-nemo-in-slumberland.
2. Google consulted with McCloud in advance of their McCay doodle, though he assigns them all the accolades. Scott McCloud (@scottmcloud), "Talked to the Google Doodle team in advance about today's beautiful Winsor McCay webcomic. Fantastic to see it in action!" Twitter, 14 October 2012, 9:54 p.m., https://twitter.com/scottmccloud/status/257705893469229057.
3. Bart Beaty, *Comics versus Art* (Toronto: University of Toronto Press, 2012), 43.
4. Kevin G. Barnhurst and John Nerone, *The Form of News: A History* (New York: Guildford, 2002).
5. Barnhurst and Nerone, 4.
6. Teresa Messmore, "A Marvelous Career: From Student Intern to Executive," interview with Tom Brevoort, *University of Delaware Messenger* 20, no. 2 (August 2012): http://www.udel.edu/udmessenger/vol20no2/stories/alumni-brevoort.html, accessed 10 June 2019.
7. "What You See Is What You Get," *Big K*, no. 6 (September 1984): 92–93, accessed 10 June 2019, https://archive.org/details/06-big-k-magazine.

8 Mike Saenz (art), Peter B. Gillis (story), and Mike Gold (editor), "Shatter," *Big K*, no. 12 (March 1985): 75–79, accessed 10 June 2019, https://archive.org/details/12-big-k-magazine.
9 Quoted in Ernesto Priego, "Un-holy Alliance: Shatter and the Aesthetics of Cyberpunk," *Comics Grid* (blog), 22 August 2011, accessed 10 June 2019, http://blog.comicsgrid.com/blog/shatter/.
10 Pepe Moreno, "Work History," Pepe Moreno's official website, 2013, http://www.pepemoreno.com/index.php/work/history. Web page no longer extant; last archived via Internet Archive: Wayback Machine (archive.org) on 23 September 2018.
11 Pepe Moreno, "Batman: Digital Justice (the Servo Cops)," Pepe Moreno's official blog, 24 February 2010, accessed 10 June 2019, http://pepemorenoart.blogspot.ca/2010/02/batman-digital-justice-servo-cops.html.
12 Joseph Szadkowski, "Digital Production Comes of Age in the Comic World," Animation World Network, 1 July 2000, accessed 10 June 2019, https://www.awn.com/animationworld/digital-production-comes-age-comic-world.
13 "Infocomics Games," MobyGames, accessed 10 June 2019, http://www.mobygames.com/game-group/infocomics-games/offset,0/so,1a/.
14 *Science Fiction Encyclopedia*, s.v. "Infocomics," 5 March 2015, accessed 10 June 2019, http://www.sf-encyclopedia.com/entry/infocomics.
15 For a detailed description of Cybercomics and Marvel's other experiments with motion comics, see Darren Wershler and Kalervo A. Sinervo, "Marvel and the Form of Motion Comics," in *Make Ours Marvel: Media Convergence and a Comics Universe*, ed. Matt Yockey (Austin: University of Texas Press, 2017), 187–206.
16 For a detailed account of the GIT Marvel disks, see Darren Wershler, "Digital Comics, Circulation, and the Importance of Being Eric Sluis," *Cinema Journal* 50, no. 3 (Spring 2011): 127–134.
17 For a history of DCBs, see Wershler and Sinervo, "Marvel and Motion Comics."
18 Kevin Michaluk [Crackberry Kevin, pseud.], "Carnival of Souls—1st Comic Book App in App World," Crackberry, 17 April 2009, accessed 10 June 2019, http://crackberry.com/carnival-souls-1st-comic-book-app-app-world.
19 Tyler Tschida, "Dark Horse Comics Launches First App, the Terminator Comics," AppAdvice, 4 May 2009, accessed 10 June 2019, http://appadvice.com/appnn/2009/05/dark-horse-comics-launches-first-app-the-terminator-comics.
20 Gerry Conway, "The ComiXology Outrage," *ComicBook* (blog), 27 April 2014, last updated 6 September 2017, accessed 10 June 2019, https://comicbook.com/blog/2014/04/27/gerry-conway-the-comixology-outrage/. Reprinted in *Forbes*, 30 April 2014, accessed 10 June 2019, http://www.forbes.com/sites/bruceupbin/2014/04/30/the-comixology-outrage/.
21 Shannon Garrity, "The History of Webcomics," *Comics Journal*, 15 July 2011, accessed 10 June 2019, http://www.tcj.com/the-history-of-webcomics/.
22 Sean Fenty, Trena Houp, and Laurie Taylor, "Webcomics: The Influence and Continuation of the Comix Revolution," *ImageText: Interdisciplinary Comics Studies* 1, no. 2 (Winter 2005).
23 In this "best-of" genre, see, for example, Garrity, "History of Webcomics"; Maria Walters, "What's Up with Webcomics? Visual and Technological Advances in Comics," *Interface: Journal of Education, Community, and Values* 9, no. 2 (2009): https://commons.pacificu.edu/inter09/9/, accessed 10 June 2019; and Eric Griffith, "The Best Webcomics 2015," *PC Magazine*, 15 February 2015, https://www.pcmag.com/news/the-best-webcomics-2015.

24 See Mark Bell, "The Salvation of Comics: Digital Prophets and Iconoclasts," *Review of Communication* 6 (2006): 131–140.
25 John Allison, "Teeshirt Treatise, a Treatise on Tees," *A Hundred Dance Moves per Minute* (blog), 8 June 2010, accessed 10 June 2019, http://sgrblog.blogspot.ca/2010/06/teeshirt-treatise-treatise-on-tees.html; and Allison, "Post Webcomics," *A Hundred Dance Moves per Minute*, 4 March 2013, accessed 10 June 2019, http://sgrblog.blogspot.ca/2013/03/post-webcomics.html.
26 See Randall Munroe, "Click and Drag," *xkcd*, http://xkcd.com/1110/; or Munroe, "Time," *xkcd*, http://xkcd.com/1190/.
27 Kevin Mahadeo, "Archie Comics Goes Day-and-Date Digital," Comic Book Resources, 12 January 2011, accessed 10 June 2019, https://www.cbr.com/archie-comics-goes-day-and-date-digital/.
28 David Hyde, "DC Comic Announces Historic Renumbering of All Superhero Titles and Landmark Day-and-Date Digital Distribution," *DC Universe: The Source* (blog), 31 May 2011, accessed 10 June 2019, https://www.dccomics.com/blog/2011/05/31/dc-comics-announces-historic-renumbering-of-all-superhero-titles-and-landmark-day-and-date-digital-distribution.
29 Dave Sim, "Weekly Update #38: Sitting on a Crumbling Ledge," *A Moment of Cerebus* (blog), 4 July 2014, accessed 10 June 2019, http://momentofcerebus.blogspot.ca/2014/07/7-ramadan-weekly-update.html.

Time Line of Selected Events

The history of comics is contested, ever-shifting terrain. As an interdisciplinary and international phenomenon, and an ensemble of techniques drawn from myriad traditions, comics art can be traced back to innumerable points of origin. Moreover, comics' past is (to paraphrase Faulkner) not even "past" but constantly in the process of being reframed and rewritten in response to present concerns and new (re)discoveries. As our introduction notes, comics studies has grown quickly, and keeps on growing, so its horizons—past, present, and future—continually need to be rewritten. The time line below, then, offers a finding aid rather than a definitive history. It follows this book's mission brief—to highlight issues that have significantly impacted Anglophone comics—yet reaches out to other cultures so as to suggest the teeming variety and global circulation of comics art. Further, it deliberately mixes formal, aesthetic, commercial, and sociocultural concerns and, at times, juxtaposes the popular and famous with (then) relatively obscure events that have turned out to be important to comics studies. Finally, we should note that this time line is frankly presentist: the great bulk of events listed hails from the twentieth and twenty-first centuries, and especially from the past fifty years, testifying to current interests. But we trust that it will have some value as a means of orienting readers to landmarks in the tangled history of comics. Our bibliography marks with an asterisk those sources that were particularly helpful in assembling this chronology.

1732 William Hogarth, *A Harlot's Progress*, self-published narrative series of prints (Great Britain)
1796 Jean-Charles Pellerin founds printing house Imagerie d'Épinal, specializing in popular prints, often didactic or propagandistic in nature (France)

1798 Thomas Rowlandson, *The Comforts of Bath*, satirical series of engravings (Great Britain)

1812 Rowlandson, with poet William Combe, *The Tour of Dr. Syntax in Search of the Picturesque*, satirical cartoon-verse narrative with popular character (Great Britain)

1814 Katsushika Hokusai, *Hokusai manga*, block-printed collection of themed sketches, the first of fifteen volumes (Japan)

1825 The *Glasgow Looking Glass*, fortnightly illustrated journal with comic strips (Great Britain)

1830 *La caricature*, satirical weekly founded and directed by Charles Philipon (France)

1832 Philipon founds daily *Le charivari* (France)

1837 Rodolphe Töpffer, *Les amours de M. Vieux Bois*, first of Töpffer's seminal comic albums (Switzerland)

1839 Cham (Amédée de Noé), *Histoire de Mr. Lajaunisse*, first of his comic albums (France)

1841 *Punch*, trendsetting humor weekly (Great Britain)

1842 *The Adventures of Mr. Obadiah Oldbuck*, an English-language plagiary of Töpffer's *Vieux Bois*, appears in album form as supplement to weekly paper *Brother Jonathan* (United States)

1843 *Punch* popularizes use of the word "cartoon" to refer to comic drawings (Great Britain)

1844 *Fliegende Blätter*, humor weekly (Germany)

1845 Töpffer, *Essai de physiognomonie*, pioneering critical essay on cartooning (Switzerland)

1847 Gustave Doré, *Les travaux d'Hercule*, comic album (France)

1862 Thomas Nast begins drawing Civil War cartoons for *Harper's Weekly* (United States)

1863 Charles Wirgman, the *Japan Punch*, satirical journal by English expatriate (Japan)

1865 Wilhelm Busch, *Max und Moritz*, illustrated verse story and forerunner to child-themed comic strips (Germany)

1867 Marie Duval (Isabelle Émilie de Tessier) and Charles Henry Ross's character Ally Sloper first appears in humor journal *Judy* (Great Britain)

1871 *Puck*, humor magazine, published in German-language edition; English-language edition follows in 1877 (United States)

1878 James Sanua (Yaʻqūb Ṣanūʻ) founds *Abu-Naddara Zarqa*, underground journal including his satirical, anticolonial cartoons (Egypt)

1884 *La caricatura*, humor weekly (Spain)

Ally Sloper's Half Holiday, first comic paper focused on a single character (Great Britain)

1887 French expatriate Georges Bigot founds the satirical magazine *Tōbaé* (Japan)

1889 Christophe, *La famille Fenouillard*, satirical graphic series in children's magazine *Le petit Français illustré* (France)
1890 Alfred Harmsworth's Amalgamated Press launches papers *Comic Cuts* and *Illustrated Chips* (Great Britain)
1895 Richard F. Outcault's newspaper feature *Hogan's Alley* introduces the popular Yellow Kid (United States)
1897 Oskar Andersson contributes comic strips to humor magazine *Söndags-Nisse* (Sweden)
Rudolph Dirks, *The Katzenjammer Kids*, strip in imitation of Busch (United States)
1900 Frederick Burr Opper, *Happy Hooligan*, strip (United States)
Opper's "Cupid's Everlasting 'Jolly'" inspires widespread adoption of word balloons (United States)
1901 Newspaper strip syndication begins, pioneered by McClure Newspaper Syndicate and papers such as *New York Herald* and *New York Journal* (United States)
1902 Outcault, *Buster Brown*, strip then merchandising phenomenon (United States)
1903 Grace Wiederseim (later Drayton), *Tootles*, later adapted into *Dottie Dimple*, *Dimples*, and *Dolly Dimples* (United States)
1905 *O Tico-Tico*, weekly children's magazine with comics (Brazil)
Joseph Pinchon and Jacqueline Rivière's *Bécassine* appears in girls' magazine *La semaine de Suzette* (France)
Tokyo Puck, monthly, popularizes American-style cartoons (Japan)
Winsor McCay, *Little Nemo in Slumberland*, strip; McCay's animated *Nemo* film follows in 1911 (United States)
1907 Bud Fisher, *Mutt and Jeff* (originally *A. Mutt*), first long-lived, successful daily newspaper strip (United States)
1908 Louis Forton, *Les pieds nickelés* (France)
Il corriere dei Piccoli, children's weekly (Italy)
1911 The *Comic Australian* magazine (Australia)
The Masses, innovative radical magazine (featuring political graphics by Robert Minor, Art Young, and others) founded in New York; later (1917) brought to trial under the Espionage Act (United States)
1912 Cliff Sterrett, *Polly and Her Pals* (United States)
1913 George Herriman's *Krazy Kat* gains its own strip (United States)
George McManus, *Bringing Up Father* (United States)
1915 Charles Folkard, *Teddy Tail*, pioneering daily newspaper strip (Great Britain)
1917 *TBO* comics magazine; origin of Spanish word *tebeo*, meaning "comics magazine" (Spain)
Sidney Smith, *The Gumps*, strip mixing domestic melodrama with long continuities (United States)

1918 Frank King, *Gasoline Alley* (United States)
1919 Frans Masereel, *Mon livre d'heures* (*Passionate Journey*), pioneering woodcut novel (Belgium/Switzerland)
1921 Jimmy Bancks, *Ginger Meggs*, originally *Us Fellers* (Australia)
1922 *Krokodil*, satirical journal and supplement to *The Worker*, founded by Konstantin Eremeev (USSR)
1923 *Al Awlad*, children's comics magazine (Egypt)
 Otto Messmer and Pat Sullivan, *Felix the Cat*, strip based on popular animated cartoon character (United States)
1924 Katsuichi Kabashima and Shōsei Oda, *Shō-chan no boken*, first serialized newspaper manga for children (Japan)
 Yutaka Asō, *Nonki na tōsan* (Easygoing Daddy), strip inspired by McManus's *Bringing Up Father* (Japan)
 Roy Crane, *Wash Tubbs*, pioneering continuity strip; later (1933) spawns *Captain Easy, Soldier of Fortune* (United States)
 Harold Gray, *Little Orphan Annie*, pioneering continuity strip (United States)
1925 Alain Saint-Ogan's *Zig et Puce*, children's adventure comic incorporating word balloons in weekly *Dimanche illustré* (France)
1928 *Shanghai manhua*, weekly (China)
 Nikolai Oleinikov, *Yozh*, children's journal with comics-like features (USSR)
1929 Hergé's *Les aventures de Tintin* strip begins in weekly *Le petit vingtième*; albums follow in 1930 (Belgium)
 Philip Francis Nowlan and Dick Calkins, *Buck Rogers*, pioneering science fiction strip (United States)
 Elzie Segar introduces Popeye the Sailor to his strip *Thimble Theatre* (United States)
 Lynd Ward, *Gods' Man*, woodcut novel (United States)
1930 Walt Disney, Ub Iwerks, and Win Smith (and soon after, Floyd Gottfredson), *Mickey Mouse*, strip based on popular animated character (United States)
 Chic Young, *Blondie* (United States)
1931 The *Kookaburra*, comics magazine (Australia)
 Chester Gould, *Dick Tracy*, pioneering crime strip (United States)
1934 *Le journal de Mickey*, weekly, popularizes American comics and American-favored device of word balloons within panels (France)
 Paquín, comics magazine (Mexico)
 Milton Caniff, *Terry and the Pirates*, innovative adventure strip with cinematic storytelling (United States)
 Al Capp, *Li'l Abner* (United States)
 Famous Funnies #1, first ongoing comics magazine in modern American "comic book" format (United States)

1935 Zhang Leping, *Sanmao* (China)
 Marjorie Henderson Buell launches panel cartoon (later strip) *Little Lulu* for the *Saturday Evening Post* (United States)
 Oliver Harrington launches *Dark Laughter* (later *Bootsie*) for New York's *Amsterdam News* (United States)
1936 *Pepín*, comics magazine (Mexico)
 Lee Falk and Ray Moore, *The Phantom* (United States)
1937 The *Dandy*, children's comic weekly; sister title the *Beano* follows in 1938 (Great Britain)
 Detective Comics #1, crime-themed anthology, published by Detective Comics Inc. (later DC; United States)
 Jackie Ormes launches *Torchy Brown in "Dixie to Harlem"* for *Pittsburgh Courier* (United States)
1938 *Le journal de Spirou*, weekly comics magazine (Belgium)
 Italian government bans American comics and other non-Italian mass culture (Italy)
 Ernie Bushmiller's *Nancy* gains its own strip (United States)
 Jerry Siegel and Joe Shuster's Superman premieres in *Action Comics* #1, sparks a craze for comic book superheroes (United States)
1939 Bob Kane and Bill Finger's Batman premieres in *Detective Comics* #27 (United States)
 C. C. Beck and Bill Parker's Captain Marvel premieres in *Whiz Comics* #2 (United States)
1940 Australian government bans import of U.S. comics (Australia)
 Walt Disney's Comics and Stories, seminal licensed comic based on film characters (United States)
 Will Eisner, *The Spirit*, weekly comic book insert, syndicated to newspapers (United States)
 Jack Kirby and Joe Simon, *Captain America Comics* #1 (United States)
 Dale Messick, *Brenda Starr, Reporter* (United States)
1941 Adrian Dingle's Nelvana of the Northern Lights premieres in *Triumph-Adventure-Comics* #1 (Canada)
 Gus Arriola, *Gordo* (United States)
 Classic Comics, later *Classics Illustrated* (United States)
 Jack Cole's Plastic Man premieres in *Police Comics* #1 (United States)
 John L. Goldwater, Bob Montana, and Vic Bloom's Archie premieres in *Pep Comics* #22 (United States)
 William Moulton Marston and H. G. Peter's Wonder Woman premieres in *All-Star Comics* #8 (United States)
1942 Charles Biro and Bob Wood launch *Crime Does Not Pay* (United States)
 Crockett Johnson, *Barnaby* (United States)

Jack Kirby and Joe Simon's *The Boy Commandos* premiere in *Detective Comics* #64 (United States)

1943 Soldier-cartoonist Bill Mauldin begins *Up Front* in *Stars and Stripes*, the military paper; national syndication follows in 1944 (United States)

1944 The Comisión Calificadora de Publicaciones y Revistas Illustradas, government comics censorship office, is created (Mexico)

1945 Willy Vandersteen's *Suske en Wiske*, a pioneering Flemish comic, begins in *De nieuwe standaard*; albums follow in 1946 (Belgium)

Asso di Picche, magazine featuring Hugo Pratt and other artists of the Venice group (Italy)

Manga magazine resumes publication in Japan following end of World War II, becoming first postwar manga (Japan)

Buell's character Little Lulu appears in comic books by John Stanley (and later Irving Tripp), becoming a regular series in 1948 (United States)

1946 *Le journal de Tintin*, weekly (Belgium)

Edgar P. Jacobs, *Blake and Mortimer* premieres in *Tintin* (Belgium)

Morris launches *Lucky Luke* in *Spirou* (Belgium)

Fang Cheng publishes his first comics in Shanghai, later becomes art editor of the *People's Daily* in Beijing (China)

Machiko Hasegawa, *Sazae-san*, pioneering topical and domestic strip by female artist (Japan)

Political cartoonist Herblock (Herbert L. Block) joins the *Washington Post* (United States)

1947 Osamu Tezuka's *Shin Takarajima*, revolutionary story manga, popularizes long-form cinematic storytelling (Japan)

Orrin C. Evans et al., *All-Negro Comics* (United States)

Jack Kirby and Joe Simon's *Young Romance* launches genre of romance comics (United States)

1948 Frew Publications begins reprinting Falk and Moore's *Phantom* in monthly (later biweekly) magazines, launching Australia's longest-running comic book (Australia)

Gian Luigi Bonelli and Aurelio Galleppini, *Tex Willer* (Italy)

Walt Kelly's *Pogo* transitions from children's comic books to satirical adult strip (United States)

1949 Fulton Bill bans crime comic books (Canada)

Loi du 16 juillet 1949 sur les publications destinées à la jeunesse begins censoring reading matter for young readers (France)

1950 *Eagle* weekly, featuring Frank Hampson's Dan Dare, Pilot of the Future (Great Britain)

School Friend, weekly (Great Britain)

EC Comics publishes *Crypt of Terror*, *Vault of Horror*, *Weird Science*, *Weird Fantasy*, and *Haunt of Fear* (United States)

Charles Schulz, *Peanuts* (United States)

1951 Héctor Oesterheld's first collaboration with Hugo Pratt, *Ray Kitt* (Argentina)
Girl, weekly sister title to *Eagle* (Great Britain)
1952 Hussein Amin Bicar founds *Sinbad*, children's magazine featuring comics (Egypt)
Tezuka's *Tetsuwan Atomu* (Mighty Atom), known in English as *Astro Boy*, gains his own series (Japan)
Harvey Kurtzman et al., *Mad*, groundbreaking satirical comic book/magazine (United States)
1953 Tezuka, *Ribon no kishi* (*Princess Knight*), landmark gender-bending shōjo manga (Japan)
Carl Barks's *Uncle Scrooge* (created in 1947) gets his own comic book (United States)
1954 Edward Gicheri Gitau, *Juha Kalulu* (Kenya)
Fredric Wertham's *Seduction of the Innocent* takes aim at depictions of violence and sexuality in comics, and at comic books in general (United States)
Comics Magazine Association of America is formed, establishes self-censoring Comics Code to regulate output of most comic book publishers (United States)
1955 Children and Young Persons (Harmful Publications) Act (Great Britain)
Dunia al-Ahdath, children's comics magazine (Lebanon)
1956 *Samir*, comics magazine (Egypt)
Jules Feiffer's *Feiffer* (originally *Sick, Sick, Sick*) begins in the *Village Voice* (United States)
1957 Héctor Oesterheld and Francisco Solano López, *El Eternauta* (Argentina)
1958 Peyo, *Les Schtroumpfs* (*The Smurfs*; Belgium)
Bunty, girls' weekly (Great Britain)
1959 *Pilote* magazine launches; René Goscinny becomes editor-in-chief in 1960 (France)
Goscinny and Albert Uderzo launch *Astérix* in *Pilote*; albums follow in 1961 (France)
Yoshihiro Tatsumi and colleagues found "Gekiga Workshop," dedicated to producing adult manga, or *gekiga*, meaning "dramatic pictures" (Japan)
1960 André Franquin, *Gaston* (Belgium)
Hara-Kiri, controversial satirical magazine (France)
1961 Jack Kirby and Stan Lee's *Fantastic Four* launches Marvel Comics line of superheroes (United States)
1962 Héctor Oesterheld and Alberto Breccia, *Mort Cinder* (Argentina)
Jean-Claude Forest, *Barbarella* (France)

Steve Ditko and Stan Lee's "Spider-Man" launches in Marvel's *Amazing Fantasy*; solo title follows six months later (United States)

1963 Jean-Michel Charlier and Moebius (Jean Giraud), *Blueberry* (France)
Kirby and Lee launch Marvel's *Avengers* and *X-Men* in same month (United States)

1964 Quino, *Mafalda*, strip (Argentina)
Jackie, influential girls' weekly and best-selling teen magazine (Great Britain)
Garo, alternative and avant-garde manga anthology (Japan)
Machiko Satonaka, *Pia no shozo*, trendsetting work by young female comics artist (Japan)
Indecency Act (Article 175 of National Penal Code) and Youth Ordinance (a Tokyo Metropolitan statute) regulate publications for young people (Japan)
First American comic book conventions held in Chicago, Detroit, and New York (United States)
Richard Kyle introduces term *graphic novel* in fan newsletter *CAPA-alpha* (United States)

1965 *Linus* magazine, including *Neutron* (later *Valentina*) by Guido Crepax (Italy)
Salone internazionale del Comics, which later joins with Lucca Comics & Games festival (Italy)
Rafael Cutberto Navarro and Modesto Vázquez González's popular radio superhero Kalimán gains his own weekly comic book (Mexico)
Rius (Eduardo del Río), *Los Supermachos* (Mexico)

1966 Philippe Druillet, *Lone Sloane* (France)
Mitsuteru Yokoyama, *Mahōtsukai Sarī*, developed simultaneously for manga and anime (Japan)
Kirby and Lee introduce the Black Panther to *Fantastic Four* (United States)

1967 Anant Pai launches *Amar chitra katha*, based on Indian mythology, history, and folklore (India)
Hugo Pratt's *Ballad of the Salt Sea* (in the monthly *Sgt. Kirk*) introduces character Corto Maltese (Italy)
Shigeru Mizuki revamps *GeGeGe no Kitarō* into hugely successful children's title (Japan)
Tezuka launches *COM* magazine in response to *gekiga* movement (Japan)

1968 Marcel Gotlib, *Rubrique-à-brac* (France)
Shōnen Jump, weekly anthology (Japan)
Takao Saitō, *Golgo 13* (Japan)
Real Free Press Illustratie, tabloid-sized underground (Netherlands)

Robert "R." Crumb, *Zap Comix*, popularizes underground comic books, becomes anthology with issue #2 (United States)
Jim Steranko relaunches Marvel's *Nick Fury* in its own graphically innovative title (United States)
Kinney conglomerate (later WarnerMedia) acquires DC and its parent company, National Periodical Publications (United States)

1969 Jacques Glénat founds fanzine (later journal) *Schtroumpf, les cahiers de la bande dessinée* (France)

1970 *Charlie Hebdo*, satirical magazine, arises from *Hara-Kiri* (France)
Cyclops, underground comics paper (Great Britain)
Wong Yuk-long (Tony Wong), *Little Rascals*, later *Oriental Heroes* (Hong Kong)
Fujiko Fujio (Hiroshi Fujimoto and Motoo Abiko), *Doraemon* (Japan)
Kazuo Koike and Goseki Kojima, *Kozure Ōkami* (*Lone Wolf and Cub*; Japan)
Tante Leny presenteert, magazine (Netherlands)
It Aint Me Babe (sic), pioneering feminist underground edited by Trina Robbins (United States)
Garry Trudeau, *Doonesbury* (United States)
Barry Smith and Roy Thomas adapt Robert E. Howard's *Conan* for Marvel (United States)
Golden State Comic-Con (now Comic-Con International: San Diego) launches (United States)
Robert Overstreet starts annual *Comic Book Price Guide* for collectors (United States)

1971 Ariel Dorfman and Armand Mattelart, *Para leer al Pato Donald*, seminal cultural studies analysis, translated into English in 1975 as *How to Read Donald Duck: Imperialist Ideology in the Disney Comic* (Chile)
Oz, underground magazine (U.K. version), charged with obscenity (Great Britain)
Tammy, girls' weekly (Great Britain)
Moto Hagio, "Jūichigatsu no Gimunajiumu," groundbreaking *shōnen-ai* (boys' love) manga (Japan)
Ray Browne and Russell Nye found the Popular Culture Association (United States)
Air Pirates Funnies, parodic underground, sparks lawsuit by Disney (United States)
Trina Robbins and Willy Mendes, *All Girl Thrills* (United States)

1972 Claire Bretécher, Marcel Gotlib, and Nikita Mandryka found *L'Écho des savanes* (France)
Riyoko Ikeda, *Berusaiyu no bara* (*The Rose of Versailles*); dramatized in 1974 by famed all-female theatrical company Takarazuka (Japan)

Rius, *Marx para principiantes* (*Marx for Beginners*; Mexico)
Lyn Chevli and Joyce Farmer, *Tits & Clits* (United States)
Justin Green, *Binky Brown Meets the Holy Virgin Mary*, influential autobiographical and confessional comic book (United States)
Wimmen's Comix, influential feminist underground anthology entirely by women (United States)

1973 Bretécher, *Les frustrés* (France)
Keiji Nakazawa begins *Hadashi no Gen* (*Barefoot Gen*), fictionalized WWII and atomic bomb survivor's memoir; U.S. edition of first volume follows in 1978, the first book-length English translation of manga (Japan)
Hillary Ng'weno and Terry Hirst launch *Joe*, humor and comics magazine (Kenya)
Phil Seuling and Jonni Levas's distribution company (later Sea Gate) establishes "direct" distribution to comic book shops: origin of direct market (United States)
Mary Wings, *Come Out Comix*, first autobiographical lesbian comic book (United States)

1974 Festival international de la bande dessinée (FIBD) launches in Angoulême (France)
Alter magazine, originally *Alter Linus* (Italy)
Jack Katz, *The First Kingdom*, early direct-market fantasy epic (United States)

1975 Carlos Sampayo and José Muñoz, *Alack Sinner* (Argentina/France/Italy)
Les Humanoïdes Associés launch *Métal hurlant*; licensed U.S. adaptation *Heavy Metal* follows in 1977 (France)
Moebius (Jean Giraud), *Arzach* in *Métal hurlant* (France)
Fluide Glaciale, magazine (France)
Comiket (Comic Market, or in Japanese, *Komikku Māketto*), not-for-profit festival focused on self-published works (*dōjinshi*), launches; now world's largest fan convention (Japan)
Chris Claremont and Dave Cockrum revive Marvel's *X-Men* (United States)

1976 Jacques Tardi, *Les aventures extraordinaires d'Adèle Blanc-Sec* (France/Belgium)
Keiko Takemiya, *Kaze to ki no uta*, *shōnen-ai* landmark (Japan)
Cathy Guisewite, *Cathy* (United States)
Harvey Pekar et al., *American Splendor*, self-published autobiographical anthology (United States)
The *Comics Journal* (originally *Nostalgia Journal*) launched by new publisher Fantagraphics (United States)

1977 Dave Sim, *Cerebus*, pioneering self-published comic book (Canada)
2000 AD, seminal weekly anthology; Judge Dredd, created by John Wagner and Carlos Ezquerra, premieres in second issue (Great Britain)
Star Wars, licensed comic, becomes major hit for Marvel (United States)

1978 *(À suivre)*, adult comics magazine, champions novelistic stories in serial form (Belgium)
Misty, horror-themed "mystery paper for girls" (Great Britain)
Suzy Varty et al., *Heröine* (Great Britain)
Lynda Barry, *Ernie Pook's Comeek*, seminal alternative strip (United States)
Jim Davis, *Garfield* (United States)
Will Eisner, *A Contract with God and Other Tenement Stories*, Eisner's first graphic novel (United States)
Wendy Pini and Richard Pini, *Elfquest*, pioneering self-published fantasy epic (United States)

1979 *Viz*, satirical magazine (Great Britain)
Lat (Mohammad Nor Khalid), *Kampung Boy* (Malaysia)
El víbora, alternative comics magazine (Spain)
Lynn Johnston, *For Better or For Worse* (Canada / United States)
Majid, children's comics magazine (United Arab Emirates)
Frank Miller starts on Marvel's *Daredevil* (United States)

1980 Enki Bilal, *The Nikopol Trilogy* (France)
Frigidaire, alternative comics-focused magazine (Italy)
Berke Breathed, *Bloom County* (United States)
Gay Comix, pioneering LGBTQ+ anthology, edited by Howard Cruse (United States)
Gary Larson, *The Far Side* (United States)
Françoise Mouly and Art Spiegelman publish and edit *Raw*, seminal avant-garde comics anthology; Spiegelman's serial *Maus* begins in issue #2 (United States)

1981 Fast Fiction (market stall, distributor, and newsletter), mainstay of British small-press scene; eponymous anthology follows in 1982 (Great Britain)
R. Crumb launches *Weirdo* magazine (United States)
Gilbert, Jaime, and Mario Hernandez, *Love and Rockets* #1, seminal alternative comic (United States)

1982 Dez Skinn's *Warrior* magazine launches Alan Moore's *Marvelman* and *V for Vendetta* (Great Britain)
Alfredo Castelli and Giancarlo Alessandrini, *Martin Mystère* (Italy)
Hayao Miyazaki, *Kaze no Tani no Naushika* (*Nausicaä of the Valley of the Wind*); film follows in 1984 (Japan)
Katsuhiro Otomo, *Akira*; film follows in 1988 (Japan)

Factsheet Five, periodical guide to zines and alternative publishing (United States)

1983 Jean Van Hamme and William Vance, *XIII* (Belgium)
Chester Brown, *Yummy Fur* minicomic; comic book series follows in 1986 (Canada)
Escape, magazine (Great Britain)
Akira Toriyama, *Dragon Ball* (Japan)
Alison Bechdel, *Dykes to Watch Out For* (United States)
Howard Cruse, *Wendel* (United States)
Clay Geerdes, "Newave Manifesto" and *Comix Wave*, minicomix-focused newsletter (United States)

1984 *Fox Comics*, Melbourne-based alternative anthology (Australia)
Strapazin, anthology (Switzerland)
Kevin Eastman and Peter Laird's *Teenage Mutant Ninja Turtles*; sparks mid-1980s boom, then bust, in self-published comic books (United States)
Marvel launches precedent-setting "crossover" event, *Secret Wars* (United States)

1985 Chantal Montellier, Nicole Claveloux, Florence Cestac, and Jeanne Puchol issue manifesto decrying sexist content in *bandes dessinées* (France)
Bill Watterson, *Calvin and Hobbes* (United States)
Crisis on Infinite Earths, DC's trendsetting event series (United States)
Mike Saenz and Peter B. Gillis, *Shatter*, first comic book drawn on computer (United States)

1986 Frank Miller et al., *Batman: The Dark Knight Returns*, for DC (United States)
Alan Moore and Dave Gibbons, *Watchmen*, for DC (United States)
Spiegelman, *Maus*, volume 1, *A Survivor's Tale*, nominated for National Book Critics Circle Award (United States)

1987 Rumiko Takahashi, *Ranma 1/2* (Japan)
Comic Book Legal Defense Fund founded to aid in Friendly Frank's obscenity case (United States)
VIZ Communications partners with Eclipse Comics to publish translated manga in direct market (United States)

1988 Julie Doucet, *Dirty Plotte* minicomic; comic book series follows in 1991 (Canada)
Mizuki, *Komikku Shōwa-shi* (*Showa: A History of Japan*; Japan)
KOM, first Russian comics collective (USSR)
Neil Gaiman and multiple artists, *Sandman* (United States)

1989 Masamune Shirow, *The Ghost in the Shell* (Japan)
T. T. Fons (Alphonse Mendy) launches popular character Goorgoorlou in satirical newspaper *Le Cafard Libéré* (Senegal)

Daniel Clowes, *Eightball* (United States)
John Porcellino, *King-Cat Comix and Stories* zine (United States)
1990 Jean van Hamme and Philippe Francq, *Largo Winch* (Belgium)
New publisher Drawn & Quarterly launches eponymous anthology (Canada)
Atelier de Création, de Recherche et de l'Initiation à l'Art founds magazine *Afro BD*, edited by Barly Baruti (Democratic Republic of Congo)
Seven artists band together to form a new publishing cooperative, L'Association (France)
Farid Boudjellal, *Juif-Arabe* (France)
High and Low exhibition at New York's Museum of Modern Art includes comics (United States)
Peter Bagge, *Hate* (United States)
1991 *GirlFrenzy*, feminist zine (Great Britain)
Naoko Takeuchi's *Bishōjo Senshi Sērā Mūn* (*Sailor Moon*) reinvigorates "magical girl" genre; eventually helps popularize shōjo manga worldwide (Japan)
Hans Bjordahl, *Where the Buffalo Roam*, internet comic strip distributed via FTP and Usenet (United States)
Roberta Gregory, *Naughty Bits* (United States)
Jeff Smith, *Bone* (United States)
Spiegelman, volume 2 of *Maus*; complete work garners Pulitzer Prize in 1992 (United States)
1992 Anton Kannemeyer (Joe Dog) and Conrad Botes, *Bitterkomix* (South Africa)
Peter Coogan and Randy Duncan found Comics Arts Conference at Comic-Con International: San Diego (then the San Diego Comic-Con; United States)
Seven popular ex-Marvel artists form self-publishing cooperative Image Comics, garnering high publicity and sales (United States)
Jim Woodring, *Frank in the River* (United States)
1993 Lewis Trondheim, *Slaloms* (France)
Eddie Campbell, *Graffiti Kitchen* (Great Britain / United States)
DC Comics launches "mature readers" imprint, Vertigo (United States)
David Farley, *Doctor Fun*, pioneering episodic webcomic (United States)
Scott McCloud, *Understanding Comics*, seminal critical text in comics form (United States)
Joe Sacco's *Palestine* models new mode of comics journalism (United States)
Chris Ware, *Acme Novelty Library* (United States)
1994 Gosho Aoyama, *Meitantei Konan* (*Detective Conan*, or known in English as *Case Closed*; Japan)
Small Press Expo (SPX) founded (United States)

1995 *Broken Pencil*, periodical metazine guide to zine culture (Canada)
Baru, *L'Autoroute du soleil* (France)
Cruse, *Stuck Rubber Baby*, pioneering queer-themed graphic novel (United States)
Garth Ennis and Steve Dillon, *Preacher* (United States)
International Comics and Animation Festival (later International Comic Arts Forum) founded at Georgetown University, Washington, DC (United States)

1996 David B., *L'Ascension du haut mal*, known in English as *Epileptic* (France)
Carla Speed McNeil, *Finder* (United States)
Upheaval in direct market; collapse of speculator boom; distribution crisis and consolidation (United States)
Marvel Entertainment Group files for Chapter 11 bankruptcy (United States)

1997 Eiichiro Oda, *One Piece*, now reportedly the best-selling manga in history, with more than 450 million book (*tankōbon*) collections sold (Japan)
Daniel Clowes, *Ghost World* (United States)
Warren Ellis and Darick Robertson, *Transmetropolitan* (United States)
Jonathan Rosenberg, *Goats*, webcomic (United States)
Tokyopop (originally Mixx Entertainment) founded (United States)

1998 Junji Ito, *Uzumaki* (Japan)
Natsuki Takaya, *Fruits Basket* (Japan)
Mike Krahulik and Jerry Holkins, *Penny Arcade*, webcomic; Penny Arcade Expo (PAX) gaming convention and other spinoffs follow (United States)
Scott Kurtz, *PvP*, webcomic (United States)

1999 Michel Rabagliati, *Paul à la campagne* (*Paul in the Country*; Canada)
Gbich!, comics and humor weekly (Côte d'Ivoire)
Masashi Kishimoto, *Naruto* (Japan)
Naoki Urasawa, *Nijūseiki shōnen* (*20th Century Boys*; Japan)
Andrei Ayoshin, *Komiksolyot*, website (Russia)
Publisher and editor John A. Lent founds *International Journal of Comic Art* (United States)
Aaron McGruder's *The Boondocks* becomes syndicated newspaper strip (United States)

2000 Guy Delisle, *Shenzhen: A Travelogue from China* (France)
Marjane Satrapi, *Persepolis* (France)
Ware, *Jimmy Corrigan* (United States)

2001 Tite Kubo, *Bleach* (Japan)

2002 John Allison, *Scary Go Round*, webcomic (Great Britain)
KomMissia, first annual Russian comics festival (Russia)

East Coast Black Age of Comics Convention, Philadelphia (United States)

Modern Tales, webcomics site (United States)

Tokyopop adopts policy of "authentic manga," translated in original Japanese right-to-left format; soon becomes America's largest manga publisher (United States)

2003 Robert Kirkman and Tony Moore, *The Walking Dead*; television series follows in 2010 (United States)

Manga Jouhou (MangaNews.net) tracks releases of manga scanlations; later (2005) runs news coverage of manga industry (United States)

2004 Bryan Lee O'Malley, *Scott Pilgrim* (Canada / United States)

Artist Yūji Suwa and publisher Shōbunkan convicted of obscenity for *Misshitsu*, a first for manga industry (Japan)

Nikolai Maslov, *Une jeunesse sovietique* (*Siberia*; Russia/France)

Richard Thompson, *Cul de Sac*, strip; nationally syndicated in 2007 (United States)

2005 Danish newspaper *Jyllands-Posten* publishes twelve satirical cartoons about Muhammad, sparking widespread protests, boycotts, debate, and violence (Denmark)

LINE Webtoon webcomics portal (originally Naver Webtoon) launched; website and mobile app go global in 2014 (South Korea)

Randall Munroe, *xkcd*, webcomic (United States)

Scholastic launches comics imprint, Graphix, with new edition of Jeff Smith's *Bone* (United States)

2006 Pahé (Patrick Essono Nkouna), *La vie de Pahé* (Gabon/Switzerland)

Alison Bechdel's *Fun Home*, watershed multi-award-winning work of graphic memoir and lesbian and gay literature (United States)

Gene Luen Yang, *American Born Chinese*, groundbreaking Asian American comic and breakout book for new publisher First Second (United States)

2007 Comixology, digital comic book distributor, launches; acquired by Amazon in 2014 (United States)

Meredith Gran, *Octopus Pie*, webcomic (United States)

2008 Kate Beaton, *Hark! A Vagrant*, breakout webcomic; books follow in 2009 (Canada)

First releases from Françoise Mouly's TOON Books imprint for young readers (United States)

2009 Michael Nicoll Yahgulanaas, *RED: A Haida Manga* (Haida/Canada)

Hajime Isayama, *Shingeki no Kyojin* (*Attack on Titan*; Japan)

Yoshihiro Tatsumi, *Gekiga Hyōryū* (*A Drifting Life*; Japan)

Modern Language Association founds Forum on Comics and Graphic Narratives (United States)

The Walt Disney Company acquires Marvel Entertainment (United States)
2010 Raina Telgemeier, *Smile*, trendsetting middle-grade graphic memoir (United States)
2011 DC and Archie Comics abandon Comics Code Authority, rendering Code defunct (United States)
Archie, then DC, adopt same day-and-date digital distribution for their comic books; other major publishers follow suit (United States)
Latino Comics Expo founded (United States)
Society for Cinema and Media Studies founds Comics Studies Scholarly Interest Group (United States)
2012 Brian K. Vaughan and Fiona Staples, *Saga* (United States)
2013 Crunchyroll, streaming anime and manga distributor, launches Crunchyroll Manga digital anthology (United States)
John Lewis, Andrew Aydin, and Nate Powell, *March*, book 1 (United States)
2014 Mariko Tamaki and Jillian Tamaki, *This One Summer* (Canada / United States), wins both a Printz Honor and a Caldecott Honor
Riad Sattouf, *L'Arabe du futur* (France)
Kōhei Horikoshi, *Boku no Hīrō Akademia* (*My Hero Academia*; Japan)
Cece Bell, *El Deafo* (United States)
Comics Studies Society founded (United States)
2015 *Charlie Hebdo* shootings; massive international outcry and debate follow (France)
2016 BD Egalité calls for cartoonists to boycott voting in FIBD's lifetime achievement award, the Grand Prix, due to absence of women among nominees (France)
Sonny Liew, *The Art of Charlie Chan Hock Chye* (Singapore / United States)
Indigenous Comic Con, Albuquerque, New Mexico (United States)
2017 Jean-Yves Ferri and Didier Conrad's *Astérix et la Transitalique* gets initial print run of 5 million copies (France)
Thi Bui, *The Best We Could Do* (United States)
Damian Duffy and John Jennings, *Kindred*, adapted from Octavia Butler's novel (United States)
Emil Ferris, *My Favorite Thing Is Monsters* (United States)
2018 Jason Lutes, *Berlin* (United States / Canada)
Dav Pilkey's *Dog Man: Brawl of the Wild* (Graphix/Scholastic) gets initial print run of 5 million copies (United States)
2019 Seth, *Clyde Fans* (Canada)

Acknowledgments

This *Guidebook* has been in the works for years and withstood serious changes along the way. More than anything, then, we owe thanks to our contributors for their patience and faith. We thank them too for their willingness to revise and resubmit and to endure multiple rounds of reformatting and tweaking. We are proud to be in the company of such scholars: colleagues who inspire us with their dedication, conceptual boldness, and insight.

We also wish to thank Nicole Solano, executive editor at Rutgers University Press, and Leslie Mitchner, editor-in-chief emeritus at Rutgers, for their patience, confidence, and efficiency, and editorial intern Hope Dormer for her considerable help. Further, we thank Rutgers University Press production editor Vincent Nordhaus, project manager Megan Grande at Scribe Inc., and designer Bethany Luckenbach, all of whom have helped this multi-headed hydra of a book cohere and look sharp.

Thanks to the rights-holders and scholars who granted permissions or provided image files for illustrations: Lynda Barry, Charles Burns, Peggy Burns of Drawn & Quarterly, Terri Gordon of King Features, Paul Gravett, Todd Hignite of Heritage Auctions, Peter Maresca of Sunday Press, Jeannie Schulz and Alena Carnes of Charles M. Schulz Creative Associates, and Marilyn Scott, Avery McGrail, and Jenny Robb of the Ohio State University's fabulous Billy Ireland Cartoon Library & Museum.

Very special thanks to Jonathan Chau, who provided the first draft and kernel of our time line; to artist Brian Biggs for our beautiful and witty cover; and to Claire Rhode for heroically compiling our index.

We two, Charles and Bart, are able to do what we do because we have colleagues and families who understand us and "get" the importance of comics

studies. Without the continued support and interest of our colleagues in the field, spread across continents, countries, and disciplines, we would have no reason to do this work—and without our families, we simply couldn't do it at all.

Deepest thanks, always, to Michele Hatfield and Rebecca Sullivan, who make all the difference.

Bibliography

Entries marked with an asterisk (*) were particularly helpful in assembling this book's time line.

Abate, Michelle Ann, Karly Marie Grice, and Christine N. Stamper, eds. "Lesbian Content and Queer Female Characters in Comics." Special issue, *Journal of Lesbian Studies* 22, no. 4 (2018).

Abrams, Kathryn, and Irene Kacandes, eds. "Witness." Special issue, *Women's Studies Quarterly* 36, nos. 1–2 (Spring/Summer 2008): 13–27.

Alaniz, José. *Death, Disability, and the Superhero: The Silver Age and Beyond*. Jackson: University Press of Mississippi, 2014.

*———. *Komiks: Comic Art in Russia*. Jackson: University Press of Mississippi, 2010.

Aldama, Frederick Luis, ed. *Multicultural Comics: From* Zap *to* Blue Beetle. Austin: University of Texas Press, 2010.

———. *Planetary Republic of Comics* (blog). https://professorlatinx.com/planetary-republic-of-comics.

Aldama, Frederick Luis, and Christopher González, eds. *Graphic Borders: Latino Comic Books Past, Present, and Future*. Austin: University of Texas Press, 2016.

Allison, John. "Post Webcomics." *A Hundred Dance Moves per Minute* (blog), 4 March 2013. http://sgrblog.blogspot.ca/2013/03/post-webcomics.html.

———. "Teeshirt Treatise, a Treatise on Tees." *A Hundred Dance Moves per Minute* (blog), 8 June 2010. http://sgrblog.blogspot.ca/2010/06/teeshirt-treatise-treatise-on-tees.html.

Alverson, Brigid. "JManga Shuts Down: Robert Newman Answers Some Questions." *Publishers Weekly*, 1 April 2013. http://www.publishersweekly.com/pw/by-topic/industry-news/comics/article/56617-jmanga-shuts-down-robert-newman-answers-some-questions.html.

Anderson, Benedict. *Imagined Communities: Reflections on the Origin and Spread of Nationalism*. London: Verso, 1983.

Anderson, J. L. "Spoken Silents in the Japanese Cinema, or Talking to Pictures: Essaying the *Katsuben*, Contextualizing the Texts." In *Reframing Japanese Cinema: Authorship, Genre, History*, edited by Arthur Nolletti Jr. and David Desser, 259–311. Bloomington: Indiana University Press, 1992.

Andrae, Thomas. "From Menace to Messiah: The History and Historicity of Superman." In *American Media and Mass Culture: Left Perspectives*, edited by Donald Lazere, 124–138. Berkeley: University of California Press, 1987.

Anime News Network. "ComiXology Surpasses 180 Million Downloads of Comic Books and Graphic Novels Worldwide." 22 July 2013. http://www.animenewsnetwork.com/press-release/2013-07-22/comixology-surpasses-180-million-downloads.

Anonymous. *Mum's Own Annual*. London: Fleetway/IPC, 1993.

Appadurai, Arjun. "Modernity at Large: Interview with Arjun Appadurai." By Anette Baldauf and Christian Hoeller, Translocation_New Media/Art symposium, Vienna, 29–30 January 1999. http://www.translocation.at/d/appadurai.htm. Archived via Internet Archive: Wayback Machine (archive.org) on 22 June 2008.

Apter, Emily. *Against World Literature: On the Politics of Untranslatability*. London: Verso, 2013.

Armitage, Hugh. "'The Dandy' Publisher Reassures Fans on the Comic's Future." Digital Spy, 5 July 2013. http://www.digitalspy.com/comics/news/a495942/the-dandy-publisher-reassures-fans-on-the-comics-future.html.

Ayroles, François. "Consécution Aléatoire." *Oubapo* 2 (2003): 18.

B., David. *Epileptic*. Translated by Kim Thompson. New York: Pantheon, 2005.

Baetens, Jan. "Revealing Traces: A New Theory of Graphic Enunciation." In *The Language of Comics: Word and Image*, edited by Robin Varnum and Christina T. Gibbons, 145–155. Jackson: University Press of Mississippi, 2001.

Baetens, Jan, and Pascal Lefèvre. *Pour une lecture moderne de la bande dessinée*. Brussels: Centre Belge de la Bande Dessinée, 1993.

Bailey, Peter. "*Ally Sloper's Half-Holiday*: Comic Art in the 1880s." *History Workshop* 16 (1983): 4–31.

Ball, David M., and Martha B. Kuhlman, eds. *The Comics of Chris Ware: Drawing Is a Way of Thinking*. Jackson: University Press of Mississippi, 2010.

Barker, Martin. *Comics: Ideology, Power and the Critics*. Manchester: Manchester University Press, 1989.

———. *A Haunt of Fears: The Strange History of the British Horror Comics Campaign*. Jackson: University Press of Mississippi, 1992.

Barnhurst, Kevin G., and John Nerone. *The Form of News: A History*. New York: Guildford Press, 2002.

Barron, Hal. *Mixed Harvest: The Second Great Transformation in the Rural North, 1870–1930*. Chapel Hill: University of North Carolina Press, 1997.

Barry, Lynda. *The! Greatest! Of! Marlys!* Rev. ed. Montreal: Drawn & Quarterly, 2016.

Barthes, Roland. *Image, Music, Text*. Translated by Stephen Heath. London: Fontana, 1977.

Beaty, Bart. *Comics versus Art*. Toronto: University of Toronto Press, 2012.

———. *Fredric Wertham and the Critique of Mass Culture*. Jackson: University Press of Mississippi, 2005.

———. "The Recession and the American Comic Book Industry: From Inelastic Cultural Good to Economic Integration." *Popular Communication* 8, no. 3 (2010): 203–207.

———. "The Search for Comics Exceptionalism." *Comics Journal*, no. 211 (April 1999): 67–72.

*———. *Unpopular Culture: Transforming the European Comic Book in the 1990s*. Toronto: University of Toronto Press, 2007.

Beaty, Bart, and Benjamin Woo. *The Greatest Comic Book of All Time: Symbolic Capital and the Field of American Comic Books*. London: Palgrave MacMillan, 2016.

Bechdel, Alison. *Fun Home: A Family Tragicomic*. Boston: Houghton Mifflin, 2007.

———. *The Indelible Alison Bechdel: Confessions, Comix, and Miscellaneous* Dykes to Watch Out For. Ithaca, N.Y.: Firebrand Books, 1998.

Bell, Mark. "The Salvation of Comics: Digital Prophets and Iconoclasts." *Review of Communication* 6 (2006): 131–140.

Berenstein, Ofer. "Comic Book Fans' Recommendations Ceremony: A Look at the Interpersonal Communication Patterns of a Unique Readers/Speakers Community." *Participations: Journal of Audience & Reception Studies* 9, no. 2 (2012): 74–96.

Berger, John. *Ways of Seeing*. London: British Broadcasting System and Penguin Books, 1972.

Berndt, Jaqueline. "Drawing, Reading, Sharing: A Guide to the *Manga Hokusai Manga* Exhibition." In *Manga Hokusai Manga: Approaching the Master's Compendium from the Perspective of Contemporary Comics*, 3–38. Tokyo: Japan Foundation, 2015.

———. "Manga and 'Manga': Contemporary Japanese Comics and Their Dis/similarities with Hokusai Manga." In *Civilisation of Evolution, Civilisation of Revolution: Metamorphoses in Japan 1900–2000*, edited by Arkadiusz Jabłoński, Stanisław Meyer, and Koji Morita, 210–222. Kraków: Manggha Museum of Japanese Art & Technology, 2009.

———. "Traditions of Contemporary Manga (1): Relating Comics to Premodern Art." *Signs: Studies in Graphic Narratives*, no. 1 (2007): 33–47.

Beronä, David. *Wordless Books: The Original Graphic Novels*. New York: Abrams, 2008.

Bishop, David, and Karl Stock. *Thrill-Power Overload: 2000 AD—the First Forty Years*. Rev. ed. Oxford: Rebellion, 2017.

*Blackbeard, Bill, and Martin Williams, eds. *The Smithsonian Collection of Newspaper Comics*. Washington, D.C.: Smithsonian Institution Press, 1977.

Blase, Cazz. "A Shocking Shade of Pink." The F-word: Contemporary UK Feminism, 13 August 2011. https://thefword.org.uk/2011/08/shocking_pink/.

Boléo, João Paulo Paiva, and Carlos Bandeiras Pinheiro. *Le Portugal en bulles: Un siècle et demi de bandes dessinées*. Lisbon: Bedeteca Lisboa, 2000.

Bono, Gianni, and Matteo Stefanelli. *Fumetto! 150 anni di storie italiane*. Milan: Rizzoli, 2012.

Bordwell, David. "Superheroes for Sale." *Observations on Film Art* (blog), 16 August 2008. http://www.davidbordwell.net/blog/2008/08/16/superheroes-for-sale/.

Bourdieu, Pierre. *Distinction: A Social Critique of the Judgement of Taste*. Translated by Richard Nice. Routledge Classics ed. London: Routledge, 2010.

Braunstein, Peter, and Michael William Doyle, eds. *Imagine Nation: The American Counterculture of the 1960s and '70s*. New York: Routledge, 2002.

Brienza, Casey. "Books, Not Comics: Publishing Fields, Globalization, and Japanese Manga in the United States." *Publishing Research Quarterly* 25, no. 2 (2009): 101–117.

———. *Manga in America: Transnational Book Publishing and the Domestication of Japanese Comics*. London: Bloomsbury, 2016.

Brooker, Will. *Batman Unmasked: Analyzing a Cultural Icon*. New York: Continuum, 2000.

———. *Hunting the Dark Knight: Twenty-First Century Batman*. London: I. B. Tauris, 2012.

Brown, Chester. Cover and interior illustration to Charles McGrath, "Not Funnies." *New York Times Magazine*, 11 July 2004.

Brown, Jeffrey A. *Black Superheroes, Milestone Comics, and Their Fans*. Jackson: University Press of Mississippi, 2001.

———. "Ethnography: Wearing One's Fandom." In *Critical Approaches to Comics: Theories and Methods*, edited by Matthew J. Smith and Randy Duncan, 280–290. New York: Routledge, 2012.

Brunetti, Ivan. *Cartooning: Philosophy and Practice*. New Haven, Conn.: Yale University Press, 2011.

Bukatman, Scott. *Hellboy's World: Comics and Monsters on the Margins*. Berkeley: University of California Press, 2016.

Burke, Liam. *The Comic Book Film Adaptation*. Jackson: University Press of Mississippi, 2015.

———. "'Superman in Green': An Audience Study of Comic Book Film Adaptations *Thor* and *Green Lantern*." *Participations: Journal of Audience & Reception Studies* 9, no. 2 (2012): 97–119.

Burns, Charles. "Tunnel Vision." In *Raw, Boiled and Cooked: Comics on the Verge*, exhibition catalog, edited by Paul Candler. San Francisco: Last Gasp, 2004.

Burton, Dwight L. "Comic Books: A Teacher's Analysis." *Elementary School Journal* 56, no. 2 (1955): 73–75.

Business Week. "Newsstand Giant Shrinks Away." 25 May 1957.

Cadogan, Mary, and Patricia Craig. *You're a Brick, Angela! The Girls' Story 1839–1985*. London: Gollancz, 1986.

Callahan, Timothy. "The Boys from Brazil." Comic Book Resources, 12 July 2010. http://www.comicbookresources.com/?page=article&id=27128.

Campbell, Eddie. *Alec: How to Be an Artist*. Paddington, Australia: Eddie Campbell Comics, 2001.

———. "In Depth: The Eddie Campbell Interview." By Milo George. *Graphic Novel Review* [September 2004]. http://www.graphicnovelreview.com/issue1/campbell_interview.php. Archived via archive.today on 4 April 2005, http://archive.today/BAiHl.

Campbell, Eddie, and Daren White. *The Playwright*. Marietta, Ga.: Top Shelf, 2010.

Campbell, W. Joseph. *Yellow Journalism: Puncturing the Myths, Defining the Legacies*. Westport, Conn.: Praeger, 2001.

Candler, Paul, ed. *Raw, Boiled and Cooked: Comics on the Verge*. Exhibition catalog, Maryland Institute College of Art. San Francisco: Last Gasp, 2004.

Carrier, David. *The Aesthetics of Comics*. University Park: Pennsylvania State University Press, 2000.

Carter, Adam. "Superheroes Smash Digital Sales Records." CBC News, 16 March 2013. http://www.cbc.ca/news/arts/story/2013/03/15/hamilton-comic-book-sales-digital.html.

Carter, James Bucky. "Introduction—Carving a Niche: Graphic Novels in the English Language Arts Classroom." In *Building Literacy Connections with Graphic Novels: Page by Page, Panel by Panel*, edited by James Bucky Carter, 1–25. Urbana, Ill.: National Council of Teachers of English, 2007.

Cates, Isaac. "Comics and the Grammar of Diagrams." In *The Comics of Chris Ware: Drawing Is a Way of Thinking*, edited by David M. Ball and Martha B. Kuhlman, 90–104. Jackson: University Press of Mississippi, 2010.

Cawelti, John. *Adventure, Mystery, and Romance: Formula Stories as Art and Popular Culture*. Chicago: University of Chicago Press, 1976.

Chabon, Michael. *The Amazing Adventures of Kavalier & Clay*. New York: Random House, 2000.

Chaney, Michael. "The Animal Witness of the Rwandan Genocide." In *Graphic Subjects: Critical Essays on Autobiography and Graphic Novels*, edited by Michael Chaney, 93–100. Madison: University of Wisconsin Press, 2011.

———, ed. *Graphic Subjects: Critical Essays on Autobiography and Graphic Novels*. Madison: University of Wisconsin Press, 2011.

Chew, Matthew M., and Lu Chen. "Media Institutional Contexts of the Emergence and Development of *Xinmanhua* in China." *International Journal of Comic Art* 12, no. 2 (2010): 171–191.

Chiang, Mark. "Autonomy and Representation: Aesthetics and the Crisis of Asian American Cultural Politics in the Controversy over *Blu's Hanging*." In *Literary Gestures: The Aesthetic in Asian American Writing*, edited by Rocío G. Davis and Sue-Im Lee, 17–34. Philadelphia: Temple University Press, 2006.

Ching, Albert. "What Is Comic-Con? A Brief History of the Mega-event." Newsarama, 19 July 2010. http://www.newsarama.com/comics/what-is-comic-con-100719.html.

Chiu, Monica, ed. *Drawing New Color Lines: Transnational Asian American Graphic Narratives*. Hong Kong: Hong Kong University Press, 2014.

Cho, Erica. "Taps and Scratches." Unpublished manuscript, 2008.

Chute, Hillary L. *Disaster Drawn: Visual Witness, Comics, and Documentary Form*. Cambridge: Belknap Press of Harvard University Press, 2016.
———. *Graphic Women: Life Narrative and Contemporary Comics*. New York: Columbia University Press, 2010.
Ciment, Gilles, et al. *L'État de la bande dessinée: Vive la crise?* Brussels: Impressions Nouvelles, 2009.
Clark, Beverly Lyon. *Kiddie Lit: The Cultural Construction of Children's Literature*. Baltimore: Johns Hopkins University Press, 2003.
Clowes, Daniel. "Clowes Encounter." Interview by David Gilson. *Mother Jones*, 13 May 2010. http://www.motherjones.com/media/2010/05/dan-clowes-comics-cartoons-interview.
Cocca, Carolyn. *Superwomen: Gender, Power, and Representation*. London: Bloomsbury, 2016.
Cohn, Jesse. "Mise-en-Page: A Vocabulary for Page Layouts." In *Teaching the Graphic Novel*, edited by Stephen Tabachnick, 44–57. New York: MLA, 2009.
Conant, Ellen P. Introduction to *Challenging Past and Present: The Metamorphosis of Nineteenth-Century Japanese Art*, edited by Ellen P. Conant, 1–27. Honolulu: University of Hawai'i Press, 2006.
Conway, Gerry. "The ComiXology Outrage." *ComicBook* (blog), 27 April 2014. https://comicbook.com/blog/2014/04/27/gerry-conway-the-comixology-outrage/. Reprinted in *Forbes*, 30 April 2014. http://www.forbes.com/sites/bruceupbin/2014/04/30/the-comixology-outrage/.
Coogan, Peter. *Superhero: The Secret Origin of a Genre*. Austin, Tex.: MonkeyBrain Books, 2006.
Cooke, Jon B., ed. *The Book of Weirdo*. San Francisco: Last Gasp, 2019.
Couch, N. C. Christopher. "The Yellow Kid and the Comic Page." In *The Language of Comics: Word and Image*, edited by Robin Varnum and Christina Gibbons, 60–74. Jackson: University Press of Mississippi, 2001.
Couser, G. Thomas. *Memoir: An Introduction*. New York: Oxford University Press, 2012.
Crumb, Robert, Rick Griffin, Paul Mavrides, Victor Moscoso, Spain Rodriguez, Gilbert Shelton, S. Clay Wilson, and Robert Williams. *The Complete Zap Comix*. Seattle: Fantagraphics, 2014.
Cvetkovich, Ann. "Drawing the Archive in Alison Bechdel's *Fun Home*." Special issue, *Women's Studies Quarterly* 36, nos. 1–2 (Spring/Summer 2008): 111–128.
Daniels, Les. *Superman: The Complete History*. New York: Chronicle Books, 1998.
Davis-McElligatt, Joanna. "Confronting the Intersections of Race, Immigration, and Representation in Chris Ware's Comics." In *The Comics of Chris Ware: Drawing Is a Way of Thinking*, edited by David M. Ball and Martha B. Kuhlman, 135–145. Jackson: University Press of Mississippi, 2010.
Dayez, Hugues. *Le duel Tintin-Spirou*. Brussels: Tournesol Conseils SPRL, 1997.
De Certeau, Michel. *The Practice of Everyday Life*. Translated by Steven Rendall. Berkeley: University of California Press, 1984.
Delisle, Guy. *Shenzhen: A Travelogue from China*. Translated by Helge Dascher. Montreal: Drawn & Quarterly, 2006.
Denson, Shane, Christina Meyer, and Daniel Stein, eds. *Transnational Perspectives on Graphic Narratives*. New York: Bloomsbury, 2013.
Deppey, Dirk, ed. *Comics Journal*. Special issue on shōjo manga, no. 269 (July 2005).
———. "The Eddie Campbell Interview." *Comics Journal*, no. 273 (January 2006): 66–114.
———. "Scanlation Nation: Amateur Manga Translators Tell Their Stories." *Comics Journal*, no. 269 (July 2005): 33–35.
*Diereck, Charles, and Pascal Lefèvre, eds. *Forging a New Medium: The Comic Strip in the Nineteenth Century*. Brussels: VUB University Press, 1998.
Dimock, Wai Chee. "Introduction: Genres as Fields of Knowledge." *PMLA* 122, no. 5 (October 2007): 1377–1388.

*Douglas, Allen, and Fedwa Malti-Douglas. *Arab Comic Strips: Politics of an Emerging Mass Culture*. Bloomington: Indiana University Press, 1993.

Dueben, Alex. "'We Know This Will Drive Book Sales': A Conversation about the EGL Awards." *Comics Journal*, 16 January 2018. http://www.tcj.com/we-know-this-will-drive-book-sales-a-conversation-about-the-egl-awards.

Duncan, Randy, and Matthew J. Smith. *The Power of Comics: History, Form and Culture*. New York: Continuum, 2009.

Economist. "Triumph of the Nerds: The Internet Has Unleashed a Burst of Cartooning Creativity." 22 December 2012. http://www.economist.com/news/christmas-specials/21568586-internet-has-unleashed-burst-cartooning-creativity-triumph-nerds.

Eco, Umberto. "The Myth of Superman." Translated by Natalie Chilton. *Diacritics* 2, no. 1 (1972): 14–22.

Eisner, Will. *Comics and Sequential Art*. Tamarac: Poorhouse Press, 1985.

———. "Keynote Address from the 2002 'Will Eisner Symposium.'" Paper presented at University of Florida Conference on Comics and Graphic Novels, Gainesville, Fla., February 2002. Published in *ImageText: Interdisciplinary Comics Studies* 1, no. 1 (2004). http://www.english.ufl.edu/imagetext/archives/v1_1/eisner.

———. "Looking Back." Interview by Arie Kaplan. *Comics Journal*, no. 267 (April–May 2005): 124–132.

El Refaie, Elisabeth. *Autobiographical Comics: Life Writing in Pictures*. Jackson: University Press of Mississippi, 2012.

"Excellence in Graphic Literature Awards." Pop Culture Classroom. http://popcultureclassroom.org/excellence-in-graphic-literature-awards. Archived via Internet Archive: Wayback Machine (archive.org) on 19 September 2018.

Fenty, Sean, Trena Houp, and Laurie Taylor. "Webcomics: The Influence and Continuation of the Comix Revolution." *ImageText: Interdisciplinary Comics Studies* 1, no. 2 (Winter 2005).

Fincher, Ruth, and Jane M. Jacobs. Introduction to *Cities of Difference*. Edited by Ruth Fincher and Jane M. Jacobs. New York: Guildford Press, 1998.

Fink, Uri. "Comics in Israel—a Brief History." *International Journal of Comic Art* 15, no. 1 (2013): 127–145.

Fischer, Craig. "Worlds within Worlds: Audiences, Jargon, and North American Comics Discourse." *Transatlantica: Revue d'études américaines*, no. 1 (2010): http://transatlantica.revues.org/4919.

Foss, Chris, Jonathan Gray, and Zach Whalen, eds. *Disability in Comic Books and Graphic Narratives*. New York: Palgrave Macmillan, 2014.

Fresnault-Deruelle, Pierre. "Du linéaire au tabulaire." *Communications* 24 (1976): 7–23.

Frow, John. "'Reproducibles, Rubrics, and Everything You Need': Genre Theory Today." *PMLA* 122, no. 5 (October 2007): 1626–1634.

*Gabilliet, Jean-Paul. *Of Comics and Men: A Cultural History of American Comic Books*. Translated by Bart Beaty and Nick Nguyen. Jackson: University Press of Mississippi, 2010.

Gardner, Jared. "Archives, Collectors, and the New Media Work of Comics." *MFS* 52, no. 4 (Winter 2006): 787–806.

———. "Autography's Biography, 1972–2007." Special issue, *Biography* 31, no. 1 (Winter 2008): 1–26.

*———. *Projections: Comics and the History of Twenty-First-Century Storytelling*. Palo Alto, Calif.: Stanford University Press, 2012.

———. "Same Difference: Graphic Alterity in the Work of Gene Luen Yang, Adrian Tomine, and Derek Kirk Kim." In *Multicultural Comics: From* Zap *to* Blue Beetle, edited by Frederick Luis Aldama, 132–148. Austin: University of Texas Press, 2010.

———. "Storylines." *Substance* 40, no. 1 (2011): 53–69.

Garrity, Shaenon. "The History of Webcomics." *Comics Journal*, 15 July 2011. http://www.tcj.com/the-history-of-webcomics/.

Gary, Nicolas. "Auteur de bande dessinée, 'un métier compatible avec la surproduction?'" *ActuaLitté*, 12 February 2015. https://www.actualitte.com/article/bd-manga-comics/auteur-de-bande-dessinee-un-metier-compatible-avec-la-surproduction/53793.

Gateward, Frances, and John Jennings, eds. *The Blacker the Ink: Constructions of Black Identity in Comics and Sequential Art*. New Brunswick, N.J.: Rutgers University Press, 2015.

Gaudreault, André. *From Plato to Lumière: Narration and Monstration in Literature and Cinema*. Translated by Timothy Barnard. Toronto: Toronto University Press, 2009.

Gearino, Dan. *Comic Shop*. Athens, Ohio: Swallow Press / Ohio University Press, 2017.

Genette, Gérard. *Paratexts: Thresholds of Interpretation*. Translated by Jane E. Lewin. New York: Cambridge University Press, 1977.

Gibson, Mel. "Bella at the Bar." In *1001 Comics You Must Read before You Die: The Ultimate Guide to Comic Books, Graphic Novels and Manga*, edited by Paul Gravett, 354. New York: Universe Publishing, 2011.

———. "'So What Is This Mango, Anyway?' Manga and Younger Readers in Ireland and Britain." *Inis Magazine, Children's Books Ireland*, no. 22 (Winter 2007): 10–15.

———. "What Bunty Did Next: Exploring Some of the Ways in Which the British Girls' Comic Protagonists Were Revisited and Revised in Late Twentieth-Century Comics and Graphic Novels." *Journal of Graphic Novels and Comics* 1, no. 2 (December 2010): 121–135.

———. "'You Can't Read Them, They're for Boys!' British Girls, American Superhero Comics and Identity." *International Journal of Comic Art* 5, no. 1 (Spring 2003): 305–324.

Gifford, Dennis. *The British Comic Catalogue, 1874–1974*. Westport, Conn.: Greenwood, 1975.

Girard, Quentin. "36% des auteurs de BD sont sous le seuil de pauvreté." *Libération*, 2 February 2017. https://next.liberation.fr/culture-next/2017/02/02/36-des-auteurs-de-bd-sont-sous-le-seuil-de-pauvrete_1545636.

Gopnik, Adam. "Comics." In *High and Low: Modern Art, Popular Culture*, edited by Adam Gopnik and Kirk Varnedoe, 153–229. New York: Museum of Modern Art, 1990.

Gordon, Ian. "Comics, Creators, and Copyright." In *A Companion to Media Authorship*, edited by Jonathan Gray and Derek Johnson, 221–236. Oxford: Wiley-Blackwell, 2013.

*———. *Comic Strips and Consumer Culture, 1890–1945*. Washington, D.C.: Smithsonian Institution Press, 1998.

———. *Superman: The Persistence of an American Icon*. New Brunswick, N.J.: Rutgers University Press, 2017.

———. "Writing to Superman: Towards an Understanding of the Social Networks of Comic-Book Fans." *Participations: Journal of Audience & Reception Studies* 9, no. 2 (2012): 120–132.

*Grand Comics Database. https://www.comics.org/.

Grant, Pat. *Blue*. Marietta, Ga.: Top Shelf Productions, 2012.

Graves, Philip. "Early Comics Fandom (Part 2)—after the Alley Awards." Examiner.com, 11 September 2009. http://www.examiner.com/article/early-comics-fandom-part-2-after-the-alley-awards.

*Gravett, Paul. *Manga: Sixty Years of Japanese Comics*. London: Laurence King, 2004.

*———, ed. *1001 Comics You Must Read before You Die: The Ultimate Guide to Comic Books, Graphic Novels and Manga*. New York: Universe, 2011.

*Gravett, Paul, and Peter Stanbury. *Great British Comics*. London: Aurum, 2006.

Griepp, Milton, and John Jackson Miller. "Comics and Graphic Novel Sales Down 6.5% in 2017." ICv2, 13 July 2018. https://icv2.com/articles/news/view/40845/comics-graphic-novel-sales-down-6-5-2017.

Griffith, Eric. "The Best Webcomics 2015." *PC Magazine*, 15 February 2015. https://www.pcmag.com/news/the-best-webcomics-2015.

Groensteen, Thierry. *Comics and Narration*. Translated by Ann Miller. Jackson: University Press of Mississippi, 2013.

———. *M. Töpffer invente la bande dessinée*. Paris: Impressions Nouvelles, 2014.

———. *The System of Comics*. Translated by Bart Beaty and Nick Nguyen. Jackson: University Press of Mississippi, 2012.

———. "Why Are Comics Still in Search of Cultural Legitimization?" Translated by Shirley Smolderen. In *A Comics Studies Reader*, edited by Jeet Heer and Kent Worcester, 3–11. Jackson: University Press of Mississippi, 2009.

Groupe Mu. *Traité du signe visuel*. Paris: Seuil, 1993.

*Grove, Laurence. *Comics in French: The European Bande Dessinée in Context*. New York: Berghahn, 2010.

gum [pseud.]. "The First Modern Scanlation Group." Inside Scanlation. https://www.insidescanlation.com/history/history-1-2.html.

———. "The Land before Time." Inside Scanlation. https://www.insidescanlation.com/history/history-1-1.html.

Gunawan, Iwan. "Multiculturalism in Indonesian Comics." *International Journal of Comic Art* 15, no. 1 (2013): 100–126.

Hajdu, David. *The Ten-Cent Plague: The Great Comic Book Scare and How It Changed America*. New York: Farrar, Straus and Giroux, 2008.

*Hall, Justin, ed. *No Straight Lines: Four Decades of Queer Comics*. Seattle: Fantagraphics, 2013.

Harpold, Terry. *Ex-foliations: Reading Machines and the Upgrade Path*. Minneapolis: University of Minnesota Press, 2008.

Harrigan, Pat, and Noah Wardrip-Fruin, eds. *Third Person: Authoring and Exploring Vast Narratives*. Cambridge, Mass.: MIT Press, 2009.

Harvey, Robert C. *The Art of the Comic Book: An Aesthetic History*. Jackson: University Press of Mississippi, 1996.

———. "Comedy at the Juncture of Word and Image." In *The Language of Comics: Word and Image*, edited by Robin Varnum and Christina T. Gibbons, 75–96. Jackson: University Press of Mississippi, 2001.

———. "How Comics Came to Be." In *A Comics Studies Reader*, edited by Jeet Heer and Kent Worcester, 25–45. Jackson: University Press of Mississippi, 2009.

Hassan, Wail. "World Literature in the Age of Globalization: Reflections on an Anthology." *College English* 63, no. 1 (2000): 38–47.

Hatfield, Charles. *Alternative Comics: An Emerging Literature*. Jackson: University Press of Mississippi, 2005.

———. "Comic Art, Children's Literature, and the New Comics Studies." *Lion and the Unicorn* 30, no. 3 (September 2006): 360–382.

———. "Defining Comics in the Classroom, or The Pros and Cons of Unfixability." In *Teaching the Graphic Novel*, edited by Stephen Tabachnick, 19–27. New York: MLA, 2009.

———. *Hand of Fire: The Comics Art of Jack Kirby*. Jackson: University Press of Mississippi, 2011.

Hatfield, Charles, and Joe Sutliff Sanders. "Bonding Time or Solo Flight? Picture Books, Comics, and the Independent Reader." *Children's Literature Association Quarterly* 42, no. 4 (Winter 2017): 459–486.

Heer, Jeet. "Inventing Cartooning Ancestors: Ware and the Comics Canon." In *The Comics of Chris Ware: Drawing Is a Way of Thinking*, edited by David M. Ball and Martha B. Kuhlman, 3–13. Jackson: University Press of Mississippi, 2010.

Heer, Jeet, and Kent Worcester, eds. *A Comics Studies Reader*. Jackson: University Press of Mississippi, 2009.

Heimermann, Mark, and Brittany Tullis, eds. *Picturing Childhood: Youth in Transnational Comics*. London: Routledge, 2018.

Heller, Steven. "Smartest Letterer on the Planet: Chicago's Comic Book Hero Has a Finely Tuned Gift for Hand-Lettering." *Eye Magazine*, Autumn 2002. http://www.eyemagazine.com/feature/article/smartest-letterer-on-the-planet.

Herriman, George. *Krazy Kat: The Complete Full-Page Comic Strips, 1935–1936*. Seattle: Fantagraphics, 2005.

Hirsch, Marianne. "Mourning and Postmemory." In *Graphic Subjects: Critical Essays on Autobiography and Graphic Novels*, edited by Michael Chaney, 17–44. Madison: University of Wisconsin Press, 2011.

Hodkinson, Paul. "'Insider Research' in the Study of Youth Cultures." *Journal of Youth Studies* 8, no. 2 (2005): 131–149.

Hofmann, Werner. *Caricature: From Leonardo to Picasso*. London: John Calder, 1957.

Hom, Jennifer. "107th Anniversary of *Little Nemo in Slumberland*." Google Doodles, 15 October 2012. http://www.google.com/doodles/107th-anniversary-of-little-nemo-in-slumberland.

Horrocks, Dylan. "Inventing Comics: Scott McCloud Defines the Form in *Understanding Comics*." *Comics Journal*, no. 234 (June 2001): 29–39.

Hounshell, David. *From the American System to Mass Production, 1800–1932: The Development of Manufacturing Technology in the United States*. Baltimore: Johns Hopkins University Press, 1984.

Howard, Sheena C., and Ronald L. Jackson, eds. *Black Comics: Politics of Race and Representation*. New York: Bloomsbury, 2013.

Howe, Sean. *Marvel Comics: The Untold Story*. New York: HarperCollins, 2012.

Howes, Craig. "Editing Twenty Years On: Biography, Life Writing, and the Future of 'Publication.'" Paper presented at "Auto/biography across the Americas: Reading across Geographic and Cultural Divides," International Auto/biography Association, San Juan, Puerto Rico, July 2013.

Huxley, David. *Nasty Tales: Sex, Drugs, Rock 'n' Roll and Violence in the British Underground*. London: Headpress, 2001.

Hyde, David. "DC Comic Announces Historic Renumbering of All Superhero Titles and Landmark Day-and-Date Digital Distribution." *DC Universe: The Source* (blog), May 2011. https://www.dccomics.com/blog/2011/05/31/dc-comics-announces-historic-renumbering-of-all-superhero-titles-and-landmark-day-and-date-digital-distribution.

Itō, Gō. "Tezuka Is Dead: Manga in Transformation and Its Dysfunctional Discourse." In *Mechademia*, vol. 6, *User Enhanced*, translated and introduced by Miri Nakamura, 69–82. Minneapolis: University of Minnesota Press, 2011.

*Ito, Kinko. "A History of Manga in the Context of Japanese Culture and Society." *Journal of Popular Culture* 38, no. 3 (2005): 456–475.

Ivy, Marilyn. *Discourses of the Vanishing: Modernity, Phantasm, Japan*. Chicago: University of Chicago Press, 1995.

Jason. *The Iron Wagon*. Seattle: Fantagraphics, 2003.

Jenkins, Henry. *Fans, Bloggers, and Gamers: Exploring Participatory Culture*. New York: New York University Press, 2006.

Jensen, Joli. "Fandom as Pathology: The Consequences of Characterization." In *The Adoring Audience: Fan Culture and Popular Media*, edited by Lisa A. Lewis, 9–29. New York: Routledge, 1992.

Johnson, Charles. *I Call Myself an Artist: Writings by and about Charles Johnson*. Bloomington: Indiana University Press, 1999.

Johnson, Derek. "'Cinematic Destiny': Marvel Studios and the Trade Stories of Industrial Convergence." *Cinema Journal* 52, no. 1 (2012): 1–24.

———. *Media Franchising: Creative License and Collaboration in the Culture Industries*. New York: New York University Press, 2013.

———. "Will the Real Wolverine Please Stand Up? Marvel's Mutation from Monthlies to Movies." In *Film and Comic Books*, edited by Ian Gordon, Mark Jancovich, and Matthew P. McAllister, 64–85. Jackson: University Press of Mississippi, 2007.

Karasik, Paul, and David Mazzuchelli. *City of Glass*. 2nd ed. New York: Picador, 2004.

Kartalopoulos, Bill, ed. "International Comics." Special section, *World Literature Today* 90, no. 2 (March–April 2016): 37–75.

Kashtan, Aaron. *Between Pen and Pixel: Comics, Materiality, and the Book of the Future*. Columbus: The Ohio State University Press, 2018.

Kern, Adam L. *Manga from the Floating World: Comicbook Culture and the Kibyōshi of Edo Japan*. Cambridge: Harvard University Press, 2006.

Keyes, Roger S. *Ehon: The Artist and the Book in Japan*. Seattle: University of Washington Press, 2006.

Kidman, Shawna Feldmar. "Five Lessons for New Media from the History of Comics Culture." *International Journal of Learning* 3, no. 4 (2011): 41–54.

*Kinsella, Sharon. *Adult Manga: Culture and Power in Contemporary Japanese Society*. 2000. Reprint, London: Routledge, 2013.

Kistler, Alan. "Jim Lee, Diane Nelson Introduce DC2 and DC2: Multiverse Digital Comics." Comic Book Resources, 5 June 2013. http://www.comicbookresources.com/?page=article&id=45889.

Kleefeld, Sean. *Comic Book Fanthropology*. 2nd ed. Hamilton, Ohio: Eight Twenty Press, 2011.

Kline, Stephen. "A Becoming Subject: Consumer Socialization in the Mediated Marketplace." In *The Making of the Consumer: Knowledge, Power and Identity in the Modern World*, edited by Frank Trentmann, 199–221. Oxford: Berg, 2006.

Køhlert, Frederik Byrn. *Serial Selves: Identity and Representation in Autobiographical Comics*. New Brunswick, N.J.: Rutgers University Press, 2019.

Koma, Kyoko. "Kawaii as Represented in Scientific Research: The Possibilities of Kawaii Cultural Studies." *Hemispheres: Studies on Cultures and Societies* 28 (2013): 5–17.

Kotoku Minoru. Interview by Frenchy Lunning and Michael Baxter. April 2008, Takadanobaba, Tokyo.

Kuhlman, Martha. "The Traumatic Temporality of Art Spiegelman's *In the Shadow of No Towers*." *Journal of Popular Culture* 40, no. 5 (2007): 849–866.

Kunka, Andrew J. *Autobiographical Comics*. London: Bloomsbury, 2017.

———. "*A Contract with God*, *The First Kingdom*, and the 'Graphic Novel': The Will Eisner / Jack Katz Letters." *Inks: Journal of the Comics Studies Society* 1, no. 1 (2017): 27–39.

*Kunzle, David. *The History of the Comic Strip*. Vol. 1, *The Early Comic Strip: Narrative Strips and Picture Stories in the European Broadsheet from c.1450 to 1825*. Berkeley: University of California Press, 1973.

*———. *The History of the Comic Strip*. Vol. 2, *The Nineteenth Century*. Berkeley: University of California Press, 1990.

*———. "Chronology." In *Rodolphe Töpffer: The Complete Comic Strips*, by Rodolphe Töpffer, translated by David Kunzle. Jackson: University Press of Mississippi, 2007.

Labarre, Nicolas. *Heavy Metal: L'autre* Métal hurlant. Pessac, France: Presses Universitaires de Bordeaux, 2017.

Lapacherie, Jean Gérard. "De la grammatextualité." *Poétique* 59 (1984): 283–294.

Lawrence, John Shelton, and Robert Jewett. *The Myth of the American Superhero*. Grand Rapids, Mich.: William B. Eerdmans, 2002.

Lécroart, Étienne. *Circle vicieux*. Paris: L'Association, 2005.

Lent, John A. "Comic Art in Asian Cultural Context." In *Medi@sia: Global Media/tion In and Out of Context*, edited by Todd Joseph Miles Holden and Timothy J. Scrase, 224–242. London: Routledge, 2006.
———. "The Comics Debate Internationally." In *A Comics Studies Reader*, edited by Jeet Heer and Kent Worcester, 69–76. Jackson: University Press of Mississippi, 2009.
———, ed. "Pioneers of Comic Art Scholarship." *International Journal of Comic Art* 5, no. 1 (Spring 2003): 3–73; 5, no. 2 (Fall 2003): 205–260; 7, no. 2 (Fall 2005): 3–88.
*———, ed. *Pulp Demons: International Dimensions of the Postwar Anti-comics Campaign*. Madison, N.J.: Fairleigh Dickinson University Press, 1999.
Lepore, Jill. *The Secret History of Wonder Woman*. New York: Knopf, 2014.
Levay, Matthew. Review of *The Greatest Comic Book of All Time: Symbolic Capital and the Field of American Comic Books*, by Bart Beaty and Benjamin Woo; *Arresting Development: Comics at the Boundaries of Literature*, by Christopher Pizzino; and *We Told You So: Comics as Art* by Tom Spurgeon and Michael Dean. *Journal of Modern Periodical Studies* 10, nos. 1–2 (2019): 189–196.
Lewis, A. David. "One for the Ages: Barbara Gordon and the (Il)-Logic of Comic Book Age-Dating." *International Journal of Comic Art* 5, no. 2 (2003): 296–311.
Lorde, Audre. *Sister Outsider: Essays and Speeches*. Berkeley: Crossing Press, 1984.
Lupoff, Dick, and Don Thompson, eds. *All in Color for a Dime*. New Rochelle, N.Y.: Arlington House, 1970.
Ma, Sheng-mei. *The Deathly Embrace: Orientalism in Asian American Identity*. Minneapolis: University of Minnesota Press, 2000.
MacDonald, Heidi. "How Graphic Novels Became the Hottest Section in the Library." *Publisher's Weekly*, 3 May 2013. https://www.publishersweekly.com/pw/by-topic/industry-news/libraries/article/57093-how-graphic-novels-became-the-hottest-section-in-the-library.html.
Madden, Matt. *99 Ways to Tell a Story: Exercises in Style*. New York: Chamberlain Bros., 2005.
Mahadeo, Kevin. "Archie Comics Goes Day-and-Date Digital." Comic Book Resources, 12 January 2011. http://www.comicbookresources.com/?page=article&id=30300.
Marion, Philippe. *Traces en cases*. Louvain-la-Neuve: Acadèmia, 1993.
Masuda, Nozomi. "Shojo Manga and Its Acceptance: What Is the Power of Shojo Manga?" In *International Perspectives on Shojo and Shojo Manga*, edited by Masami Toku, 23–31. New York: Routledge, 2015.
*Mazur, Dan, and Alexander Danner. *Comics: A Global History, 1968 to the Present*. London: Thames & Hudson, 2014.
Mazurier, Stéphane. *Bête, méchant et hebdomadaire: Une histoire de Charlie Hebdo 1969–1982*. Paris: Buchet-Chastel, 2009.
Mazzucchelli, David. *Asterios Polyp*. New York: Pantheon, 2009.
McAllister, Matthew P. "Ownership Concentration in the U.S. Comic Book Industry." In *Comics and Ideology*, edited by Matthew P. McAllister, Ian Gordon, and Edward H. Sewell Jr., 15–38. New York: Peter Lang, 2001.
McAllister, Matthew P., Ian Gordon, and Mark Jancovich. "Art House Meets Graphic Novel, or Blockbuster Meets Superhero Comic? The Contradictory Relationship between Film and Comic Art." *Journal of Popular Film and Television* 34, no. 3 (2008): 108–114.
McAllister, Matthew P., and Stephanie Orme. "Cinema's Discovery of the Graphic Novel: Mainstream and Independent Adaptation." In *The Cambridge History of the Graphic Novel*, edited by Jan Baetens, Hugo Frey, and Stephen E. Tabachnick, 543–557. Cambridge: Cambridge University Press, 2018.
McCay, Winsor. *The Complete Little Nemo in Slumberland*. Vol. 1, *1905–1907*. Seattle: Fantagraphics, 1998.

McCloud, Scott. *Reinventing Comics*. New York: HarperCollins, 2000.

——— (@scottmccloud). "Talked to the Google Doodle team in advance about today's beautiful Winsor McCay webcomic. Fantastic to see it in action!" Twitter, 14 October 2012, 9:54 p.m. https://twitter.com/scottmccloud/status/257705893469229057.

———. *Understanding Comics: The Invisible Art*. New York: HarperCollins, 1994. First published 1993 by Tundra (Northampton, Mass.).

McGuire, Richard. *Here*. New York: Pantheon, 2014.

McInturff, Kate. "The Uses and Abuses of World Literature." *Journal of American Culture* 26, no. 2 (June 2003): 224–236.

McKean, Dave. *Cages*. Milwaukie, Ore.: Dark Horse, 2010. First published 1998 by Kitchen Sink Press (Northampton, Mass.).

*McLain, Karline. *India's Immortal Comic Books: Gods, Kings, and Other Heroes*. Bloomington: Indiana University Press, 2009.

McLaughlin, Thomas. Introduction to *Critical Terms for Literary Study*, 2nd ed., edited by Frank Lentricchia and Thomas McLaughlin, 1–8. Chicago: University of Chicago Press, 1995.

McNeil, Carla Speed. *Finder: Voice*. Milwaukie: Dark Horse Comics, 2011.

McRobbie, Angela. *Feminism and Youth Culture: From* Jackie *to* Just Seventeen. London: Macmillan, 1991.

McShane, John. "Through a Glass, Darkly—the Revisionist History of Comics." *Drouth* 16 (2007): 62–69.

Medley, Stuart. "Discerning Pictures: How We Look at and Understand Images in Comics." *Studies in Comics* 1, no. 1 (2010): 53–70.

Meehan, Eileen R. "'Holy Commodity Fetish, Batman!' The Political Economy of a Commercial Intertext." In *The Many Lives of the Batman: Critical Approaches to a Superhero and His Media*, edited by Roberta E. Pearson and William Uricchio, 47–65. New York: Routledge, 1991.

Menu, Jean-Christophe. *Plates-bandes*. Paris: L'Association, 2005.

Messmore, Teresa. "A Marvelous Career: From Student Intern to Executive." *University of Delaware Messenger* 20, no. 2 (August 2012). http://www.udel.edu/udmessenger/vol20no2/stories/alumni-brevoort.html.

Michaluk, Kevin. "Carnival of Souls—1st Comic Book App in App World." Crackberry, April 2009. http://crackberry.com/carnival-souls-1st-comic-book-app-app-world.

*Miller, Ann. *Reading* Bande Dessinée: *Critical Approaches to French-Language Comic Strip*. Bristol, England: Intellect, 2007.

Miller, John Jackson. "Digital Comics: 40 Million Paid Downloads a Year?" *Comichron* (blog), 14 June 2013. http://blog.comichron.com/2013/06/digital-comics-40-million-downloads-year.html.

Mills, Pat. *Be Pure! Be Vigilant! Behave!* 2000 AD *and Judge Dredd: The Secret History*. Bury, England: Millsverse, 2017.

Mitchell, W. J. T. *Iconology. Image, Text, Ideology*. Chicago: University of Chicago Press, 1985.

———. *Picture Theory*. Chicago: University of Chicago Press, 1992.

———. "Showing Seeing: A Critique of Visual Culture." *Journal of Visual Culture* 1, no. 2 (August 2002): 165–181.

———. "There Are No Visual Media." *Journal of Visual Culture* 4, no. 2 (2005): 257–266.

MobyGames. "Infocomics Games." Accessed 10 June 2019. http://www.mobygames.com/game-group/infocomics-games/offset,0/so,1a/.

Molotiu, Andrei. "List of Terms for Comics Studies." Comics Forum, 16 July 2013. https://comicsforum.org/2013/07/26/list-of-terms-for-comics-studies-by-andrei-molotiu.

Moreno, Pepe. "Batman: Digital Justice (the Servo Cops)." Pepe Moreno's official blog, 24 February 2010. http://pepemorenoart.blogspot.ca/2010/02/batman-digital-justice-servo-cops.html.

———. "Work History." Pepe Moreno's official website, 2013. http://www.pepemoreno.com/index.php/work/history. Archived via Internet Archive: Wayback Machine (archive.org) on 23 September 2018.

Morgan, Harry. *Principes des littératures dessinées*. Angoulême: Editions de l'an 2, 2003.

Mouly, Françoise. "Our TOON Books Mission." TOON Books, 2 November 2007. http://www.toon-books.com/our-mission.html.

Munroe, Randall. "Click and Drag." *Xkcd*. http://xkcd.com/1110/.

———. "Time." *Xkcd*. http://xkcd.com/1190/.

Muri, Philippe. "Trop de bandes dessinées publiées en 2014." *Tribune de Genève*, 7 January 2015. https://www.tdg.ch/culture/bandes-dessinees-publiees-2014/story/12795888.

Murray, Chris. "Signals from Airstrip One: The British Invasion of Mainstream American Comics." In *The Rise of the American Comics Artist: Creators and Contexts*, edited by Paul Williams and James Lyons, 31–45. Jackson: University Press of Mississippi, 2010.

Nakamura, Miri. Translator's introduction to "Tezuka Is Dead: Manga in Transformation and Its Dysfunctional Discourse," by Gō Itō. In *Mechademia*, vol. 6, *User Enhanced*, 69–82. Minneapolis: University of Minnesota Press, 2011.

Nama, Adilifu. *Super Black: American Pop Culture and Black Superheroes*. Austin: University of Texas Press, 2011.

Newman, Michael. *Indie: An American Film Culture*. New York: Columbia University Press, 2011.

Newsarama. "The Full Nielsen: DC's Complete New 52 Consumer Survey." 12 April 2012. http://www.newsarama.com/14637-the-full-nielsen-dc-s-complete-new-52-consumer-survey.html.

New York Times. "American News to Sell Assets." 18 June 1957.

Ngai, Sianne. *Our Aesthetic Categories: Zany, Cute, Interesting*. Cambridge: Harvard University Press, 2012.

Nodelman, Perry. *The Hidden Adult: Defining Children's Literature*. Baltimore: Johns Hopkins University Press, 2008.

Nyberg, Amy Kiste. "How Librarians Learned to Love the Graphic Novel." In *Graphic Novels and Comics in Libraries and Archives*, edited by Robert G. Weiner, 26–40. New York: McFarland, 2010.

———. "Percival Chubb and the League for the Improvement of the Children's Comic Supplement." *Inks* 3, no. 3 (1996): 31–34.

*———. *Seal of Approval: The History of the Comics Code*. Jackson: University Press of Mississippi, 1998.

O'Leary, Shannon. "Comics Retailers Upbeat on 2013 Sales, Digital, Indie Comics." *Publishers Weekly*, 10 July 2013. http://www.publishersweekly.com/pw/by-topic/industry-news/comics/article/58161-comics-retailers-upbeat-on-2013-sales-digital-indie-comics.html.

Orbaugh, Sharalyn. "Kamishibai and the Art of Interval." In *Mechademia*, vol. 7: *Lines of Sight*, 78–100. Minneapolis: University of Minnesota Press, 2012.

Overstreet, Robert M., comp. *The Overstreet Comic Book Price Guide*. 49th ed. Timonium, Md.: Gemstone, 2019.

Pagliassotti, Dru, Kazumi Nagaike, and Mark McHarry. "Boys' Love Manga Special Section." Editorial. *Journal of Graphic Novels and Comics* 4, no. 1 (2013): 1–8.

Pax, Salam. "I Spent Most of the Day at Home Reading [*Persepolis*]." *Where Is Raed?* (blog), 7 December 2003. http://dear_raed.blogspot.com/2003/12/i-spent-most-of-day-at-home-reading.html.

Peeters, Benoît. *Case, planche, récit*. Paris: Casterman, 1998.

Peirce, Charles S. *Writings of Charles S. Peirce: A Chronological Edition*. Vol. 2, *1867–1871*, edited by Edward C. Moore et al. Bloomington: Indiana University Press, 1984.

"Peirce Edition Project: Writings of Charles S. Peirce." Indiana University, 1976–. http://peirce.iupui.edu/index.html.

Perry, George, and Alan Aldridge. *The Penguin Book of Comics: A Slight History*. Harmondsworth: Penguin, 1971.

Peter, Philippe. "BD: Le cercle vicieux de la surproduction." *France Soir*, 5 January 2012. https://archive.francesoir.fr/loisirs/litterature/bd-cercle-vicieux-surproduction-170993.html.

Peterson, Theodore. *Magazines in the Twentieth Century*. Urbana: University of Illinois Press, 1956.

Pizzino, Christopher. *Arresting Development: Comics at the Boundaries of Literature*. Austin: University of Texas Press, 2016.

Pratt, Geraldine. "Grids of Difference: Place and Identity Formation." In *Cities of Difference*, edited by Ruth Fincher and Jane M. Jacobs, 26–48. New York: Guildford Press, 1998.

PreviewsWorld. "Publisher Market Shares: February 2019." 18 March 2019. https://www.previewsworld.com/Article/227363-Publisher-Market-Shares-February-.

Priego, Ernesto. "Un-holy Alliance: *Shatter* and the Aesthetics of Cyberpunk." *Comics Grid* (blog), 22 August 2011. http://blog.comicsgrid.com/blog/shatter/.

Prough, Jennifer S. *Straight from the Heart: Gender, Intimacy, and the Cultural Production of Shōjo Manga*. Honolulu: University of Hawai'i Press, 2011.

Pustz, Matthew J. *Comic Book Culture: Fanboys and True Believers*. Jackson: University Press of Mississippi, 1999.

Queer Voices. "Apple Homophobic? Company in Crossfire over *Saga* #12 Comic with 'Images of Gay Sex.'" HuffPost, 10 April 2013. http://www.huffingtonpost.com/2013/04/10/apple-homophobic-bans-saga-12-comic-gay-sex_n_3052783.html.

Raeburn, Daniel. *Chris Ware*. New Haven, Conn.: Yale University Press, 2004.

Ratier, Gilles. *Rapports annuels de l'ACBD signés Gilles Ratier, secrétaire général de l'ACBD*. Association des critiques et journalistes de bande dessinée. https://www.acbd.fr/category/rapports.

———. *Rapport sur la production d'une année de bande dessinée dans l'espace francophone européen: 2016, l'année de la stabilization*. Association des critiques et journalistes de bande dessinée. https://www.acbd.fr/wp-content/uploads/2016/12/Rapport-ACBD_2016.pdf.

Raviv, Dan. *Comic Wars: How Two Tycoons Battled Over the Marvel Comics Empire . . . and Both Lost*. New York: Broadway, 2002.

Regalado, Aldo J. *Bending Steel: Modernity and the American Superhero*. Jackson: University Press of Mississippi, 2015.

Repetti, Massimo. "African Wave: Specificity and Cosmopolitanism in African Comics." *African Arts* 40, no. 2 (2007): 16–35.

Reynolds, Richard. *Super Heroes: A Modern Mythology*. 1992. Reprint, Jackson: University Press of Mississippi, 1994.

*Robbins, Trina. *From Girls to Grrrlz: A History of Women's Comics from Teens to Zines*. San Francisco: Chronicle Books, 1999.

*———. *Pretty in Ink: American Women Cartoonists, 1896–2013*. Seattle: Fantagraphics, 2013.

Robbins, Trina, and Catherine Yronwode. *Women and the Comics*. N.p.: Eclipse, 1985.

Robbins, Trina, et al. *The Complete Wimmen's Comix*. Seattle: Fantagraphics, 2016.

Robertson, Jennifer. *Native and Newcomer: Making and Remaking a Japanese City*. Berkeley: University of California Press, 1991.

Rodriguez, Ralph E. "In Plain Sight: Reading the Racial Surfaces of Adrian Tomine's *Shortcomings*." In *Drawing New Color Lines: Transnational Asian American Graphic Narratives*, edited by Monica Chiu, 87–106. Hong Kong: Hong Kong University Press, 2014.

Rogers, Mark C. "Merchandising and Licensing." In *Encyclopedia of Comic Books and Graphic Novels*, edited by M. Keith Booker, 412–415. Santa Barbara: Greenwood, 2010.

———. "Political Economy: Manipulating Demand and 'The Death of Superman.'" In *Critical Approaches to Comics: Theories and Methods*, edited by Matthew J. Smith and Randy Duncan, 145–156. New York: Routledge, 2012.

———. "Understanding Production: The Stylistic Impact of Artisan and Industrial Methods." *International Journal of Comic Art* 8, no. 1 (2006): 509–517.

Rogers, Sean. "Q&A: Seth." *Walrus Magazine* (blog), 21 August 2008. http://walrusmagazine.com/blogs/2008/08/21/an-interview-with-seth-part-one. Archived via Internet Archive: Wayback Machine (archive.org) on 8 August 2012.

Rogers, Vaneta. "ComiXology Selling Digital Comics through Retail Stores." Newsarama, 27 January 2011. http://www.newsarama.com/6920-comixology-selling-digital-comics-through-retail-stores.html.

Roman, Zak, and Matthew P. McAllister. "The Brand and the Bold: Synergy and Sidekicks in Licensed-Based Children's Television." *Global Media Journal* 12, no. 20 (2012). http://lass.calumet.purdue.edu/cca/gmj/index.htm.

Rosenkranz, Patrick. *Rebel Visions: The Underground Comix Revolution*. Seattle: Fantagraphics, 2008.

Rowe, Adam. "What DC Comics' New Service Says about the Future of Digital Subscriptions." *Forbes*, 30 June 2018. https://www.forbes.com/sites/adamrowe1/2018/06/30/what-dc-comics-new-service-says-about-the-future-of-digital-subscriptions/#6aa282d86cd4.

Royal Commission on the Press. *The Women's Periodical Press in Britain, 1946–1976*. CLW Working Paper No. 4. London: HMSO, 1977.

*Rubenstein, Anne. *Bad Language, Naked Ladies, and Other Threats to the Nation: A Political History of Comic Books in Mexico*. Durham, N.C.: Duke University Press, 1998.

Sabeti, Shari. "'Arts of Time and Space': The Perspectives of a Teenage Audience on Reading Novels and Graphic Novels." *Participations: Journal of Audience & Reception Studies* 9, no. 2 (2012): 159–179.

———. "The Irony of 'Cool Club': The Place of Comic Book Reading in Schools." *Journal of Graphic Novels and Comics* 2, no. 2 (2011): 137–149.

Sabin, Roger. *Adult Comics: An Introduction*. London: Routledge, 1993.

———. "Ally Sloper: The First Comics Superstar?" *Image & Narrative* 7 (October 2003). http://www.imageandnarrative.be/inarchive/graphicnovel/rogersabin.htm.

*———. *Comics, Comix and Graphic Novels*. London: Phaidon, 1996.

Saenz, Mike, Peter B. Gillis, and Mike Gold. "Shatter." *Big K*, no. 12 (March 1985): 75–79. https://archive.org/details/12-big-k-magazine.

Saguisag, Lara. "The Child of the Comic Supplement Is the 'Smart Kid': Early Twentieth Century Comics and Their Child Readers." Lecture, annual conference of the Children's Literature Association, Biloxi, Miss., 14 June 2013.

———. *Incorrigibles and Innocents: Constructing Childhood and Citizenship in Progressive Era Comics*. New Brunswick, N.J.: Rutgers University Press, 2019.

Sanders, Joe Sutliff. "Chaperoning Words: Meaning-Making in Comics and Picture Books." *Children's Literature* 41 (2013): 57–90.

San Diego State University Library. *The Comic-Con Kids*. Oral history project. Accessed 2 April 2020. http://comiccon.sdsu.edu.

Satrapi, Marjane. *The Complete Persepolis*. Translated by Mattias Ripa and Blake Ferris. New York: Pantheon, 2007.

———. *Embroideries*. Translated by Anjali Singh. New York: Pantheon, 2005.

Sawatari, Kiyoko. "Innovational Adaptations: Contacts between Japanese and Western Artists in Yokohama, 1859–1899." In *Challenging Past and Present: The Metamorphosis of*

Nineteenth-Century Japanese Art, edited by Ellen P. Conant, 83–113. Honolulu: University of Hawai'i Press, 2006.

Sayer, Andrew. *The Moral Significance of Class*. Cambridge: Cambridge University Press, 2005.

*Schodt, Frederik L. *Manga! Manga! The World of Japanese Comics*. Tokyo: Kodansha International, 1986.

Science Fiction Encyclopedia. S.v. "Infocomics." 23 October 2011. http://www.sf-encyclopedia.com/entry/infocomics.

Scieszka, Jon. Introduction to *The TOON Treasury of Classic Children's Comics*, edited by Art Spiegelman and Françoise Mouly, 6–7. New York: Abrams, 2009.

Scott, Darieck, and Ramzi Fawaz, eds. "Queer about Comics." Special issue, *American Literature* 90, no. 2 (2018).

Serchay, David. "The Day Comics Won." Diamond Bookshelf [14 June 2012]. http://www.diamondbookshelf.com/Home/1/1/20/630?articleID=121866.

Seth. *It's a Good Life, If You Don't Weaken*. Montreal: Drawn & Quarterly, 2003.

Shimizu, Isao. Interview by Frenchy Lunning. March 2008, Tokyo Imperial Hotel, Tokyo.

———. *Manga no rekishi*. Tokyo: Iwanami Shoten, 1991.

———. *"Nihon" manga no jiten: Zenkoku no manga fan ni okuru*. Shohan ed. Tokyo: Sanseidō, 1985.

Shyminsky, Neil. "Mutant Readers, Reading Mutants: Appropriation, Assimilation, and the X-Men." *International Journal of Comic Art* 8, no. 2 (2006): 387–405.

Siebers, Tobin. *Disability Aesthetics*. Ann Arbor: University of Michigan Press, 2000.

Siegel, Jerry, and Joe Shuster. *The Superman Chronicles*. Vol. 1. New York: DC Comics, 2006.

Sim, Dave. "Weekly Update #38: Sitting On a Crumbling Ledge." *A Moment of* Cerebus (blog), 4 July 2014. http://momentofcerebus.blogspot.ca/2014/07/7-ramadan-weekly-update.html.

Skinn, Dez. "Early Days of UK Comics Conventions and Marts." dezskinn.com (blog), 9 October 2011. http://dezskinn.com/fanzines-3/.

Smith, Matthew J., and Randy Duncan, eds. *Critical Approaches to Comics: Theories and Methods*. New York: Routledge, 2012.

———, eds. *The Secret Origins of Comics Studies*. New York: Routledge, 2017.

Smith, Sidonie, and Julia Watson. *Reading Autobiography: A Guide to Interpreting Life Narrative*. 2nd edition. Minneapolis: University of Minnesota Press, 2010.

Smolderen, Thierry. "Of Labels, Loops, and Bubbles: Solving the Historical Puzzle of the Speech Balloon." *Comic Art* 8 (Summer 2006): 90–112.

———. *Naissances de la bande dessinée: De William Hogarth à Winsor McCay*. Brussels: Impressions Nouvelles, 2009.

*———. *The Origins of Comics: From William Hogarth to Winsor McCay*. Translated by Bart Beaty and Nick Nguyen. Jackson: University Press of Mississippi, 2014.

Sorkin, Michael, ed. *Variations on a Theme Park: The New American City and the End of Public Space*. New York: Hill and Wang: 1999.

Spiegelman, Art. *Breakdowns: Portrait of the Artist as a Young %@&*!* New York: Pantheon, 2008.

———. *Comix, Essays, Graphics and Scraps: From* Maus *to Now to* Maus *to Now*. Palermo, Italy: Sellerio Editore—La Centrale dell'Arte, 1999.

———. *The Complete Maus*. New York: Pantheon, 1996.

———. *In the Shadow of No Towers*. New York: Pantheon, 2004.

Spiegelman, Art, and Françoise Mouly, eds. *The TOON Treasury of Classic Children's Comics*. New York: Abrams, 2009.

Stanley-Baker, Joan. *Japanese Art*. London: Thames & Hudson World of Art, 2000.

Stromberg, Frederik. "Naked Manga = Child Pornography." *Comics Journal*, 4 August 2010. https://classic.tcj.com/manga/naked-manga-child-pornography. Archived via Internet Archive: Wayback Machine (archive.org) on 25 May 2018.

Swafford, Brian. "Critical Ethnography: The Comics Shop as Cultural Clubhouse." In *Critical Approaches to Comics: Theories and Methods*, edited by Matthew J. Smith and Randy Duncan, 291–302. New York: Routledge, 2012.

Szadkowski, Joseph. "Digital Production Comes of Age in the Comic World." Animation World Network, 4 July 2000. http://www.awn.com/mag/issue5.04/5.04pages/szadkowskicomic.php3.

Tabachnick, Stephen, ed. *Teaching the Graphic Novel*. New York: MLA, 2009.

Tensuan, Theresa. "Comics." In *The Routledge Companion to Asian American and Pacific Islander Literature*, edited by Rachel Lee, 415–425. New York: Routledge, 2014.

Thorn, Rachel Matt. "Shôjo Manga—Something for the Girls." *Japan Quarterly* 48, no. 3 (2001): 43–50.

Tilley, Carol L. "Seducing the Innocent: Fredric Wertham and the Falsifications That Helped Condemn Comics." *Information & Culture* 47, no. 4 (2012): 383–413.

Tinker, Emma. "Identity and Form in Alternative Comics, 1967–2007." PhD diss., University College, London, 2009. Available online at http://emmatinker.oxalto.co.uk.

Tinkler, Penny. *Constructing Girlhood: Popular Magazines for Girls Growing Up in England 1920–1950*. London: Taylor & Francis, 1995.

———. "'A Material Girl'? Adolescent Girls and Their Magazines, 1920–1958." In *All the World and Her Husband: Women in Twentieth-Century Consumer Culture*, edited by Maggie Andrews and Mary M. Talbot, 97–112. London: Cassell, 2000.

Toth, Alex, and John Hitchcock. *Dear John: The Alex Toth Doodle Book*. N.p.: Octopus Press, 2006.

Troutman, Phillip. "The Discourse of Comics Scholarship: A Rhetorical Analysis of Research Article Introductions." *International Journal of Comic Art* 12, nos. 2–3 (2010): 432–442.

Tschida, Tyler. "Dark Horse Comics Launches First App, The Terminator Comics." AppAdvice, May 2009. http://appadvice.com/appnn/2009/05/dark-horse-comics-launches-first-app-the-terminator-comics.

*Walker, Brian. *The Comics since 1945*. New York: Abrams, 2002.

———. "Lightning at the Crossroads." In *Masters of American Comics*, edited by John Carlin, Paul Karasik, and Brian Walker, 186–193. New Haven, Conn.: Yale University Press, 2005.

Walker, Mort. *Backstage at the Strips*. New York: Mason/Charter, 1975.

———. *The Lexicon of Comicana*. Port Chester, N.Y.: Museum of Comic Art, 1980.

Walters, Maria. "What's Up with Webcomics? Visual and Technological Advances in Comics." *Interface: Journal of Education, Community, and Values* 9, no. 2 (2009). https://commons.pacificu.edu/inter09/9/.

Ware, Chris. *The Acme Novelty Library*. New York: Pantheon, 2005.

———. *Building Stories*. New York: Pantheon, 2012.

———. *Jimmy Corrigan: The Smartest Kid on Earth*. New York: Pantheon, 2000.

———. *Quimby the Mouse*. Seattle: Fantagraphics, 2003.

———. "Richard McGuire and 'Here': A Grateful Appreciation." *Comic Art* 8 (Summer 2006): 5–7.

Watson, Julia. "Autographic Disclosures and Genealogies of Desire in Alison Bechdel's *Fun Home*." Special issue, *Biography* 31, no. 1 (Winter 2008): 27–58.

Weber, Eugene. *Peasants into Frenchmen: The Modernization of Rural France, 1870–1914*. Palo Alto, Calif.: Stanford University Press, 1976.

Weeks, John. "Economics and Comics: Khmer Popular Culture in Changing Times." *International Journal of Comic Art* 13, no. 1 (2011): 3–31.

Weldon, Glen. "Bil Keane's Dotted Line: An Appreciation." *Pop Culture Happy Hour*, National Public Radio, 11 November 2011. https://www.npr.org/2011/11/11/142218444/bil-keanes-dotted-line-an-appreciation.

Wershler, Darren. "Digital Comics, Circulation, and the Importance of Being Eric Sluis." *Cinema Journal* 50, no. 3 (Spring 2011): 127–134.

Wershler, Darren, and Kalervo A. Sinervo. "Marvel and the Form of Motion Comics." In *Make Ours Marvel: Media Convergence and a Comics Universe*, edited by Matt Yockey, 187–206. Austin: University of Texas Press, 2017.

Wertham, Fredric. *Seduction of the Innocent*. New York: Rinehart, 1954.

"What You See Is What You Get." *Big K*, no. 6 (September 1984): 92–93.

White, Cynthia L. *Women's Magazines 1693–1968*. London: M. Joseph, 1970.

White, Ted. "The History of Comics Fandom, Part Five." *Comics Journal*, no. 234 (June 2001): 107–110.

———. "The History of Comics Fandom, Part Four." *Comics Journal*, no. 233 (May 2001): 107–109.

———. "The History of Comics Fandom, Part Three." *Comics Journal*, no. 232 (April 2001): 97–100.

Whitlock, Gillian. "Autographics: The Seeing 'I' of the Comics." *Modern Fiction Studies* 52, no. 4 (Winter 2006): 965–979.

———. *Soft Weapons: Autobiography in Transit*. Chicago: University of Chicago Press, 2007.

Whitlock, Gillian, and Anna Poletti, eds. "Autographics." Special issue, *Biography* 31, no. 1 (Winter 2008).

———. "Self-Regarding Art." Introduction to "Autographics," special issue, *Biography* 31, no. 1 (Winter 2008): v–xxiii.

Widiss, Benjamin. "Autobiography with Two Heads: *Quimby the Mouse*." In *The Comics of Chris Ware: Drawing Is a Way of Thinking*, edited by David M. Ball and Martha B. Kuhlman, 159–173. Jackson: University Press of Mississippi, 2010.

Williams, Kevin. *Read All about It! A History of the British Newspaper*. New York: Routledge, 2009.

Williams, Paul. "The Strange Case of Byron Preiss Visual Publications." *Journal of American Studies*, 14 May 2019. https://doi.org/10.1017/S0021875818001494.

Willis, Paul. *Common Culture: Symbolic Work at Play in the Everyday Cultures of the Young*. Milton Keynes, U.K.: Open University Press, 1990.

Winchester, Mark D. "Hully Gee, It's a War!!! The Yellow Kid and the Coining of 'Yellow Journalism,'" *Inks* 2, no. 3 (November 1995): 22–37.

Witek, Joseph. "American Comics Criticism and the Problem of Dual Address." *International Journal of Comic Art* 10, no. 1 (2008): 218–225.

———. "The Arrow and the Grid." In *A Comics Studies Reader*, edited by Jeet Heer and Kent Worcester, 149–156. Jackson: University Press of Mississippi, 2009.

———. *Comic Books as History: The Narrative Art of Jack Jackson, Art Spiegelman, and Harvey Pekar*. Jackson: University Press of Mississippi, 1989.

———. "Comics Modes: Caricature and Illustration in the Crumb Family's *Dirty Laundry*." In *Critical Approaches to Comics: Theories and Methods*, edited by Matthew J. Smith and Randy Duncan, 27–42. New York: Routledge, 2012.

Wong, Wendy Siuyi. "Globalizing Manga: From Japan to Hong Kong and Beyond." *Mechademia* 1 (2006): 23–45.

Woo, Benjamin. "An Age-Old Problem: Problematics of Comic Book Historiography." *International Journal of Comic Art* 10, no. 1 (2008): 268–279.

———. "The Android's Dungeon: Comic-Bookstores, Cultural Spaces, and the Social Practices of Audiences." *Journal of Graphic Novels and Comics* 2, no. 2 (2011): 125–136.

———. "Understanding Understandings of Comics: Reading and Collecting as Media-Oriented Practices." *Participations: Journal of Audience & Reception Studies* 9, no. 2 (2012): 180–199.
*Wright, Bradford W. *Comic Book Nation: The Transformation of Youth Culture in America*. Rev. ed. Baltimore: Johns Hopkins University Press, 2003.
———. "From Social Consciousness to Cosmic Awareness: Superhero Comic Books and the Culture of Self-Interrogation, 1968–1974." *English Language Notes* 46, no. 2 (2008): 155–174.
Zehnder, Frank Günter, *Wow! 100 Jahre Comics: Die Originale*. Köln: Rheinland-Verlag, 1996.
Zorbaugh, Harvey. "The Comics—There They Stand!" *Journal of Educational Sociology* 18, no. 4 (1944): 196–203.
———. Editorial. *Journal of Educational Sociology* 18, no. 4 (1944): 250–255.
Zwirek, Jeff. *Burning Building Comics*. Chicago: Imperial Comics, 2012.

Notes on the Contributors

JAN BAETENS is professor of literary theory and cultural studies at the University of Leuven, Belgium, where he works in the fields of French poetry analysis and graphic narrative. He has published widely on both topics, and his recent books include *À voix haute: Poésie et lecture publique* (2016), *The Graphic Novel: An Introduction* (coauthored with Hugo Frey, 2014), and *The Cambridge History of the Graphic Novel* (coedited with Hugo Frey and Stephen Tabachnick, 2018). He is also a published French-language poet; his most recent collection is *Ici, mais plus maintenant* (incorporating photographs by Milan Chlumsky, 2019).

BART BEATY is the author, editor, and translator of more than twenty books in the field of comics studies, including *Twelve-Cent Archie* (2015) and *Comics versus Art* (2012). He is the general editor of the *Critical Survey of Graphic Novels* (2012; revised 2018–2019) and the lead researcher on the What Were Comics? project (whatwerecomics.com).

ISAAC CATES has published essays on the difficulty of Chris Ware, the pseudoautobiographical collaborations of Neil Gaiman and Dave McKean, the diary comics of James Kochalka, and climactic fistfights between Batman and Superman. He has also written several essays on poetry, as well as numerous poems (including one that appeared in *The Best American Poetry 2017*) and comics. He edited and published the award-winning, all-ages fantasy comics anthology *Cartozia Tales*. He teaches in the English Department at the University of Vermont.

MEL GIBSON is associate professor at Northumbria University, United Kingdom, specializing in teaching and research related to comics, graphic novels, picture books, and fiction for children. She has published widely in these

areas, including the monograph *Remembered Reading* (2015), on British women's memories of their girlhood comics-reading. Her most recent work focuses on girlhoods, agency, and contemporary comics. She has also run training and promotional events about comics, manga, and graphic novels for schools and other organizations since 1993, when she contributed to *Graphic Account*, a publication that focused on developing graphic novel collections for sixteen-to-twenty-five-year-olds, which was published by the Youth Libraries Group in the United Kingdom.

IAN GORDON's most recent books are *Superman: The Persistence of an American Icon* (2017), the Eisner-nominated *The Comics of Charles Schulz* (coedited with Jared Gardner, 2017), *Ben Katchor: Conversations* (2018), and *The Superhero Symbol: Media, Culture, and Politics* (coedited with Liam Burke and Angela Ndalianis, 2019). His other works include *Kid Comic Strips: A Genre across Four Countries* (2016) and *Comic Strips and Consumer Culture, 1890–1945* (1998). He teaches cultural history and American studies at the National University of Singapore, where he is the head of the Department of History. He is a member of the editorial boards of the *Australasian Journal of American Studies*, *ImageText*, *Inks*, the *International Journal of Comic Art*, the *Journal of American History*, *Journal of Graphic Novels and Comics*, *Popular Communication*, and *Studies in Comics*.

CHARLES HATFIELD is professor of English at California State University, Northridge, author of *Alternative Comics* (2005) and *Hand of Fire: The Comics Art of Jack Kirby* (2011), coeditor (with Jeet Heer and Kent Worcester) of *The Superhero Reader* (2013), and curator of the exhibition *Comic Book Apocalypse: The Graphic World of Jack Kirby* (2015). His essays have appeared in the *Oxford Handbook of Children's Literature*, *Keywords for Children's Literature*, *The Lion and the Unicorn*, *Children's Literature Association Quarterly*, *ImageText*, *SubStance*, the *Comics Journal*, and other books and periodicals. He has chaired both the International Comic Arts Forum and the MLA Forum on Comics and Graphic Narratives, and served as founding president (2015–2018) of the Comics Studies Society.

MARTHA KUHLMAN is professor of comparative literature and chair of the Department of English and Cultural Studies at Bryant University. With Dave Ball, she coedited *The Comics of Chris Ware: Drawing Is a Way of Thinking* (2010), and she has contributed chapters to a number of books about graphic novels, including *The Cambridge Companion to the Graphic Novel* (2017), *Abstraction and Comics / Bande dessinée et abstraction* (2019), and *Teaching the Graphic Novel* (2009). She served on the MLA Forum on Comics and Graphic Narratives from 2012 to 2017 and on the Comics Studies Society executive board from 2017 to 2019. Most recently, she has coedited, with José Alaniz, the anthology *Comics of the New Europe: Reflections and Intersections* (2020).

FRENCHY LUNNING is professor of liberal arts at Minneapolis College of Art and Design, specializing in art and design history and cultural studies. She has written two books and is working on a third, *Revolutionary Girl: Shōjo*. She has recently begun working in object-oriented ontology and has chapters in two anthologies, *After the "Speculative Turn": Realism, Philosophy and Feminism* (2016), edited by Katerina Kolozova and Eileen A. Joy, and *Object-Oriented Feminism* (2016), edited by Katherine Behar. As the director of the internationally recognized Mechademia Conferences on Asian Popular Cultures, she was previously the editor-in-chief of *Mechademia*, a book series published by the University of Minnesota Press dedicated to Japanese popular culture and theory, and she currently coedits *Mechademia: Second Arc*, a biannual journal covering Asian popular culture.

BRIAN MACAULEY was, in the Pre-Crisis universe, a full-time assistant professor at Newbury College in Brookline, Massachusetts. Current continuity reboots the character and depicts MacAuley as a stay-at-home father to two sons.

MATTHEW P. MCALLISTER is professor of communications, communication arts and sciences, and women's, gender, and sexuality studies at the Pennsylvania State University, as well as Graduate Programs Chair of Penn State's Bellisario College of Communications. His research focuses on the political economy of media and critiques of commercial culture. He is the author of *The Commercialization of American Culture* (1996) and coeditor of *Comics and Ideology* (2001), *Film and Comic Books* (2007), *The Advertising and Consumer Culture Reader* (2009), and *The Routledge Companion to Advertising and Promotional Culture* (2013).

ANDREI MOLOTIU is senior lecturer in the Department of Art History at Indiana University, Bloomington. His books include *Fragonard's Allegories of Love* (2008), the Eisner-nominated *Abstract Comics: The Anthology* (2009), and *Nautilus* (2009), a collection of his own comics. He is currently completing his first graphic novel.

PHILIP NEL is university distinguished professor of English at Kansas State University. He is the author or coeditor of eleven books, including *Was the Cat in the Hat Black? The Hidden Racism of Children's Literature, and the Need for Diverse Books* (2017), three volumes of Crockett Johnson's *Barnaby* (coedited with Eric Reynolds, 2013, 2014, 2016), a double biography of Crockett Johnson and Ruth Krauss (2012), *Keywords for Children's Literature* (coedited with Lissa Paul, 2011), and *Tales for Little Rebels: A Collection of Radical Children's Literature* (coedited with Julia Mickenberg, 2008). Forthcoming in 2020 are the second edition of *Keywords for Children's Literature* (coedited with Lissa Paul and Nina Christensen) and the fourth volume of Johnson's *Barnaby* (coedited with Reynolds).

ROGER SABIN is professor of popular culture at the University of the Arts London. He is the author, coauthor, or editor of eight books, including *Adult Comics* (1993) and *Comics, Comix and Graphic Novels* (1996), and was part of the team that put together the 2016 Marie Duval Archive (marieduval.org), a collaboration of Chester University, Central Saint Martins at University of Arts London, and Guildhall Library. He serves on the boards of eight research journals, and is series editor for the booklist Palgrave Studies in Comics and Graphic Novels. His journalism includes work for the *Guardian*, BBC, and Channel 4, and he has been a curatorial consultant for the British Museum, British Library, and Tate Gallery. The Sabin Award for Comics Scholarship is awarded annually at the International Graphic Novel and Comics Conference.

KALERVO SINERVO holds a degree in Interdisciplinary Humanities from Concordia University, where he wrote his thesis on the transmedial intersections of fandom, video games, and Gotham City. He served for two terms as the Communications Vice President for the Canadian Society for the Study of Comics and has written broadly on comics as a form and culture, including a chapter (cowritten with Darren Wershler) on Marvel's early digital strategies for *Make Ours Marvel: Media Convergence and a Comics Universe* (2017) and an article on comics piracy for *Amodern* (cowritten with Wershler and Shannon Tien, 2013). In 2019, he began a Fonds de recherche du Québec—Société et culture postdoctoral fellowship at the University of Calgary. Find him online @kalervideo and at badpanels.com.

MARC SINGER is professor of English at Howard University in Washington, DC. He is the author of *Breaking the Frames: Populism and Prestige in Comics Studies* (2018) and *Grant Morrison: Combining the Worlds of Contemporary Comics* (2012), and is the coeditor, with Nels Pearson, of *Detective Fiction in a Postcolonial and Transnational World* (2009).

THERESA TENSUAN, dean of Diversity, Access, and Community Engagement and director of the Office of Multicultural Affairs at Haverford College, works to foster connections among diversity, academic excellence, and community engagement. As a teacher and scholar, she focuses on autobiography, visual culture studies, and critical discourses around race and gender. She has published essays in *Biography* and in *Transforming the Academy: Faculty Perspectives on Diversity and Pedagogy* (edited by Sarah Willie-LeBreton, 2016), and she coedited, with Cynthia Dobbs and Daphne Lamothe, a special issue of *Biography* on "Life Stories from the Creole City" (2012).

SHANNON TIEN holds an MA in English from Concordia University and is currently the inbound marketing lead at Hootsuite, where she runs the world's number-one educational blog on social media marketing. She teaches search

engine optimization and best practices in web writing to traditionally trained writers and helps organizations of all sizes build their own lead-generating online publications. Her cultural criticism and essays have appeared in the *Walrus*, the *Globe and Mail*, the *National Post*, the *Believer*, and more.

DARREN WERSHLER holds the Concordia University Research Chair in Media and Contemporary Literature, and is the cofounder of the Media History Research Centre and the director of the Residual Media Depot. He is currently writing *The Lab Book: Situated Practice in Media Studies*, with Jussi Parikka and Lori Emerson.

GILLIAN WHITLOCK is emeritus professor of English in the School of Communication and Arts at the University of Queensland and a fellow of the Australian Academy of the Humanities. She is author of *The Intimate Empire: Reading Women's Autobiography* (2000), *Soft Weapons: Autobiography in Transit* (2006), and *Postcolonial Life Narrative: Testimonial Transactions* (2015), as well as numerous chapters and articles on life writing. Her current research project on "The Testimony of Things" focuses on the literature and arts of the asylum-seeker camps in the Pacific.

BENJAMIN WOO is associate professor of communication and media studies at Carleton University (Ottawa, Canada) and director of the Comic Cons Research Project (comicconsproject.org). His research examines contemporary geek media cultures and the production, circulation, and reception of comic books and graphic novels. He is the author of *Getting a Life: The Social Worlds of Geek Culture* (2018), coauthor (with Bart Beaty) of *The Greatest Comic Book of All Time: Symbolic Capital and the Field of American Comic Books* (2016), and coeditor (with Stuart R. Poyntz and Jamie Rennie) of *Scene Thinking: Cultural Studies from the Scenes Perspective* (2016).

Index

Aardvark-Vanaheim, 263
Abel, Jessica, 49
aca-fan, 115, 118, 120
ACME Novelty Library. See Ware, Chris
Action (British weekly), 243
Action Comics, 28, 175–176, 213–214
Action Girl, 248
Adam, Peggy, 61
Adams, Neal, 103, 153–154
adaptations: digital comics as, 105, 153–154, 258; intermedial, 97–99, 106, 127, 184, 200, 221–222; literary adaptations in comics, 28, 134
Addams, Charles, 141
Adult Comics: An Introduction (Sabin), 5
advertising, 50, 98, 100, 105, 245; comic books as premiums, 27; for webcomics 261
Agents of S.H.I.E.L.D. (television series), 97
ages model of comic book history, 29, 121–122, 215
Air Pirates Funnies, 45
akahon, 68
Akatsuka, Fujio, 74
Alley Awards, 116
All Girl Thrills, 247
All in Color for a Dime, 116
Allison, John, 261
Ally Sloper (character), 15–17, 19–22, 56
Ally Sloper's Half Holiday, 15
Alphona, Adrian, 222
Alter, 58

Alter Ego, 34, 116, 217
alternative comics, 45–52, 100, 120, 188; anthologies in, 46–47; authenticity debates in, 49–50; autobiography in, 48; creator rights in, 103; diversity in, 46; in Europe, 50–51, 59, 91; minicomix (small-press or newave comix) as, 48–49; underground comix, roots in, 45
Amalgamated Press, 242
Amanat, Sana, 222
amateur press associations, 34, 120
American Born Chinese, 89
American Comics Group, 29
American Library Association, 133
American Splendor, 48, 50
Amok, 59
Anarchy Comics, 44
Anderson, Benedict, 123
Andersson, Oskar, 56
Andrae, Thomas, 222
Andrews McMeel, 99; GoComics, 105
Anglo-American Publishing, 29
Animal Scrolls, 6
anime, 4, 72–73, 249; conventions, 78
APE (Alternative Press Expo), 49
Apex Novelties, 26, 39
A. Piker Clerk, 21
Apple computers, 254, 256–257
Arcade, 43
Archie (series), 28, 34, 134, 159, 163
Archie Comics (company), 29, 35, 218, 262

311

Arctic Marauder, The (*Le démon des glaces*), 178
Asō, Yutaka, 72
Association des critiques et journalistes de bande dessinée (ACBD), 54
Asso di Picche, 57
Asterios Polyp, 188, 198–199
Astérix, 55, 58, 188
Astro Boy, 74
Astro City, 220
(À suivre), 58
Athanas, Charlie, 256
Atrabile, 59, 61
Auster, Paul, 184
Authority, The, 221
autobiography, 7, 42, 46–48, 51, 56, 247–248; autographics, 227–238; in graphic novel form, 86–87, 89–90
Avant Verlag, 59
Avengers (film series), 98, 102

B., David (Pierre-François Beauchard), 51, 53; *Epileptic*, 91, 185, 232, 234, 237
Babymouse, 130
Baetens, Jan, 6–7, 187
Bagge, Peter, 46–47, 49–50
Bails, Jerry, 116, 217
Bakshi, Ralph, 45
Baladi, Alex, 61
Balak (Yves Bigerel), 63
bande dessinée, 3–4, 44, 51, 53–54, 99; autobiography in, 91, 237
Bantam Books, 83
Bar2 (Christian Debarre), 55
Barbarella, 58
Barbe-Rouge, 58
Barker, Ed, 44
Barker, Martin, 15, 245
Barks, Carl, 130, 134, 153
Barnhurst, Kevin G., 255
Barry, Lynda, 6, 197, 236; *Ernie Pook's Comeek*, 138–140; *One Hundred Demons*, 87, 227
Barthes, Roland, 194, 196
Baru (Hervé Barulea), 63
Batgirl, 219
Batman (film), 101
Batman (television series), 35, 218, 221
Batman: Digital Justice, 257
Batman: The Animated Series, 101
Batman: The Brave and the Bold (television series), 101

Batman: The Dark Knight Returns, 86, 132; publication history, 37, 84, 89; revisionism in, 219, 223; stylistics, 184; themes, 146, 167
Batman: The Order of Beasts, 90
Batman: Year One, 184
Battaglia, Dino, 57
Bazooka collective, 50
BC's Quest for Tires, 254
Beano, 44, 47, 57, 61
Beaton, Kate, 261
Beat publications, 41
Beaty, Bart, 5, 100, 254–255; *Unpopular Culture*, 50–51
Bécassine, 56
Bechdel, Alison, 236–237; *Dykes to Watch Out For*, 144; stylistics, 185–186, 207. See also *Fun Home*
Before Watchmen, 223
Bella at the Bar, 243
Bell Features, 29
Benes, Ed, 108
Bennett, Carol, 248
Berberian, Charles, 51
Berger, John, 142
Berkeley Barb, 42
Berlin: City of Stones, 85–86, 89
Berndt, Jaqueline, 67, 70
Beronä, David, 193
Better Little Books, 127
Betty and Veronica, 153
Beyer, Mark, 46
Beyond Time and Again, 83
Big Ass, 42
Biggu komikku (Big comic), 75
Big K, 256
Big Little Books, 127
Big Numbers, 85
Bigot, Georges, 71
Bijou Funnies, 43
Bilbolbul, 56
Bill 10 (Canada), 129
Binky Brown Meets the Holy Virgin Mary, 84, 235–237
Birmingham Arts Lab, 247
Bishop Toba, 67–68, 71
Bjordahl, Hans, 260
Blab!, 47
Black Kiss, 48
Blake and Mortimer, 55, 58
Blankets, 86–87, 89

Blondie (comic), 144
Blondie (film series), 101
Bloodstar, 83
Bloom County, 131
Blue, 3
Blueberry, 58
Bodyworld, 89
Bogeyman, 43
Bolland, Brian, 44
Bone, 92, 133
Bonelli, Gian Luigi, 61
Boom! Studios, 104
Boondocks, The, 130
Bordwell, David, 221
Boule et Bill, 58
Bourdieu, Pierre, 51, 119
Boyfriend, 245
Brainstorm, 44
Brave and the Bold, The, 117
Bravo, 57
Breakdowns, 92, 182–183
Breathed, Berkeley, 131
Bretécher, Claire, 58
Brienza, Casey, 248
Briggs, Amy, 257
Briggs, Clare, 21
Bringing Up Father, 26, 72
Britton, David, 48
Broken Pencil, 49
Brosch, Robert, 116
Brown, Chester, 47, 49, 87–88
Brown, Jeffrey A., 115
Brunetti, Ivan, 183; *Cartooning: Philosophy and Practice*, 160
Buenaventura Press, 51
Building Stories, 51, 182, 187–189
Bukatman, Scott, 2
Bunty, 242
Burns, Charles, 46, 50, 85, 188; *Black Hole*, 48, 51, 187; "Tunnel Vision," 183–184
Burton, Tim, 101, 221
Burton, Virginia Lee, 128
Busch, Wilhelm, 56, 127
Bushmiller, Ernie, 130–131, 153–154, 167
Busiek, Kurt, 167, 220
Buster Brown: Buster Brown children's books, 127; strip, 19–22, 127–128. *See also* Outcault, Richard F.
Buster Brown Shoes, 19–20

Bypass, 49
Byrne, John, 218–219

Cages, 196, 201–202
Calvin and Hobbes, 22, 131, 174
Campbell, Eddie, 46, 48–49, 51, 85–86, 91, 197, 200; *Alec*, 87; "Graphic Novel Manifesto," 90; and graphic novel movement, 85; on *Understanding Comics* (McCloud), 22
Caniff, Milton, 21, 142–143
CAPA-alpha, 116
Captain America Comics, 215
Captain Marvel Jr., 133
Caption festival, 49
caricature, 67–68, 70–71, 142–143, 145, 168n1, 215
Carlson, George, 130
Carnival Comics, 259
cartooning, 6, 42, 56, 153–168; as autographic and embodied, 232–233; cartoonism, 159–161, 169n8, 169n9; semiotic perspectives on, 163, 166, 170n12
Cartoonmuseum Basel, 62
Cash, Megan Montague, 128
Casterman, 59
Catalan Communications, 63
Cates, Isaac, 5
Cathy, 144
Centre Belge de la bande dessinée, 62
Centro Fumetto Andrea Pazienza, 62
Cerceau vicieux, 180
Cerebus, 47, 104; digital editions, 263
Chabon, Michael, 223
Chaney, Michael, 228
Charlie Hebdo, 60
Charlier, Jean-Michel, 58
Charlton Comics, 29, 218
Chaykin, Howard, 48
Chiang, Mark, 140
Chicago Comicon, 256
Chicago Tribune, 19; syndicate, 21
childhood: and adulthood, 132; comics as aspect of, 126–127; comics as threat to, 60, 128–129; cuteness as marker or boundary in, 132–133; formative reading of comics during, 135
child pornography laws, 60
Children's and Young Person's (Harmful Publications) Act (Britain), 129

children's comic magazines, 56, 58, 61
children's literature: adapting comics, 127; comics creators within, 127–128; qualities of, 130–131; recent embrace of comics, 133
Chlorophylle, 58
Cho, Erica, 140
Christophe (Georges Colomb), 56
Chubb, Percival, 128
Chute, Hillary, 229, 231, 234, 236
Cité internationale de la bande dessinée et de l'image (in Angoulême, France), 53, 62
City of Glass, 184
Claremont, Chris, 218–219
Clark, Beverly Lyon, 134
Classics Illustrated, 134
Clerc, Serge, 46
Clowes, Daniel: *The Death-Ray*, 88–89, 91; *Eightball*, 47, 88–89; *Ghost World*, 50, 85; *Ice Haven*, 86, 88–89
Cockrum, Dave, 218–219
Coe, Sue, 46
Coeurs vaillants, 57
collectors, 25–27, 31, 45, 215, 220; and nostalgic memory, 30; shadow economy of, 34–36, 116–117
college magazines, 41
COM, 75
Combe, William, 16
Come Out Comix, 43, 247
Comic Art (fanzine), 34, 116
comic books, 25–38; and nostalgia, 29–30; rise of, 31–32; U.S. comic book format, definition, 27–28. *See also* collectors; Comics Code Authority; direct market; fandom, comic book
Comic Books as History, 227
Comic Buyer's Guide, 116
Comic Cuts, 14, 18
Comichron, 107
Comico, 29
Comicollector, 116
Comic Reader, 116
Comics and Narration, 173, 185
Comics Code, 34, 41, 43, 133, 216, 218, 244; establishment of, 33; revision of, 132; standards of, 131
Comics Code Authority, 33, 128–129, 216
Comics Creators Guild, 103
comics festivals, 53, 62
Comics Forum, 49

comic shops, 31, 35–37, 100, 105–107, 114–117; as clubhouse and cultural site, 120; imported manga in, 249; and superheroes, 220. *See also* direct market
Comics Journal, 49
Comics Kingdom, 105
Comics Magazine Association of America, 33
comics prizes, 49, 53, 61
comics studies: canon formation in, 230; definitional debates in, 13, 82, 91, 173–175; disciplinary differences within, 122; fan scholarship in, 118; growth within academia, 1–2; influence of fandom upon, 120–122
Comics Studies Society, 2
comic strips, 13–23, 109, 114; daily comic strips, 20–21, 154; ideology in, 143–145; in Japan, 71–72; licensing, 101; and newspaper industry, 99–100; ownership of, 17, 20, 102; Sunday comic strips, 18, 20–22, 129
Comic Strips and Consumer Culture, 1890–1945 (Gordon), 4
Comics versus Art, 254
Comix, Essays, Graphics and Scraps, 145
Comix Book (Marvel), 45
ComiXology, 107, 109, 260; Guided View technology, 106, 259
"Complacency Kills," 140
Conan the Barbarian, 47
"Confessions of R. Crumb, The," 42
Contract with God and Other Tenement Stories, A, 82–84, 87, 89
conventions, 49, 83, 116, 120
Conway, Gerry, 260
Coogan, Peter, 214
copyright, 17, 20, 45, 221
Corben, Richard, 43, 83
Corentin, 58
Cornélius, 59
Corto Maltese, 58
cosplay, 34, 116
counterculture, 40–43, 45, 49, 217
Couser, G. T., 234–235
Cox, Palmer, 128
cOZmic Comics, 44
Crepax, Guido, 58, 61
crime comics, 28, 32, 128–129, 131, 215–216
Crime Does Not Pay, 28
Crisis on Infinite Earths, 220

crowdfunding, 263
Crumb, Robert "R.," 48, 140; in anthologies, 46, 50; influence of, 44, 47; stylistics, 186–187; *Zap Comix*, 26, 42–43, 45, 130
Cruse, Howard, 44, 86–87
Crypt of Terror, 28
Cupples & Leon, 26
Cuvelier, Paul, 58
Cvetkovich, Ann, 235
Cybercomics, 258
Cyclops, 44

Dandy, 57, 61, 107
Daredevil, 219
Daredevil: Yellow, 259
Dargaud, 59
Dark Horse, 29, 46, 100–101, 104, 221; and digital comics, 259
Dark Knight, The (film), 221
Dark Knight III: The Master Race, 223
Dark Knight Strikes Again, The, 223
David Boring, 85–86
Davis, Jim, 134
DC Comics, 108–109, 176, 215–217; corporate ownership, 29, 98, 101; creators, disputes with, 103, 223; digital formats, 106, 262; direct market, influence in, 36–37, 100; early history (as National Allied), 28–29; films and television, 97–98, 106; and graphic novels, 85; "New 52," 115, 262; and superhero revival, 34–35; Vertigo imprint, 104
DC Thomson, 107, 242–243, 245
DeCarlo, Dan, 153, 157–158
Delisle, Guy, 186
Dell Comics, 29, 121, 132; licensed comics, 101
Dennis the Menace (comic), 135, 173
Dennis the Menace (television series), 101
Denoël Graphic, 59
Denslow, W. W., 128
Deodato, Mike, 108
Der Stürmer, 134
Despair, 42
Detective Comics Inc. *See* DC Comics
Detroit Triple Fan Fair, 116
Deviant Slice, 43
Diabolik, 61
Diamond Comic Distributors, 107
Dick Tracy, 22, 127, 129
Digital Comic Books (DVDs), 258–259

digital comics, 7, 104–107, 249, 253–264; cloud-based distribution, 259–260
digital print production, 256–257
digital rights management (DRM) technology, 106
Dilbert, 105
dime novels, 28, 31
Dimock, Wai Chee, 230, 237
direct market, 31, 33, 49–50; alternative comics within, 45–46; comic book industry shift toward, 36, 117–118, 218; digital comics' impact on, 106–107; independent publishers in, 36, 104; origins of, 35–37; superhero comics in, 37, 100, 220. *See also* comic shops
Dirks, Rudolph, 18, 131
Dirty Plotte, 48
Disney, 74, 223; appropriation by underground and alternative artists, 42, 45, 145; and Benito Mussolini, 200; and Dell Comics, 101, 121; influence on Osamu Tezuka and manga, 73, 132; Walt Disney Company, 29, 101–102, 109; *Walt Disney's Comics and Stories* (comic book), 28, 133
Ditko, Steve, 103
Doctor Fun, 260
Dodd, Ed, 144
dōjinshi, 249
Doonesbury, 22, 129
Doré, Gustave, 56
Dorf, Shel, 116
dot.comics, 258
Doucet, Julie, 48–49, 197, 237
Dozier, William, 221
Drake, Stan, 153–154
Drawn & Quarterly (anthology), 47
Drawn & Quarterly (company), 46, 88–89, 261
Dreamer, The, 87
Drozophile, 59, 61
Dr. Seuss, 57
Druillet, Philippe, 58
Dupuis, 59
Dupuy, Philippe, 51
Dürer, Albrecht, 173
Duval, Marie, 56
Dyer, Sarah, 248
Dyke Shorts, 43, 247
Dynamite Damsels, 44, 247
Dystel, Oscar, 83

Eagle, 44, 61, 242
Eastern Color, 27
Eastman, Kevin, 104, 220
East Village Other, The, 42, 44, 246
EC Comics, 29, 32, 34, 43
EC Fan-Addict Club, 117
Eclipse, 29, 46, 104, 220
Eco, Umberto, 222–223
ecopolitics, 44
Edition Moderne, 59, 62
Editorial Bruguera, 61
Editorial Valenciana, 61
Edo manga, 70
education, comics in, 133–134
EduComics, 44
Ego Comme X, 51, 59
ehon, 68
Eisner, Will, 85–86, 88, 90, 92, 201; *A Contract with God and Other Tenement Stories*, 82–84, 87, 89; critical terms, 174, 177, 185
Elder, Will, 133
Elfquest, 48
Ellis, Warren, 108, 146, 221
El Refaie, Elisabeth, 233
El víbora, 50, 58
emakimono, 67–68
emanata, 166–167, 170n15, 171n16
Emerson, Hunt, 44, 46
Entertainment Weekly, 97–98
Epic Comics, 104
Escape, 46
Escape Publishing, 46
Essai de physiognomonie, 161
États généraux de la bande dessinée, 53
Excellence in Graphic Literature Awards, 134
Exercises in Style, 180

Fabulous Furry Freak Brothers, The, 43
Factsheet Five, 49
Falconer, Ian, 128
Faller, Régis, 128
Family Circus, The, 144
Famous Funnies, 27–28, 31
fandom, comic book, 5–6, 26, 29, 33, 99, 113–123; as entryway to comics profession, 118, 217; fan clubs, 77, 117; growth of, 34–35, 116; influence on comics scholarship, 121–122; roots in science fiction fandom, 116–117, 217; as social world, 119–120. See also fanzine

Fanny, 248
Fantagor, 43
Fantagraphics, 29, 46, 63, 104, 188; Eros Comix imprint, 48
Fantastic Four, 217
fanzine, 34, 83, 116, 120, 217
Farley, David, 260
Fat Freddy's Cat, 43
Fawcett, 29, 215
Feiffer, Jules, 128
Feininger, Lyonel, 180–182
feminist comics, 7, 48; autographics as, 232, 236; roots in underground era, 43–44, 241, 246–248
Festival international de la bande dessinee (FIBD) d'Angouleme, 53
Fiction House, 29
film comedy, influence on comics, 131
Fincher, Ruth, 146
Finder, 145–146
Finder: Voice, 6, 145–148
First Comics, 29, 104, 220, 256
First Kingdom, 83
Fisher, Bud, 21
Fiske, John, 118
Flash Gordon, 142
Fleischer Studios (Max and Dave Fleischer), 73
Flenniken, Shary, 43
Folkard, Charles, 21, 56
Forest, Jean-Claude, 58
formalist analysis of comics, 6–7, 172, 176–177; graphic design perspectives on, 172–192; image/text perspectives on, 193–209; versus social perspectives on the comics world, 254–255; webcomics, applied to, 262, 264
Forton, Louis, 56
Four Marys, The, 242
Fox and the Crow, The, 134
Fox Comics, 29
Foxy Grandpa, 127
Francq, Philippe, 55
Franquin, André, 58
Fred (Frédéric Othon Théodore Aristidès), 58
Fréon, 59
Fresnault-Deruelle, Pierre, 177, 195
Fritz the Cat, 45
From Hell, 48, 197; as a graphic novel, 51, 85–86, 89

Frost, A. B., 127
Frow, John, 235
Fruits Basket, 248
Fujio, Fujiko, 74
Fuller, Larry, 43–44
Fumetto festival, 62
Fun Home, 141, 207; as autobiography, 7, 89, 230–235; as graphic novel, 51, 82, 86–87, 89, 91; layout in, 185–186. *See also* Bechdel, Alison
Funnies on Parade, 27
Funny Aminals, 134, 233
Futuropolis, 59

Gabilliet, Jean-Paul, 32, 51, 117
Gaiman, Neil, 128, 219
Gaines, Maxwell, 27
Gallimard, 59
Gamma Force in Pit of a Thousand Screams, 257
Ganges, 91–92
Gardner, Jared, 141, 145; on autobiographical comics, 234–236; on drawing, 197–198
Garfield, 85
Garo, 75
Gasoline Alley, 22, 84, 127, 183
Gaston, 58
Gay Comics, 44
Gay Heartthrobs, 44
gay liberation, 41, 43–44
Gebbie, Melinda, 43
gekiga, 74–75
Gemma Bovery, 85
Genette, Gérard, 193
Getting a Life: The Social Worlds of Geek Culture (Woo), 5
Ghura, Antonio, 44
Giardino, Vittorio, 58, 61
Gibbons, Dave, 44; *Watchmen*, 37, 82, 84, 132, 187, 219
Gibson, Charles Dana, 154–155, 157
Gibson, Mel, 7
Gilberton Comics, 29
Gil Jourdan, 58
Gillis, Peter B., 256
Giraud, Jean. *See* Moebius
Girl, 242
GirlFrenzy, 248
Girl Genius, 22
Girlhero, 248

girls' comics, 7, 241–251
Glasgow Looking Glass, The, 16
Gloeckner, Phoebe, 46, 236
Goats, 261
God Nose, 42
Gods' Man, 84
Goethe, Johann Wolfgang von, 185
Golden Age of Comics, 25, 29, 31, 33; as superhero fan term, 121, 215–216. *See also* ages model of comic book history
Golden Press, 63
Golden State Comic-Minicon, 116
Gold Key Comics, 29
Goodman, Martin, 217
Google Doodles, 253–255
Gopnik, Adam, 143–144
Goscinny, René, 55, 58
Gotlib, Marcel, 58
Götting, Jean-Claude, 46
Gould, Chester, 127
Graffiti Kitchen, 90–91
Gramatky, Hardie, 128
grammatextuality, 201–203, 205–207
Grant, Pat, 3
graphiator, 197–198
graphic memoir. *See* autobiography
graphic novel, 2, 5, 51, 59, 82–92, 126, 220; in academia, 121; in bookstores, 100, 219; versus comic book, 29, 90; in direct market, 31, 37; versus graphic memoir, 228; in libraries, 133–134
Graphic Story Monthly, 47
Graphix. *See* Scholastic
Gravett, Paul, 70, 73, 248–250
Gravitation, 250
Gray, Harold, 133
Great Depression, 28, 42
Green, Justin, 48, 84, 90, 233, 235–237
Green Lantern / Green Arrow, 153
Gregory, Roberta, 44, 247
Griffin, Rick, 43
Griffith, Bill, 43, 46
Groensteen, Thierry, 30, 173, 183, 185–187, 197; on the origins of comics, 126–127
Gross, Milt, 84
Groth, Gary, 49
Groupe Madrigall, 59
Guardian First Book Award, 85
Guisewite, Cathy, 144
Gulf Comic Weekly, 27

Gumps, The, 21–22
gutter, 141, 147, 173–174, 183

Hagio, Moto, 76, 250
Happy Hooligan, 18
Hara-Kiri, 58, 60
Hark! A Vagrant, 261
Harlot's Progress, A, 193
Harvey, Robert C., 173
Harvey Comics, 29, 35
Harvey Kurtzman's Jungle Book, 84
Hasegawa, Machiko, 72
Hate, 47, 49
Hatfield, Charles, 118, 174, 177, 197, 236; *Alternative Comics*, 46, 227–228, 230; on superheroes, 223
Hayes, Rory, 43
Hays Office, 32–33
Hearst, William Randolph, 17–19, 21
Heart of Juliet Jones, The, 153
Heavy Metal, 63
He Done Her Wrong, 84
Hellboy, 221
Help!, 41
Henkes, Kevin, 128
hentai, 70
Hergé (Georges Rémi), 55, 57–58, 178, 180, 188; as children's author, 130; *ligne claire* aesthetic, 197; translations of, 63. See also *Tintin*
Hernandez, Gilbert, 47, 85
Hernandez, Jaime, 47, 85
Hernandez, Mario, 47
Heröine, 44, 247
Herriman, George, 21, 90, 182; as page designer, 178, 180. See also *Krazy Kat*
Hi and Lois, 144
Hicksville, 85–86
Hideko, Mizuno, 74
High and Low, 143
hikime kagihana (line-eye, hook-nose) style, 67–68
Hilda, 133
Hillman Periodicals, 29
Himawari, 75
Hitch, Bryan, 221
Hoff, Syd, 127
Hogan's Alley, 16–17, 145, 173
Hogarth, William, 56, 193
Hokusai, Katsushika, 70

Holkins, Jerry, 261
Holm, Jennifer, 130
Holm, Matthew, 130
homophobia, 107, 216
Honk, 47
Horrocks, Dylan, 85–86, 90–91
Howard, Robert E., 83
"How to Spot a Jap," 142–143
Hubinon, Victor, 58
Hughes, Rian, 46
Huizenga, Kevin, 91
hyakumenso, 70

Icon (imprint), 104
IDW Publishing, 22, 29, 101, 105, 263
Ignatz Awards, 49
Ikeda, Riyoko, 76–77, 250
Il corriere dei Piccoli, 56–57
Image Comics, 29, 100, 104, 220–221, 261
independent publishing, 59, 78, 104, 249
I Never Liked You, 87
Infinite Crisis, 220
Infocomics, 257
Insect Fear, 43
International Journal of Comic Art, 107
Iron Man (film), 97, 221
Irons, Greg, 43
Ishinomori, Shōtarō, 74
IT (International Times), 44
It Aint Me Babe, 43, 246–247
Itō, Gō, 74–75
Ito, Kinko, 71, 74
It's a Good Life, If You Don't Weaken, 86
Ivy, Marilyn, 66

Jackie, 245, 247
Jackman, Hugh, 97
Jackson, Jack, 43
Jacobs, Edgar P., 55, 58
Jacobs, Jane, 146
Jansson, Tove, 127
Japan Punch, The, 71
Jason (John Arne Sæterøy), 178
Jenkins, Henry, 118, 120
Jerry Spring, 58
Jewett, Robert, 222–223
Jijé (Joseph Gillain), 58
Jiji Shimpo, 71
Jimmy Corrigan: The Smartest Kid on Earth, 51, 141; braiding in, 187; grammatextuality

in, 207; as graphic novel, 82, 85. *See also* Ware, Chris
Jinty, 243
jManga, 106
Jodelle, 58
Joe Bar Team, 55
Johnny Boo, 133
Johnson, Charles, 141
Johnson, Crockett: *Barnaby*, 6, 127; *Harold the Purple Crayon*, 127, 131
Johnson, Derek, 102
josei (women's) manga, 76
Josie, 157–158
J. Rufus Lion, 131
Judy, 15, 56
Jungle Taitei, 73
Junior soreiyu, 75
Justice League of America, 217

Kabashima, Katsuichi, 71–72
kamishibai, 72
Karasik, Paul, 184
Katz, Jack, 83, 86
Katzenjammer Kids, The, 18, 131
kawaii (cuteness) aesthetic, 132
Kaze to ki no uta, 250
Keane, Bil, 144
Keane, Jeff, 144
Kelly, Walt, 129–130
Kelso, Megan, 50, 248
Kern, Adam L., 69
Ketcham, Hank, 173
kibyōshi, 69
Kick-Ass, 104
Kihara, Toshie, 76
Kim, Derek Kirk, 145
Kimba the White Lion, 73
Kimura, Minori, 76
King, Frank, 127, 183
King Comics, 27
Kingdom Come, 153, 161
King Features Syndicate, 57, 99, 105, 129
Kinsella, Sharon, 70
Kirby, Jack, 215, 217, 244; role in creating Marvel, 103; visual style, 180, 214
Kishimoto, Masashi, 55
Kitazawa, Rakuten, 71
Kitchen, Denis, 45
Kitchen Sink Press, 29, 43, 46
Knockabout, 46, 248

Kochalka, James, 133
Kodansha, 74
Kodomo manga kurabu, 74
Kodomo manga shimbun, 74
Kominsky-Crumb, Aline, 43, 46, 48, 236, 247
Krahulik, Mike, 261
Kramer's Ergot, 47, 189
Krazy Kat, 21, 44, 84, 90; grammatextuality in, 205–206; style of, 178–179
Krupp Comic Works, 43
Kuhlman, Martha, 6
Kumanbati, 74
Kunka, Andrew J., 83
Künstlerroman, 230
Kunzle, David, 125, 173
Kurtz, Scott, 261
Kurtzman, Harvey, 41, 133
Kyle, Richard, 83, 86

La famille Fenouillard, 56
Laird, Peter, 104, 220
Lane Mastodon vs. the Blubbermen, 257
Langosy, Elizabeth, 257
Laocoön, 194
Lapick, Rudy, 157–158
L'Arabe du futur, 56
Largo Winch, 55
Larson, Hope, 134
La semaine de Suzette, 56
L'Association, 51, 59, 91, 188, 237
Last Gasp, 29, 43, 46, 247
Last Man, 63
Laugh It Off, 127
L'Autoroute du soleil, 63
Lawrence, John Shelton, 222–223
Lawson, JonArno, 128
layout, 174; conventional, rhetorical, decorative, and productive (per Peeters), 178–180; in early American comic books, 31; linear versus tabular readings (sequence versus surface), 175–177, 180–182, 195; in manga, 70, 76, 250; multilayer, 183–184; nonlinear and multilinear, 182; repetition in, 185–187; split panels, 183
League for the Improvement of the Children's Comics Supplement, 128
Leather Goddesses of Phobos, 257
L'Écho des savanes, 58
Le concombre masqué, 58

Lécroart, Étienne, 180
Lee, Jim, 104, 220
Lee, Stan, 103, 117, 217
Lefèvre, Pascal, 187
Legman, Gershon, 216
Lejeune, Phillipe, 228
Le journal de Mickey, 57
L'Engle, Madeleine, 134
Lent, John A., 129
L'Épatant, 56
Les pieds nickelés, 56
Les Requins Marteaux, 59
Lessing, Gotthold Ephraim, 194
Le téméraire, 57
letter columns, 116
Levas, Jonni, 35
Lev Gleason, 29
lianhuanhua, 3
Library of American Comics, 22
licensing, 100–103, 109
Liefeld, Rob, 104, 220
Linus, 58
Lion Forge, 105
Little Annie Fanny, 133
Little Lulu, 130
Little Nemo in Slumberland, 20; and Art Nouveau, 130; book versions, 127; grammatextuality in, 202–204; layouts, 178–179; *Little Nemo in Google-Land* (homage), 253–255; visual style, 155–156. *See also* McCay, Winsor
Little Nothings, 91
Little Orphan Annie, 22, 133
Loeb, Jeff, 259
Loi du 16 juillet 1949 sur les publications destinées à la jeunesse (France), 129
Lola e Lalla, 56
Lombard, 59
Lone Wolf and Cub, 91
Lorde, Audre, 142
Lord Horror, 48
Lord Northcliffe (Alfred Harmsworth), 14
Love and Rockets, 47
Lovely Complex, 133
Lucky Luke, 55
Luks, George, 17
Lulu, 134
Lupoff, Dick, 116
Lupoff, Pat, 116
Lutes, Jason, 85–86

Luther Arkwright, 48
Lynch, Jay, 43

Macherot, Raymond, 58
Madden, Matt, 90, 180
MAD magazine, 41–42, 84
Mâgaretto, 75
Mahōtsukai Sarī, 249
Manara, Milo, 58
Mandryka, Nikita, 58
manga, 2–5, 60, 66–79, 129–130, 132, 248–251; digital, 106; in Europe, 54, 63; stylistics, 76, 184, 250; in the United States, 108–109, 114–115
Manga akashon, 75
Manga kurabu, 74
Manga panchi, 75
Manga shōnen, 74
Mangold, James, 97
manhwa, 3
Mano, 59
Man of Steel, 97
Marilyn, 245
Marion, Philippe, 197
Mariscal, Javier, 46, 50
Mark Trail, 144
Marrs, Lee, 43, 246–248
Marshall, John, 144
Marston, William Moulton, 215
Marty, 245
Marvel, 45, 108–109, 256; bankruptcy, 220; corporate ownership, 29, 101; creators, disputes with, 103; digital formats, 105, 258; direct market, influence in, 36–37, 100; Epic (imprint), 104; fandom, outreach to, 117; films and television, 97–98; Icon (imprint), 104; Marvel Studios, 101–102; Marvel Unlimited, 106
Marvels, 161, 167, 220
Masereel, Frans, 84, 193
Matt, Joe, 48
Matthews, Mike, 44
Mattotti, Lorenzo, 61
Maus, 7, 51, 140, 187, 227; as autobiography, 231–237; as graphic novel, 82, 84–87, 89, 91–92, 134–135; and *MetaMaus*, 229, 231, 234; publication history, 46, 219; and stereotypes, 145; visual style, 198, 205. *See also* Spiegelman, Art
Mavrides, Paul, 43

Max und Moritz, 56
Mayer, Sheldon, 130–131, 134
Mazzucchelli, David, 184, 188, 198–199
McCay, Winsor, 20, 128, 180, 253; drawing style, 156–157; *The Dream of the Rarebit Fiend*, 155. See also *Little Nemo in Slumberland*
McCloud, Scott: cartoonism, 159–161, 168; definition of comics, 173–174; and the gutter, 147, 233; and infinite canvas, 253, 262, 264; and panel transitions, 177, 180; *Understanding Comics*, 89, 91, 228
McClure Newspaper Syndicate, 19
McDonnell, Patrick, 128
McFarlane, Todd, 104, 220
McGrath, Charles, 88
McGruder, Aaron, 130
McHarry, Mark, 250
McKean, Dave, 196, 202, 219
McKie, Angus, 44
McLaughlin, Thomas, 91
McLuhan, Marshall, 122
McManus, George, 26, 72
McNeil, Carla Speed, 6, 145–148
McRobbie, Angela, 245–246
Mechademia, 5
Média participations, 59
Mendes, Willy, 43, 246–247
merchandising, 55, 97, 100–103, 116, 133, 221; of early comic strips, 15, 17, 19–22; of manga, 75; of webcomics, 261
Meretzky, Steve, 257
Merry Marvel Marching Society, 117
Métal hurlant, 44, 58
Metzger, George, 83
Meulen, Ever, 46
Michel Tanguy, 58
Mickey Mouse, 45, 127, 145
Milestone Comics, 222
Millar, Mark, 104, 108
Miller, Frank, 219, 223. See also *Batman: The Dark Knight Returns*
Millikin, Eric Monster, 260
Mills, Pat, 243
minicomix. *See* alternative comics
Mirabelle, 245
mise-en-page, 174, 177–178, 180
Misty, 243
Mitchell, W. J. T., 142–143, 193
Mizuki, Shigeru, 72

Moebius (Jean Giraud), 44, 58, 63, 146
Mome, 47
MonkeyBrain, 105
Moomins, 127
Moon Mullins, 22
Moore, Alan, 92, 108, 220, 223; *Lost Girls*, 85; *Miracleman* (a.k.a. *Marvelman*), 219; *V for Vendetta*, 219. See also *From Hell*; *Watchmen*
Moreno, Pepe, 257
Morgan, Harry, 173
Moronobu (Moronobu Hishikawa), 70
Morris (Maurice De Bevere), 55
Morris, Marcus, 242
Morris, William, 231
Morrison, Grant, 108, 219
Moscoso, Victor, 43
Motor City Comics, 42
Mouly, Françoise, 46, 131, 133
Ms. Marvel (2014), 222
Munroe, Randall, 262, 264
Mussino, Attilio, 56
Mutt and Jeff, 21
My Date, 244

Nagaike, Kazume, 250
Nakahara, Aya, 133
Nakahara, Jun'ichi, 75
Nakamura, Miri, 74
Nakayoshi, 75
Nancy, 130–131, 153–154, 167
Napa, 51
National Allied. *See* DC Comics
Natsume, Fusanosuke, 67
NBM, 63
Neat Stuff, 47
Neaud, Fabrice, 51, 53
Nerone, John, 255
New Cartoonist Association of Japan (*Shin Nippon Mangaka Kyōkai*), 72
New Comics, 28
New Fun, 28
Newgarden, Mark, 128
Newman, Michael, 13
Newsarama, 115
newspapers, 14–16, 18–20, 56, 99, 105, 114, 144; and the building of community, 123, 202; decline of, 22–23, 100, 109; radical newspapers, 42, 44
New World Pictures, 101

NextPlanetOver.com, 258
Ngai, Sianne, 132
99 Ways to Tell a Story: Exercises in Style, 180
Nishitani, Yoshiko, 75, 249
Nodelman, Perry, 130
Nolan, Christopher, 221
Nonki na tōsan, 72
No-Prizes, 117
North, Sterling, 215–216
Nosotros somos los muertos, 51
Nostalgia Journal, 49
Nothing Ever Goes Right, 243

Oda, Shōsei, 71–72
Of Comics and Men, 51
Ong, Walter, 216
Oni Press, 104–105
onna-e (female pictures) versus otoko-e (male pictures), 67
On the Drawing Board, 116
Opper, Frederick Burr, 17–18. See also word balloon
Ōshima, Yumiko, 76
Ott, Thomas, 62
Oubapo, 180
Oulipo, 180
Outcault, Richard F.: *Buster Brown*, 19–22, 127; *Hogan's Alley*, 16–17, 145, 173. See also Yellow Kid, The
Overstreet, Robert, 25
Overstreet Comic Book Price Guide, 25–27, 29, 38
Owly, 133
Oz, 44–45

Pacific Comics, 29, 104, 220
Pagliassotti, Dru, 250
panel. See layout
Panter, Gary, 46
Pantheon Books, 51, 88
Passionate Journey, A, 84
Pax, Salam, 237
Pazienza, Andrea, 61
Peanuts, 22; book publication, 178; as a children's comic, 130–131, 144; visual style, 164–166, 197
Pearson, Luke, 133
Peellaert, Guy, 58
Peepshow, 48
Peeters, Benoît, 178, 180, 185

Peeters, Frederik, 61
Pekar, Harvey, 48
Penny Arcade, 22, 261
Penny Arcade Expo, 261
Perelman, Ronald, 220
Persepolis. See Satrapi, Marjane
Petit Journal, 14
PhD Comics, 23, 51
Philémon, 58
photo-realism, 153, 159, 161, 166–168
Pictopia, 47
PictureBox, 51
Pilgrim's Progress, 193
Pilote, 58
Pinchon, Joseph, 56
Pini, Richard, 48
Pini, Wendy, 48
Pinsent, Ed, 46
Platinum Age of comics, 26–28
Playboy, The, 87
Playwright, The, 200
Pocket Guide to China, 142–143
Pogo, 129
ponchi, 71
Pop art, 29, 35
Pop Culture Classroom, 134
Popular Comics, 27
Porcellino, John, 49
Pralong, Isabelle, 61
Pratt, Geraldine, 146
Pratt, Hugo, 57–58, 61
Prime Cuts, 47
Print Mint, The, 29, 43, 247
Prix de la ville de Genève, 61
Prix Töpffer, 61
Prize Comics, 29
Project Zero, 256
Publishers Weekly, 133
Pudge, Girl Blimp, 247
Pulitzer, Joseph, 18–19
pulp magazines, 28, 31, 35
Punch, 154–155
punk, 45–46, 49–50, 247
Punk Magazine, 167
PvP, 261

Quadrado, 51
Quality Comics, 29
Queneau, Raymond, 180
Quimby the Mouse, 182

racism, 42, 71, 140, 142, 145, 215–216
Ralph, Brian, 50
Raschka, Chris, 128
Ratier, Gilles, 54–55
Raw, 46, 50, 85
Raw Books and Graphics, 46
Raymond, Alex, 142
Reading Autobiography: A Guide for Interpreting Life Narratives, 227–228, 230
Real Free Press, 44
redîsu manga, 76
"Reign of the Superman, The," 214
Reinventing Comics, 253–254, 262
Reis, Ivan, 108
Rémi, Georges. *See* Hergé
Reprodukt, 59
Rey, H. A., 128
Rey, Margret, 128
Reynolds, Richard, 214, 223
Ribon, 75
Rifas, Leonard, 44
Rip Off Press, 29, 43
Rivière, Jacqueline, 56
Roba, Jean, 58
Robbins, Trina, 43, 243, 246–248
Robertson, Darick, 146
Robertson, Jennifer, 76
Rodriguez, Ralph E., 142
Rodriguez, Spain, 43, 46
romance comics, 7, 32, 121, 241, 243–246, 249, 251
Romeo, 245
Romita, John, Jr., 104
Roomies! (webcomic), 51
Rosenberg, Jonathan, 261
Rosenstiehl, Agnès, 133
Ross, Alex, 153, 161, 166–167, 220
Ross, Charles Henry, 56
Rowlandson, Thomas, 16
Roxy, 245
Royal Commission on the Press, 243, 245
royalties, 45, 103–104, 217, 221
Rozenkranz, Patrick, 40
Rubino, Antonio, 56
Runton, Andy, 133

Sabeti, Shari, 115
Sabin, Roger: on *Ally Sloper*, 15–17; on gender and comics, 244, 246–247
Sacco, Joe, 87; *Palestine*, 48, 51; *Safe Area Goražde*, 85, 140–141
Saenz, Mike, 256
Safe Area Goražde, 85, 87, 140
Saga, 107
Saint-Ogan, Alain, 57
Saitō, Takao, 74
Sale, Tim, 259
Sanders, Joe Sutliff, 128
San Diego Comic-Con, 116
San Francisco Comic Book Company, 29, 43
Sanlaville, Michaël, 63
Satō, Masaaki, 74
Satonaka, Machiko, 249
Satrapi, Marjane, 55, 60, 128; and autobiography, 174–175, 232–234, 237; *Embroideries*, 232; *Persepolis*, 51, 91, 108
Sattouf, Riad, 55, 60
Sayer, Andrew, 113
Sazae-san, 72
scanlation of manga, 78
Scary Go Round, 261
Schodt, Frederik L., 67, 75–76
Scholastic, 133–134
School Friend, 242
Schrag, Ariel, 234
Schuiten, François, 58
Schultze, Carl Emile, 127
Schulz, Charles. See *Peanuts*
Schwartz, Julius, 117, 216
science fiction comics, 44, 63
Scieszka, Jon, 134
Scorpions of the Desert, The, 58
Sea Gate Distributors, 35–36
Seda, Dori, 46
Seduction of the Innocent, 32, 129, 216
self-publishing, 36, 41, 47, 89, 100, 261, 263
Sendak, Maurice, 57; *In the Night Kitchen*, 92, 128; *Where the Wild Things Are*, 131
serialization, 57, 99, 102; as commercial standard, 55–56; declining use in European comics, 59–60; of graphic novels, 84–85, 89, 187; of superhero narratives, 222–223
Serieteket, 62
Seth (Gregory Gallant), 86, 90, 160, 178, 182
Seuling, Phil, 35
Sfar, Joann, 60
Sgt. Kirk, 58

Shanower, Eric, 134
Shatter, 256–257
Shaw, Dash, 89
Shelton, Gilbert, 43–44, 50
Shenzen: A Travelogue from China, 186
Shiga, Jason, 264
Shimizu, Isao, 66, 70–71, 79
Shirato, Sanpei, 72
Shō-chan no boken, 71–72
Shocking Pink, 247
shōjo (girls') manga, 67, 75–77, 129, 241, 248–251
Shōjo Club, 249
Shōjo furendo, 75
shōnen (boys') manga, 67, 75, 129
shōnen-ai (boys' love) manga, 250
Shōnen Jump, 74, 106
Shueisha, 74
Shûkan shōnen sande, 74
shunga, 70
Shuster, Joe, 55; and *Superman*, 103, 214, 221; visual style, 175–177
Siebers, Tobin, 140
Siegel, Jerry, 55; and *Superman*, 103, 214, 221
Silent Three, The, 242
Silver Age of Comics, 29, 34, 121, 132, 217. *See also* ages model of comic book history
Sim, Dave, 47, 104, 263
Simmonds, Posy, 85
Simon, Joe, 214, 244
Simpsons Comics, The, 133
Skull, 43, 48
Slow Death, 44
Slow Wave, 51
small-press comics. *See* alternative comics
Smith, Erica, 248
Smith, Jeff, 92, 133
Smith, Sidney, 21
Smith, Sidonie, 227–228, 230
Smith, Sydney, 128
Smolderen, Thierry, 14–15, 18, 56
Snake Eyes, 47
Snide, 41
Snow White, 132
Sommer, Anna, 62
Söndags-Nisse, 56
Sonic the Hedgehog, 133
Soreiyu, 75
Sorkin, Michael, 146
Sourcream, 247

space race, 216
Spawn, 220–221
Spellbound, 243
Spider-Man (film), 221
Spiegelman, Art: and autobiography, 227, 229, 231–234, 236–237; *Breakdowns*, 182–183; and *Comix Book*, 45; "A Day at the Circuits," 182; and graphic novels, 84–85, 87–88; *In the Shadow of No Towers*, 88, 91–92, 182, 233; *Maus*, 51, 82, 140, 187, 205, 219; *Raw*, 46; and stereotypes, 145; *TOON Treasury of Classic Children's Comics*, 131, 133–134. *See also Maus*
Spirit, The, 142
Spirou, 57, 58
SPX (Small Press Expo), 49
Spy vs. Spy, 254
Stack, Frank, 42
Stakhano, 59
Standard Comics, 29
Stanley, John, 130
Stanley-Baker, Joan, 70
Staples, Fiona, 107
Star*Reach, 29
St. John Publications, 29
St. Louis Republic, 19
Strange Tales, 261
Strapazin, 51, 62
Street Comix, 44
Stuck Rubber Baby, 86
Sturm, James, 178
Suárez, Arturo, 57
superheroes, 7, 30, 90, 123, 141, 213–224; as children's or adolescent reading, 131–132; and comic book industry, rise of, 28, 214–215; and comic book labor, 102–104; dominance of direct market, 37, 118; in film and media, 29, 37, 97–102, 106, 121, 221–222; in graphic novels, 86, 89; international influence, 63, 108; revival of, post-Comics Code, 34, 216; stylistics, 178, 184
Superman, 175–176
Supreme, 220
Swamp Thing, 219
Swarte, Joost, 46
Syndicat des Éditeurs Alternatifs (SEA), 53
syndication, 19–22, 99, 102–103, 105, 129
Szurek, Dave, 116

Tabachnick, Stephen, 227
Taboo, 48
Tagosaku to Mokubê no Tōkyō kembutsu, 71
Takaya, Natsuki, 248
Takemiya, Keiko, 76, 250
Talbot, Bryan, 44, 48
Tale of Two Cities, A, 134
Tammy, 242–243
Taniguchi, Jirō, 56
Tante Leny presenteert, 58
Tardi, Jacques, 58, 178
Tate, Cath, 248
Tatsumi, Yoshihiro, 74
TBO, 56–57, 61
tebeo, 57
Teddy Tail, 21, 56
Teenage Mutant Ninja Turtles, 104, 220
Tegneseriemuseet I Danmark, 62
Telgemeier, Raina, 134
Terminator: Death Valley, 259
Terry and the Pirates, 21–22, 142
Tetsuwan Atomu (Mighty Atom), 73–74
Texas Ranger, The, 41, 43
Tezuka, Osamu: influence on manga and culture, 74, 132; *Ribon no kishi* (*Princess Knight*), 75–76, 249; *Shin Takarajima*, impact of, 72–73
Thomas, Roy, 116, 217
Thompson, Craig, 86–87
Thompson, Don, 116
Thompson, Maggie, 116
Thorn, Rachel Matt, 75
365 Days, 237
Three Mouseketeers, The, 134
Tillieux, Maurice, 58
Timely. *See* Marvel
Tinker, Emma, 42
Tintin, 59, 63, 91, 130, 188, 197, 200; *The Castafiore Emerald*, 178; serialization in *Le petit vingtième*, 57; *Tintin in the Land of the Soviets*, 57; *Tintin* magazine, 58; *Tip Top Comics*, 27
Tirabosco, Tom, 61
Titeuf, 55, 59
Tits & Clits, 43, 247
Tōbaé (magazine), 71
Toba-e pictures, 68
Tokyo pakku, 71
Tokyopop, 77, 248–250
Tomine, Adrian, 49, 145

TOON Books, 133
Töpffer, Rodolphe, 14–16, 54, 56; *Les amours de M. Vieux Bois*, 126; theory of cartooning, 161–164, 166–167, 173
Topolino, 57
To the Heart of the Storm, 87
Tower Comics, 218
translinearity, 187
Transmetropolitan, 146
Tripp, Irving, 130
Trondheim, Lewis, 53, 91
Trudeau, Garry, 22
Truth, 16
Tuffy, 127
24 Nengumi, 76, 250
Twinkle, 242
2000 AD, 58, 108, 243

Uderzo, Albert, 55, 58
ukiyo-e, 70
Uncle Scrooge, 153
underground comix, 26–27, 40–46, 59, 83, 100, 140, 241, 261; alternative comics, influence on, 46–48; autographics in, 232, 235; and direct market, 35–36; in head shops, 42, 45, 117; publishers, 29, 43–44; by women, 246–248, 251. *See also* feminist comics
Understanding Comics. *See* McCloud, Scott
U.S. Senate Subcommittee on Juvenile Delinquency, 32, 129, 216
Utamaro (Utamaro Kitagawa), 70

Vaillant, 58
Valentina, 58
Valentine, 245
Valvoline group, 50
Vance, William, 55
Van Hamme, Jean, 55
Varley, Lynn, 37
Varty, Suzy, 44, 247
Vaughan, Brian K., 107
Veitch, Tom, 43
Vertigo. *See* DC Comics
V for Vendetta, 219
Vivès, Bastien, 63
Viz (British magazine), 47
Viz Media, 77, 106
Vortex, 29

Walker, Brian, 144
Walker, Mort, 129, 144
Walt Disney Studios, 101
Ward, Lynd, 84, 90, 128, 193
Ware, Chris, 85, 90, 160–162, 166, 185; *Acme Novelty Library*, 47, 182–183; and book objects, 187–189; *Building Stories*, 51, 182, 187–189; and fine art, 50; *Thrilling Adventure Stories*, 141; visual style, 197, 205; "The Whitney Prevaricator," 160. See also *Jimmy Corrigan*
WarnerMedia, 29, 98, 101
Was the Cat in the Hat Black? (Nel), 6
Watchmen: as graphic novel, 82, 84–86, 89, 92; publication history, 37, 89; stylistics, 167, 187; and superhero revisionism, 132, 219, 223
Watson, Julia, 227–228, 230–231, 234
Watterson, Bill, 22, 131, 174
webcomics, 7, 23, 51, 115, 121, 260–262
Weber, Eugene, 14
weekly comics magazines: British, 3, 15, 61, 241; continental, 57–58
Wee Willie Winkie's World, 180–181
Weirdo, 46
Wiesner, David, 128
Welch, Chris, 44
Weldon, Glen, 144
Weller, Mike, 44
Wertham, Fredric, 32, 128–129, 216
Wet Satin, 247
Where the Buffalo Roam, 260
White, Cynthia L., 245
White, Daren, 200
White, Ted, 116
Whitlock, Gillian, 7, 140
Whitman Publishing Company, 127
WildC.A.T.s, 220
Wildenberg, Harry, 27
Wilhelm Busch Museum, 62
Williams, Robert, 43
Williamson, Skip, 43
Wilson, G. Willow, 222
Wilson, S. Clay, 43, 45
Wimmen's Comix, 43, 247
Winckler, Paul, 57
Wings, Mary, 43, 247
Winnie Winkle, 22
Wirgman, Charles, 71
Witches and Stitches, 260

Witek, Joseph, 42, 173, 227, 236; on dual address in comics scholarship, 122
Wizard: The Guide to Comics, 257–258
Wolverine, The (film), 97
women's liberation, 41, 43, 246
Wonderful Wizard of Oz, The (2009 comics adaptation), 134
woodcuts, 69–70; woodcut novels, 193
word balloon, 13, 173, 198, 207, 232, 236; adoption in Europe, 57, 200; versus caption, 200; in manga, 70–72; Opper, influence of, 17–18; stylistics, 201; thought balloon, 167
word-image relationships (convergence versus divergence), 195–196
work-for-hire system, 41, 102–103, 221, 223–224
World War II, 7, 32, 57, 72, 215, 242
Wright, Bradford, 35, 244

Xero, 34, 116
XIII, 55
xkcd, 262
X-Men, 37, 218–219, 221
X-Men: The Last Stand (film), 97

Yamagishi, Ryōko, 76
Yang, Gene Luen, 89, 145
Yellow Kid, The, 16–20, 22, 71, 101, 118, 173
Yokoyama, Mitsuteru, 249
Young, Chic, 144
Young, Dean, 144
Young, Skottie, 134
Young Adult Library Services Association, 133
Youngblood, 220
Young Love, 244
Young Lust, 43
Young Romance, 28, 244
Yronwode, Catherine, 243–244
Yummy Fur, 47

Zap Comix. See Crumb, Robert "R."
Zep (Philippe Chappuis), 55
Zig et Puce, 57
zine, 34, 47, 49, 261
ZorkQuest series (Infocomics), 257
zosan manga, 72
Zwigoff, Terry, 233
Zwirek, Jeff, 183